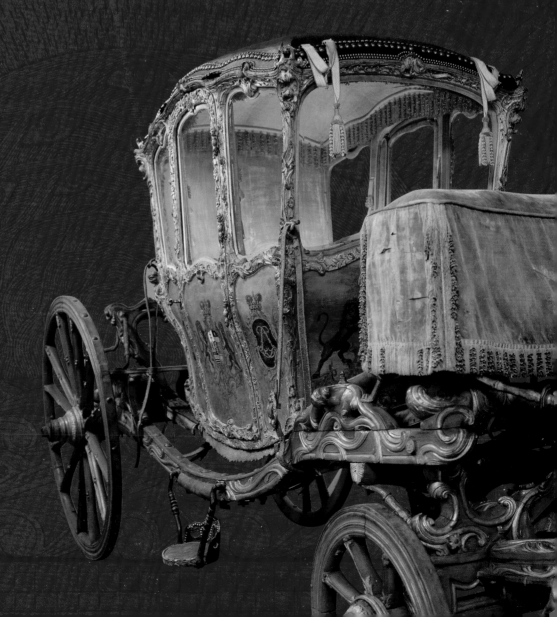

HESSE

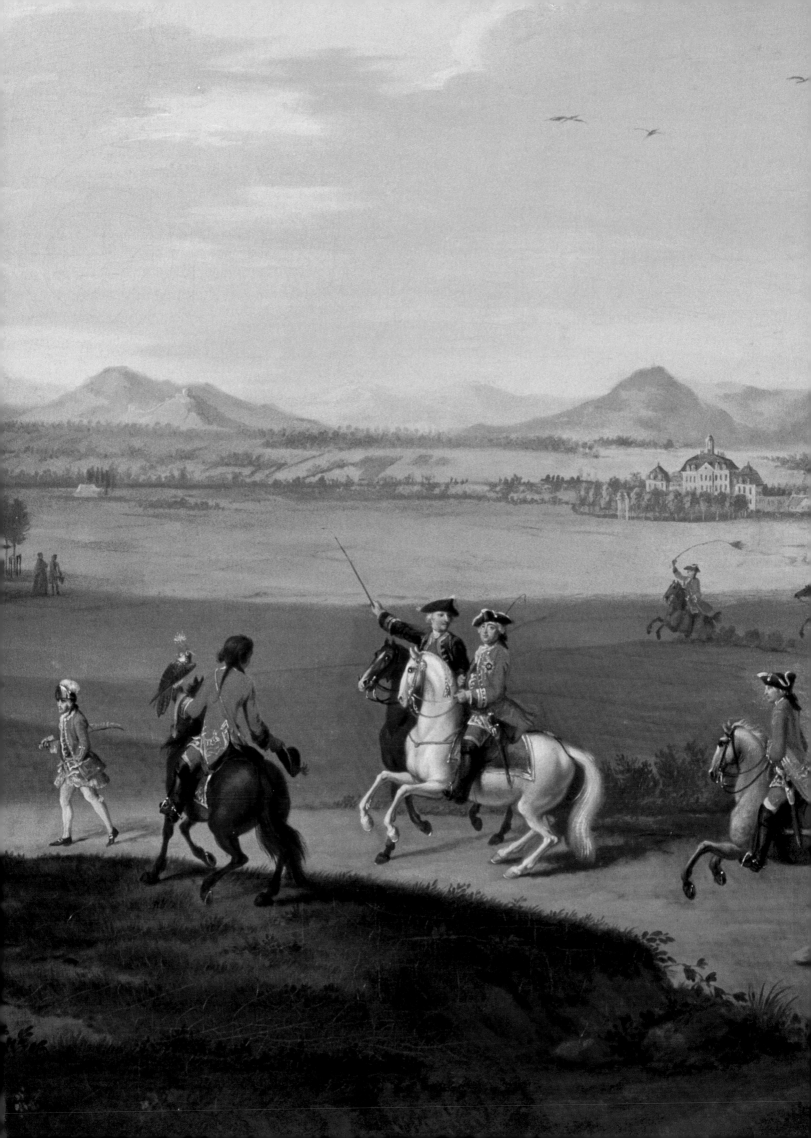

Hesse is one of the sixteen states that make up the Federal Republic of Germany.

It was created as the first German federal state after World War II by an American decree of September 19, 1945, with the city of Wiesbaden designated as the seat of government. The territory of Hesse extends from Kassel, located in the very center of Germany, south and west to the metropolis of Frankfurt am Main. The roots of the modern state of Hesse go deep in history and are inextricably interwoven with the dynasty of princes who bear the name to this day.

The German princely states

In other European countries, the importance of the great feudal nobles faded with the gradual transfer of power effected by kings. By the end of the 17th century, most of the modern European nation-states had been forged by monarchs who ran them with professional centralized administrations. This was not so for a considerable area in central Europe that was not defined by natural boundaries. The German language was the only common denominator among its principalities. In the centuries following Charlemagne's coronation as Holy Roman Emperor in 800, this area of central Europe became known as "The Holy Roman Empire of the German Nation." Although the designation lasted until 1806, it meant little in terms of political power. From the 16th century onward, the Emperor was usually a member of the Habsburg dynasty. Still, he had to be elected and was obliged to consult with the hereditary and ecclesiastical German princes and representatives of the great cities who voted him into office. When Charles V became Emperor in 1519, the Habsburgs appeared to have global rule within their grasp. At the same time Charles inherited rule of Austria, Spain, Burgundy, the Netherlands, and part of Italy, he was colonizing the Americas to the west and defending Europe against Mohammedan attacks from the east. In Germany, however, his powers were kept well in check by the princes who elected him.

Thus he found that he could not stamp out the Reformation once German princes, including the Landgraf of Hesse, adopted the Lutheran faith as their state religion. While the emperor increasingly lost authority, the dynastic leaders of the principalities retained full sovereignty in this loose-knit Empire.

German princes were always in competition and often at war with one another. Exercising independent sovereignty, they formed ever-changing foreign alliances with the opposing powers of Europe. Armies of various nationalities marched unimpeded by natural boundaries, crisscrossing and temporarily occupying various German states in repeated military campaigns. Only the effort to expel the Napoleonic occupation kindled the sense of national identity that would eventually supersede local loyalties. Prussia finally created a unified German Empire in 1871 through a series of wars during which it annexed Hesse-Kassel. After World War II, the occupying Allies divided Germany yet again, and the eastern zone became part of the Communist bloc. Even in today's Germany, reunited since 1990, the federal administration echoes the divisions of the historic principalities. Although the German federal state of Hesse is somewhat larger than the traditional Hessian territories, it retains an identity based on history as much as geography and is as different from the state of Bavaria as the American state of Virginia is from Massachusetts.

The Hesse Dynasty

Descending from the 13th-century Dukes of Brabant, the family of Hesse assembled a domain out of various territories primarily by means of marriage and dynastic transfer. By the 16th century, Hesse had grown to be one of the largest German principalities, its power enhanced by its strategic central location. The dynamic Hessian Landgraf Philipp the Magnanimous (1504–1567) played a leading role in the success of the Reformation, but the division of his lands among his heirs put an end to the possibility that Hesse would dominate the region. Four centuries

were to pass before the branches of the family would be brought together again when in 1960 Ludwig (1908–1968), head of the Hesse-Darmstadt branch, who had no children, adopted Moritz (b. 1926) of the Hesse-Kassel line.

Hessian rulers were significant participants in all the great movements of European history. They exemplified the best German princes of their respective times—from Philipp the Magnanimous, who was the first prince to install the Lutheran Church in his state; to the exceptional military entrepreneurs and patrons of arts and culture of the late 17th and 18th centuries; as well as Grand Duke Ernst Ludwig (1868–1937), who promoted the Jugendstil fusion of arts and industry. Further, they intermarried with all the ruling houses of Europe, forming an essential part of the network that was intended to restore liberalized stability to Europe after the cataclysm of the French Revolution and Napoleonic occupation had overturned the old order. The German nobility was divested of its political role in 1918 by the Weimar Republic, only to be solicited again by Hitler in his rise to power. In this publication, the noted historian Rainer von Hessen (b. 1939, cousin of the current landgraf) recounts the full story of the Hesse dynasty in an essay that traces its path from the Middle Ages to the present (see pp. 241–77).

Hessian soldiers

The history of Hesse intersects with that of the United States in the War of Independence. Hessian regiments of crack troops were brought over by the British to put down the colonial rebellion. They won such respect that all German soldiers in America were termed "Hessians." They represented the finest examples of "auxiliaries." These were professional armies raised, trained, and equipped for hire to a client state. The practice was much criticized in the 19th century but had been long accepted in European politics, and even today the Papal Swiss Guard recalls centuries of distinguished Swiss auxiliaries. Hesse had become a valued, and often subsidized, ally on the basis of its outstanding military when

Landgraf Karl of Hesse-Kassel (1654–1740) shifted the arrangement onto a commercial basis in his 1677 contract with the king of Denmark. Hessian princes continued as leading entrepreneurs of military excellence, personally training their troops and often sharing the perils of the battlefield. Hessian soldiers were so sought after by the warring states of Europe that landgrafs were able to negotiate highly favorable subsidy treaties that brought prosperity to Hesse. Beyond enriching the state treasury, the monies from abroad were filtered to the many trades engaged in supplying the armies and the peasant families of the well-paid soldiers.

custodians of Art

From generation to generation, the Hesse family passed on not only titles and lands but the belief that they were responsible for an inalienable cultural heritage. This moral duty derived from their Lutheran creed, which justified the sovereign as leader of both spiritual and secular administration for his domain, with God-given responsibility for the direction and welfare of his people. The art collection—amassed, preserved, and enhanced by members of the Hesse family over the centuries—illustrates the family's interests, ambitions, and means, but it also introduces the broader picture of German culture in all its complexity.

As active participants in the German Renaissance, Landgraf Wilhelm the Wise (1532–1592) and his son Moritz the Learned (1572–1632) regarded the assembling of a collection of works of art, be they paintings, scientific instruments, or antiquities, as part of the enhancement of the state and a personal duty of leadership. In 1591–1593 they established a *Kunstkammer* in the buildings of their residence complex in Kassel, consisting of rooms where their collections could be organized and presented so that the wonders of the works of man could be properly appreciated. Wilhelm VIII (1682–1760) became enamored of 17th-century Dutch painting during his service as military governor in

Holland. The gallery he built to house his purchases on his return to Kassel earned fame throughout Europe. (Seized by Prussia in the annexation of Hesse-Kassel in 1866, Wilhelm's collection is now the pride of the Old Masters gallery of the Kassel Museums.) Reflecting the intellectual approach of the Enlightenment, Landgraf Friedrich II (1720–1785) erected the *Fridericianum* in 1779. It was the first museum building on the continent undertaken to house and display princely collections for the general public. In 1820 Grand Duke Ludwig I opened his collections to the public in the Grand Ducal Museum, which was housed in his residence castle in Darmstadt. In 1908 Grand Duke Ernst Ludwig (1868–1937) installed the extensive Hesse-Darmstadt porcelain collections as a public museum in the Georg Palace of Darmstadt. After World War II, Landgraf Philipp (1896–1980) marshaled the family resources to restore Schloss Fasanerie and open it to the public as a museum of the Hesse-Kassel collections. Adapting this tradition to today's art world, his son Landgraf Moritz, conceived of the present exhibition that would bring his heritage to an American audience.

A multi-faceted collection

The Hesse family collection, now incorporated in the Hessian House Foundation, is truly a treasure trove. Although Hesse lies geographically in the heart of Germany, it has been far from insular. The cosmopolitan character of the Hesse family is reflected in their collections, which are not limited to the art produced in German-speaking countries. Marriage was the greatest tool of political alliance in Europe over the centuries, and none used it to better advantage than the Hesse family. As Protestants, they avoided marriage with Catholic dynasties, preferring to join with the blood lines of the ruling families of England, Denmark, and Russia as well as of other German princes. The dowries, gifts, and inheritances resulting from these marriages are constantly evident in the Hesse collections. Beyond this, there was the impulse to collect for aesthetic satisfaction; this was carried through to the 20th century by

Landgraf Philipp, whose focus on classical antiquities did not stop him from acquiring a superb Japanese porcelain vase or a fine French cabinet. Landgraf Moritz is a presence in the art market today, sleuthing out meaningful additions to his heritage.

The Exhibition

The selection of works to realize Landgraf Moritz's vision of an exhibition for an American audience is an attempt to re-create the voyage of discovery as one follows him through room after room in castle after castle. He speaks of every object as if it were a lifelong friend, whether a painting or a carriage created by specialist in the employ of the Hessian court, or a Fabergé *objet de vertu* given by a Romanov relative, or the great Holbein Madonna passed down from a Prussian ancestor. The assemblage of these works of art defines his family, but it also gives insight into the broader culture that underlies the modern Germany. For the "old" Europe is not dead; its culture is the living root system supporting the strength of today's "new" Europe. Citizens of Hesse now, as in ages past, find a sense of identity and pride in Hessian castles and their contents. That was why they were created in the first place, and their emotional appeal has weathered the centuries. As Americans we can share in the delight and awe that these works of art inspire, and through our shared aesthetic appreciation come closer to an understanding of a country that is our partner in the modern world.

Penelope Hunter-Stiebel

In this publication first names have been given in the German form (e.g. *Wilhelm*, rather than *William*); but English usage has been followed for titles (e.g. *Prince of Hesse*, rather than *Prinz von Hessen*), with the exception of the title *Landgraf*, which is exclusive to Germany.

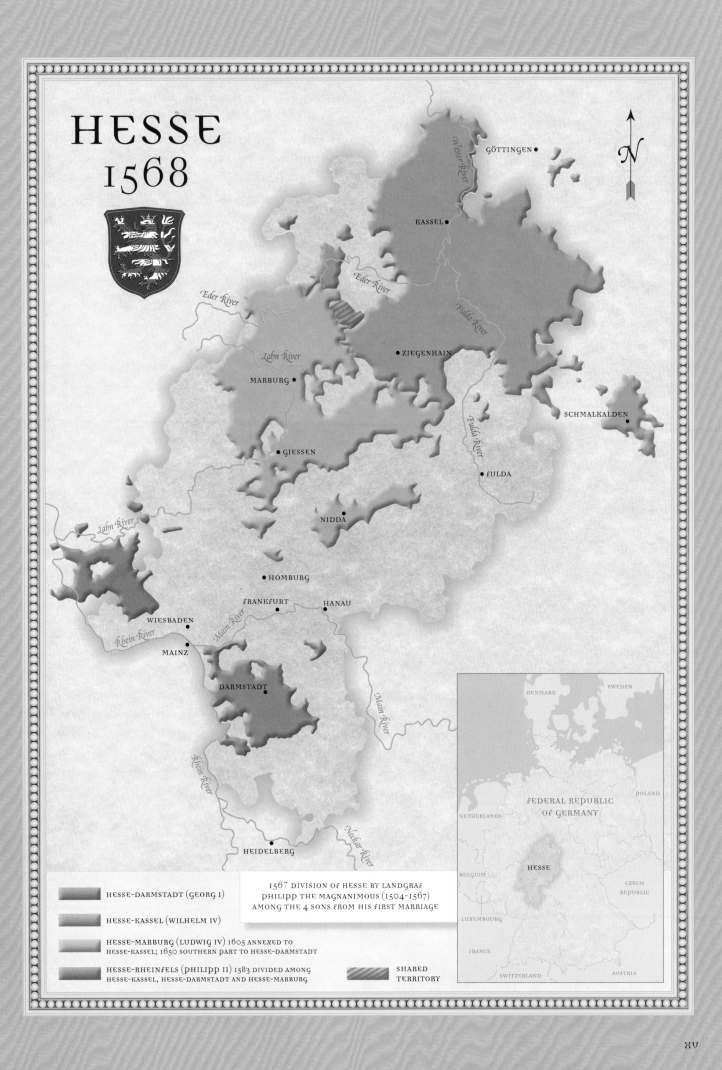

HESSE
1568

GÖTTINGEN

Weser River

KASSEL

Eder River

Eder River

Fulda River

Lahn River

ZIEGENHAIN

MARBURG

SCHMALKALDEN

Fulda River

GIESSEN

FULDA

NIDDA

Lahn River

HOMBURG

FRANKFURT HANAU

Main River

WIESBADEN

MAINZ

Rhein River

DARMSTADT

Main River

Rhein River

Neckar River

HEIDELBERG

1567 DIVISION OF HESSE BY LANDGRAF
PHILIPP THE MAGNANIMOUS (1504-1567)
AMONG THE 4 SONS FROM HIS FIRST MARRIAGE

HESSE-DARMSTADT (GEORG I)

HESSE-KASSEL (WILHELM IV)

HESSE-MARBURG (LUDWIG IV) 1605 ANNEXED TO
HESSE-KASSEL; 1650 SOUTHERN PART TO HESSE-DARMSTADT

HESSE-RHEINFELS (PHILIPP II) 1583 DIVIDED AMONG
HESSE-KASSEL, HESSE-DARMSTADT AND HESSE-MARBURG

SHARED TERRITORY

DENMARK SWEDEN

FEDERAL REPUBLIC
OF GERMANY

NETHERLANDS

POLAND

HESSE

BELGIUM

CZECH
REPUBLIC

LUXEMBOURG

FRANCE

SWITZERLAND AUSTRIA

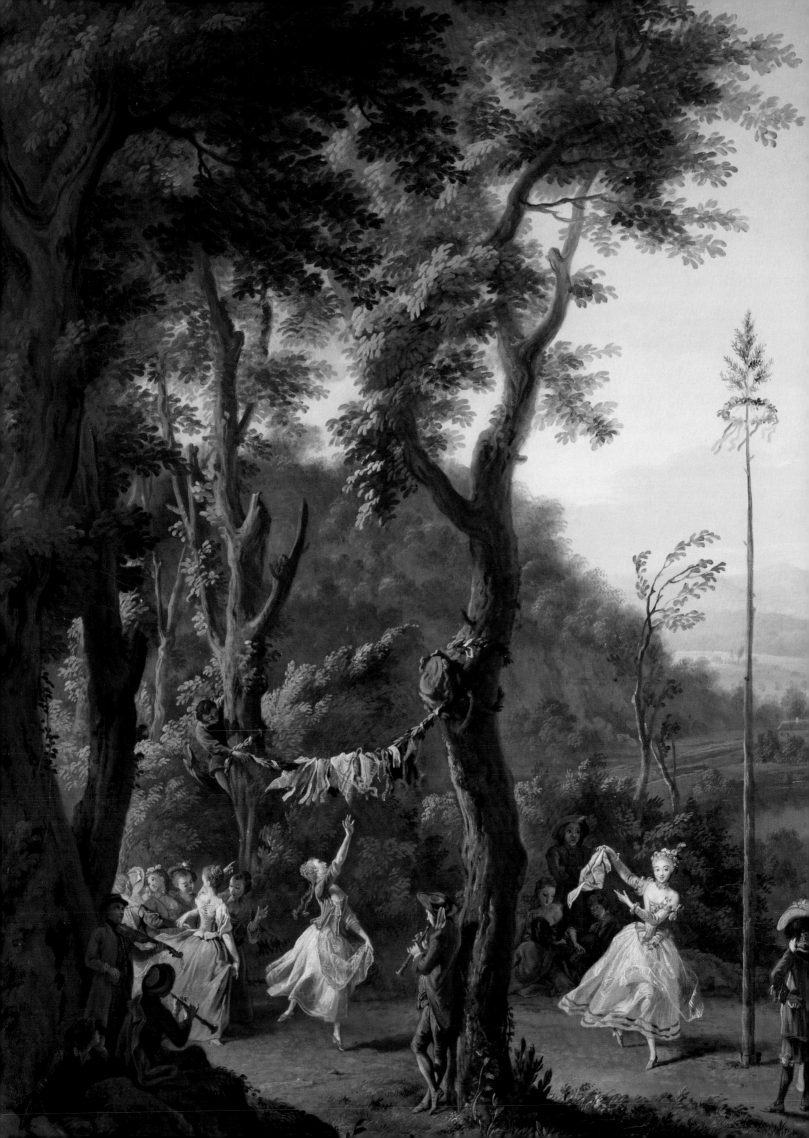

HESSE

A PRINCELY GERMAN COLLECTION

penelope Hunter-stiebel

WITH FOREWORDS BY

H.R.H. Moritz Landgraf of Hesse

and

john E. Buchanan, JR.

portland Art museum

oregon

contents

This book is dedicated to Ann and Bill Swindells, whose support has made it possible to document and commemorate the exhibition *Hesse: A Princely German Collection* organized by the Portland Art Museum for exclusive presentation in Portland, Oregon. With a lifetime far beyond the exhibition dates, the publication is a legacy for the international cultural exchange project as well as one for the princely House of Hesse.

The Portland Art Museum began to lay the foundation for this extraordinary exhibition from the private collections of the princes of Hesse during its collaboration with the museums of St. Petersburg in 2000. Through entrée provided by the Stroganoff Foundation and its trustee, Mrs. William McCormick Blair, Jr., the Museum was introduced to His Royal Highness Moritz Landgraf of Hesse.

At the Landgraf's invitation, I visited the Hesse family, whose castles and properties lie geographically in the heart of Germany surrounding Frankfurt. During my interviews and tours with the Landgraf and his son, Prince Donatus, I was consistently astonished to find objects and works of art known to me—up until that time—only through books and reproductions.

Equally intriguing was the unfolding saga of how these artistic treasures came into the Hesse family, which finds itself at the center of a royal web spun over centuries by intermarriages with most of the ruling houses of Europe, particularly with that of Queen Victoria.

Our conclusion was that American museumgoers have had many opportunities to view the art collections found within the treasure houses of Great Britain as well as those from the chateaux of France and the palaces of Russia. However, we have not, until today, studied the princely collections of Germany.

Together with the Hesse family, we determined that the time was right to share with the American public their family's story and its venerable artistic holdings in an exhibition that would present, *de facto,* an overview of Germany's cultural history manifested in the artistic holdings of one of that country's most distinguished families.

Although less well-known today by those who are not scholars or specialists, the Hesse collection is one of the most important private art holdings in central Europe. In its day, it was the first to be made accessible to the public in the *Fridericianum,* erected in Kassel by Landgraf Friedrich II in 1779, as the first museum building on the Continent devoted to the exhibition of princely collections.

Remarkably, given the vagaries of history, the Hesse collections have remained intact for hundreds of years. Today, they continue to be conserved and enhanced by the connoisseurship of Landgraf Moritz.

We are indebted to His Royal Highness Moritz Landgraf of Hesse for his enthusiastic agreement to work with the Portland Art Museum in the organization and realization of this exhibition and book. His knowledge of the collections and family history equal that of any curator or scholar. He has lived throughout his life knowing each object and its intrinsic value and fully appreciating its beauty and uniqueness.

It has been empowering and pleasurable to also have the close involvement of His Royal Highness Donatus Prince of Hesse. He is taking up the mantle in agreeing to share the family's private art and stories with the world as we enter a new century. I am indebted to Prince Donatus for his daily efforts in assisting our Museum to realize this project.

From its inception, Penelope Hunter-Stiebel, Portland Art Museum's Curator of European Art, exercised her inimitable skills of connoisseurship, scholarship, and determination to realize this project. I am deeply grateful to her for her herculean efforts to achieve an exhibition and book of such distinguished quality. She was guided in Germany by Dr. Markus Miller, Director, Museum Schloss Fasanerie.

Dr. Miller deserves our special thanks for his collaboration on the organization of the exhibition and direction of the complex issues of restoring works of art for the Hessische Hausstiftung. He was ably assisted by Joann Skrypzak, Research Assistant and Coordinator for the exhibition in Germany, who also served as a translator and contributor to the catalogue. She is to be commended for her exemplary work.

I would also like to extend our appreciation to Christine Klössel, Archivist, and Andreas Dobler, Registrar and Collections Manager, both at Schloss Fasanerie. In addition, we thank Bettina John-Willeke, Director Residenzschloss Darmstadt, and Monika Kessler, Director Jagdschloss Kranichstein, for their invaluable assistance.

The Portland Art Museum is indebted to the following individuals for lending their expertise. Our thanks go to: Joseph Baillio, Wildenstein & Co., New York; Anthony Blumka, Blumka Gallery, New York; Barry Friedman, Barry Friedman Ltd., New York; Eduardo Galán, Curator of Carriages, Patrimonio Nacional, Madrid; Walter J. Karcheski, Jr., Frazier Historical Arms Museum, Louisville; Bruce Livie, Galerie Arnoldi-Livie, Munich; Marcus Marschall, Daxer & Marschall, Munich; Peter L. Schaffer, A La Vieille Russie, New York; Gerald G. Stiebel, Stiebel, Ltd., New York; David Tunick, David Tunick, Inc., New York; and Michael Ward, Ward & Company, New York.

The staff of the Museum is to be commended for its diligence and perseverance in successfully bringing this international cultural exchange to fruition. In particular, I would like to thank Lucy Buchanan, Elizabeth Martin-Calder, Karen Christenson, Sharon Johnson, Lisa Borok, and Susan Egger for their work. And, Clifford La Fontaine and Matthew Juniper once again deserve credit for an outstanding installation.

This exhibition and book are made possible by the generous support of many Museum friends and patrons. We thank, in particular, our corporate sponsors Wells Fargo, Lufthansa, Freightliner Corporation, Margulis Jewelers, Mario's, Maybelle Clark Macdonald Fund, Fidelity National Title Company of Oregon, Pacific Coast Restaurants, Christie's, The Boeing Company, and Stimson Lumber Company. In addition, we extend our appreciation to Ann and Bill Swindells, Marty and Kay Brantley, Andrée Stevens, Peter and Julie Stott, Nani Warren, Katrina and Ted Wheeler, Don and Mary Frisbee, Janet and Richard Geary, Ronna and Eric Hoffman, John and Willie Kemp, Helen Jo and Bill Whitsell, and the numerous others for their investment in this unique cultural opportunity for the many Americans who share in its worthiness.

John E. Buchanan, Jr.
The Marilyn H. and Dr. Robert B. Pamplin, Jr. Director
Portland Art Museum

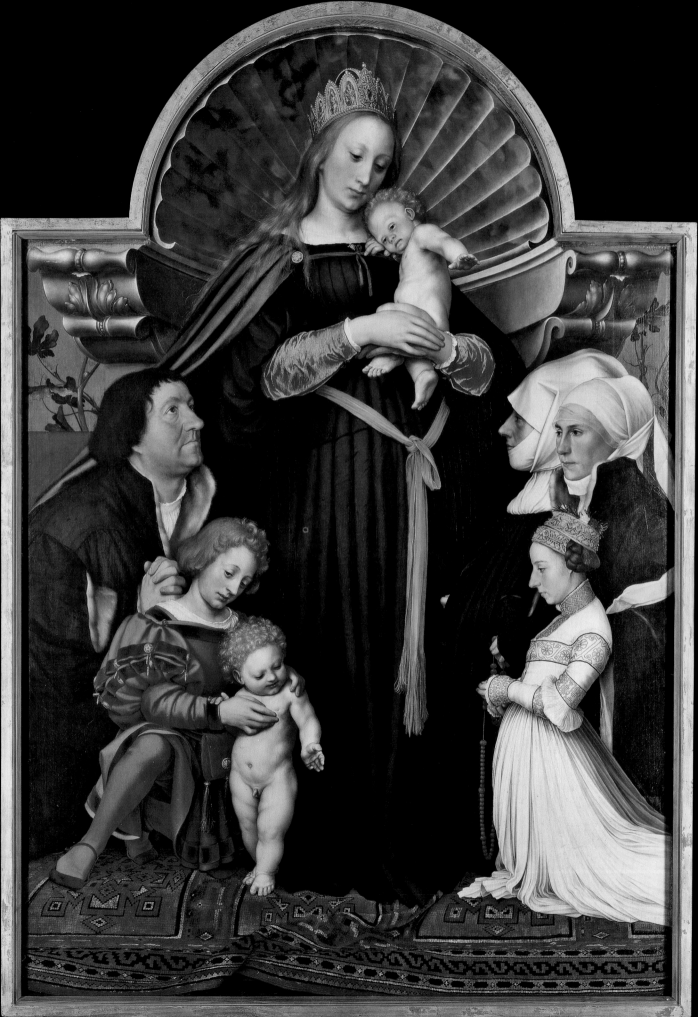

I f there is anything that gives me more pleasure than collecting art, it is the delight of sharing my pleasure in art with other people.

I inherited both these things almost from my cradle: my ancestors, both in Darmstadt and in Kassel, had already engaged in building up collections and founding museums, so that in this way they could share the experience of their own collections with people who were similarly interested in art.

Since my youth I have personally shared in the experience of the development of the museum at Schloss Fasanerie, the family's newest museum, whose first exhibition spaces were created and opened by my father in 1951. Forty years later, I added my contribution to his life's work by having the bathhouse of the Schloss converted into an exhibition building in which a special exhibition of works of art from the Hessian House Foundation has since been presented every year.

It has long been my great dream to exhibit the treasures of my family in the United States, a country whose activities in the fields of museums and art exhibitions we "old Europeans" have long observed with great admiration. This dream is now being fulfilled by the opening of the exhibition "Hesse: A Princely German Collection" in the Portland Art Museum. I am grateful for the mediation of Mrs. William McCormick Blair, Jr., who introduced me one evening in the fall of 2002 to her friends John and Lucy Buchanan: this could be described as the moment of birth of a great, and for me enormously meaningful, project.

I have followed the path of this idea from its origin to the brilliant opening of the exhibition with excitement and pleasure and would like to thank from the bottom of my heart all those on both sides of the Atlantic who have been involved in making my dream a reality.

The exhibition being shown here also represents a special first in the history of my family: it is the first time in Hesse's history that the best works of art from the private collections of both the Darmstadt and the Kassel branches of my family have been shown together side by side. I am very enthusiastic about this, even if the tragic air crash of 1937, which led to the extinction of the Hesse-Darmstadt branch of the family, still occupies my thoughts. For myself and all subsequent generations, the merging of the art collections of both branches of the Hesse family means a gift, but also a responsibility, part of which I see as being fulfilled by the exhibition in Portland.

The most important treasure in my family's art collection is Hans Holbein the Younger's Madonna, a work that is close to my heart for very personal reasons. As a nineteen-year-old, I was sent by my uncle, Prince Ludwig, on an unforgettable adventure on the cold snowy night of December 28, 1945: with the help of Clyde Harris, an American Fine Arts and Monuments officer, I was to retrieve the Holbein Madonna from Coburg Castle. With Harris leading the way in a jeep, I followed in the back of an American army truck. The painting had been sent from Darmstadt to Silesia for safe storage during the war. In February of 1945, to keep it from the advancing Red Army, it had been transferred to Coburg via Dresden on the very day the city was bombed. The painting was spared the flames that engulfed Dresden only because its transport truck was parked in an open public park in nearby Herrenhut. We found it in the Coburg Castle dungeon, where by luck it had been spared in both the Polish looting and the American bombardment of the castle. Leaving Coburg, our truck caught fire. Lacking tools, it was impossible to release the painting whose crate was lashed and nailed to the truck bed, and the fire extinguishers of passing jeeps failed. We finally suffocated the flames with sand and earth, and I was able to bring the family treasure to Schloss Wolfsgarten intact. At that time I never would have dared to dream that I would one day accompany this most important family painting on its journey to the West Coast of America—this time carefully packed with all the latest safety precautions.

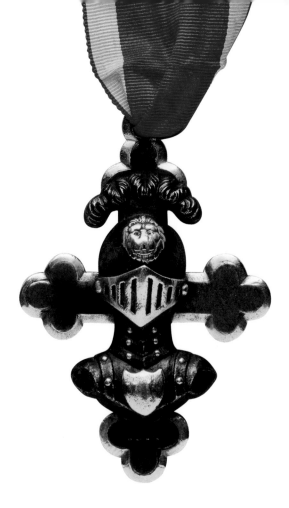

As head of my family and its foundation, I have striven to expand and care for a major art collection and the Museum Schloss Fasanerie largely without state support. I am therefore particularly appreciative of the staff of the Portland Art Museum, who with their personal commitment and expert knowledge have made this exhibition and catalogue possible. I congratulate the Museum on its wonderful trustees and patrons, who have made the concerns and needs of the Museum their own with great devotion and immense generosity. We have this admirable group to thank for the fact that over the last two years the objects that have taken the journey to the United States have been restored and conserved with a commitment unique in the history of the Hessian House Foundation.

I hope that you and everyone who sees the exhibition and the catalogue will feel part of this community and share my delight in the works of art that are being shown.

H.R.H. Moritz Landgraf of Hesse

Above: The Hessian Order of the Iron Helmet (see p. 145).

International Committee of Honor

H.R.H. Moritz Landgraf von Hessen, *Chairman*

H.R.H. Donatus Prinz von Hessen, *Co-Chairman*

S.K.H. Franz Herzog von Bayern

Mrs. William McCormick Blair, Jr.

Owsley Brown

S.H. Dr. Christoph Graf Douglas

Pierre Durand

Christopher C. Forbes

Nicholas Hall

I.K.H. Alexandra Prinzessin von Hannover

Waring Carrington Hopkins

Richard Knight

Ministerpräsident von Hessen, Roland Koch

Dr. Otto Graf Lambsdorff

Baroness Hélène de Ludinghausen

Conte Enrico Marone-Cinzano

Mrs. Michael Rockefeller

Baron Eric de Rothschild

Mr. and Mrs. Rolf Sachs

Suzanne Syz

S.K.H. Dr. Philipp Herzog von Württemberg

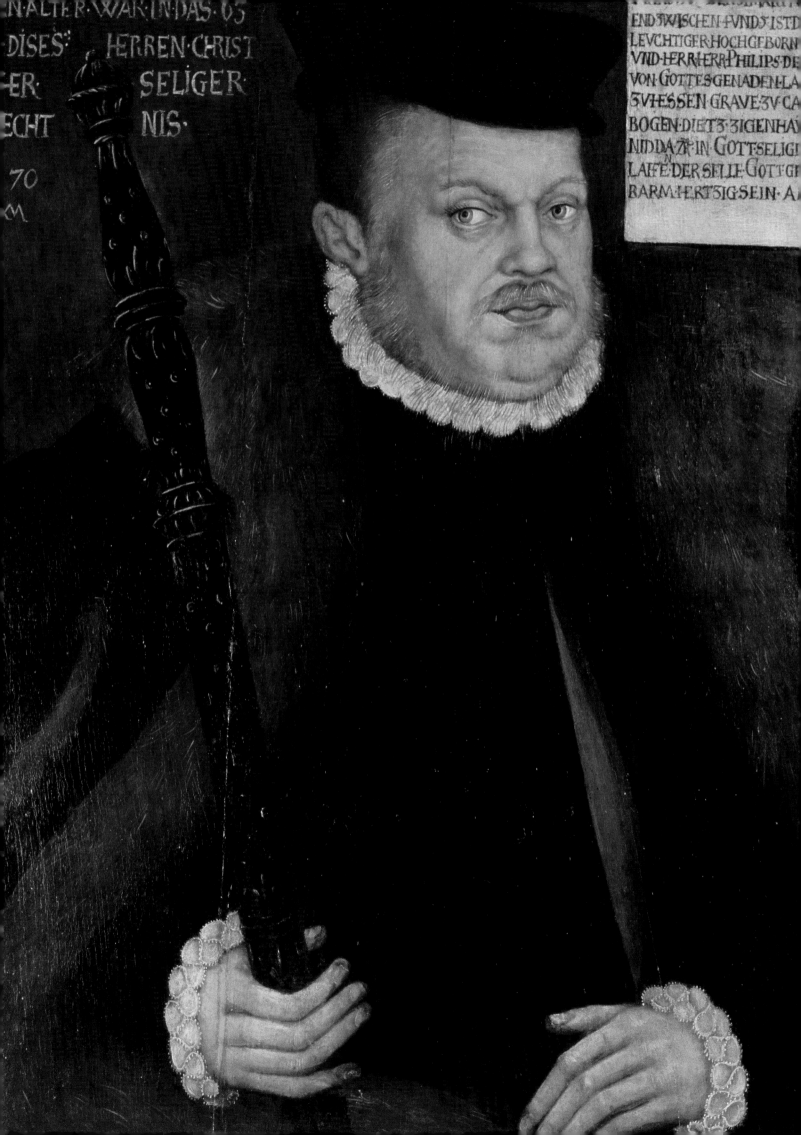

N ALTER WAR IN DAS 65
DISES HERREN CHRIST
ER SELIGER
ECHT NIS
70
M

END ZWISCHEN ↑ VND 5 IST D
LEVCHTIGER HOCHGEBORN
VND HERR HERR PHILIPS DE
VON GOTTES GENADEN LA
ZVHESSEN GRAVE ZV CA
BOGEN DIETZ ZIGENHA
NIDDA ZV IN GOTTSELIGI
LAIFE DER SELLE GOTT G
BARM HERTZIG SEIN A

Reformation and the Rise of Hesse

Few of the world's millions of Protestants today know the name of Philipp the Magnanimous, Landgraf of Hesse (1504–1567), or what they owe to him. Previous generations of the Hessian dynasty assembled small territories into a sizeable state that sprawled across the heart of Germany. Philipp thus wielded considerable weight when, in 1526, he became the first German prince to instate the reforms of Martin Luther in his domain. The impassioned landgraf of Hesse went on to rally other princes to form a Protestant league against Emperor Charles V. The very term "Protestant" derives from their protest against the outlawing of the followers of Luther at the Imperial Diet of 1529.

Hesse might well have become the most important state in Germany had Philipp been less magnanimous in his decision to divide his land among his offspring. The dynasty was to remain divided into the late 20th century, with Hesse-Kassel as the more important branch until the rise of Hesse-Darmstadt during the Napoleonic era. Even with only half of his territory, Philipp's immediate successors in Hesse-Kassel kept their court and capital at the cultural forefront among German principalities.

Philipp's Protestant initiative was part of the current of social change at the end of the medieval era. The Catholic Church's status as the dominant organization in Europe was a thing of the past. The growing power of the rulers of territorial states was the way of the future. The arts in Protestant German states were diverted from the Church to the glorification of princes. Lutheran doctrine discouraged religious imagery in churches, so painters were obliged to focus on the more restricted scope of dynastic portraiture. Architects, however, were encouraged to build ever more impressive edifices that would demonstrate the ruler's importance. The looms of Flanders were never idle as weavers supplied the portable furnishings that countered the chill of princely castles with monumental scenes from mythology and classical history. The goldsmiths of Nuremberg and Augsburg could hardly keep up with the demand for the glittering showpieces that came to define the status of the highly competitive German princes. Hesse was a full participant in this movement by which politics were expressed through art.

The shift away from a faith-based society spurred intellectual life. Philipp founded the first Protestant university at Marburg in 1527, and his successors were to assemble an important library of books they are known to have read. Fueled by the personal enthusiasm of the Landgrafs Wilhelm the Wise and his son Moritz the Learned, Kassel became a center for the study of mathematics and astronomy. They formed a renowned collection of scientific instruments that offered aesthetic as well as intellectual gratification.

Most of the Renaissance and Baroque treasures of the Hesse family were lost to Prussia in 1866 when it annexed Hesse-Kassel. The examples in the Hesse family collection today came through marriage with the Prussian line. With the specific intent to replenish the depleted Hessian cultural heritage, Empress Friedrich (oldest daughter of Queen Victoria and wife of the Prussian Kaiser Friedrich III) bequeathed her own extensive collections to her youngest daughter Margarethe, who had married Friedrich Karl of Hesse-Kassel.

PH-S

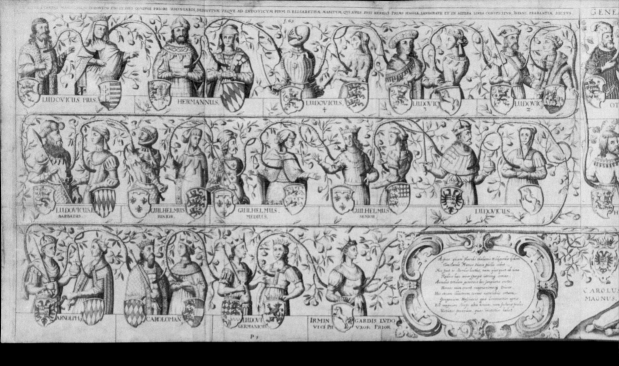

Geneaology (Genealogia Hassiaca a Carolo Magno . . . from *Monumentum Sepulcrale),* Kassel, 1638
Engraving
H. 12⅛ in. (30.8 cm); W. 5⅜ in. (131 cm)
FAS Library G IV HessK LM 1638 1c

An important element of a sovereign's self-representation was proof of his own origin of higher nobility. Accordingly, the Hessian Family greatly valued its historical legitimization. The print series, composed of three sheets totaling 131 centimeters in length, depicts the Hessian House line of ancestry in three registers beginning with Charlemagne. The line of Hessian princes begins with its forefathers, the dukes of Lorraine-Brabant, from which Lambert I (d. 1015), seen in the lower right with his wife Gerberga of the Carolingian line, descended. In the center of the middle register is the first Landgraf of Hesse, Heinrich I, whose succession ends in the upper right with Landgraf Wilhelm V (1602–1637). The pictorial representation of the genealogy is modeled on the Old Testament motif of the tree of Jesse (Isaiah 11:1). From the breasts of the sleeping Romano-German emperor Charlemagne and his wife lying next to him, springs a root that entwines through the breast of each succeeding generation as it winds across the page. The name of the heirs, his coat of arms, and that of his spouse complement the family tree, which on the left side develops into a rose tree and, on the right, the "Hessian" bough appears as a grapevine.

CK

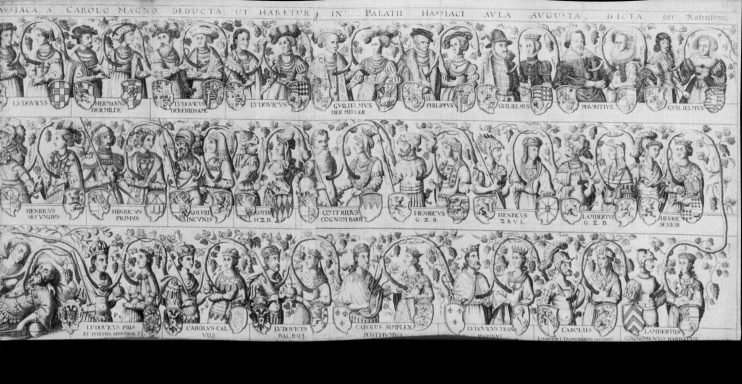

ASSIACA A CAROLO MAGNO DEDUCTA, UT HABETUR, IN PALATII HASSIACI AULA AUGUSTA, DICTA der Rotenstein.

LUDOVICUS	HERMANNUS DER MILDE	LUDOVICUS DER FRIDSAM	LUDOVICUS	GUILIELMUS DER MITLER	PHILIPPUS	GUILIELMUS	MAURITIUS	GUILIELMUS

HENRICUS SECUNDUS	HENRICUS PRIMUS	AGUFRIDUS INCUNIS	GUITH H.Z.B	GOTFRIDUS COGNOM BARB	HENRICUS G.Z.B	HENRICUS Z.B.V.L	LAMBERTUS G.Z.B	HENRIC SENIOR	

LUDOVICUS PIUS ET IUDITHA EIUS UXOR	CAROLUS CALVUS	LUDOVICUS BALBUS	CAROLUS SIMPLEX POSTHUMUS	LUDOVICUS TRANSMARINUS	CAROLUS	LAMBERTUS COGNOMENTO BARBATUS

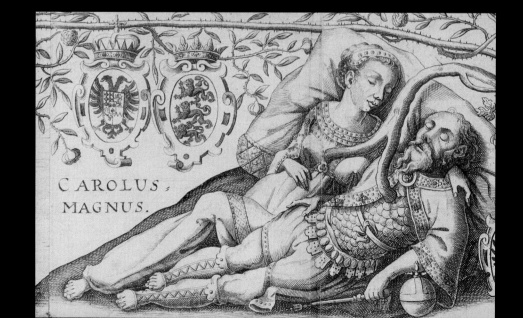

CAROLUS MAGNUS.

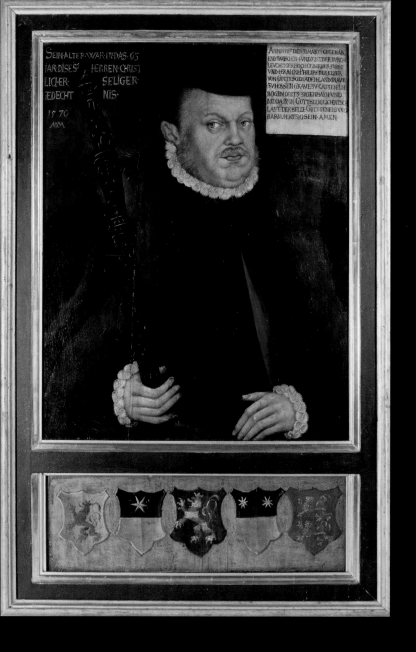

MICHAEL MÜLLER (Kassel, act. 1536–1574)

Landgraf Philipp I of Hesse (Philipp the Magnanimous), aged 63, 1570

Oil on panel

H. 31 in. (78.8 cm); W. 25 in. (63.5 cm)

Signed upper left: 1570 MM; inscribed upper left: *Sein Alter war in das 65 Jar dises Herren Christlicher Seliger Gedechtnis* ("In blessed Christian memory, this gentleman's age was 65"); upper right: *Anno 1567 den 31 Marty gegen Abend zwischen 4 und 5 ist der durchleuchtiger hochgeborner Furst und Herr Herr Philips der Elter von Gottes Genaden Landgrave zu Hessen, Grave zu Catzenelnbogen, Dietz, Zigenhaÿn, und Nidda in gottseliglich entschlafen der se[e]le Gott geneig und barmherzig sein Amen.* ("On March the 31st, 1567, near evening between 4 and 5, the illustrious, highborn Prince and Gentleman, Gentleman Philipp the elder, by God's grace the Landgraf of Hesse, Count of Katzenelnbogen, Dietz, Ziegenhain, and Nidda, God-blessedly passed away, God be inclined toward and merciful on his soul, amen.")

FAS on loan from City of Kassel; schwarz 17 1905 A

Hessen court painter Michael Müller depicts Philipp the Magnanimous as a robust, older statesman in this portrait painted three years after the landgraf's death in 1567. A commission from Phillip's successor, Wilhelm IV, it reproduced one of Müller's own earlier paintings. The official representation presents the late landgraf with his scepter and the shields of the Hesse counties of Katzenelnbogen (red lion), Ziegenhain (single star), Nidda (two stars), and Diez (two golden leopards) all united under Hesse (striped lion). The portrait was widely reproduced and remained the basis for many engravings for centuries to come.

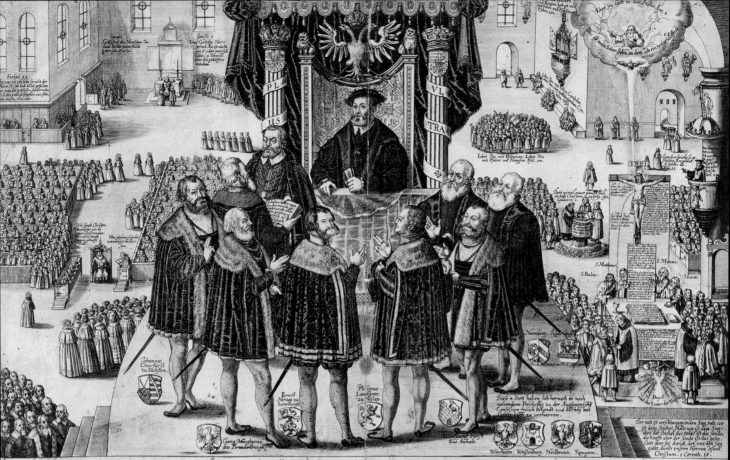

JOHANN DÜRR (Augsburg, act. ca. 1625, d. 1680)

Presentation of the Confessio Augustana *at the Imperial Diet of Augsburg on June 25, 1530,* Dresden, 1630

Engraving

H. 11⅛ in. (28.2 cm); W. 15⅞ in. (40.5 cm)

Inscribed bottom right: *Johann Dürr sculpsit;* bottom center: *1630*

FAS Archiv HA 528

To restore peace in the empire after the turmoil of the Reformation, the Reichstag, or Imperial Diet, of Augsburg of 1530 attempted to settle the differences between Catholics and Protestants. Philipp Melanchthon's *Confessio Augustana,* the fundamental writings of the Protestant imperial body, were presented on the occasion to Emperor Charles V in the Chapter Hall of the Episcopal Palace. Before him stand the Protestant imperial princes in a semicircle. They are identified with their names and coats of arms: from left to right, Johannes Elector of Saxony, Georg Margrave of Brandenburg, Ernst Duke of Luneburg, Philipp of Hesse, and Wolfgang Prince of Anhalt. In the background, several scenes of Protestant religious practices, such as a christening, preaching, singing, and marriage, are depicted. In the right foreground, believers gather to receive communion at an altar where the four evangelists point to writings that represent the core of the faith.

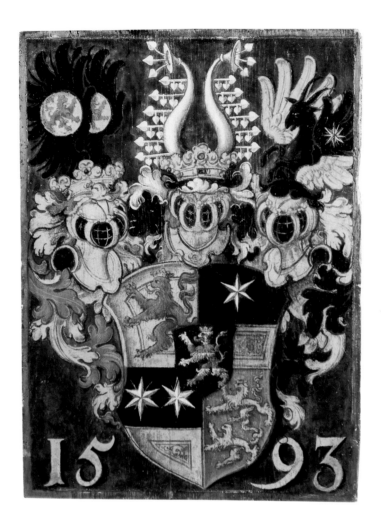

Armorial Panel with Coat of Arms of Landgraf Moritz the Learned, 1593
Oil on panel
H. 22½ in. (57 cm); W. 16¾ in. (42.5 cm)
FAS B 986

Central to the coat of arms is a heart shield with the silver and red striped Hessian lion. The red lion directly above stands for the county of Katzenelnbogen, the single star for the Ziegenhain county, the two golden leopards for the Diez county, and the two silver stars for Nidda. The center helmet in the upper part of the coat of arms is topped with two silver buffalo horns, each sprouting six linden branches with three leaves. The golden helmet on the left is decorated with the Katzenelnbogen red lion, while the one on the right depicts a winged goat, the symbol of Ziegenhain.

 JMS

GERMAN SCHOOL
Prince Ernst of Hesse (1623–1693), aged one year and ten months, 1625
Oil on canvas
H. 41¼ in. (104.8 cm); W. 32⅛ in. (81.6 cm)
Inscribed upper right: *V. G. G. Herr Ernst L. Z. H. ist itzo ait 1 Jahr 10. Monat 1625*
FAS B 552

The dress of small children of the 17th century was not differentiated in terms of gender, and so we have little hint of the military leader that Ernst, the sixth son of Moritz the Learned, would become. He led the Hessian troops in the Thirty Years' War but is remembered in history for his conversion to Catholicism and his eloquent challenge to the Protestant theologians of Hesse.

 PH-S

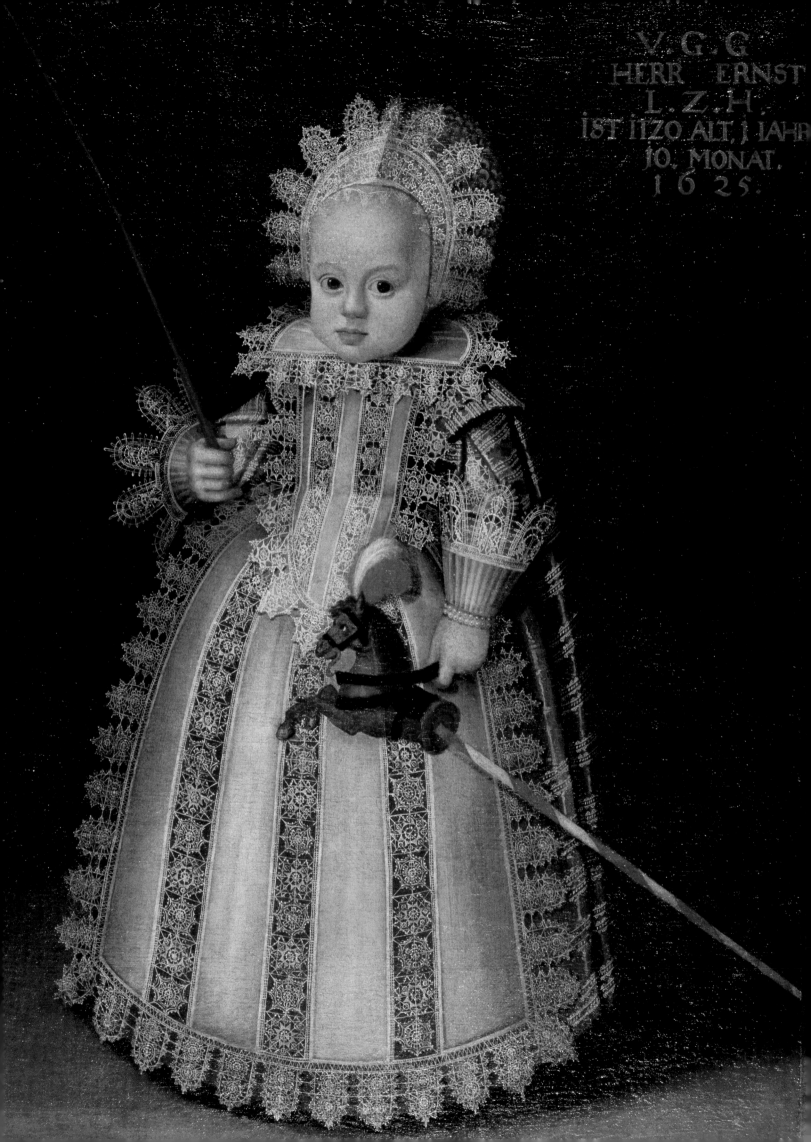

V. G. G.
HERR ERNST
L. Z. H.
IST ITZO ALT, 1 IAHR
10. MONAT.
1625.

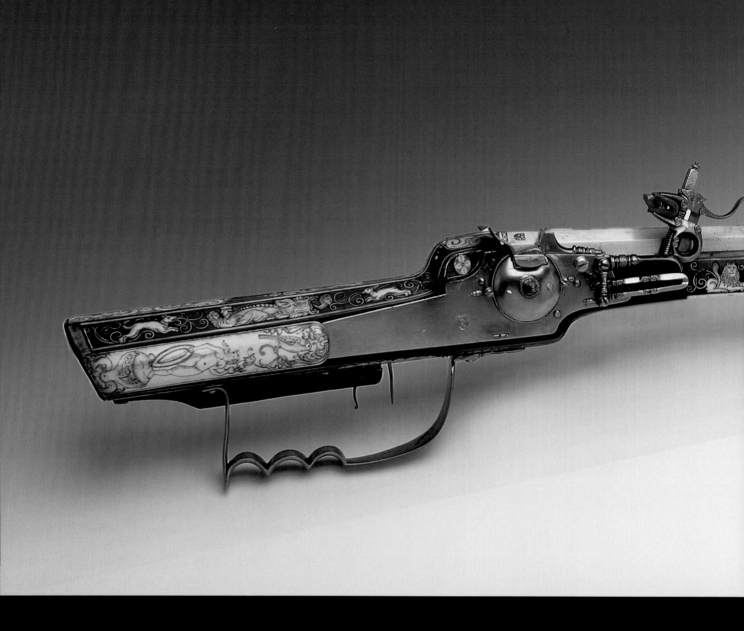

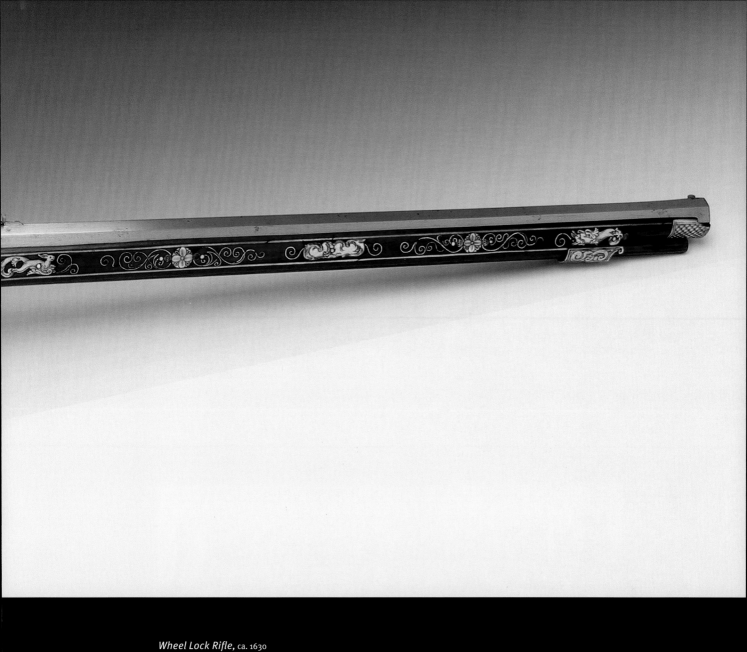

Wheel Lock Rifle, ca. 1630

Johannes Spangenberg (Suhl, act. mid-17th century)

Barrel: iron, copper; shaft: walnut, ash; inlays: bone, silver, ivory

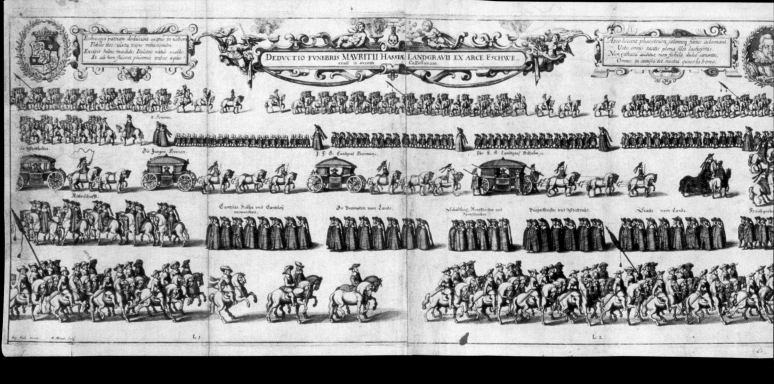

DEDVCTIO FVNEBRIS MAVRITII HASSIÆ LANDGRAVII EX ARCE ESCHWE censi in arcem Cassellanam.

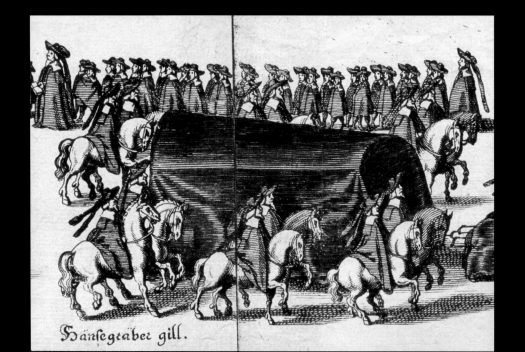

Hänsegraber gill.

Matthaeus Merian (Basel 1593–Bad Schwalbach 1650); after August Erich (Saxony, act. 1620–1644)
Funeral of Landgraf Moritz (Moritz the Learned), from *Monumental Sepulcrale,* Kassel, ca. 1638
Engraving
H. 11⅜ in. (29 cm); W. 52 in. (132 cm)
Inscribed lower left: *aug. erich invent m. merian sculpt.*
FAS Archive HA 589

Landgraf Moritz the Learned died during the Thirty Years' War (1618–1648) on March 15, 1632, in Eschwege. On March 20, his body was transferred to Kassel. Six years later, a splendid commemorative volume was published with funeral sermons and poems. These are complemented by fifty-two engravings that show the ceremonial sequence of the landgraf's funeral service and depict portraits of the family and a family tree (see pp. 2–3).

Across four combined sheets, this engraving shows the long funeral procession winding its way toward the gates of Kassel. Protestant funeral processions followed a fixed order in which constituents of the community had their assigned places. With groups of horsemen riding ahead and behind, the procession was led by pupils and parish gentlemen, followed by professors, musicians, mounted trumpeters, and nobles. Then came the coffin mounted on a funeral carriage drawn by six horses, and the horse of the deceased. The relatives follow the catafalque. Behind city officials came different craftsmen guilds, followed by servants of the courts with distinguished ladies in last place. These various groups are represented in generalized fashion with prominent participants identified by name.

CK

A Scientific Renaissance

While the Renaissance in Italy focused on the model of classical antiquity and the development of sensual beauty, the focus north of the Alps was on scientific thinking. From the 16th century in Germany it was customary for a prince to assemble the most advanced tools and instruments along with works of art and rare natural specimens in a private museum called a *Kunstkammer*. The Hesse *Kunstkammer* in Kassel was an outstanding example. Swept up in the intellectual current, the princes themselves delved into the literature and practiced with tools from their collections.

Timepieces were particularly prized among scientific instruments and Augsburg and Nuremberg became centers of clock-making excellence. By 1600 clocks had taken on metaphorical importance as the intellectual model for the Protestant state. God was cast as a divine clockmaker, creating the world based on strict order. The prince was held responsible for maintaining this order and balance in society, while the individual subject was regarded as a wheel within the works.

The rulers of Hesse in this period demonstrated the depth and breadth of their intellectual curiosity by building an outstanding library that has been augmented with each generation to the present. From the start, the books were meant for reading, whether they were tracts on religion, science, heraldry, history, good government, or editions of great literature like the well-used, illustrated pocket edition of Dante's *Divine Comedy* (see p. xxvii).

PH-S

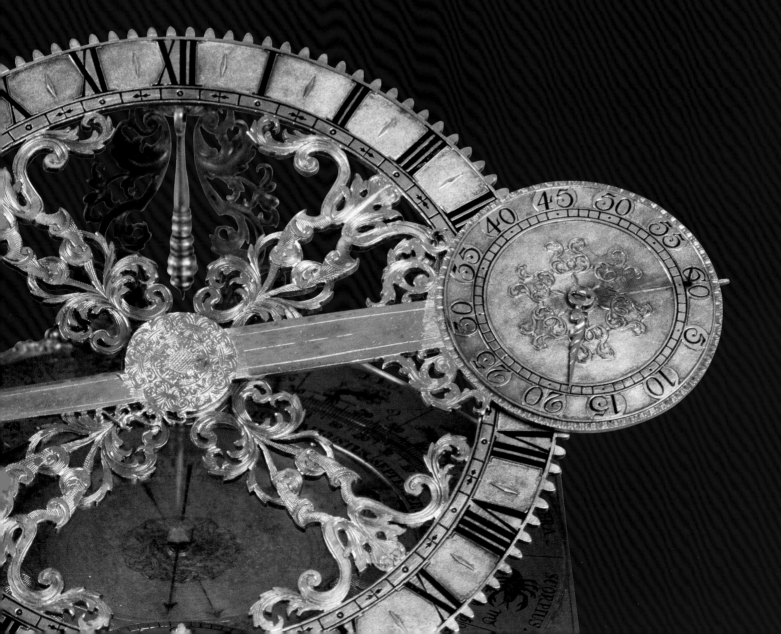

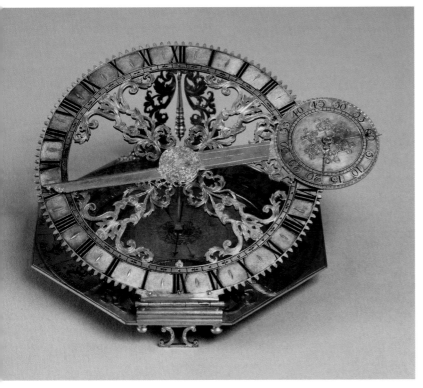

Portable Sundial, ca. 1700
Johann Martin Willebrand (Augsburg, act. 1682, d. 1726)
Silver, gilded brass
H. 2¼ in. (5.6 cm); W. 5⅜ in. (13.5 cm); D. 6¼ in. (15.7 cm)
FAS K 96

The sundial is equipped with chapter ring, minute dial, Zodiac plate, and inset compass.

 ᴘʜ–s

Portable Sundial, late 17th–early 18th century
Johann Martin (Augsburg 1642–1721)
Silver, gilded brass
H. 1½ in. (3.6 cm); W. 2½ in. (6.2 cm); D. 2½ in. (6.2 cm)
FAS K 97

The double crescents have a calendar scale and latitude arm, while the horizontal plate has a table of latitudes with a perpetual calendar on the underside.

 ᴘʜ–s

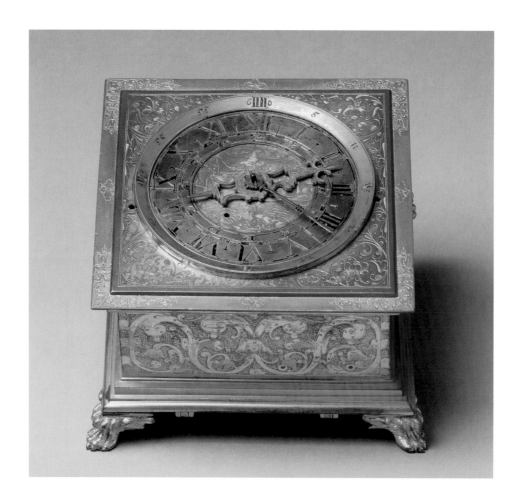

Gilded Table Clock, 1600–1620
Hans Somer (Augsburg or Nuremberg)
Gilded bronze
H. 4⅛ in. (10.5 cm); W. 6⅞ in. (17.5 cm); D. 6⅞ in. (17.5 cm)
FAS U 9

The clock strikes every quarter hour and has an alarm function.

ᴘʜ–s

Plumb Line, 17th century
Probably German
Brass
H. 2⅛ in. (5.3 cm); W. 2¾ in. (6.9 cm); D. 1½ in. (3.7 cm)
FAS K 342

The small size indicates this plumb line was used to align the astronomical instruments necessary for marking time and geographic location.

ᴘʜ–s

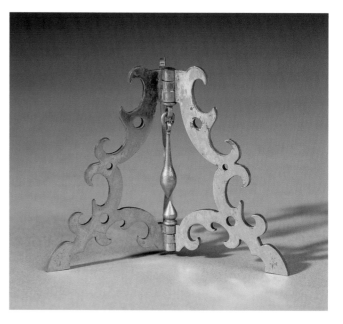

FACING PAGE

Watch on Stand, early 17th century
Attributed to Jerg Ernst (Augsburg, act. first quarter 17th century)
Watch: gilded silver, silver, enamel; stand: smoked quartz,
yellow and red agate, gilded brass, ebonized wood
H. 5⅝ in. (14.2 cm); W. 2⅝ in. (6.6 cm); D. 2⅜ in. (6 cm)
FAS U 48

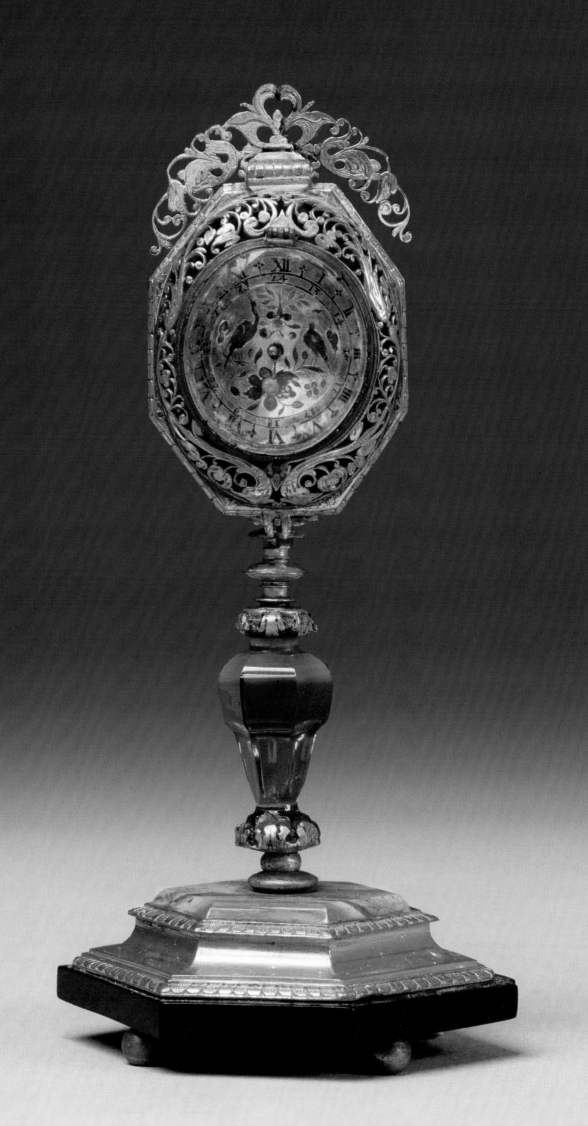

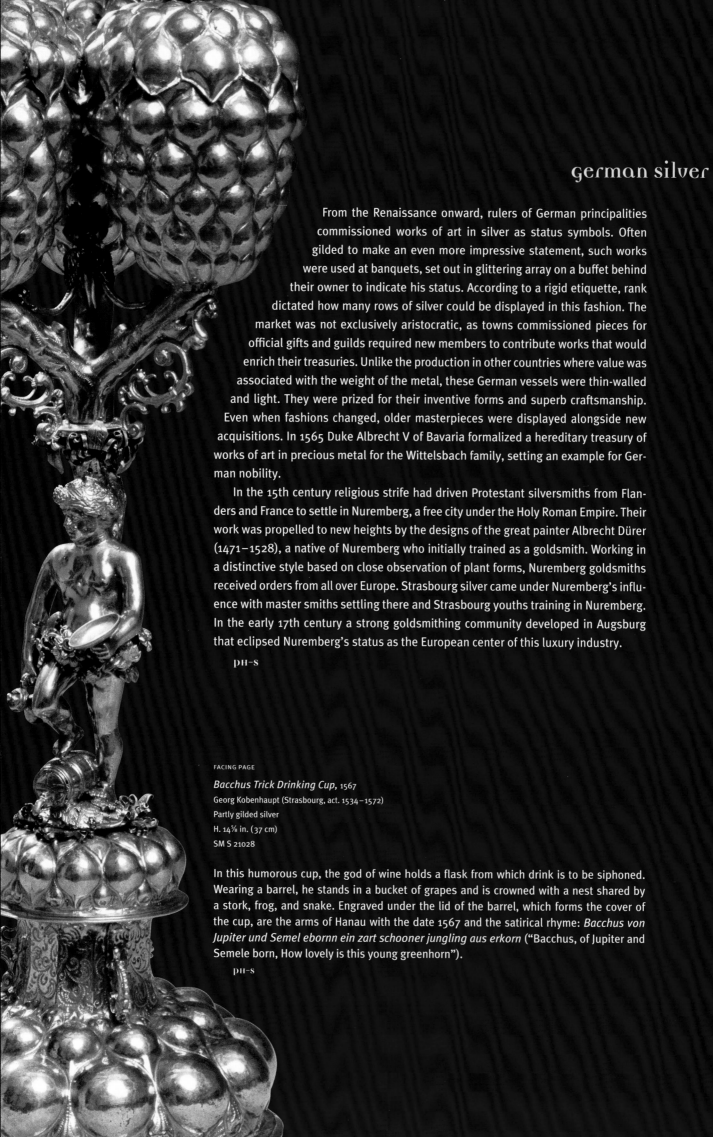

From the Renaissance onward, rulers of German principalities commissioned works of art in silver as status symbols. Often gilded to make an even more impressive statement, such works were used at banquets, set out in glittering array on a buffet behind their owner to indicate his status. According to a rigid etiquette, rank dictated how many rows of silver could be displayed in this fashion. The market was not exclusively aristocratic, as towns commissioned pieces for official gifts and guilds required new members to contribute works that would enrich their treasuries. Unlike the production in other countries where value was associated with the weight of the metal, these German vessels were thin-walled and light. They were prized for their inventive forms and superb craftsmanship. Even when fashions changed, older masterpieces were displayed alongside new acquisitions. In 1565 Duke Albrecht V of Bavaria formalized a hereditary treasury of works of art in precious metal for the Wittelsbach family, setting an example for German nobility.

In the 15th century religious strife had driven Protestant silversmiths from Flanders and France to settle in Nuremberg, a free city under the Holy Roman Empire. Their work was propelled to new heights by the designs of the great painter Albrecht Dürer (1471–1528), a native of Nuremberg who initially trained as a goldsmith. Working in a distinctive style based on close observation of plant forms, Nuremberg goldsmiths received orders from all over Europe. Strasbourg silver came under Nuremberg's influence with master smiths settling there and Strasbourg youths training in Nuremberg. In the early 17th century a strong goldsmithing community developed in Augsburg that eclipsed Nuremberg's status as the European center of this luxury industry.

ph-s

In this humorous cup, the god of wine holds a flask from which drink is to be siphoned. Wearing a barrel, he stands in a bucket of grapes and is crowned with a nest shared by a stork, frog, and snake. Engraved under the lid of the barrel, which forms the cover of the cup, are the arms of Hanau with the date 1567 and the satirical rhyme: *Bacchus von Jupiter und Semel ebornn ein zart schooner jungling aus erkorn* ("Bacchus, of Jupiter and Semele born, How lovely is this young greenhorn").

ph-s

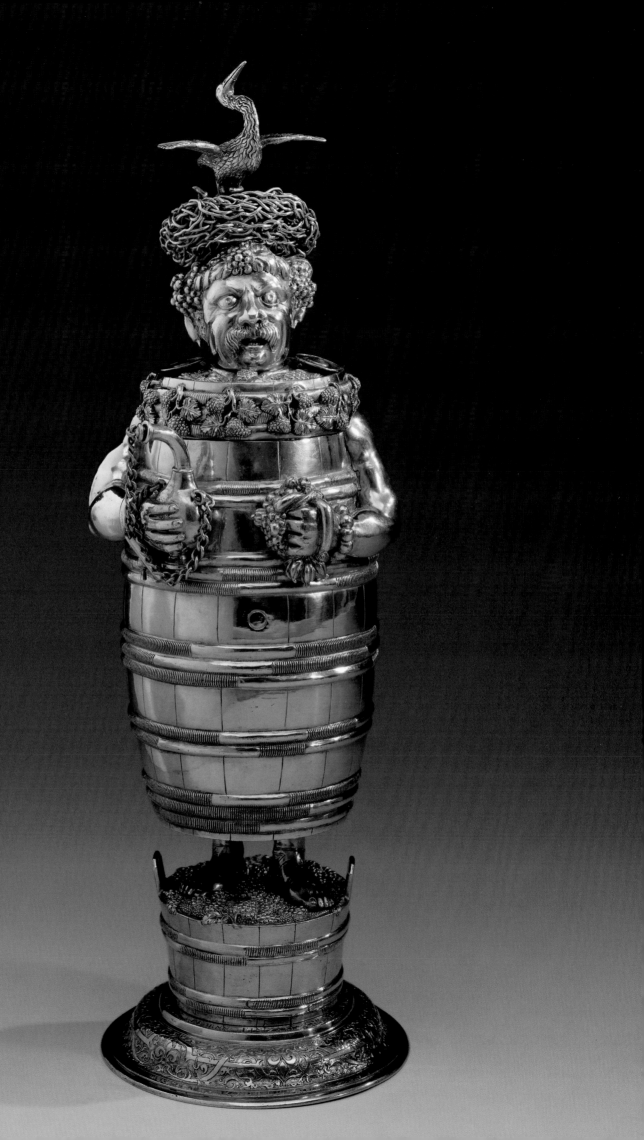

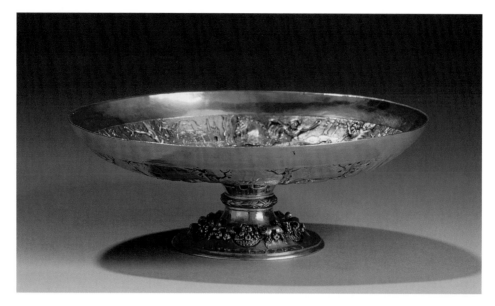

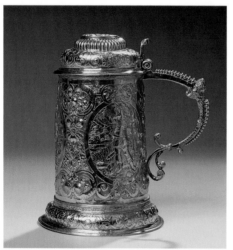

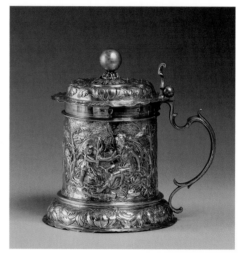

TOP

Tazza, ca. 1580
Christof Epfenhauser II (Augsburg, act. 1518–1582)
Gilded silver
H. 2¾ in. (7 cm); Dia. 7⅞ in. (20 cm)
Engraved beneath base: *F* below Prussian royal crown
WO

The tazza was a type of wine cup revived from classical antiquity during the Renaissance and remained in use through the 17th century. Its shallow bowl offered a field for the rendering of full scenes in relief by the skillful embossing and chasing of the silver: here the hunter with a hound at the center is encircled by episodes of a boar hunt, which is given a mythological cast with classical costuming.

PH-S

Tankard, 1600–1620
By a member of the Ehkirch family (Ulm)
Gilded silver
H. 9⅛ in. (23 cm); W. 7⅜ in. (18.8 cm); D. 6⅛ in. (15.5 cm)
FAS S 3047

Tankard, 1675–1678
Friedrich Schwestermüller (Augsburg, act. 1682–1752)
Partly gilded silver
H. 7 in. (17.8 cm); W. 7¼ in. (18.3 cm); D. 5¾ in. (14.8 cm)
FAS S 3035

These silver tankards are deluxe versions of the drinking vessel that originated in 16th-century Germany for the consumption of beer. Their decoration illustrates the evolution from the detailed Renaissance style of small-scale ornament derived from prints and circumscribed within frames, into the robust Baroque mode of figural scenes expanding across the surface in the manner of a sculptural frieze.

PH-S

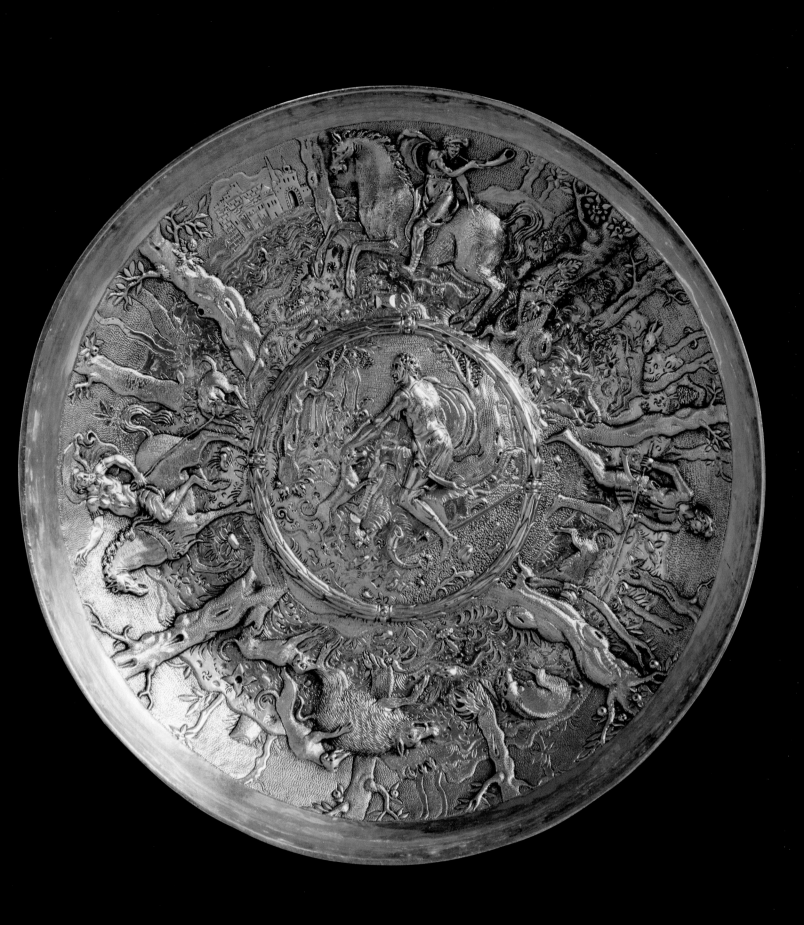

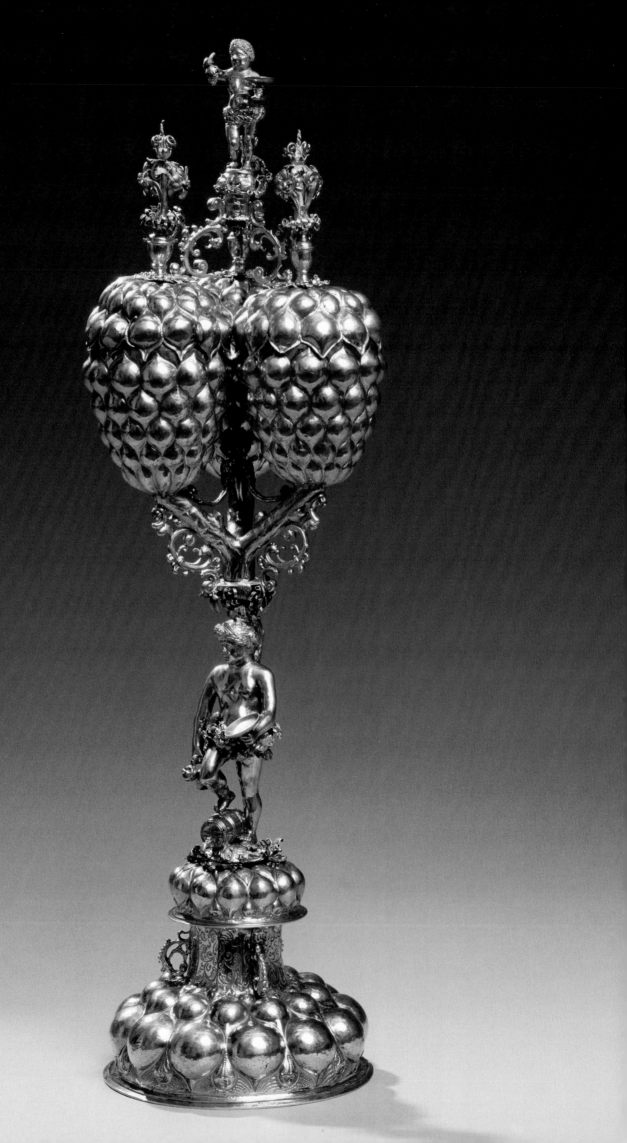

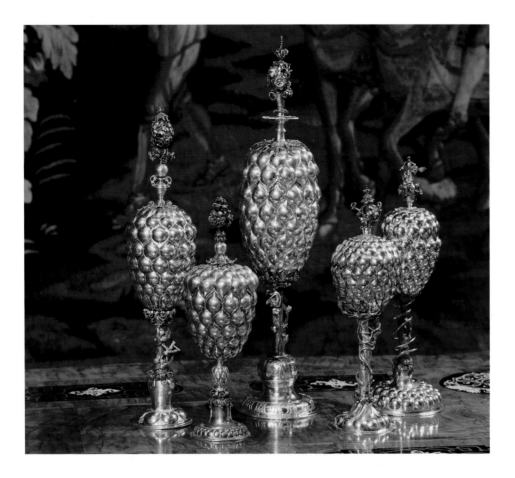

Pineapple Cup, ca. 1620
Heinrich Mack (Nuremberg, act. 1612–1626)
Partly gilded silver
H. 15¾ in. (40 cm); Dia. 3⅝ in. (9 cm)
Stamped on foot and lip of cup: *HM*
WO S 8091

Pineapple Cup, ca. 1620
Nicolaus Emmerling (Nuremberg, act. 1515–1655)
Partly gilded silver
H. 11⅝ in. (29.5 cm); Dia. 3¾ in. (9.5 cm)
Engraved on bottom: *Catharina Navarts;* stamped on lip: *N*
within circle and *NI*
WO S 8092

Pineapple Cup, 1639
Unknown maker (Nuremberg)
Gilded silver
H. 13⅛ in. (33.3 cm); Dia. 3⅛ in. (7.8 cm)
Stamped within circle on lip of cup: *N;* engraved on lip of cup:
*Johannes von den BIRGHDEN verehrt den 2 Decembris Anno
1639*
WO S 8102

Pineapple Cup, 17th century
Unknown maker (German)
Gilded silver
H. 12⅛ in. (30.7 cm)
WO S 8105

Pineapple Cup, ca. 1620
Tobias Schaumann (Augsburg)
Partly gilded silver
H. 19⅝ in. (49 cm); Dia. 4½ in. (11.5 cm)
Stamped within a circle on bottom of foot and lip of cup: *TS;*
inscribed on lip of cup: *Π ô /.F. /Tp ~ □ u*
WO S 8100

Triple Pineapple Cup, ca. 1620
Meinrad Bauch the Younger (Nuremberg, act. 1612, d. 1633)
Partly gilded silver
H. 20½ in. (52 cm); W. 5⅞ in. (15 cm); D. 5⅞ in. (15 cm)
WO

Although they are now commonly known as pineapple cups, these lobed vessels were origi-
nally termed *Traubenpokal,* indicating the shape was derived from a bunch of grapes. Eighteen
of these cups were among the official gifts commissioned from the goldsmith Hans Petzolt
(1551–1633) by the Nuremberg City Council. The triple cup with a figure of Bacchus serving as
the stem and a bacchic infant as a finial represents a tour de force of the form.

PH-S

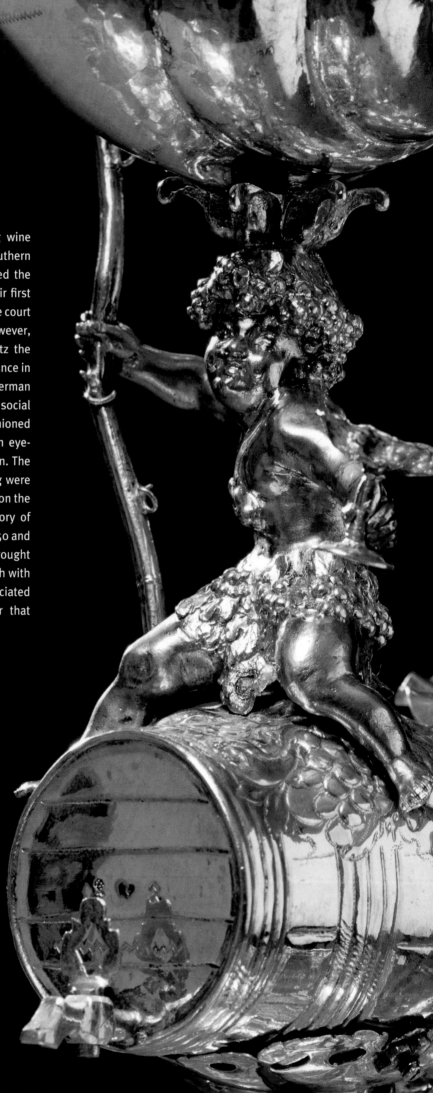

TABLE FOUNTAINS

The classical Greek practice of diluting wine with water remained customary in southern Europe. Table fountains, which performed the procedure quasi-mechanically, made their first appearance in 16th-century Florence at the court of the Medici. In northern Europe, however, wine was consumed full strength. Moritz the Learned's creation of an Order of Temperance in 1601 is an indication of the concern of German princes that drunkenness had become a social problem. The novel table fountains fashioned as glamorous silver sculpture offered an eye-catching means of advocating moderation. The Gelb dynasty of silversmiths in Augsburg were leaders in creating fascinating variations on the form, borrowing from the figural repertory of Italian Renaissance bronzes. Between 1650 and 1690 the landgrafs of Hesse-Darmstadt brought together a set of five table fountains, each with appropriate mythological figures associated with the reservoirs of wine and water that spilled out to mix in shell-shaped basins.

DH-S

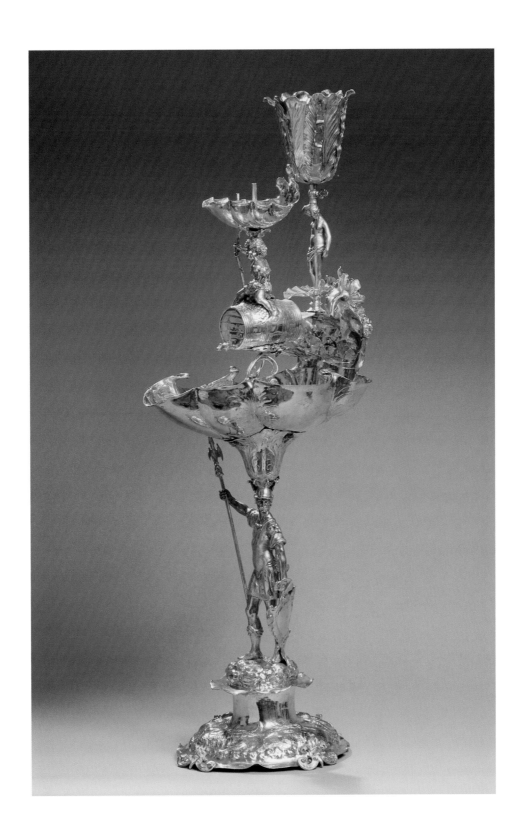

Table Fountain with Mars and Bacchus, ca. 1680

Balthasar Gelb (Augsburg 1646–1695)

Gilded silver

H. 33⅞ in. (86 cm); W. 9⅞ in. (24 cm); D. 14⅝ in. (37 cm)

WO

In this largest and most complex of the Hesse table fountains, Mars, the god of war, supports the basin where wine and water mix. A small figure of Mercury is the stopper for the conduit of wine into the barrel straddled by Bacchus. A tulip serves as the receptacle for water which channels through the breasts of a figure of Venus Marina.

PH-S

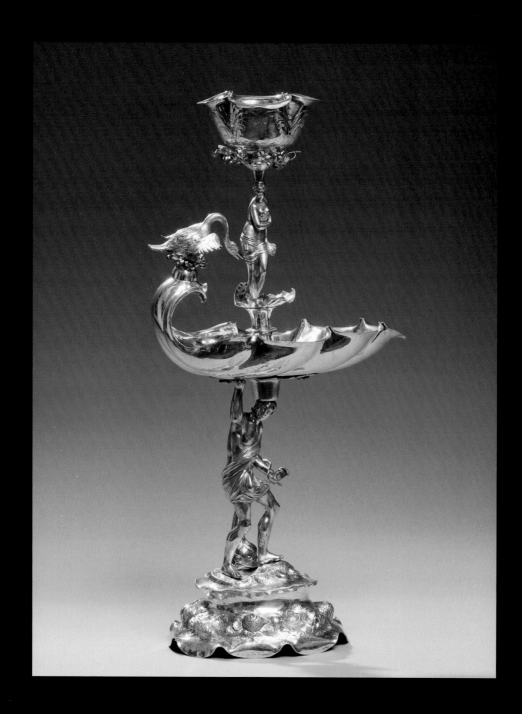

Table Fountain with Leda and Swan, ca. 1675
Jakob Jäger (Augsburg)
Partly gilded silver, gold
H. 19⅜ in. (49 cm); W. 7½ in. (19 cm); D. 9¼ in. (23.5 cm)
WO

Wine, poured into the cup supported by a figure of Leda, flows through her breasts into a shell upheld by a figure with a dolphin.
PH–S

Table Fountain with Neptune and Fortuna, ca. 1660
Matthias Gelb I (Augsburg, 1597–1671)
Partly gilded silver
H. 24¾ in. (63 cm); W. 10⅜ in. (27 cm); D. 9⅜ in. (24 cm)
WO

A figure of Neptune supports a bowl of water to which wine is added as it flows from a tulip-shaped cup, through the breasts of the figure of Fortune poised on a winged sphere.
PH–S

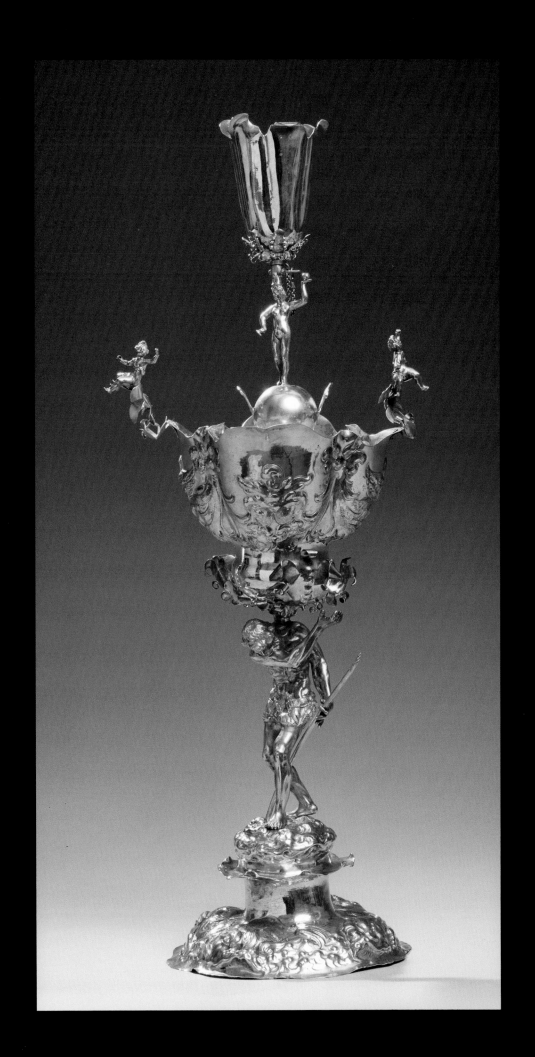

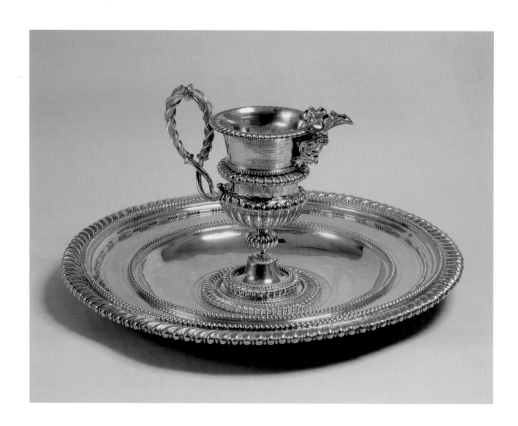

Ewer and Basin, ca. 1700
Johann Ludwig Biller the Elder (Augsburg 1656–1732)
Gilded silver
Ewer: H. 12⅜ in. (31.5 cm); W. 13³⁄₁₆ in. (31 cm); basin: Dia. 24¾ in. (63 cm)
FAS S 3027-8

Before the adoption of the use of knives and forks over the course of the 17th century, diners ate with their fingers. The ewer and basin provided a means for them to rinse their hands at table. By the date of this ewer and basin, the hygienic function had become secondary to the spectacular effect of such massive pieces displayed on a buffet.

PH-S

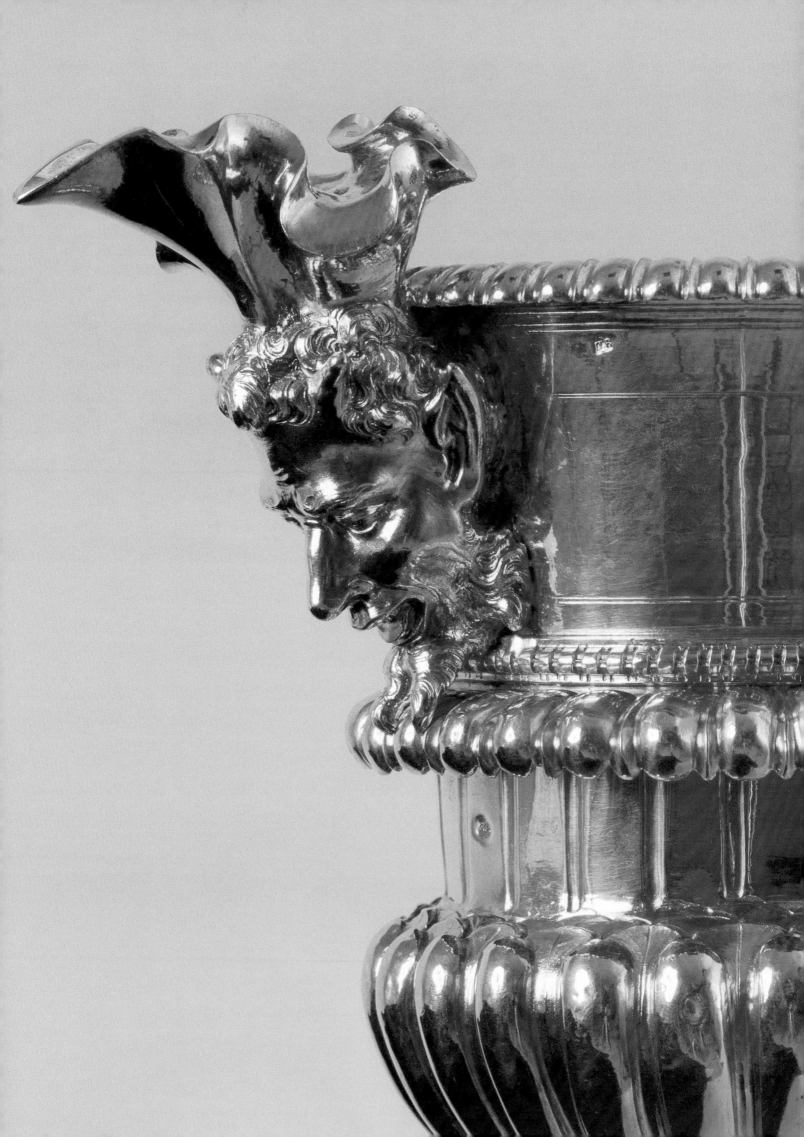

Stoneware is a water-resistant ceramic made of clay that has been vitrified by firing at extremely high temperatures. Production was a major industry for small German towns from the 13th through the 17th century. The vessels were raised on the potter's wheel but some had elaborate relief ornament that was separately cast and adhered to the surface with liquid clay before firing. The products of Siegburg were distinguished by white clay and elegant reliefs, and the more rugged wares of Raeren by salt glaze. German stoneware jugs and tankards were used by every level of society from peasants to royalty across northern and central Europe, and numerous examples have been excavated at archaeological sites of early colonies in America.

PH–S

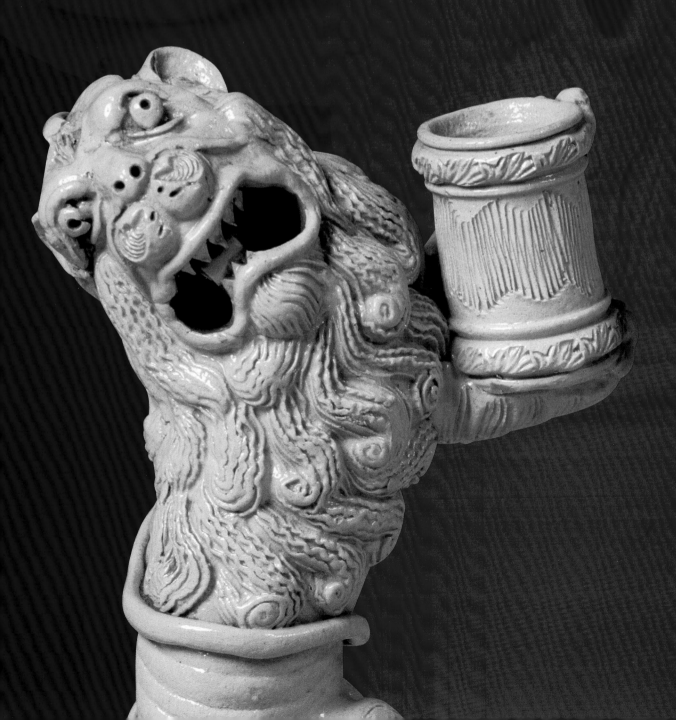

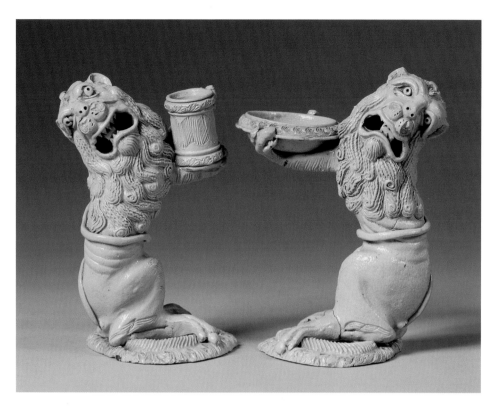

Pair of Lions with Candleholder and Sand Bowl,
17th century
German
Stoneware
H. 5⅞ in. (15 cm); W. 3¾ in. (9.5 cm); D. 3¾ in. (9.5 cm); and
H. 6⅛ in. (15.5 cm); W. 4½ in. (11.5 cm); D. 3¾ in. (9.5 cm)
FRDH Pt 3007-1, 2

Tankard, 1576
Raeren
Brown salt-glaze stoneware, pewter
H. 17½ in. (44.5 cm); W. 9⅛ in. (23 cm); Dia. 8½ in. (21.5 cm)
Signed: *IE*
FRDH PS 3046

Siegburg Tankard with the Story of Tobias,
1560–1570
Hans Hilgers (Germany, act. 1569–1595)
White stoneware, pewter
H. 11 in. (28 cm); Dia. 3⅞ in. (10 cm)
FRDH PS 3087

Glassmaking in Germany dates from Roman times. The glass produced was impure with a slight green or gray tint. It is called *Waldglas,* or "forest glass," as the small glass manufactories were located in forests where the wood fuel for their furnaces was readily available. Different formulas for glass were kept secret and passed down within a family, and a document of 1537 known as the *Hesse Bundesbrief* records the effort to regularize the hereditary profession within a guild structure.

The *Humpen,* a simple cylindrical beaker blown into a mold, was popular from medieval times. It became part of the tradition of the *Wilkommen* or "welcome" glass offered to a guest on arrival in a German home. From the late 16th through the mid-17th century, *Humpen* were embellished with colorful enamel decoration, particularly armorial devices. As these were commissioned pieces, they were often dated.

Around 1680 the efforts of glassmakers to create a purer glass, closer in effect to rock crystal, succeeded in Bohemia. The addition of potash and lime made a clear body, hard enough to cut and engrave. Goblets made of the new luxury glassware, engraved with armorials or portraits of rulers, were presented as official gifts. Internationally recognized under the generic term "Bohemian crystal," the clear heavy glass has remained a prestige product to this day.

PH-S

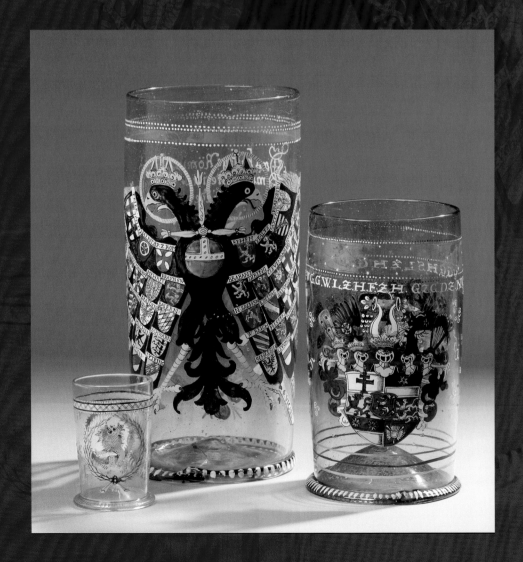

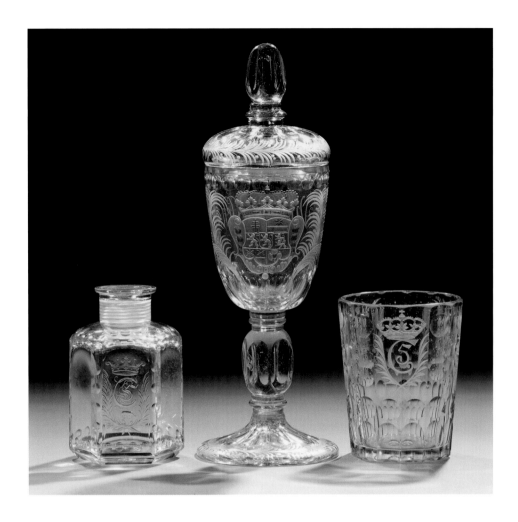

Enamelled Humpen with Hesse Lion, 1694
Glass, enamel
H. 3½ in. (8.9 cm); Dia. 2½ in. (6.3 cm)
Painted on reverse: *VIVAT HESSEN ANNO 1694*
FAS G 14

*Enamelled Humpen with Arms of Holy Roman
Empire,* 1646
Glass, enamel
H. 11⅜ in. (29 cm); Dia. 5½ in. (14 cm)
Kronberg G 3171

Enamelled Humpen with Arms of Hesse, 1655
Glass, enamel
H. 8⅝ in. (21.2 cm); Dia. 4¾ in. (12 cm)
Painted on upper register: *V.G.G.W.L.Z.H.F.Z.H.G.Z.C.DZN.V.S.V.
G.G.H.S.L.Z.H.G.A.C.S.D.M.Z.B*
FAS G 19

Bottle with Crowned Monogram of Christian V,
late 17th century
Glass
H. 6½ in. (15.5 cm); W. 3⅞ in. (10 cm); D. 4⅛ in. (10.5 cm)
FAS G 75

Covered Goblet with Hesse Armorial, ca. 1700
Glass
H. 14¾ in. (37.5 cm); Dia. 5⅜ in. (13.6 cm)
Engraved on reverse: *VIVAT HESSEN*
FAS G 78

Beaker with Crowned Monogram of Christian V,
late 17th century
Glass
H. 5¾ in. (14.7 cm); Dia. 4⅛ in. (12 cm)
FAS G 34

The marriage of Charlotte of Hesse (1650–1714) to King Christian V of Denmark (1646–1699) in 1667 was among the first of many Hesse marriages into the ruling families of Europe.

ᴘʜ–ѕ

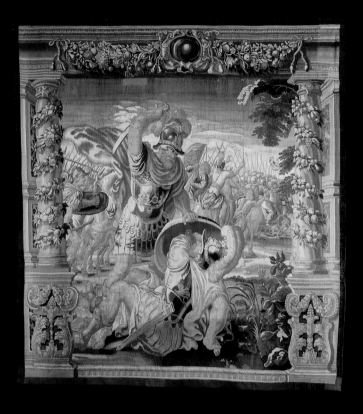

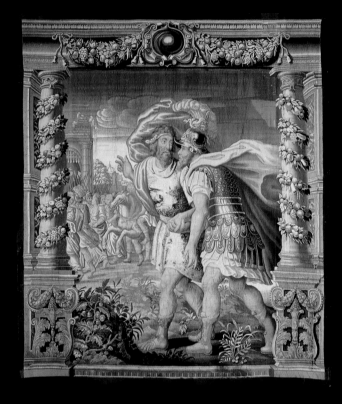

Tapestries, 1640–1660
Flemish
Wool, silk
H. 137⅜ in. (349 cm); W. 127¼ in. (323 cm); and H. 138¼ in. (351 cm); W. 118½ in. (300 cm)
FAS T 23, 24

These are two of a set of four tapestries made in Brussels in the monumental style popularized
by Peter Paul Rubens. The niches with twisted Solomonic columns framing the classical scenes
place the heroic figures in a contemporary context of Baroque architecture. Flemish weavers pro-
duced tapestry sets for princes across Europe, who valued them more highly than paintings.

PH-S

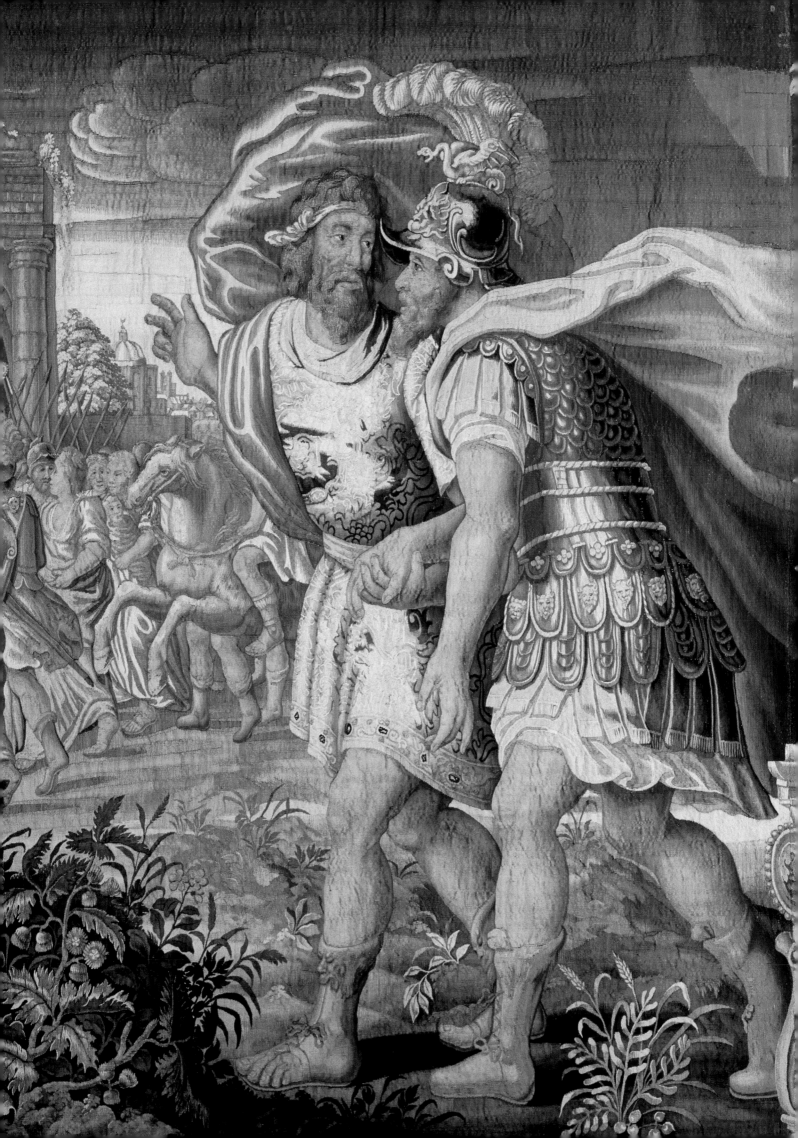

18th-century court life

Court life in the 18th century consisted of a system of codes. They informed behavior and all the physical aspects of life, from urban planning to clothing and included every element of architecture and interior decoration. The collective message conveyed the sovereign's role as the center of all aspects of life in his domain. The code originated with Louis XIV, the Sun King of France, who created Versailles and its court as the center of his absolutist monarchy.

An important part of the system was the idea of demonstrating "distinction," or one's difference from the rest of society. Those who belonged to court society differentiated themselves from others, not necessarily through great wealth, but rather through a code of refined etiquette. Beyond their practical functions, buildings, furniture, and clothing served as vehicles to demonstrate distinction in visual terms.

The system emanated from France and reached all the principalities of Europe, including the courts of the Hessian landgrafs in Darmstadt and Kassel. Unlike France, Germany had no single ruler; each German prince, however, saw himself as an absolute ruler in his own right, in competition with other princes and free towns.

The German princes regulated fundamental aspects of the economy such as agriculture, forestry, and mineral resources. Taxation of all goods represented the main source of income for the court treasury. To ensure the favorable balance in foreign trade, German princes followed the French example by founding manufactories for luxury goods. These activities served to glorify the ruler princes, who even accepted losses on endeavors that enhanced their prestige in competition with the other princes of Europe. This was true of nearly all royal porcelain manufactories.

Princes gave important commissions to artists and architects and created posts to attract and permanently attach creative talent to their courts. Artists were called to be court suppliers for very specialized tasks: Ludwig VIII of Hesse-Darmstadt, for instance, commissioned the painter Johann Christian Fiedler for his portraits, Georg Adam Eger for his hunting scenes, and Johann Conrad Seekatz for genre paintings. For artists and craftsmen, the court's protection from the guild regulations of the cities meant economic and creative freedom.

The absolutist system was based on the ruler having all privileges, which he could dispense to those enjoying his favor. Since he could not be everywhere at once, the ruler's appointed representatives were vested with sweeping judicial powers. The prince was able to direct society by giving, withholding, or withdrawing appointments to civil and military offices. The court employed a wide assortment from the populace and encouraged their talents.

The Hessian landgrafs were personally present in different regions of their country, following a regular calendar of seasonal changes of residence. At the end of spring, the landgrafs moved with their court to their summer residences. In fall they traveled to several castles for different types of hunting. They made special trips to the farthest reaches of their territories, as they regularly inspected their troops, and also surveyed the progress of their mines and manufactories of textiles and arms. Despite this peripatetic life, they focused their attention on building up their residence cities of Kassel and Darmstadt as cultural centers to show their wealth and importance to the world.

MM

The gala berlin coach of Landgraf Ludwig VIII of Hesse-Darmstadt is one of the greatest treasures of the Hessian House Foundation collections. Very few coaches associated with the splendor and luxury of the European courts of the Baroque period still exist. Designed by architects and sculptors, they are important expressions of courtly art that convey the hierarchy of society in terms of sensual experience.

The importance accorded to this coach can be seen in the painted inventory number dating from the late 18th or early 19th century, indicating it was assigned first place in the records of the Darmstadt court stables. There are no stylistic elements to support the traditional attribution to the coach makers of Vienna. It is more logical that it would have been made locally around 1750: craftsmen in the Darmstadt region who worked on the princely apartments of the Hessian court were capable of the coach's rich Rococo decoration. Ludwig VIII's coat of arms and monogram on the box of the carriage and his crown at the rear indicate his ownership. The emblematic lion of Hesse holding a monogram shield is carved on each corner.

Carriages took on great social importance beginning in the 16th century. Princely stables for the Darmstadt residence can be traced back to 1589, and carriages were housed next to the horse stalls and tack rooms, with those used daily by the sovereign kept separate. Into the early 16th century, riding in carriages was considered unmanly for gentlemen. It was suitable for ladies, though, who might appear in particularly splendid carriages at their weddings. According to the earliest account, the bridal carriage for Anna Eleonore of Hesse-Darmstadt, who married Duke George of Braunschweig-Lüneburg in 1617, had a red velvet interior trimmed with exquisite silver embroidery, harnesses for six horses, and was worth 2000 *guilders.*

In the 17th and 18th centuries, not a single celebration went by without an entrance of a contingent made up of numerous carriages. This included visits from princely relatives, guests, and envoys, or meetings of the highest political rank, such as the Imperial Diet or Imperial coronations. At such occasions, the newest artistic and technical advances in coach building received great attention. The decoration and outfitting of coaches were regulated by formal royal etiquette according to the owner's rank. Gilding itself, for instance, and double-rowed upholstery studs along the edge of the carriage roof, were seen and understood as a sovereign's privilege.

At the French court of Louis XIV, whose etiquette was adopted by the rest of Europe, a heavy coach termed "grand carosse" was used by the king for public appearances. With its rich sculptural, painted, and embroidered adornment programmatically related to the identity of the owner, the grand carosse astonished crowds. Around 1661–1663, the Piedmontese architect and engineer Philippe de Chieze, in the service of Grand Elector Friedrich Wilhelm of Brandenburg, designed a touring carriage for the sovereign's business trip to Paris. Built by Berlin cartwrights, the carriage caused a sensation in France and entered coach-building history as a "berlin." By 1710 the berlin had established itself as the fashionable city carriage of Paris. It was designed with two or four seats and was lighter than the existing traveling carriages and large state coaches. Beginning in 1740, the carriages were used at the French court of King Louis XV, where they were referred to as a "de suite" gala coach. At ceremonial appearances *(entrées solennelles),* they followed the heavy state coaches *(carrosses de parade)* in second or third place. Such gala coaches were designed for show, not travel. They were transported by boat to the port closest to the location where the ceremony was to take place. Sturdy wheels were then attached for the final ground transport. The wheels seen here were only used during the ceremony.

The berlin distinguishes itself from the carosse by its innovative chassis design. It has two shafts *(brancards)* connecting the axles instead of the previous single shaft. Two long

leather braces *(longues soûpentes)* support the carriage box lengthwise and can be tightened with a winding device on the rear platform. Along with the vertical leather braces, these horizontal braces provide better shock absorption and resistance against tipping. The carosse box, in contrast, was mounted on short straps attached crosswise between the chassis bridges. The berlin thus became renowned for being both more comfortable and safer. Moreover, its basic "ship form" *(en bateau)* was in demand for numerous two- and four-seat vehicle types. Around 1770 the berlin replaced the grand carosse as the gala carriage for formal ceremonies and became the preferred everyday carriage for the promenade and hunt in all the German courts. The berlin remained the model for the design of many later coaches, as well as the first automobiles.

CM

Gala Berlin Coach of Landgraf Ludwig VIII of Hesse-Darmstadt, ca. 1750
Probably Darmstadt
Box: beech, gilt, leather, glass, velvet, fabric, gilded bronze; chassis and wheels: ash or robinia, gilt, gilded iron, gilded bronze, leather
L. 217⅜ in. (552 cm); H. 107½ in. (273 cm); W. 84⅝ in. (215 cm)
Painted on box door and rear of box under crown: gilded coat of arms; inscribed on each side of door below crown: mirror double-L monogram of Landgraf Ludwig VIII; on metal plate on rear axle: *no. 1*
SM N 21028

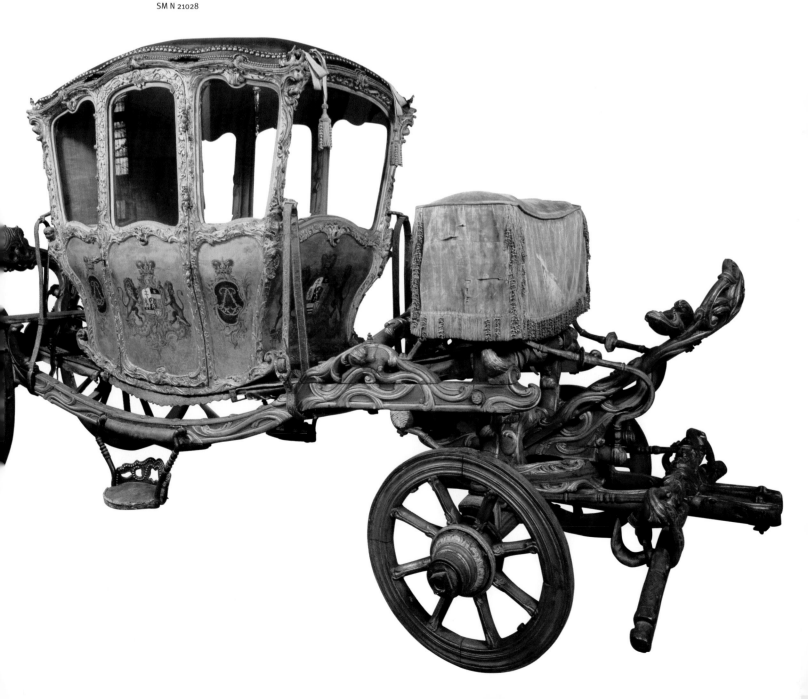

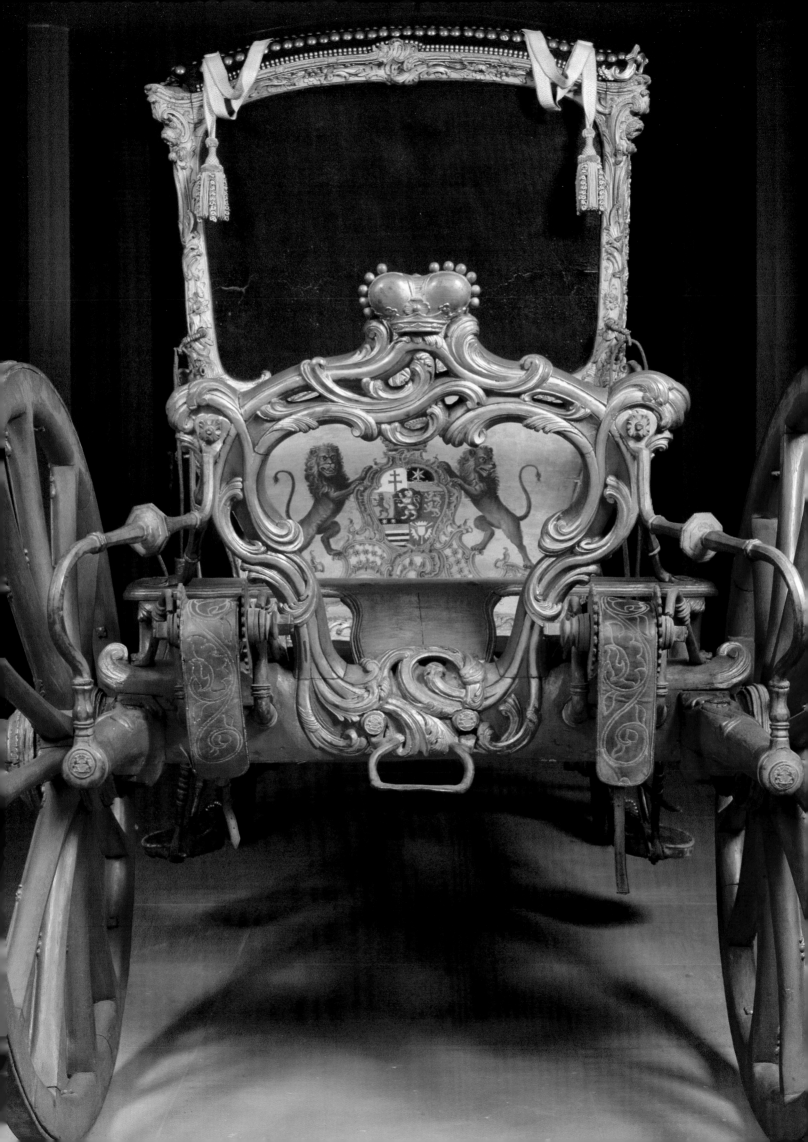

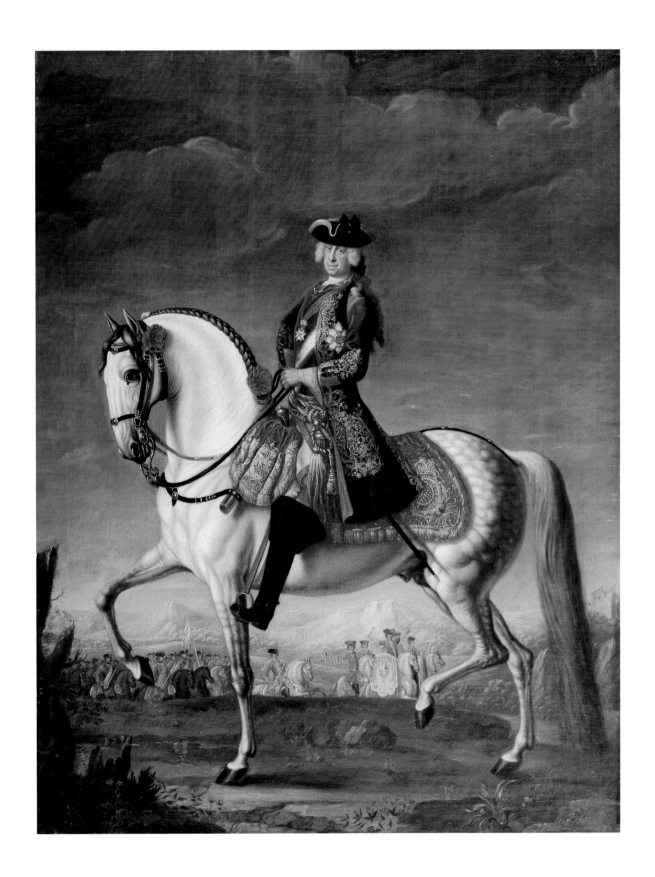

JOHANN CHRISTIAN FIEDLER (Pirna 1697–Darmstadt 1765)
Equestrian Portrait of Landgraf Ludwig VIII of Hesse-Darmstadt (1691–1768), mid-18th century
Oil on canvas
H. 32⅛ in. (82 cm); W. 25 in. (63.5 cm)
FAS B 1160

furniture

As a part of interior design, the furniture arts served to convey social status in the 18th century. During this period, a distinction was often made between pieces that were integral components of an interior decoration and those that were purchased as individual items. The first group, which included sets of seating furniture, was conceived in connection with wall decoration and mostly carried out by domestic craftsmen. Cabinets and tables, on the other hand, could be bought from other parts of the German Empire and foreign countries. Almost all German princes of the 18th century appointed their own court cabinet-makers, whom they commissioned to furnish their castles.

The furniture forms and styles in 18th-century Germany were primarily based on models from the court of the French kings, from which marked regional styles evolved. Northern Germany additionally was influenced by English furniture and the trend became widespread by the end of the 18th century.

MM

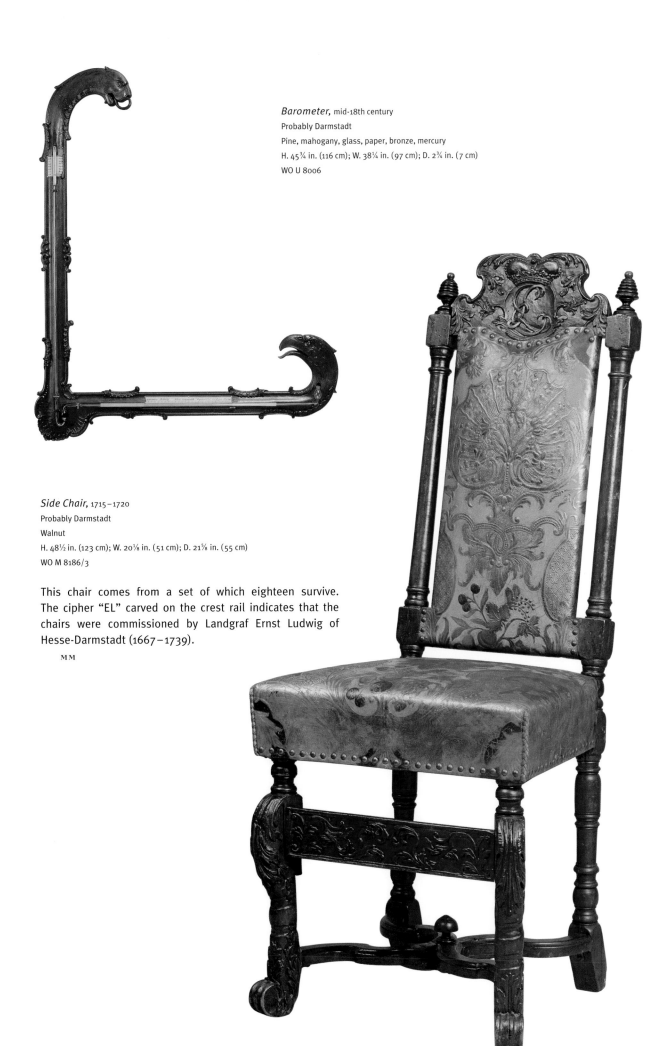

Barometer, mid-18th century
Probably Darmstadt
Pine, mahogany, glass, paper, bronze, mercury
H. 45¾ in. (116 cm); W. 38¼ in. (97 cm); D. 2¾ in. (7 cm)
WO U 8006

Side Chair, 1715–1720
Probably Darmstadt
Walnut
H. 48½ in. (123 cm); W. 20⅛ in. (51 cm); D. 21⅝ in. (55 cm)
WO M 8186/3

This chair comes from a set of which eighteen survive. The cipher "EL" carved on the crest rail indicates that the chairs were commissioned by Landgraf Ernst Ludwig of Hesse-Darmstadt (1667–1739).

M M

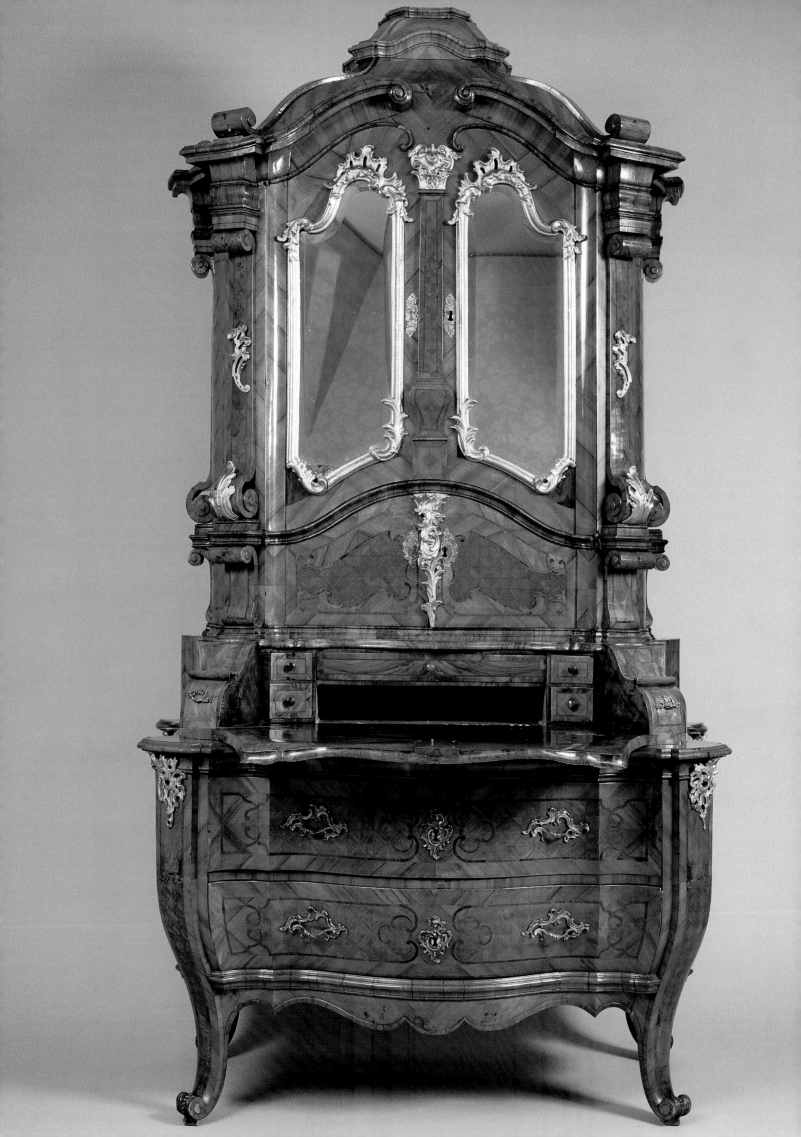

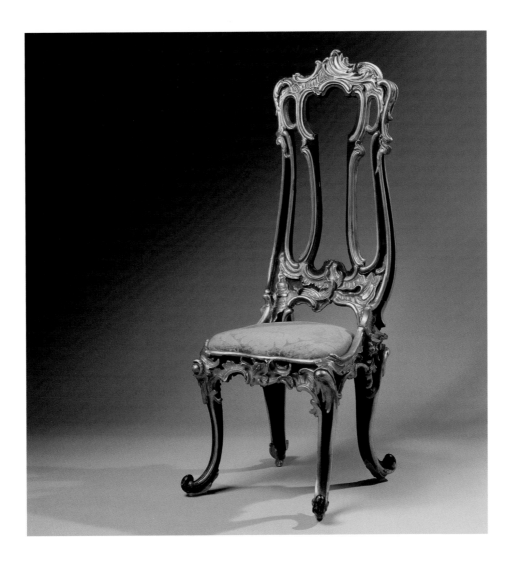

Side Chair, 1740–1750
Berlin or Potsdam
Beech, paint, gilt
H. 49¼ in. (125 cm); W. 19⅝ in. (49 cm); D. 20¾ in. (53 cm)
FAS M 401

Though the chair frame is not decorated with Rococo ornament, the shape itself is ornamental. It relates to the mid-18th-century *rocaille* furniture patterns published in Augsburg by Johann Georg Hertel.

MM

Secretary, ca. 1760
Probably Franz Anton Herrmann (Mainz, act. 1733–1770)
Pine, walnut, maple, boxwood veneers, gilt, mirror glass
H. 94⅛ in. (239 cm); W. 50 in. (127 cm); D. 27¼ in. (69 cm)
WO M 8049

In the 18th century, the city of Mainz became a regional furniture-making center. When Lothar Franz von Schoenborn became Prince Bishop Elector in 1695, he contributed to the city's development by commissioning residences and castles. Mainz furniture developed under strict guild regulation that enforced the high level of craftsmen's training and carefully regulated their business activites. At the same time, the guild protected them from outside competition.

In addition to the combination of veneered surfaces with finely carved ornament, Mainz furniture is characterized by heavy curving cornices and corner pilasters that swell free of the body of the cabinet.

MM

JOHANN AUGUST NAHL THE ELDER (Berlin 1710–Kassel 1781)

Beginning in 1741, Johann August Nahl worked as a decorator and ornament designer in the court of Prussian King Friedrich II, where he was apppointed *"directeur des ornements."* He oversaw the renovation of the castles in Berlin and Potsdam and created the interior furnishings of the new palace of Sanssouci. Among Nahl's collaborators were the sculptors Johann Michael (the elder) Hoppenhaupt and his brother Johann Christian (the younger). Thanks to the ingenuity of this creative team, these projects were among the greatest Rococo interiors in Germany.

In 1746, following disagreements with his patron Friedrich II, Nahl hastily left the Prussian court and was called to Kassel by Wilhelm VIII of Hesse, who appointed him court sculptor.

The furniture shown here originates not from Nahl's Hessian work but, rather, from his earlier Prussian phase. The pieces come from the Berlin castles and entered into the possession of the Hessian House through the art collection of Empress Friedrich (1840–1901).

MM

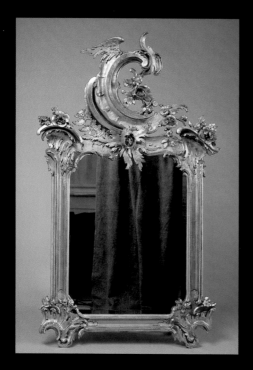

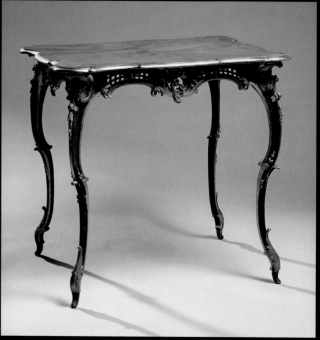

Wall Mirror, ca. 1740
Johann August Nahl the Elder (Berlin 1710–Kassel 1781)
Beech, limewood, gilt, mirror glass
H. 49¼ in. (125 cm); W. 27⅝ in. (70 cm)
FAS M 3403

Table, ca. 1745
Johann August Nahl the Elder (Berlin 1710–Kassel 1781)
Walnut, gilt
H. 29½ in. (75 cm); W. 31⅞ in. (81 cm); D. 26⅜ in. (67 cm)
FAS M 45

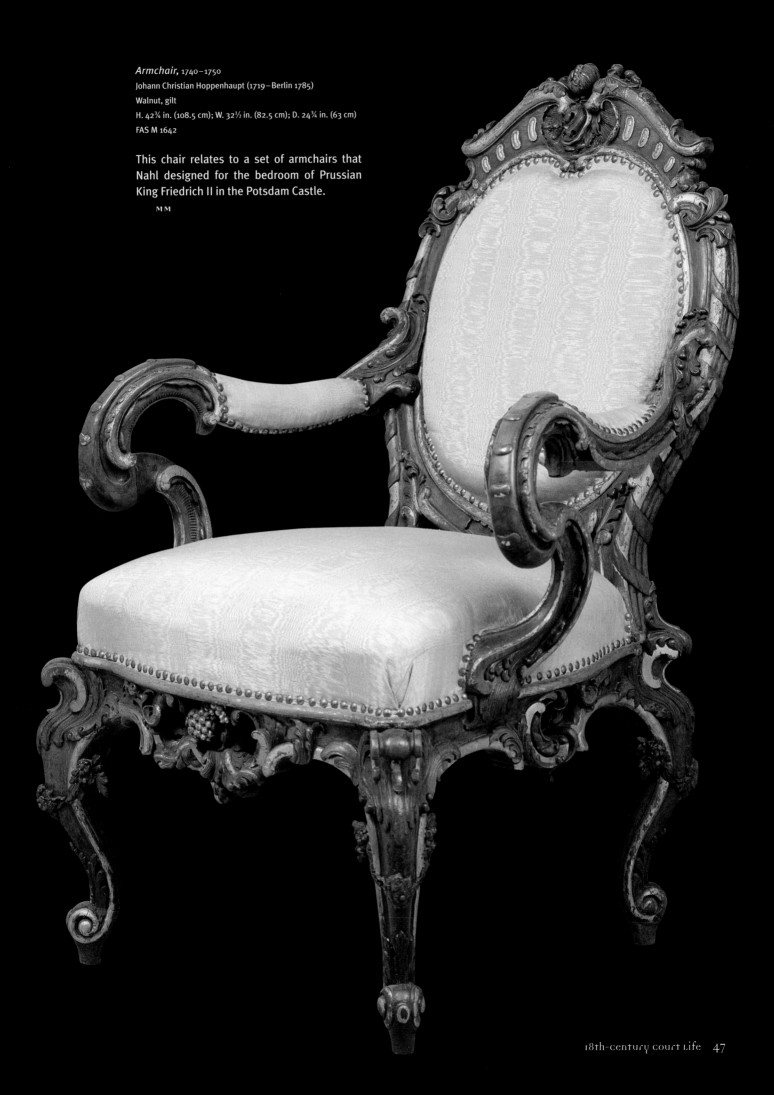

Armchair, 1740–1750
Johann Christian Hoppenhaupt (1719–Berlin 1785)
Walnut, gilt
H. 42¾ in. (108.5 cm); W. 32½ in. (82.5 cm); D. 24¾ in. (63 cm)
FAS M 1642

**This chair relates to a set of armchairs that
Nahl designed for the bedroom of Prussian
King Friedrich II in the Potsdam Castle.**

MM

The furniture produced by Abraham Roentgen (1711–1793) and his son David (1743–1807) represents the most technically and artistically accomplished craftsmanship of the time. In 1742, after several years in London where he observed modern business practices, Abraham Roentgen opened his own factory in Neuwied on the outskirts of Cologne. Here he benefited from the protection of the Prince of Wied, as well as the religious community of Moravian Brothers, to which he belonged. This allowed him to expand his operation to eighty employees, well beyond the limit set by the guild. Master watchmakers, painters, engravers, and bronze casters collaborated in the production of his furniture.

David Roentgen entered his father's workshop in 1767 and expanded its clientele to European courts including Kassel, Munich, Württemberg, and Baden, as well as Berlin, Paris, and St. Petersburg. Among the workshop's technical innovations were various mechanisms for transforming the function of a piece as well as secret compartments that became the hallmark of Roentgen furniture. The production and marketing strategies that David Roentgen developed anticipate furniture production of the industrial age.

The early products of the workshop, like Abraham Roentgen's writing commode, are basically Rococo, drawing elements from English, Dutch, and French design. With David's entry into the business, the style changed to Neo-classicism. Beginning in 1780, pictorial marquetry was replaced by large expanses of mahogany veneer, framed and accented by gilded bronze mounts.

MM

Writing Commode, 1755–1760
Abraham Roentgen (Mühlheim/Cologne 1711–Herrnhut 1793)
Oak, mahogany veneer, walnut marquetry, gilded bronze
H. 24¼ in. (86 cm); W. 38⅜ in. (136 cm); D. 18⅞ in. (67 cm)
FAS M 124

The top of this ingeniously designed commode ratchets up to form a desk for use in the standing position. A slim block can be popped up to prevent books and papers from sliding off.

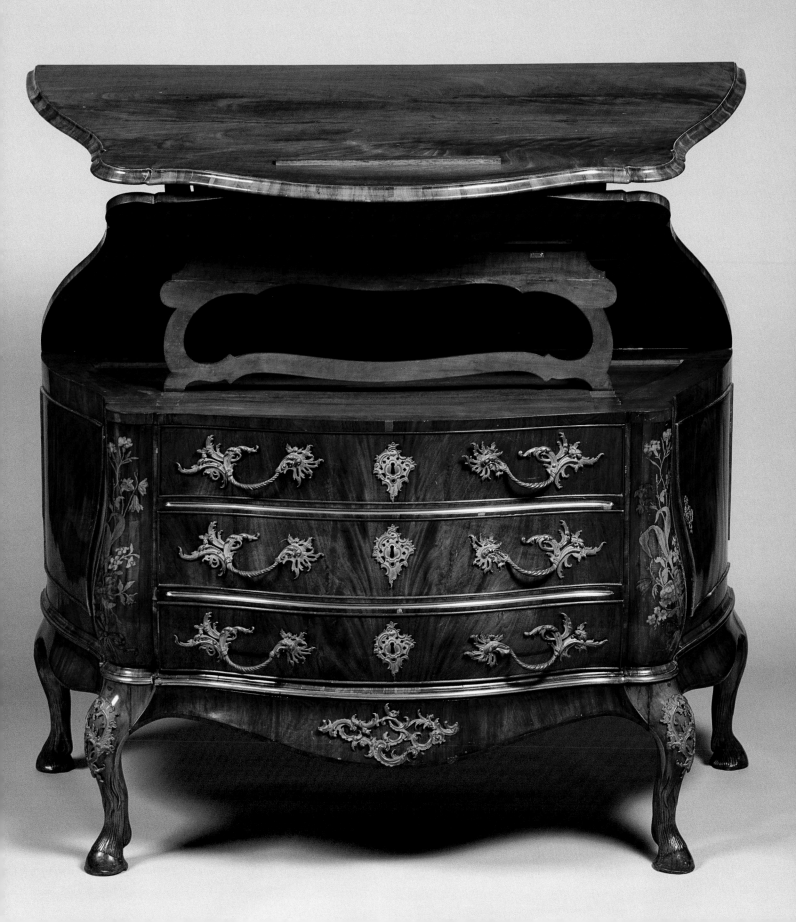

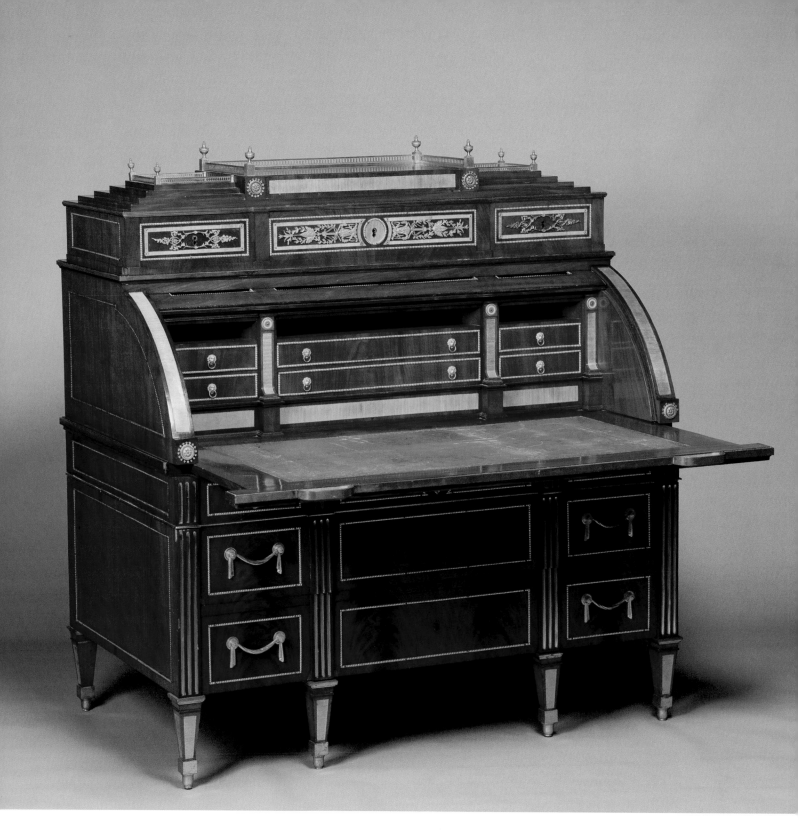

Cylinder Desk, 1785–1790

David Roentgen (Herrenhag near Büdingen 1743–Wiesbaden 1807)

Oak, mahogany veneer, gilded bronze, brass

H. 56¾ in. (144 cm); W. 52⅜ in. (133 cm); D. 32¾ in. (83 cm)

FAS M 89

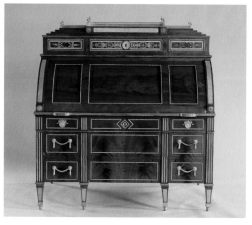

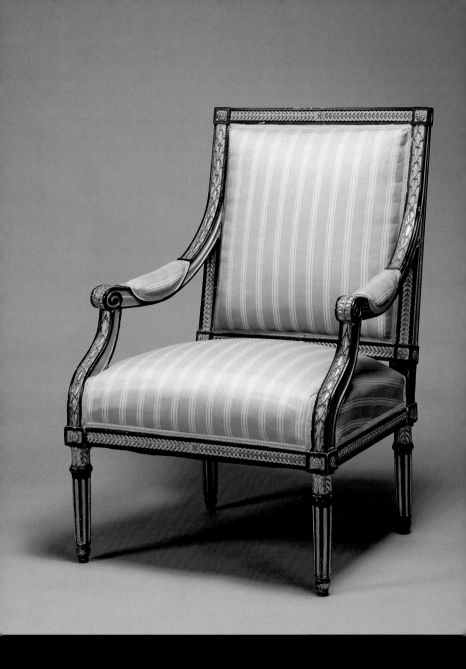

Armchair, ca. 1800
Designed by Heinrich Christoph Jussow (Kassel 1754–1825); made by Nicholaus Vallois
Beech, paint, gilt
H. 41⅜ in. (105 cm); W. 27¾ in. (69 cm); D. 22¾ in. (58 cm)
AS M 427c

In 1788, Landgraf Wilhelm IX of Hesse-Kassel commissioned Heinrich Christoph Jussow to build a new castle at Weissenstein, later known as Castle Wilhelmshöhe. Designs for chairs figure among Jussow's surviving drawings for interior decorations of the castle. The present chair illustrates how Jussow drew on contemporary Neo-classical French models

J. H. Tischbein's *Pastoral Festival in Freienhagen near Kassel* (1766) (see p. 54) depicts a rural dance around a maypole viewed by Landgraf Friedrich II of Hesse-Kassel (1720–1785), his wife, and courtiers. Friedrich's Freienhagen gardens, with their manicured hedges and precisely clipped cedars, reflect the Baroque tradition of the pleasure garden *(Lustgarten)*. By contrasting this courtly scene with the peasants' casual play on the left, Tischbein suggests the growing appreciation for more informal gardens in the latter 18th century.

Like most gardens of German Baroque courts, those in Hesse-Kassel and Hesse-Darmstadt were based on French and Italian models. Formal gardens were laid out to be viewed from a central position of a sovereign's house and meant to dazzle guests as an extension of grand court architecture. Their ornate, symmetrical designs were set out in precise geometric patterns. Axes and allées were punctuated by statues, fountains, or temples to produce strictly controlled views. In the spirit of Absolutism, such gardens manifested the sovereign's authority over nature.

In 1701 Landgraf Karl of Hesse-Kassel began construction of a gigantic Baroque hillside park he named Karlsberg. Designed by the Italian garden architect Giovanni Francesco Guerniero (ca. 1665–1745), the park's central element was a cascade running down from a huge octagon-shaped monument (see below). A copper figure of Hercules holding golden apples crowns the structure, symbolizing the fruits of Karl's own colossal task of building the Karlsberg gardens. Over the next hundred years, Karl's grandson Friedrich II and great-grandson Wilhelm IX (Elector Wilhelm I) transformed the park into an idealized natural landscape in the English style. A variety of dramatic fountains, waterfalls, and pseudo-ruins were added in the Romantic spirit. Renamed Wilhelmshöhe, the park remains one of the most splendid in Europe.

The 18th-cenury pleasure garden of Prince Georg Wilhelm of Hesse-Darmstadt (1722–1782) signaled a new informality corresponding to the Rococo style. The four-acre rectangular grounds were designed in 1764 by the prince and his wife Luise (1729–1818) as part of their summer residence. High walls ensured an air of privacy as the ducal family staged open air festivals and theater and relaxed with friends away from court ceremony. An orangerie, tea house, and aviary provided amusement on a personal scale. A "kitchen garden" component combined usefulness alongside beauty. Placed next to small box trees and ornamental plants are rows of colorful edible plants that give the garden a provincial charm. The Prince Georg Palais now houses the Hesse Grand Ducal porcelain collection (see pp. 55, 60–67, 84–85), and its gardens have been restored based on their original form. Visitors can even purchase the produce.

Exotic plants held great scientific and artistic importance. The first botanical gardens were set up in 16th-century Italy to house plants from foreign lands; a century later the French Queen Marie de Medici was the first to appoint a court botanical painter. The botanical paintings (see facing page) from the Hesse collection celebrate the exotic plants of Prince Bishop Amand von Buseck of Fulda (1685–1756), who not only built Schloss Fasanerie but also designed its Baroque gardens (see facing page) and was an avid botanist. Flora from the New World, the pineapple and cactus were two of the Prince Bishop's prized foreign plants. Set on a ledge overlooking the Fasanerie pleasure garden, they are displayed in blue and white pots from the Fulda Faience Manufactory.

JMS

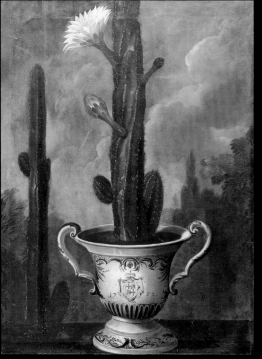

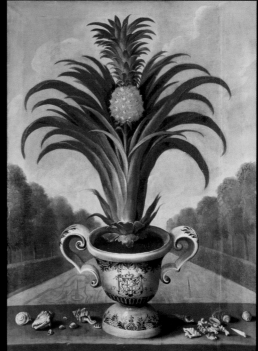

EMANUEL JOHAN KARL WOHLHAUBTER
(Brünn 1683–Fulda 1756)
Blooming Cactus, 1752
Oil on canvas
H. 52 in. (132 cm); W. 38½ in. (97.8 cm)
Dated on flower pot: *1752*
FAS B 716

EMANUEL JOHAN KARL WOHLHAUBTER
(Brünn 1683–Fulda 1756)
Pineapple, 1748
Oil on canvas
H. 51.9 in. (131.8 cm); W. 38 in. (96.6 cm)
Dated on flower pot: *1748*
FAS B 649

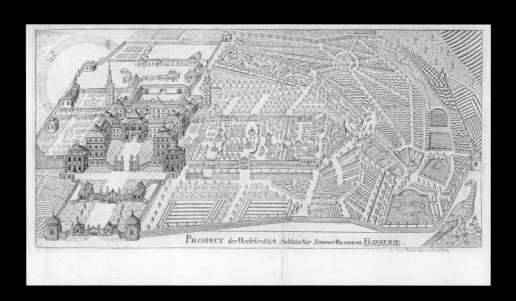

PROSPECT der Hochfürstlich fuldaischer Sommer-Residenz FASANERIE.

FRANZ PFEIFFER (Aachen 1741–Brussels 1807)
The Fasanerie, the Princely Summer Residence near Fulda,
from *Calendarium Parvum Capituli Fuldensis,* 1770
Engraving
L. 5¼ in. (13.1 cm); W. 3⅜ in. (8.5 cm); D. ½ in. (1.2 cm)
Inscribed lower right: *Franz Pfeiffer delin et sculp Fulda*
FAS T Hess Deu Fulda 1771 2d

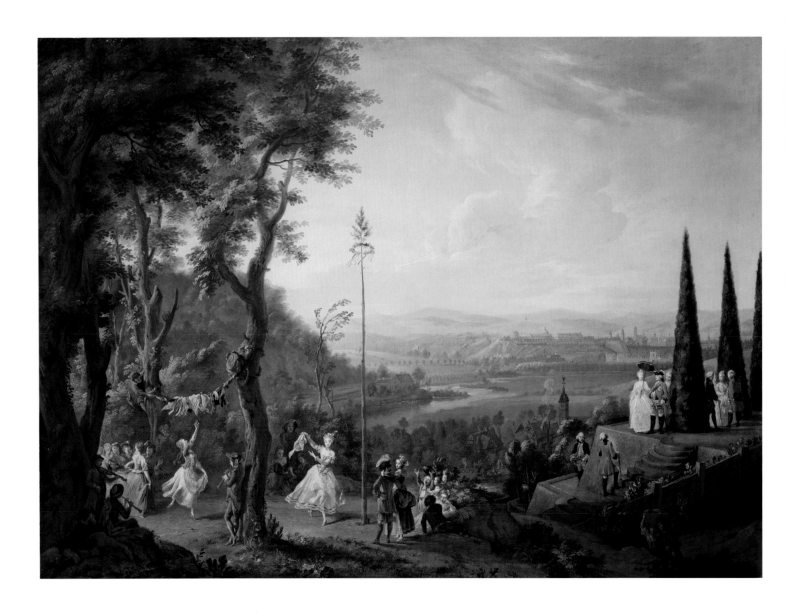

JOHANN HEINRICH TISCHBEIN THE ELDER (Haina 1722–Kassel 1789)

Known as the "Kassel" Tischbein, Johann Heinrich Tischbein the Elder was the first within his talented family to achieve greater renown as an artist. In 1753, after a painting apprenticeship in Kassel and studies in France and Italy, he was appointed court painter by Hesse-Kassel Landgraf Wilhelm VIII. In the three years before the French occupation of Kassel forced the landgraf into exile, Tischbein painted portraits of Wilhelm (see p. 240) and his court. He idealized sitters with a Rococo style, arranging them in rich surroundings. When he returned to the Hesse-Kassel court in the service of Landgraf Friedrich II, his production shifted toward history painting and landscape. Along with painting cycles of classical history, he received commissions for German history scenes, such as *Hermann's Battle,* which reflected a growing interest in national history. Tischbein's landscapes for Friedrich immortalized the prince's architectural achievements but played down courtly pomp and included a connection to middle-class life. Through his appointment in 1762 as Professor of Painting at the Collegium Carolinum and as Director of Friedrich's new Art Academy in Kassel in 1777, Tischbein trained many of Kassel's next generation of artists.

JMS

Pastoral Festival in Freienhagen near Kassel, 1766
Oil on canvas
H. 34⅞ in. (88.6 cm); W. 47⅜ in. (120.2 cm)
Signed and dated lower left: *1766*
FAS B 342

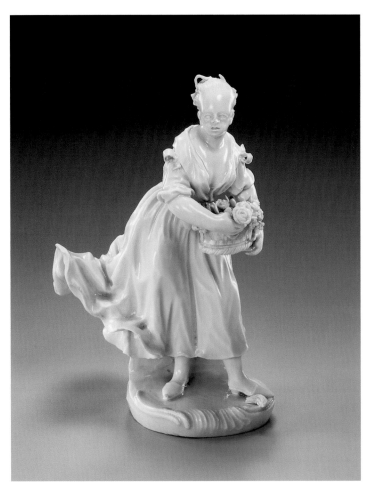

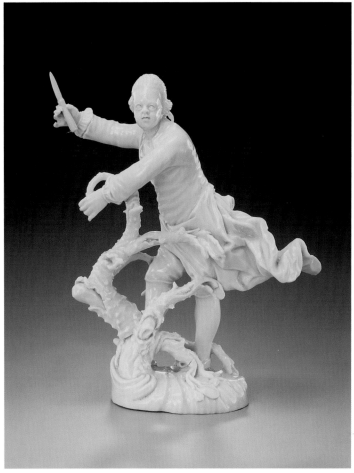

Girl with Flower Basket, 1763–1764
Kelsterbach; modeler, Jakob Carlstadt
Porcelain
H. 4⅜ in. (11 cm)
PM DA PE 230118

Gardener Pruning a Fruit Tree, 1763–1764
Kelsterbach; modeler, Jakob Carlstadt
Porcelain
H. 4⅞ in. (12.4 cm)
PM DA PE 230120

Fluttering garments bring the spirit of caprice typical of Rococo art to these porcelain figures of a gardener and a girl gathering flowers.

JMS

Dessert Plate from Iron Helmet (*Eiserner Helm*)
Porcelain Service, 1819–1820
Royal Porcelain Manufactory, Berlin
FAS PE 0458

The depiction of the Octagon Cascade is one of a series of views of Wilhelmshöhe Park painted on pieces of the Iron Helmet service.

PH-S

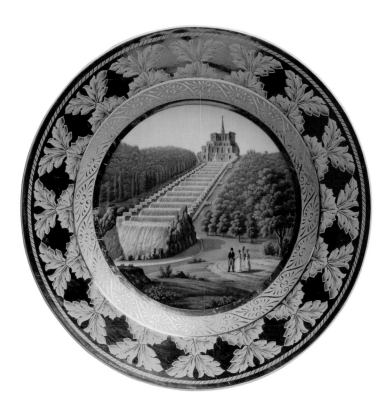

WILHELMSBAD

Wilhelmsbad was the name Crown Prince Wilhelm (1743–1821), later Landgraf Wilhelm IX and Elector Wilhelm I, gave to the spa resort he founded close to the city of Hanau, where a medicinal spring had been discovered in 1709. Wilhelm commissioned the local architect Franz Ludwig Cancrin (1738–1816) to construct the first buildings in 1777. The grounds centered around the springs, which were housed in a temple-shaped structure on a long promenade bordered by a series of pavilions. Wilhelm financed the rapid construction of the resort with profits from his military contracts with King George III of England.

Surrounding the late Baroque building ensemble is one the first English landscape parks constructed in Germany. Winding paths over the hilly grounds lead to many pleasure attractions, including a large carousel. The prince's private retreat, constructed in 1779 in the form of a ruined medieval tower, was an early expression of the Romantic Movement. Located on an island in an artificial lake, it could be reached only by a bridge. This neo-Gothic "tower" became Wilhelm's favorite refuge where he could enjoy seclusion from court life.

When Wilhelm became landgraf and moved to Kassel in 1785, building activity ceased at Wilhelmsbad. As the spring also dried up, the resort lost its attraction. The buildings and park remain largely unchanged, a unique survival of a complete 18th-century resort complex.

MM

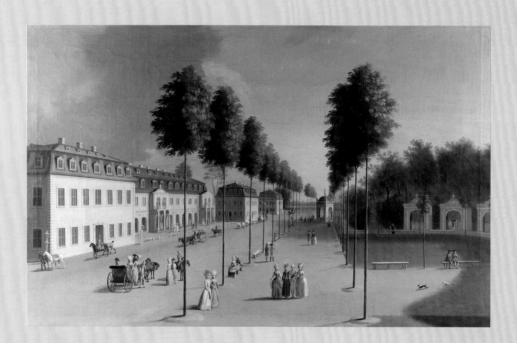

ANTON WILHELM TISCHBEIN (Haina 1730–1804)
View of the Promenade at Wilhelmsbad, ca. 1785
Oil on canvas
H. 26⅜ in. (67 cm); W. 41⅜ in. (105 cm)
FAS B 432

The composition of the painting focuses on the temple-shaped housing for the healing springs. On the promenade lined with linden trees, we see the elegant visitors who will make use of lodgings, a bathhouse, and theater in the buildings aligned on the left.

MM

ANTON WILHELM TISCHBEIN (Haina 1730–1804)
View of Wilhelmsbad Park with Pyramid, ca. 1785
Oil on canvas
H. 27⅜ in. (69.5 cm); W. 38¾ in. (98.3 cm)
FAS B 431

On an island in the Wilhelmsbad park stands a pyramid, a fantasy building typical of English
landscape gardens. Housing a funerary urn, the pyramid was built by Wilhelm IX as a memorial
for his son Friedrich, who died in 1784.

MM

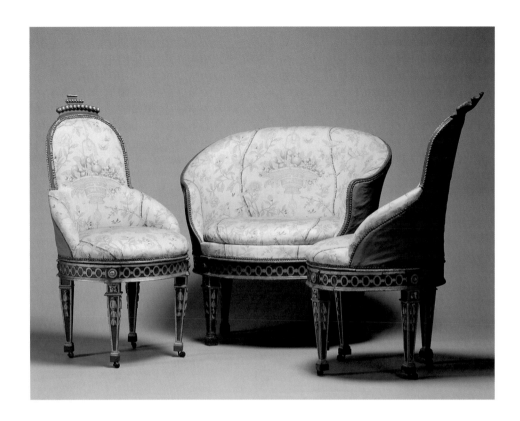

Settee and Swivel Chairs, ca. 1780
Designed by Franz Ludwig Cancrin (1738–1816)
Red beech; chairs: red beech, horn
Settee: H. 36¼ in. (92 cm); W. 37⅜ in. (95 cm); Dia. 25¼ in. (64 cm);
chairs: H. 42¾ in. (109 cm); W. 23¼ in. (59 cm); D. 25⅝ in. (65 cm)
FAS M 14, M 16 a & b

Originally painted pink and gilded, these pieces belonged to the appointments of the "round cabinet" of the Wilhelmsbad tower. Although the designs were compacted to fit this small circular sitting room, the first consideration was comfort. These early swivel chairs are set on rollers made of horn. Wilhelm wrote in his memoirs that it was in the apartment of his tower retreat that he "enjoyed the conveniences of life for the first time."

MM

ANTON WILHELM TISCHBEIN
(Haina 1730–1804)
*View of Wilhelmsbad Park
with Tower and Carousel,* ca. 1785
Oil on canvas
H. 25¾ in. (65.5 cm); W. 37⅜ in. (95 cm)
FAS B 435

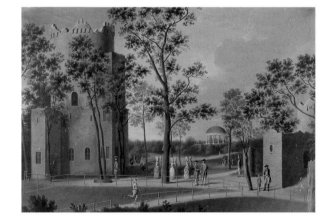

Visitors stroll between Wilhelm's tower on the left and the kitchen building on the right, also built in the style of a ruin. The round temple in the background was actually a carousel. The interior of the Wilhelmsbad tower, with its luxurious Louis XVI décor, presents a striking contrast to the building's forbidding stone exterior. Pieces specially designed for the tower by Wilhelm's architect Franz Ludwig Cancrin furnished the seven small rooms of the ground floor and the circular domed hall above.

MM

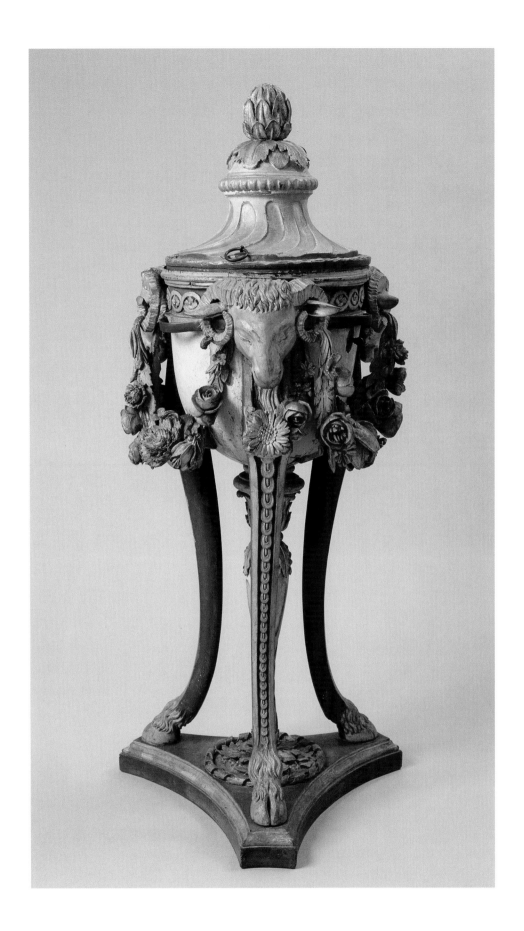

Athenienne (wash basin), ca. 1780

Linden wood (repainted and gilded)

H. 44⅛ in. (112 cm); Dia. 15¾ in. (40 cm)

FAS M 10

The French term "Athenienne" refers to the antique bronze burners that recently had been excavated in Italy. The form was adapted as a washstand and became a signature piece of the Neo-classical style of the late 18th century. In this example made for the Wilhelmsbad tower, the carved cover lifts to reveal a wash basin underneath.

MM

kelsterbach, the Hesse-Darmstadt porcelain factory

The highly vitrified white ceramic imported from China was so treasured in the West that princes hired alchemists to discover the secrets of its manufacture. Although approximations were achieved earlier in Italy and France, true hard-paste porcelain with the essential ingredient of kaolin was first produced around 1708 at Meissen for Augustus the Strong of Saxony. Frenzied competition ensued, with princes eager to start factories on their own territory.

In the second half of the 18th century, twenty-three factories were producing porcelain in German principalities and the Hessian landgrafs were not to be left behind. At Kassel from 1766 to 1768, Friedrich II subsidized a porcelain-making branch at one of the established potteries and production consisted primarily of tablewares. It was clearly the sculptural potential of the new medium, however, that intrigued Ludwig VIII of Hesse-Darmstadt. In 1761 he had the Kelsterbach manufactory of faience (tin-glazed earthenware) converted to porcelain production under the direction of Christian Daniel Busch, an arcanist with impressive credentials. Busch had worked first at Meissen and then at various other factories, including the French Royal Manufactory of Sèvres. Carl Vogelmann, from the factory of Ludwigsburg, was engaged to create models and brought with him the sensibility of south German sculpture with robust figures and extremely expressive faces. A second modeler, Jakob Carlstadt, worked at Kelsterbach only from 1763 to 1764, but is most likely responsible for the innovative flying draperies that distinguish many of the figures.

In 1764 Busch returned to Meissen, and Vogelmann went back to Ludwigsburg. Direction of the factory was taken over by one of Ludwig VIII's financial administrators, Eberhard Dietrich Pfaff. New artistic ideas arrived in 1767 in the person of modeler Peter Antonius Seefried. Trained at the Nymphenburg factory, he had learned the vocabulary of the sculptor Franz Anton Bustelli and could make fashionably clad figures that appeared to undulate with ineffable grace.

Landgraf Ludwig IX took no interest in the unprofitable prestige production of porcelain, so it was discontinued at Kelsterbach after his father's death in 1768. The factory continued to make faience, and porcelain was re-introduced sporadically in 1789–1792 and again in 1799–1802. The later porcelains were mainly tablewares in the Neo-classical style. The factory mark of a conjoined "HD" appears to have been only occasionally impressed or painted on wares until 1789, when a crown was added to the mark.

Due to the limited quantities that were made, examples of early Kelsterbach production are rare and its sculptural achievement is little known. In 1908 Grand Duke Ernst Ludwig of Hesse-Darmstadt organized the family porcelain collection and presented it to the public in the Prinz Georg Palais, a summer residence in Darmstadt. Today, it is in these beautifully restored 18th-century rooms that one can discover the 150 examples of Kelsterbach that form the core of the Hessian Grand Ducal porcelain collection and appreciate the unique character of this moment in German Rococo art.

PH-S

Lady Dulcimer Player and Putto in Rococo Setting, 1763–1764
Kelsterbach; modeler, possibly Jakob Carlstadt
Porcelain
H. 8⅞ in. (22.5 cm)
Inv. Nr. DA PE 230123

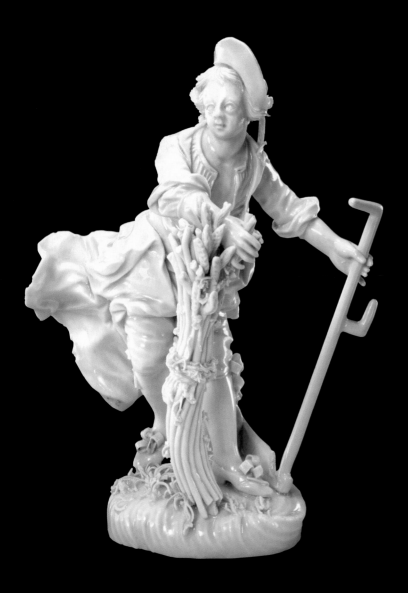
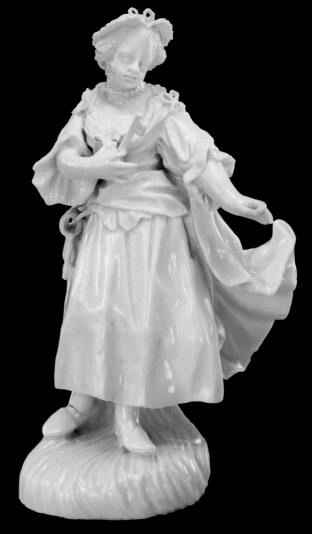

Young Reaper, 1763–1764
Kelsterbach; modeler, possibly Jakob Carlstadt
Porcelain
H. 4¾ in. (12.5 cm)
Inv. Nr. DA PE 230119

Girl with Keys, 1763–1764
Kelsterbach; modeler, possibly Jakob Carlstadt
Porcelain
H. 5⅛ in. (12.8 cm)
Inv. Nr. DA PE 230126

FACING PAGE

Set of Four Seasons, 1761–1764
Kelsterbach; modeler, Carl Vogelman (act. 1760–1784)
Porcelain
H. 3⅞ in. (9.8 cm) (tallest)
Inv. Nr. DA PE 230249, 50, 51, 52

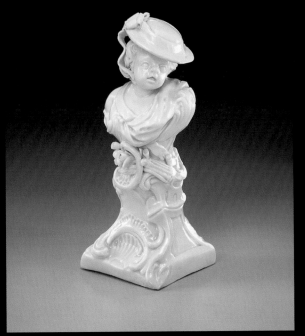

Singer and Musician with Viola de Gamba,
1763–1764
Kelsterbach; modeler, possibly Jakob Carlstadt
Porcelain
Singer: H. 6 in. (15.7 cm); musician: H. 6⅜ in. (16.1 cm)
Inv. Nr. DA PE 230121, 122

Snuff Box, ca. 1765
Kelsterbach; landscape after Georg Adam Eger (1727–1808); portrait after Johann Christian Fiedler (1697–1765)
Porcelain
H. 1⅝ in. (3.9 cm); W. 3⅛ in. (7.7 cm); D. 2¾ in. (6.8 cm)
Inv. Nr. DA PE 230195

This container for the fashionable consumption of snuff was surely conceived to delight the factory's princely patron. The contoured box was covered on all sides of the exterior with scenes of the hunt that Ludwig VIII so loved. When it was opened to extract a pinch of snuff, the landgraf's smiling image was revealed inside the lid.

PH-S

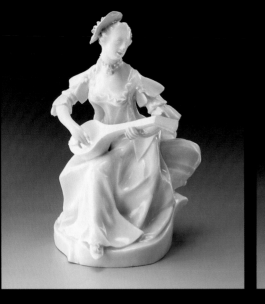

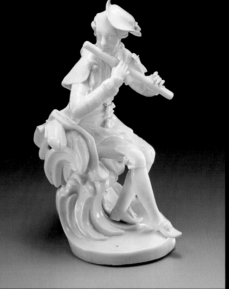

Lute Player and Flautist, 1767–1768
Kelsterbach; modeler, Peter Antonius Seefried
Porcelain
Lute player: H. 6¼ in. (15.9 cm); flautist: H. 6⅜ in. (16.1 cm)
Inv. Nr. DA PE 230131,32

Shell-Shaped Dish, ca. 1765
Kelsterbach
Porcelain
H. 3⅜ in. (9 cm); W. 14½ in. (36.6 cm); Dia. 12⅜ in. (31.2 cm)
Inv. Nr. DA PE 230571

In this highly original dish, the forms of a shell
and a splashing wave are combined to capture
the amorphous essence of Rococo design.

PH-S

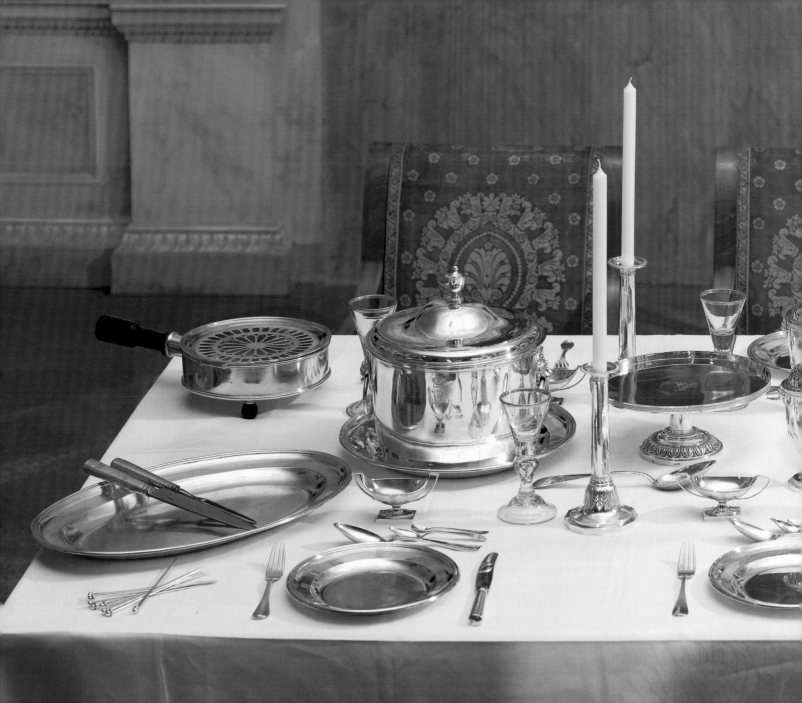

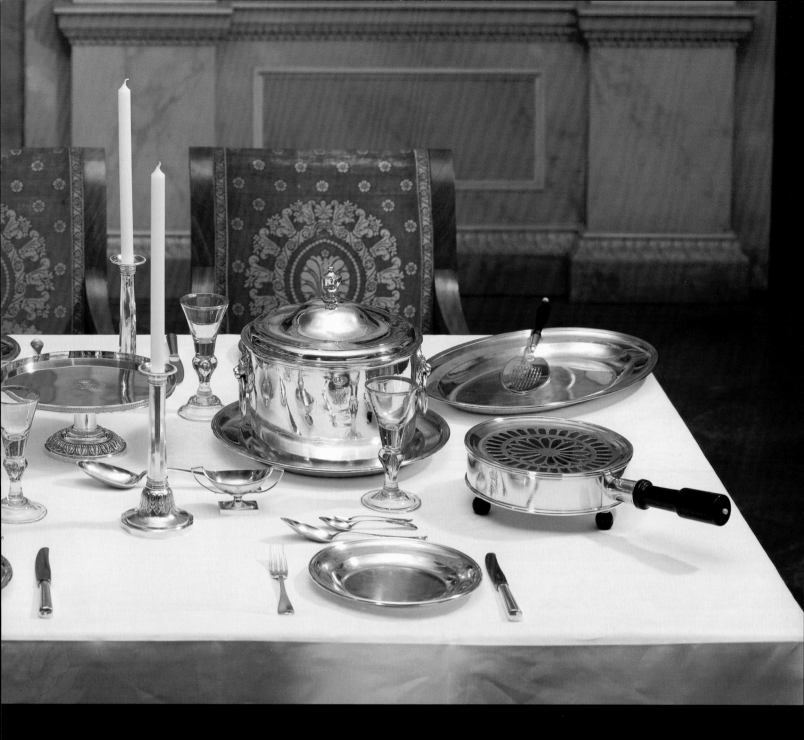

crown and the initials "WK" for "Wilhelm Kurfürst," these pieces were to display the house's new rank in an appropriate manner.

Wilhelm I went on to commission a complete new silver service of thirty-six place settings in 1806 from Heinrich Wilhelm Kompff, who held the rank of Royal Gold- and Silversmith. Typical of the best Huguenot silver tradition in Kassel, the service's metal was weighty and its forms simple, clear, and classical. How much of the service Wilhelm I was able to save when he had to flee in advance of Napoleonic troops is uncertain. It is known, however, that after his return in 1813 he had Kompff expand the service and enlarge its number of place settings to fifty.

In addition to the six plates per place setting, the equipment included round and oval platters of different sizes, various serving cutlery, and candlesticks, tazza, salt dishes, and sugar shakers. Remarkable in this service are its large covered pots for *pot à l'oille,* an elaborate meat and vegetable dish. These pots were equipped with *réchauds,* whose lighted flame kept the food hot. Unique to this service, such food warmers were a novelty in Germany.

The hunt in the court of the Landgrafs of Hesse

From the Middle Ages, the nobleman's exhilarating outdoor sport of hunting was gradually transformed into a carefully organized demonstration of the splendor and power of a sovereign's court. Hunts took the prince to the most remote of his lands and made his subjects aware of his presence in a personal and animated manner. The sporting event had a strong political subtext as important guests were invited, allowing for the develoment of alliances in a social setting. By the 18th century, the princely hunt developed into an elaborate culture fueled as much by the need for courtly pageantry as by sheer hunting passion.

Following medieval practice, the prince was entitled to hunt anywhere within his domains. Non-nobles were normally excluded from this right. Together with his staff of huntsmen, the sovereign pursued stags and wild boar, as well as pheasants, and left smaller game to others. With the Revolution of 1848, hunting rights were turned over to private land owners, whose estates, however, had to be of sufficient size to contain the hunt.

The traditional princely hunt in Hesse was the *eingestelle Jagd,* also known as the German Hunt, where numerous huntsmen spread out over a large forested area to flush out and herd the game into a pen formed by linen cloths. From there the animals were herded into a second, smaller enclosure circled by linens. From a platform at its center, hunters waited to shoot the game and sometimes finish it off with the thrust of a lance.

In 1708 Landgraf Ernst Ludwig (1667–1739) of Hesse-Darmstadt introduced the "parforce" hunt developed in France, replacing the *eingestelle Jagd.* First a professional huntsman searched out a particular animal. Then a pack of ten to fifteen hounds was set on its trail. Special hunting signals, barking dogs, and French commands accompanied red-uniformed hunters on horseback as they pursued the game through an artfully landscaped park. When the game was cornered the gentlemen hunters shot it or finished it off with a double-edged sword.

The falcon hunt, brought to Europe from the Orient during the Crusades, flourished in Hesse under Landgrafs Ludwig VIII of Hesse-Darmstadt and Friedrich II of Hesse-Kassel. The landgraf kept several prized falcons. Taken on a hunt, the falcon remained hooded and perched on the glove of the falconer. On command, the hood was removed and the falcon was released to pursue his natural prey, which, if it was a heron, resulted in a spectacular mid-air fight.

The game parks established in the 16th century near Kassel and Darmstadt still exist, comprising fenced areas of around 8,650 and 24,700 acres. Wolfsgarten and Fasanerie are surviving examples of the numerous hunting lodges and castles built throughout Hesse in the 18th century. Guests were housed and festivities hosted in surroundings furnished with trophies and works of art celebrating the hunt. The collections of the Hesse family related to the hunt are now assembled at the most important of their surviving hunting castles, Kranichstein, near Darmstadt, which is now the Hessian Museum of the Hunt.

PH-S & JMS

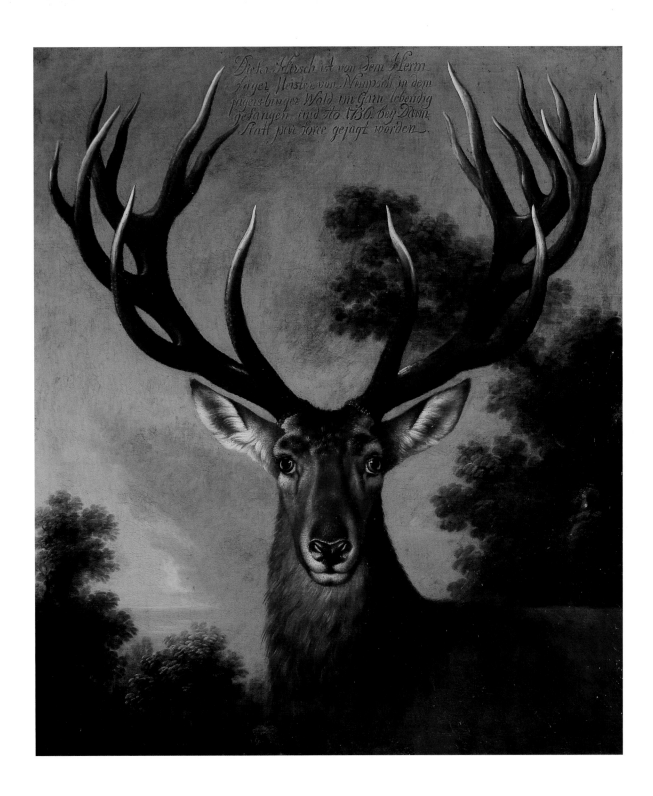

GEORG ADAM EGER (Murrhardt 1727–1808)
Stag Portrait, 1756
Oil on canvas
H. 46⅝ in. (118.5 cm); W. 41⅛ in. (104.5 cm); D. 1 in. (2.6 cm)
Inscribed top center: *Dieser Hirsch ist von dem Jäger-Meister von Nimpsch in dem jägers-bürger Wald im Garn lebendig gefangen und Ao. 1756 beij Darmstatt par force gejagt worden.* ("This stag was caught live by the professional hunter of Nimpsch in the hunter-townsman forest in Garn and in 1756 parforce hunted near Darmstadt.")
SDJ 004/001/174

Deer portraits commemorated stags caught during the hunt. Deer were particularly prized for their antlers, which have long symbolized supernatural animal power. Eger's representation depicts a stag slain in 1756 during a parforce hunt in Garn near Darmstadt. Around 1748, Eger became Landgraf Ludwig VIII's favored court painter of the parforce hunt and often accompanied the landgraf when hunting. Ludwig even provided the painter with hunting garments to put him more on par with the hunting guests of nobility.

Johann Elias Ridinger (1698–1767), a Baroque specialist in animal representations, popularized the Hessian court hunt as he traveled from one hunting seat to another and transferred the paintings into prints.

JMS

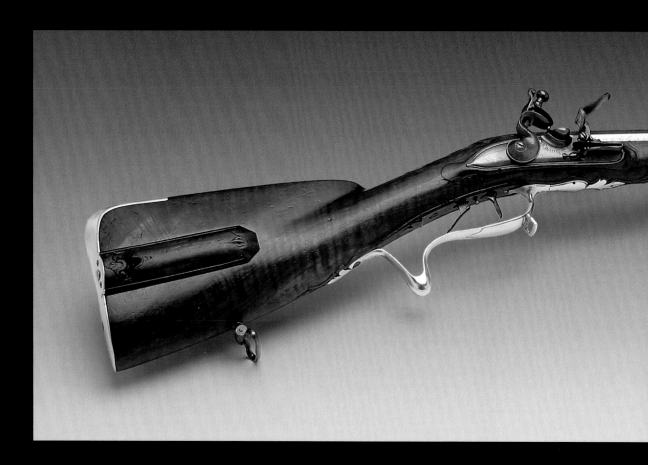

Flintlock Rifle, ca. 1720
Johann Peter Bosler (Zella 1689–Darmstadt 1742)
Barrel: walnut, steel; barrel end: horn, silver; trigger and piston plate: brass, iron
L. 42⅜ in. (107.5 cm); W. 8¼ in. (21 cm); caliber: ⅝ in. (1.5 cm)
Engraved in silver thumbplate: mirror double-L monogram with crown of Landgraf Ludwig VIII of Hesse-Darmstadt
SDJ 002/006/57

The firearms used for hunting by generations of Hessian landgrafs are showpieces of both craftsmanship and technical excellence. Some were purchased in Dresden, Vienna, and Paris, although most were made by Hessian gunsmiths. Born in Thuringia, Johann Peter Bosler established himself as a gunsmith in Darmstadt, where his workshop was later taken over by his son Friedrich Jakob. In Landgraf Ludwig VIII, the family found an enthusiastic patron for their exquisite firearms. Today weapons by the Boslers are found in museum collections in Dresden, Vienna, and London.

MM

FACING PAGE

Pneumatic Rifle, ca. 1750
Friedrich Jakob Bosler (Darmstadt 1717–1793)
Barrel: walnut, gold; trigger and piston plate: brass
L. 54⅜ in. (138 cm); W. 8¼ in. (21 cm); caliber: ⅝ in. (1.5 cm)
Engraved in gold on barrel: mirror double-L monogram with crown of Landgraf Ludwig VIII of Hesse-Darmstadt
SDJ 002/007/9

The introduction of gunpowder in 11th-century Europe transformed court hunt traditions. First the matchlock rifle, then around 1600 the wheel lock and flintlock rifles augmented the crossbow, sword, and lance that had been used since medieval times. In the 18th century hunters in Hesse favored pneumatic rifles, which were invented in the early 1500s and remained popular into the 19th century. Built on the principle of a vacuum or air surge, the gun's wind chamber generated a considerable force. In the mid-1700s, for example, the avid hunter Landgraf Ludwig VIII of Hesse-Darmstadt used a large bore pneumatic rifle to kill 500-pound stag elk at ranges of 150 to 160 paces.

JMS

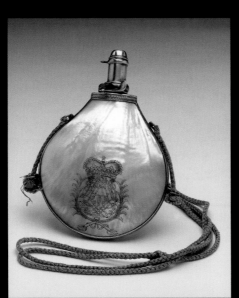

Air Pump, ca. 1750
Darmstadt
Iron, rubber
L. 24⅜ in. (62 cm); W. 7⅜ in. (18.5 cm)
SDJ 003/002/243

This air pump attaches to the butt of the pneumatic rifle via a screw mechanism.

Powder Flask, ca. 1750
Darmstadt
Mother-of-pearl, silver, iron
H. 5⅞ in. (15 cm); W. 3⅛ in. (8 cm)
Engraved on obverse: mirror double-L monogram with crown of Landgraf Ludwig VIII of Hesse-Darmstadt
SDJ 003/002/267

JOHANN CONRAD SEEKATZ (Grünstadt 1719 – Darmstadt 1768)

Johann Seekatz trained in Mannheim and was appointed court painter by Landgraf Ludwig VIII in 1753. Since Seekatz initially received few court commissions at the Darmstadt court, he found a clientele among the wealthy citizens of Frankfurt for his genre paintings in the Dutch and French manner. Around 1765 Ludwig VIII commissioned Seekatz to paint seventeen overdoor pictures for his summer castle of Braunshardt.

MM

A Parforce Hunt Led by Landgraf Ludwig VIII of Hesse-Darmstadt, 1765–1768
Oil on canvas
H. 26 in. (66 cm); W. 32⅜ in. (82 cm)
WO B 8043

Painted Rococo ornament that frames this scene includes hunting motifs and a crowned cartouche with the mirror double-L monogram of Ludwig VIII.

MM

Nocturnal Pheasant Hunt, 1765–1768
Oil on canvas
H. 20⅛ in. (51 cm); W. 26 in. (66 cm)
WO B 8042

The painting shows Landgraf Ludwig VIII on a night hunt in the pheasant park of Kranichstein Castle. Four versions exist, undoubtedly painted to decorate the landgraf's castles.

MM

JOHANN HEINRICH TISCHBEIN THE ELDER (Haina 1722–Kassel 1789)
Landgraf Friedrich II of Hesse-Kassel Heron Hunting with Falcons, 1766
Oil on canvas
H. 38⅛ in. (96.8 cm); W. 55⅛ in. (140 cm)
FAS B 0340

In the painting's center, Friedrich II sits on a white horse as a falconer gives him a hunting falcon. In the background is Castle Wabern, from which the court undertook heron hunts. In these hunts, the heron were not killed; rather, after one had been brought to the ground by the falcon, a band was put on one of its feet and it was set free. Fasanerie has six large-scale paintings by J. H. Tischbein representing a heron hunt that took place in 1763 (see pp. 34–35). These were originally painted for a salon in Castle Wabern.

MM

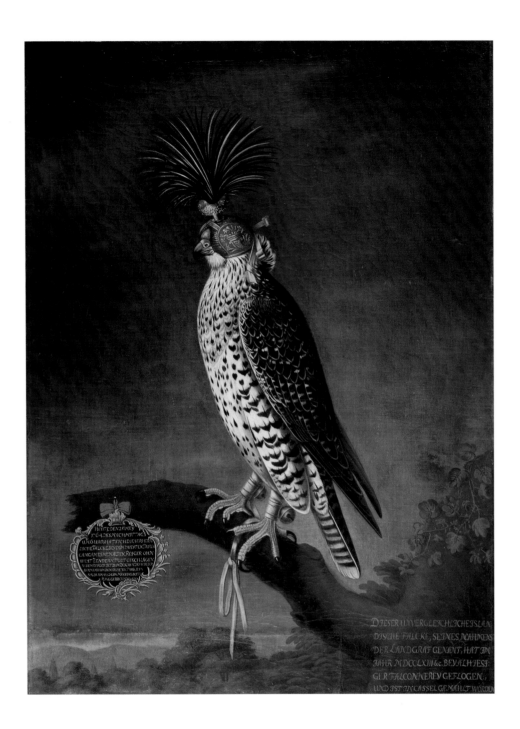

CHRISTOPH WILHELM GROTE (Kassel, act. 1763–1803)
Hooded Falcon "Landgraf," 1763
Oil on canvas
H. 37½ in. (95.2 cm); W. 27¾ in. (70.5 cm)
Inscribed lower left: *Heute den 25t Mey 1764 des Nachmittags um 6 Uhr hat sich dieser herrliche Falcke bey dem zweyten durch
gang an einem alten Reiger [Reiher] ohnweit zendern Todt geschlagen—dem Reiger ist zum Zeichen des wiederkennens um den
rechten Fuss ein silbern- und ein messinger Ring gebogen worden* ("Today, May 25th, 1764, at 6 o'clock in the afternoon near
Zendern, this marvelous falcon struck dead an old heron on the second pass. The heron had been fitted on its right foot with
a silver and a brass ring as marks of identification"); inscribed lower right: *Dieser unvergleichliche Islandische Falcke, seines
Nahmes der Landgraf genant, hat im Jahr MDCCLXIII&c. bei alheisiger Falconnerey geflogen und ist in Cassel Gemahlt worden.*
("In 1763 this incomparable Icelandic falcon, named Landgraf, flew in a local falconry and was painted in Kassel.")
FAS B 0479

The painting belongs to a series of falcon portraits that Landgraf Friedrich II of Hesse-Kassel
commissioned for Castle Wabern. Each painting bears an inscription that indicates the origin and
the name of the falcon it represents. The names "Landgraf," "Prince," and "Landgräfin" reveal
the court's esteem for these birds and their role in the heron hunt. Grote later added a cartouche
that appears near the painting's center attached to a bough. Its text relates that the falcon was
slain by an old heron during a hunt in May 1764.

MM

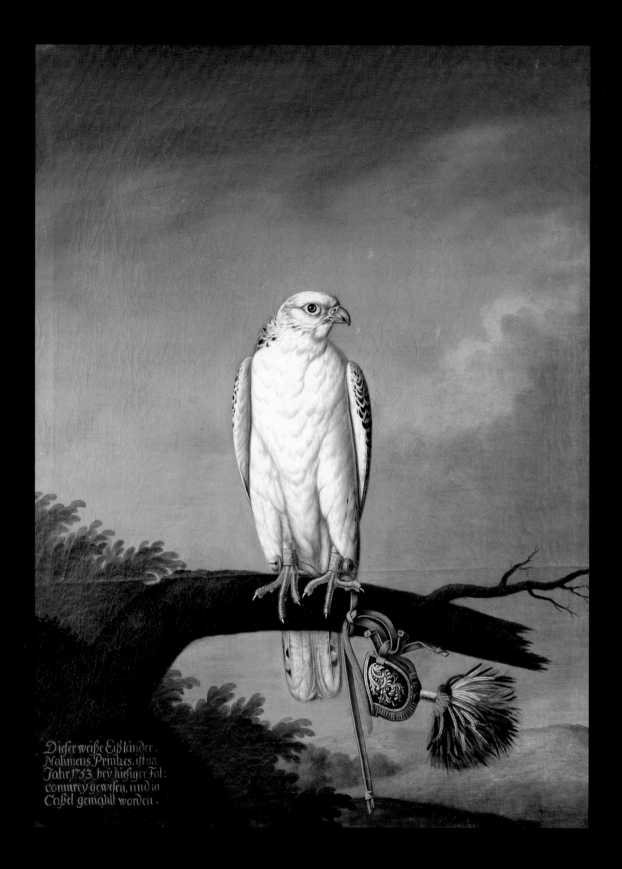

Dieſer weiße Eißländer.
Nahmens Printzes. iſt im
Jahr 1753. bey hieſiger Fal:
connirey geweſen, und in
Caßel gemahlt worden.

CHRISTOPH WILHELM GROTE (Kassel, act. 1763–1803)
Falcon "Printzes" on a Branch, 1753
Oil on canvas
H. 37⅞ in. (96.2 cm); W. 28¼ in. (71.7 cm)
Inscribed lower left: *Dieser weiße Eisländer Nahmens Printzes ist im Jahr 1753 bey hiesiger Falconnirey gewesen, und in Caßel*
gemahlt worden ("In 1753, this white Icelandic falcon named Printzes engaged in local falconry and was painted in Kassel");
inscribed on falcon's footbands: left: *WL* [Wilhelm Landgraf], right: *ZH* [zum Hessen]
FAS B 0497

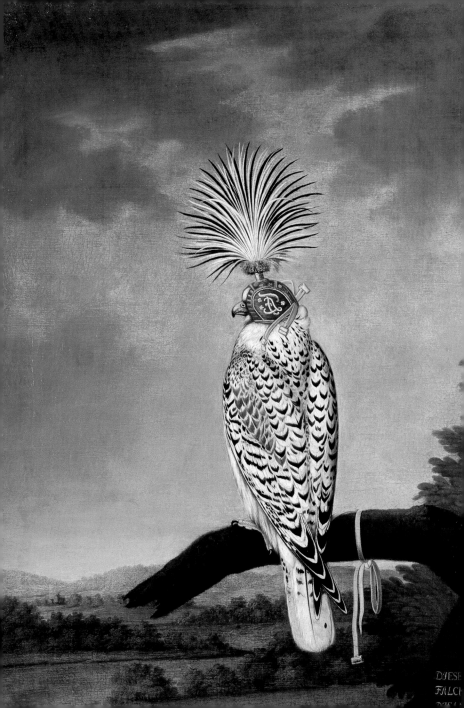

DIESE
FALCH

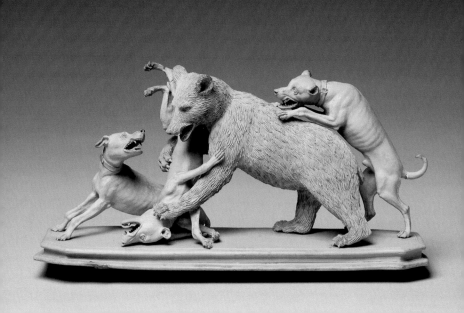

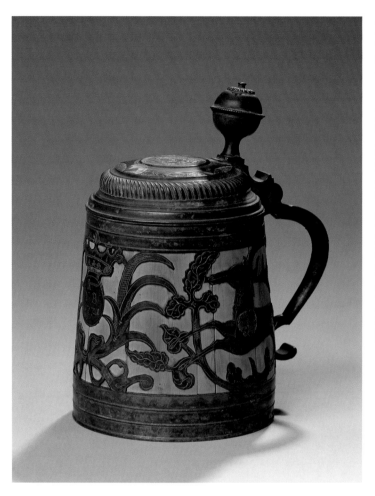
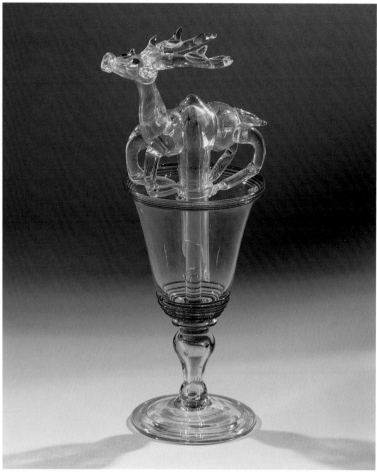

Stave Tankard, 1721
German
Birch or pine, pewter; lid inset with coin medallion
H. 9¼ in. (23.5 cm); D. 5½ in. (14 cm)
Inscribed on lid: *Der Engel schüzt begleit Tobiae Frömmigkeit in der Gefährlichkeit;* engraved between hunt scene on armorial
below axe and crown: *VB 1721*
FAS K 0002a

Known as a *Daubenkrug* (stave tankard), this traditional German vessel is constructed like a barrel. Its body is composed of strips of wood that are held together by circular bands and decorated cutout of pewter. Made of unrefined materials and meant for daily use, the tankard's rugged appearance easily lends itself to hunting themes. The engraved blessing, which translates as "The angel protects, piety accompanies Tobias in danger," refers to the Old Testament figure Tobias, who was protected by the archangel Raphael during his adventures; this, along with the engraved date, lend the tankard a ceremonial meaning.

JMS

Beaker with Stag, early 18th century
German
Clear and blue glass
H. 12 in. (30.5 cm); Dia. 4⅜ in. (11 cm)
SM G 21136

In the center of this trick drinking beaker is a glass stem fitted with a larger cylinder topped by a hollow figure of a deer. The device functions like a straw whereby the drinker draws the liquid up through the stag's mouth. The beaker's novel shape and use capitalize on the stag's mythological and magical powers, here symbolically transferred to the drinker.

JMS

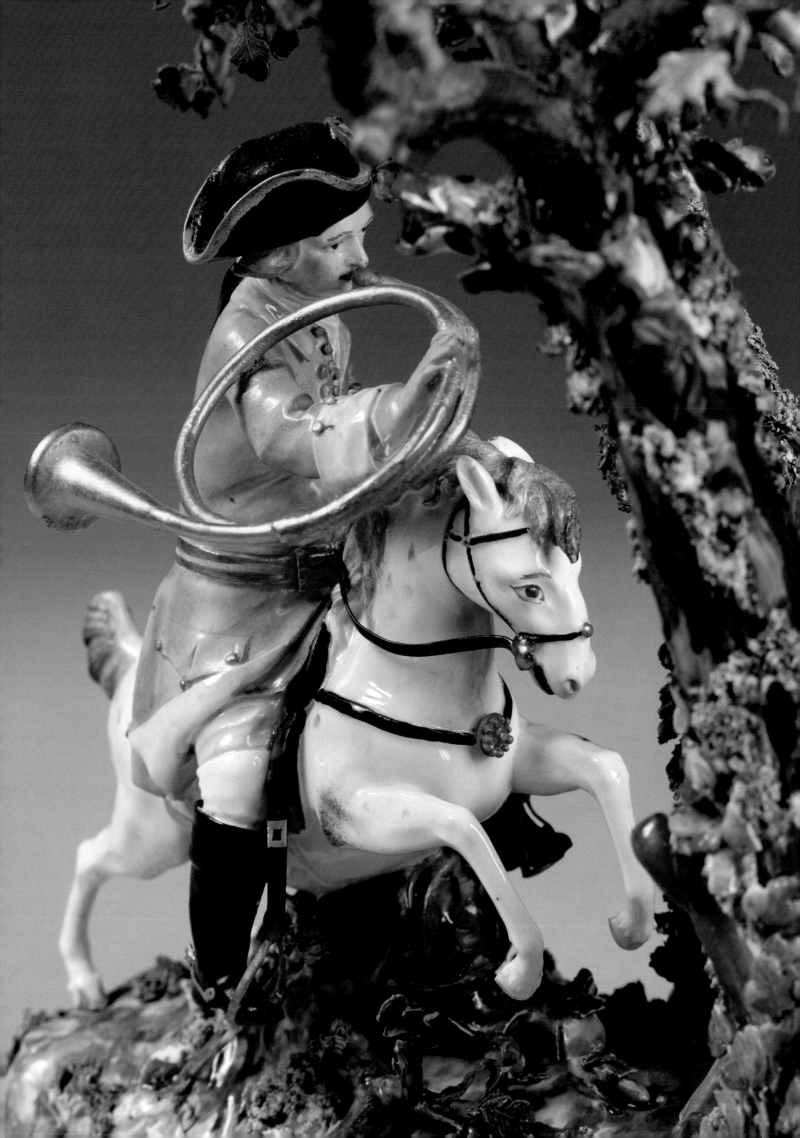

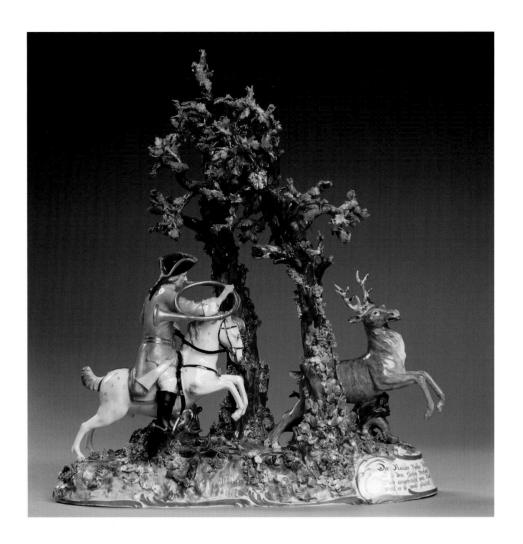

The Hunter of Kurpfalz, ca. 1770

Frankenthal; modeler, Johann Friedrich Lück (Freiburg, Sachsen 1728/29–Meissen 1797)

Porcelain

H. 14⅜ in. (36.5 cm); W. 12⅝ in. (32 cm)

Inscribed front lower left: *Der Reuter voller Wuth/als er den Hirsch Verheret/Wird angefrischt von Muth/weil er so wohl phisiret* ("The rider in such a rage / as the stag he does esteem / is recharged with courage/because his aim is so keen"); front lower right: *Der Hirsch von Hunden/ganz verlaßen/muß sich selbst die/Vue belaßen [?]* ("The stag to the hounds / full forsaken / must himself leave / the location")

PM DA PE 230008

Around 1750 *Ein Jäger aus Kurpfalz* ("Hunter of Kurpfalz") became a popular folk song. According to legend, its jolly character celebrates the hereditary forester Friedrich Wilhelm Utsch (1732–1795), who hunted in Germany's largest continuous wooded area, the Soon forest west of Wiesbaden in the Rhine-Pfalz region. Many also trace the identity of the Kurpfalz hunter to Johann Adam Melsheimer (1719–1757), who was a Soon forester and hunter as well.

JMS

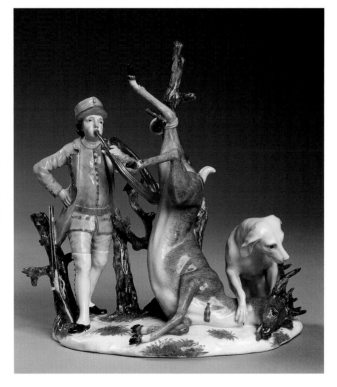

Das Halali, ca. 1760

Frankenthal; modeler, Johann Wilhelm Lanz (Strasbourg, act. 1748–1761)

Porcelain

H. 9 in. (22.8 cm)

PM DA PE 230021

The hunting call "Das Halai" derives from the 16th-century French "hal à luy-hal à luy," meaning "chase after him [the stag]!" Later the call was used to announce a hunt kill and was blown on a horn.

JMS

military excellence

In 1592 Landgraf Moritz set up a standing army in Hesse-Kassel. His successors enlarged the army into various troop units, which formed the basis for the well-developed Hessian military of the 18th century. A large standing army was an instrument to display power and actively participate in the Empire's politics; it also proved to be an economic engine. In the 18th century, special contracts by which the sovereign hired out his troops brought the state important revenue. These so-called subsidy contracts, which had existed since the mid-17th century, regulated the recruitment, outfitting, and payment of the soldiers by a "client." From 1730 to 1750, such subsidy monies had grown to nearly forty percent of the income for the otherwise economically weak state. The much sought-after Hessian troops fought in all of Europe's wars, mostly on the Protestant side. Landgraf Wilhelm VIII hired out an especially large contingent from Hesse-Kassel to King Georg III of Great Britain in the Seven Years' War (1756–1763) and, at the same time, strengthened Prussia's position as a major European power against Austria.

From the revenues, Wilhelm VIII built Castle Wilhelmstal and the garrison church in Kassel, extended his painting gallery, and planned a new theater. However, during the reign of his son, Friedrich II, the subsidy contract came into disrepute as a "soldier market." In particular this applied to the Hessian auxiliary troops that Georg III requested for the suppression of the revolt in North America. There the colonies' fight for freedom and independence from the crown of England, combined with the noble aim of general human rights, cast a negative light on the efforts of the Hessian mercenaries. Thus, over the next two centuries, contemporary German literature and the political press repeatedly reproached the landgraf for having hired out his subjects. Many Hessian soldiers, however, remained in North America, which since the end of the War of Independence had become the predominant emigration destination.

This reproach also was directed at Friedrich's son, the later Elector Wilhelm I, who governed the small earldom of Hanau-Münzenberg and commanded his own army. From the subsidies he received, Wilhelm developed the spa resort of Wilhelmsbad, creating an important economic resource for his residence city of Hanau.

On account of the geographical location of his territory, Landgraf Ludwig IX of Hesse-Darmstadt was militarily allied with France. As such, his Royal-Hesse-Darmstadt Regiment was to have participated in the North American war on the side of the colonists, but England capitulated before they had to serve. Ludwig IX was a decided opponent of the soldier market, even as he focused on the enlargement of his own military and the construction of a historical military collection. In 1793–1796 his son, however, concluded several subsidy contracts to restore the state's finances. In Hesse-Darmstadt, as in Hesse-Kassel, it was impossible to maintain an imposing military power for any length of time without the subsidies.

CK

JOHANN CHRISTIAN ERNST MÜLLER (Troistedt 1766–Weimar 1824); after J.H. Carl
The Hesse-Hanau Regiment that Went to America, ca. 1783
Etching
H. 8⅞ in. (22.6 cm); W. 13 in. (33 cm)
FAS Library M V HessK o.J. 1

The colored etching shows the grenadier regiment, known as the "Crown Prince" Hesse-Hanau Infantry Regiment, formed by Prince Wilhelm a year after he began his reign in Hanau. Grenadiers initially were infantrymen known for throwing grenades; later the name was applied to denote preferred or favored troops. Toward the end of the 17th century, unified clothing and equipment began to be introduced into the military units. Their colors in particular were critical distinguishing features among the great number of different troop units and were of lifesaving importance in war.

Standing in different positions, the four soldiers present the regiment's uniform in exemplary fashion. The dark blue fitted jacket with red lapels and braided trim and the front shield of the hat were largely derived from the Prussian model. During wartime, black gaiters were worn along with the trousers and waistcoat of yellow linen or wool. Regiment badges were worn on lapels and flaps on the jacket, and the metal fronts of the grenadier hats also were embossed with the regiment's insignia.

In accordance with a subsidy contract signed on February 5, 1776, the battalion of 668 men came into English service and fought under the command of Colonel Christian von Gall in the North American War of Independence. On their return to Germany, the Hessian troops introduced novelties from America such as the bearskin cap and the black drummers, shown here dressed in a turban and striped garment. Hessian soldiers in America encountered blacks mainly as servants or slaves of prosperous colonists. During the course of the campaign, however, they also were employed as retinue servants by the Hessians troops. Black drummers were especially popular and, at the end of the war, a group of these drummers returned with the troops to Hesse.

This page is one of thirty-three illustrations of Hessian regiments that were produced between 1655 and 1763. Bound together as a book, they show the composition of the Hessian troops in 1783.

CK

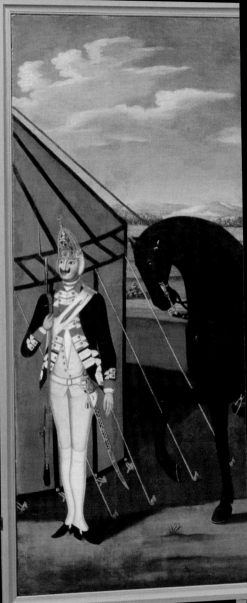

The uniforms identify the regiments: from left to right, Leibregiment, Kreisregiment, Leib-Grenadier-Garde-Regiment, Reiter-Regiment Royal Almande, Royal Hesse-Darmstadt, Infanterie-Regiment Erbprinz von Hessen-Darmstadt, Regiment Waldeck, and Regiment Landgraf.

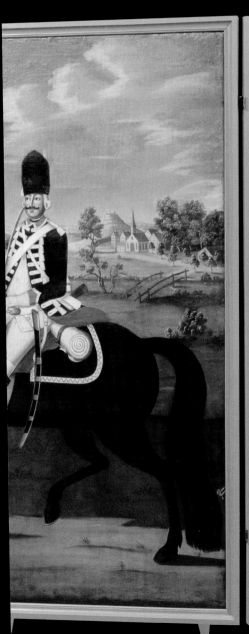
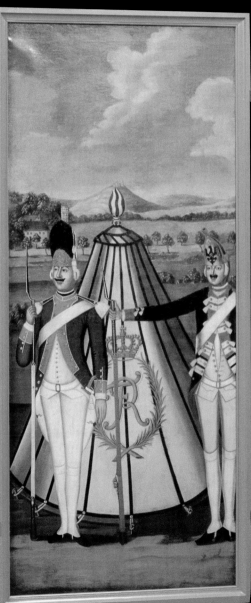
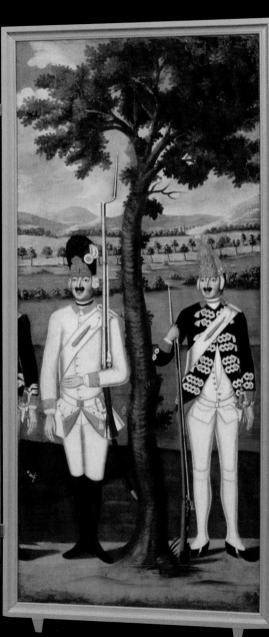

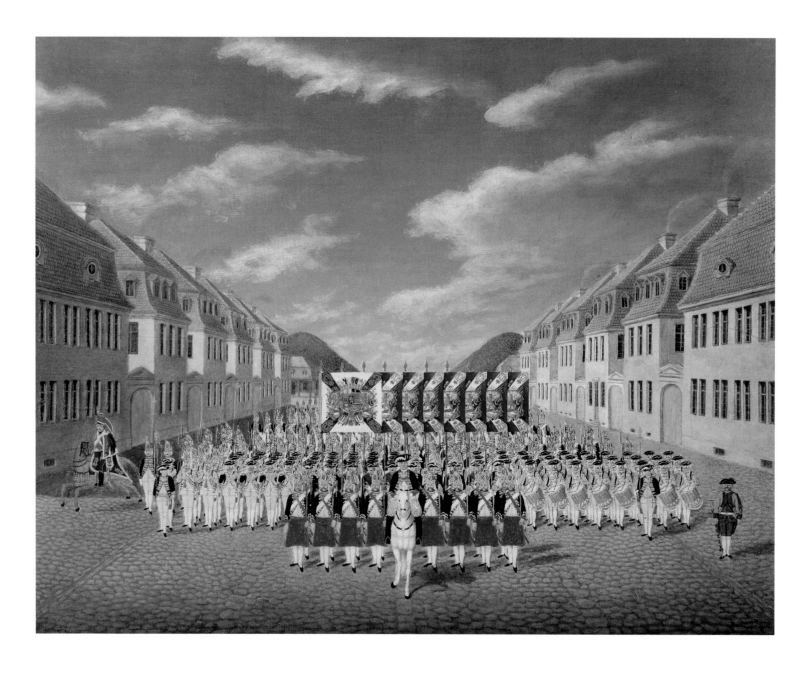

JOHANN MICHAEL PETZINGER (Pirmasens 1755–Darmstadt 1833)

"Year in and year out two court painters are busy painting all the existing or possible of existing uniforms on board, up to one and a half shoe in height [around nineteen inches]." Written in 1780, these observations by Johann Heinrich Merck refer to the court of Ludwig IX of Hesse-Darmstadt, known as the "Soldier Landgraf." Although Merck mentions no specific artists, one of these painters must have been Johann Michael Petzinger, who was born in the provincial town of Pirmasens, where Ludwig IX took up residence in the early 1760s and established a base for his princely soldiers. Petzinger's paintings of Ludwig's grenadier soldiers were among the best in the Darmstadt court. With their precise draftsmanship and vivid color, Petzinger's scenes are full of careful details. His red-cheeked figures in pressed uniforms appear charmingly efficient rather than stern or intimidating. After Ludwig IX's death in 1790, Petzinger painted in the service of Prince Friedrich of Hesse-Darmstadt. In 1802 he received the title of court painter.

JMS

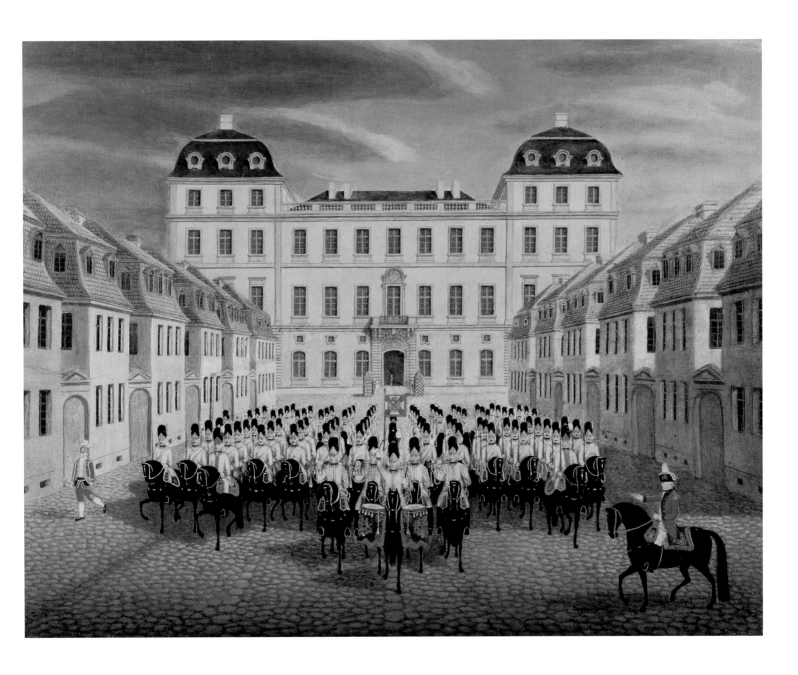

The Princely Grenadier Corps of Darmstadt in Grand Parade, ca. 1780

Oil on panel

H. 13 in. (33 cm); W. 17⅜ in. (44 cm)

Inscribed on reverse: *Die fürstliche Garde du Corps zu Darmstadt in großer Parade und ein Läufer der Frau Fürstin Georg in Galla. Gemalt von Johann Michael Petzinger.*

SM B 21118

FACING PAGE

The Princely Corps-Regiment with Flagbearers Grandly Parade into Darmstadt, ca. 1780

Oil on panel

H. 13 in. (33 cm); W. 17⅛ in. (43.5 cm)

Inscribed on reverse: *Das fürstliche Leib-Regiment rückt in großer Parade mit den Fahnentrupp in Darmstadt ein. Gemalt von Johann Michael Petzinger.*

SM B 21119

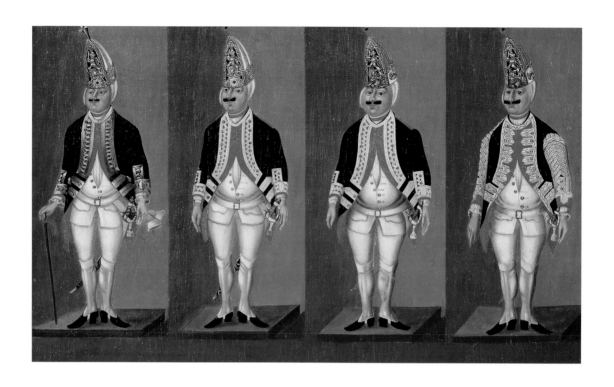

JOHANN MICHAEL PETZINGER (Pirmasens 1755–Darmstadt 1833)
Four Pirmasens Grenadiers, ca. 1780
Oil on canvas mounted on board
H. 11¼ in. (28.6 cm); W. 18⅛ in. (46 cm)
SM B 21125

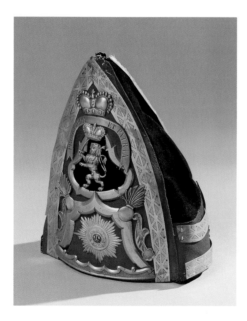
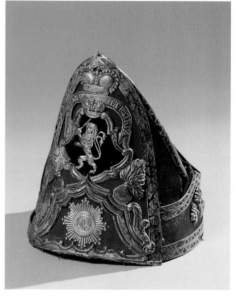

German Centennial Jubilee Grenadiers' Hats, 19th century
Felt, silver-plated brass, cardboard, silk, thread
H. 9½ in. (24 cm); L. 6¾ in. (17.7 cm); W. 7¾ in. (19.5 cm); and H. 8½ in. (21.5 cm); L. 8½ in. (21.5 cm); W. 8⅛ in. (19 cm)
Inscribed on front top below crown: *Pro Gloria et Patria;* on regiment badge below: *Suum Cuique*
SM K 21498, SM K 21497

JOHANN FRANZ GOUT (Berlin, ca. 1748–1812)
A Battalion of the Princely Corps-Regiment in the Darmstadt Drill Hall, ca. 1780
Oil on panel
H. 8¼ in. (21 cm); W. 11¾ in. (29.7 cm)
Inscribed on reverse: *Eine Batallion des Fürstlichen Leib-Regiments im Exercierhaus zu Darmstadt gemalt von dem Landgräflich Hesse-Darmstädtischen Hof- und Theatermaler Gout.*
SM B 21116

While Landgraf Ludwig IX lived frugally and trimmed the costs of the royal household, he made an exception for his soldiers. In 1771 he commissioned Johann Heinrich Schuknecht to build an imposing drill house in Darmstadt. Here fifteen hundred men drilled for four to six hours a day in a huge open space heated by sixteen to twenty stoves. Maintaining this enterprise had its costs, however, and as a result, two-thirds of the state's employees had their salaries reduced to one-third. In 1892 the building was removed to make way for the Darmstadt Landesmuseum.

JMS

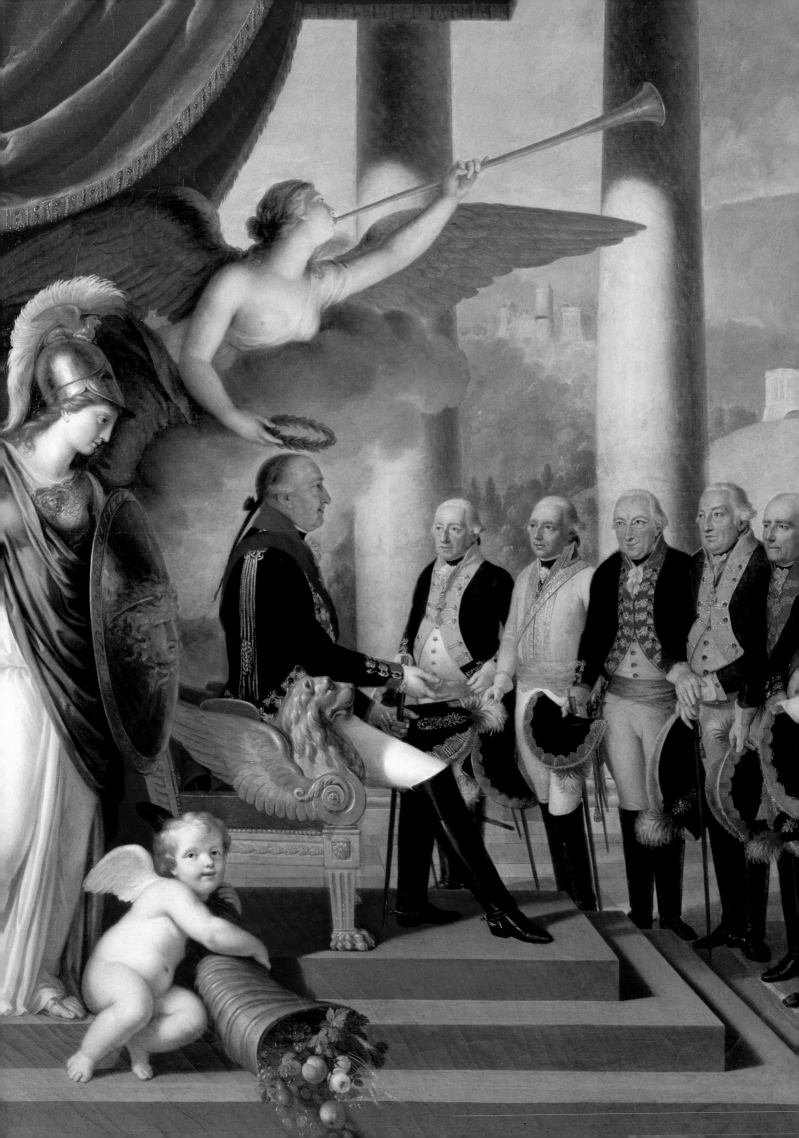

splendor

European politics and culture of the early 19th century reflected the consequences of the French Revolution and the period of Napoleonic control over broad sections of the continent. In Germany the secularization of Church territory and property begun in 1803 transformed territorial relations that had existed since the Middle Ages. Political changes led to the replacement of old, economically regressive structures and the rise of the middle class.

For both Hesse-Kassel and Hesse-Darmstadt, the period was marked by upheavals from which they ultimately came away strengthened (see pp. 260–61). In 1803 Landgraf Wilhelm IX of Hesse-Kassel fulfilled the dynasty's long-held ambition when he submitted to Napoleon's sphere of influence and his rank was raised to elector. Nonetheless, the French occupied his country and Wilhelm went into temporary exile. Napoleon's policies likewise led to Hesse-Darmstadt's 1806 elevation to the status of a grand duchy with added territory. In the post-Napoleonic reorganization of Germany by the Congress of Vienna in 1816, the new titles were retained while Hessian sovereignty was restored. There followed a cultural and building boom, with princely commissions to manifest the Hesse dynasty's elevated status.

Germany's most important architects and designers active during the early 19th century were Karl Friedrich Schinkel (1781–1841) in Prussia and Leo von Klenze (1784–1864) in Bavaria, both of whose buildings and interior designs formed the stylistic basis for architects of smaller German states. Heinrich Christoph Jussow (1754–1825) carried out interior and furniture designs for the court in Hesse-Kassel. Johann Conrad Bromeis (1788–1855), who was named chief court architect by Wilhelm II in 1821, designed the refurbishing of the Hessian residences and their furnishings, including the renovation of the Fasanerie in the 1820s (see pp. iv and v). In Hesse-Darmstadt, Georg Moeller (1784–1852) was appointed court architect and, while he did not emerge as a designer of furniture and furnishings, his buildings and city squares left his mark on the Darmstadt city profile.

Despite victory over Napoleon and rising nationalistic sentiment, design in the German states was primarily defined by the "Empire" style shaped by French architects Charles Percier (1764–1838) and Pierre Fontaine (1762–1853). Commissioned by Napoleon for the redecoration of the old royal residences, they designed wall decorations, furniture, porcelain, and tapestries. The publication of Percier and Fontaine's pattern books beginning in 1812 disseminated the formal repertoire of the Empire style throughout Europe.

The Empire style distinguished itself from Neo-classical styles of the late 18th century by drawing directly from the art of Napoleon's role models, Julius Caesar and Alexander the Great, with motifs of the Roman Empire that symbolized majestic grandeur and military power. The architectonic structure of its applied art objects was accentuated by massive pedestals, pilasters, columns, and entablatures. However, a new form of Neo-classicism developed in German-speaking lands around 1815. Known as *Biedermeier,* this style reflected the living requirements of the middle class in simple, reductive shapes, flat surfaces, and minimal ornament. Nevertheless, the Empire style remained the official mode of state representation in all the German princely courts.

MM

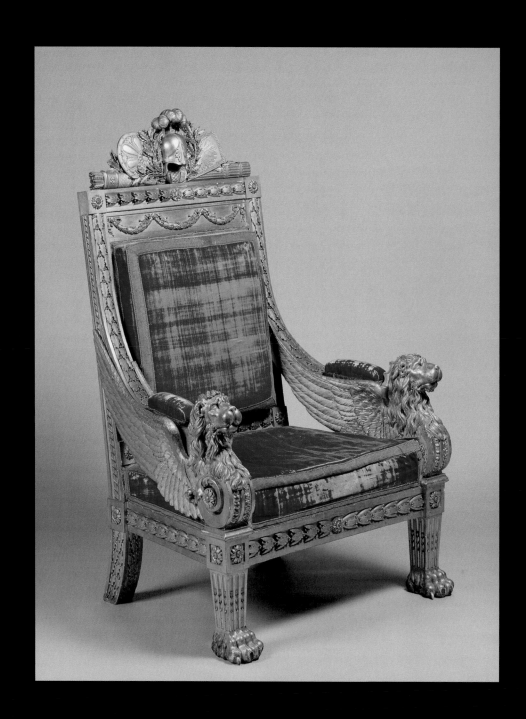

Throne, ca. 1803
Kassel
Beech, gilt, velvet, silver thread, silk
H. 60⅝ in. (154 cm); W. 38⅝ in. (98 cm); D. 27⅝ in. (70 cm)
FAS M 359

The throne was meant as a visual sign of the new importance Hesse-Kassel acquired on becoming a German electorate and is featured as such in the painting by Böttner (facing page). It was made by local craftsmen as part of Wilhelm's new outfitting of his residence castle. The powerful winged lions and claw feet reflect the new Empire style, while the construction and some ornamental details recall 18th-century Neo-classicism.

MM

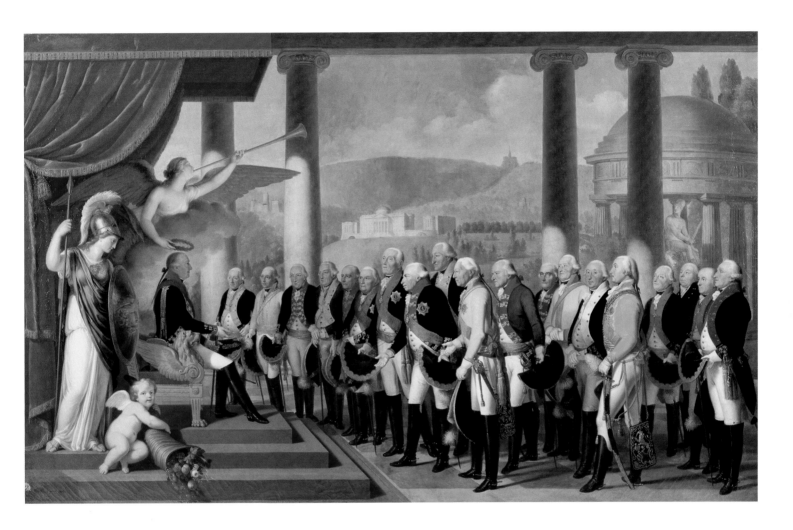

WILHELM BÖTTNER (Ziegenhain 1752–Kassel 1805)
Elevation of Elector Wilhelm I of Hesse, 1805
H. 54½ in. (138.3 cm); W. 88¾ in. (225.5 cm)
Oil on canvas
Signed and dated lower left: *Wilhelm Böttner pinx 1805*
FAS B 365

The inscription at the top of the painting's frame (not pictured) translates: "To Wilhelm the first Elector of Hesse from his grateful army—June 3, 1805." Böttner meticulously depicted each of the generals assembled before the enthroned Hesse-Kassel sovereign, whose rank was elevated in 1803 to Elector. Wilhelm dedicated a great deal of time to his troops and built a considerable fortune on the business of hiring out his soldiers. The newly completed castle of Wilhelmshöhe, a source of great pride to the elector, is visible in the center background.

MM

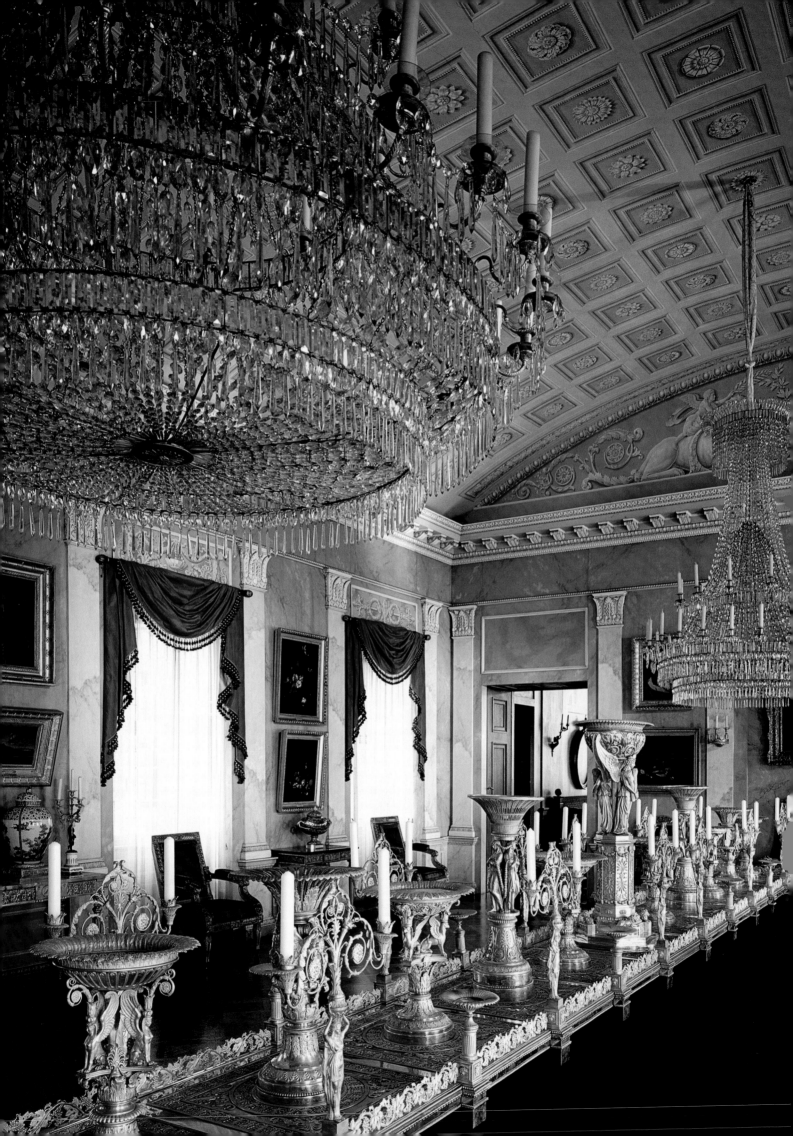

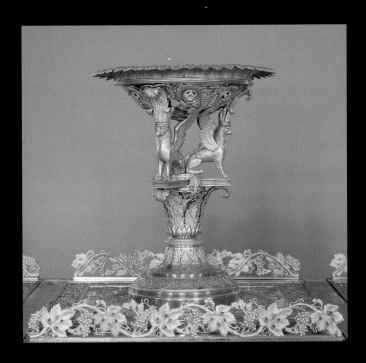

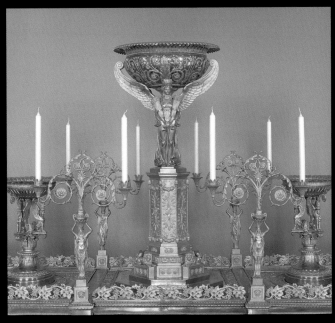

Gilded Bronze Surtout de Table, 1815–1820
Designed by Karl Friedrich Schinkel (Neuruppin 1781–Berlin 1841)
Gilded bronze
L. 265½ in. (674.5 cm); H. 44⅛ in. (112 cm); W. 32⅝ in. (83 cm); 12-arm candlestick: H. 26¾ in. (68 cm)
FAS F 74

The *surtout de table* traditionally served as a centerpiece for a formal table setting. In the 18th century such centerpieces were usually composed of footed dishes for fruit and candies or assemblages of porcelain figures. Around 1800 these were replaced by gilded bronze centerpieces featuring a long deck with various sculptural embellishments. The fashion reached its pinnacle in the French Empire centerpieces by the bronze-worker Pierre Philippe Thomire (1751–1843).

Inspired by French models, several gilded bronze centerpieces were produced in Berlin. The designs were commissioned by Prussian King Friedrich Wilhelm III and his court from Karl Friedrich Schinkel, the most famous German architect and designer of the time. Similarly, the ensemble now in the Fasanerie was probably ordered in Berlin by Elector Wilhelm I of Hesse for his residence in Kassel.

MM

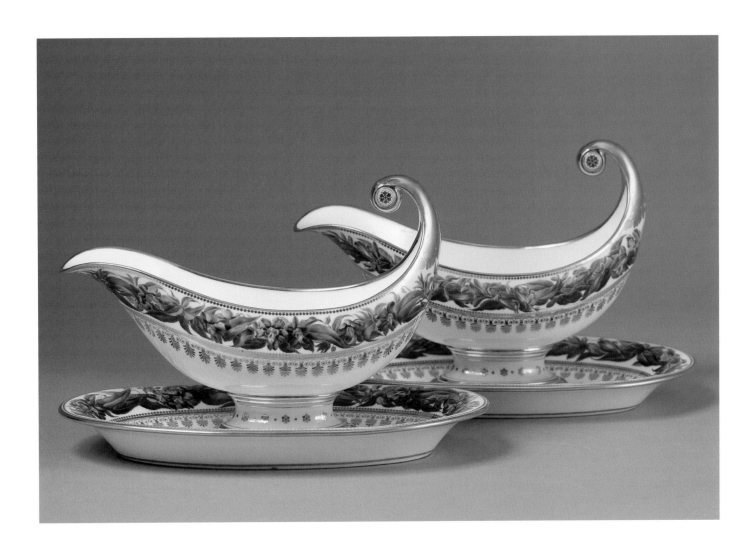

Botanical Dinner Service of Elector Wilhelm II of Hesse-Kassel, 1827–1831
Sèvres Porcelain Manufactory
Porcelain
FAS PE 1696/7

In 1829 Elector Wilhelm II of Hesse commissioned a large hors d'oeuvre and dessert service from the *Manufacture Royale des Porcelaines* in Sèvres. It originally comprised 566 pieces, with 348 plates alone. It is one of several botanical services produced by European porcelain manufactories at the beginning of the 19th century. Instead of the conventional 18th-century floral decoration, these services were painted with individual plants copied from contemporary botanical books. Emphasizing the decoration's scientific exactness, each plate is inscribed on the underside with the name of the flower it represents. Unique to the Hessian service is that despite its great number of pieces, each is decorated with a garland of blossoms of a different flower.

The Sèvres factory worked two and a half years on the Hessian commission, employing seven of the best flower painters on the service. For the most important pieces—the vase-shaped coolers—the manufactory brought in the renowned flower painter Louis Schilt, who exhibited at the Paris Salons of 1831 and 1839. While the service's decoration was an exclusive design, the majority of its vessels conformed to the manufactory's repertory of forms fashionable at the time.

Immediately after its completion in October 1831 the service was divided into two nearly equal parts. Elector Wilhelm furnished his castle in Philippsruhe near Hanau with the half that remains in the Hessian House Foundation.

MM

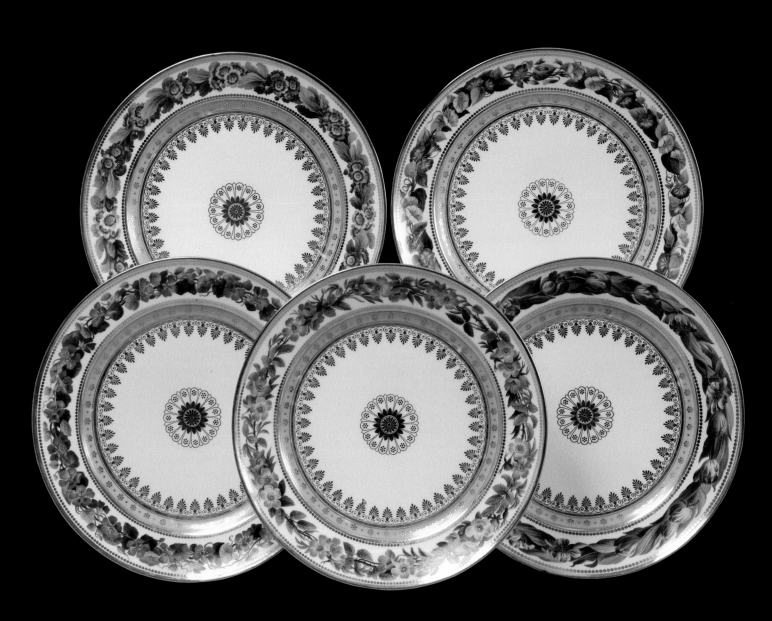

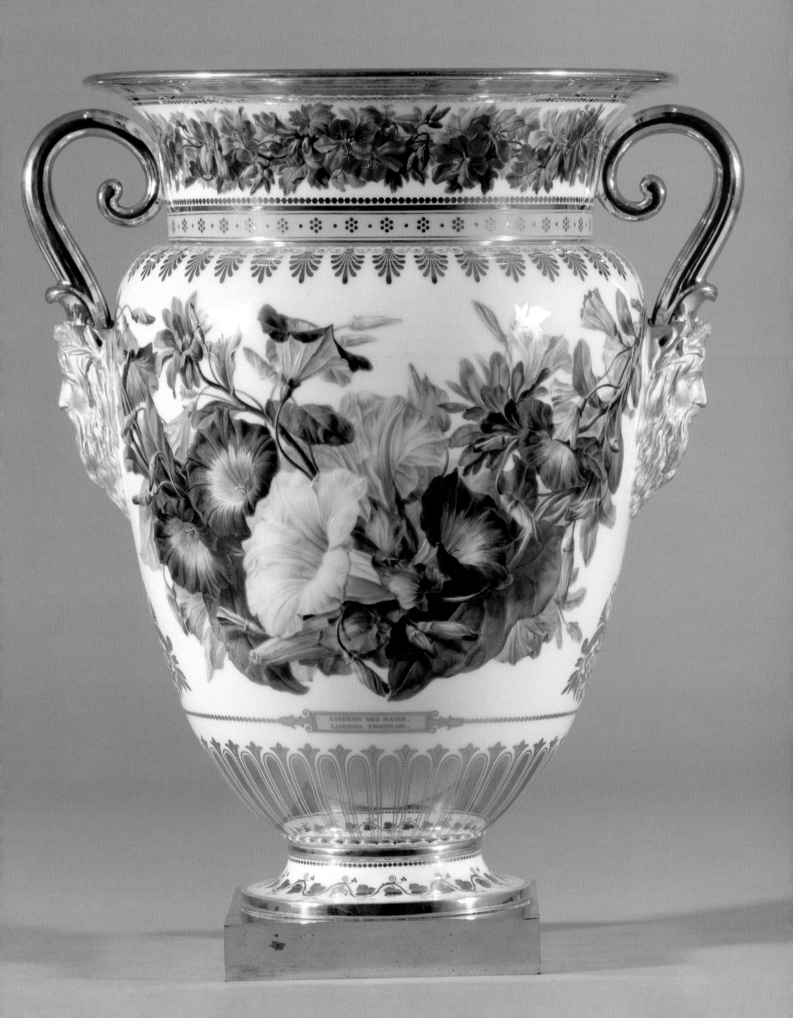

LISERON DES HAIES.
LISERON TRICOLOR.

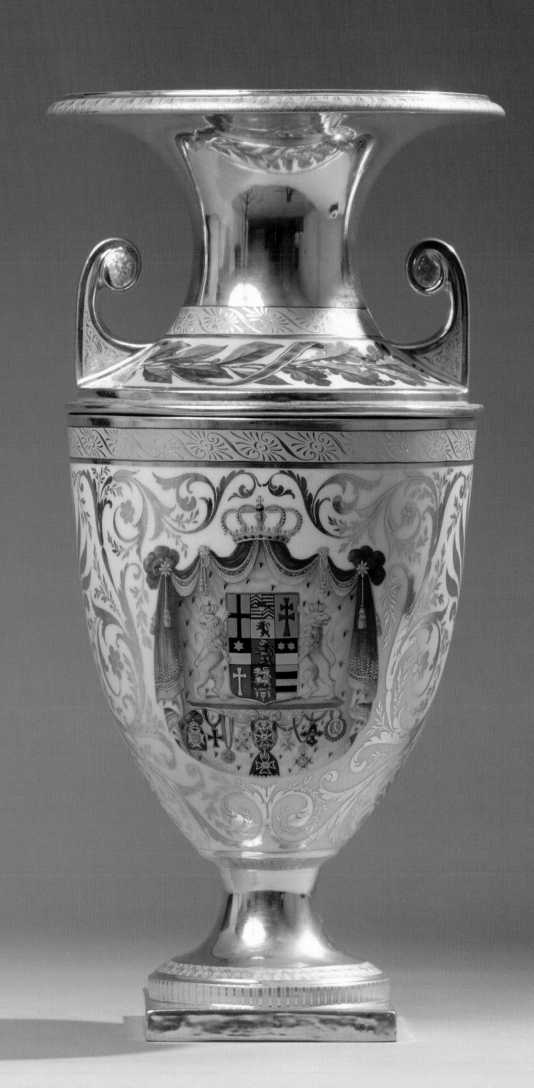

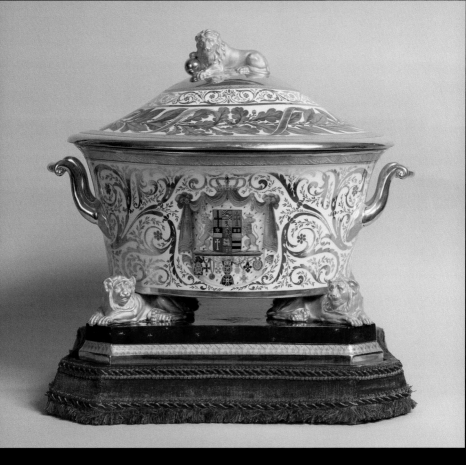

Iron Helmet Service, 1819–1820
Royal Porcelain Manufactory
Porcelain
FAS PE 664

The largest and most important of the many services owned by the Hessian House Foundation is the Berlin "Iron Helmet" *(Eisernen Helm)* service. In 1814 Elector Wilhelm I founded the Hessian order of the same name (see p. 145) to honor the military in the liberation wars against Napoleon's army. For the banquets of the order's members, Crown Prince Wilhelm commissioned a large service in 1818 from the Royal Porcelain Manufactory in Berlin. Its design was based on the "Commander Service" *(Feldherrenservice)* that Prussian King Friedrich Wilhelm III had recently ordered. Common to these "patriotic" services is the reproduction of an order on the face of the plates, in this case a black Brabant cross with a knight's helmet in the center. The dinner plates are bordered with an ivy garland and laurel branches wrapped with the order's violet ribbon. Major pieces such as tureens and vases bear the large electoral coat of arms. The service, delivered in 1819–1820, comprised nearly 2,000 individual pieces of which around 1,850 survive.

While the origin of the service is associated with the victory over Napoleonic France, its decoration is closely based on French models of the Empire style. In fact, the dessert plates' design draws directly from the Sèvres *service de l' Empereur* that Napoleon ordered in 1807.

Among the decorative themes are views of Prussian and Hessian cities and castles, including many of Wilhelmshöhe Park. To decorate the great number of plates ordered, the manufactory had to make use of its entire stock of subjects, reproducing well-known paintings and refined imitations of cameos. The simulation of different materials, seen in the delicate micro-mosaic motifs and the tureens' lapis lazuli bases, reveals the extraordinary skill of porcelain painters of the time. The high level of craftsmanship at the Berlin Manufactory is demonstrated in the elaboration of matte and polished gilding in various tones on the borders of the plates.

MM

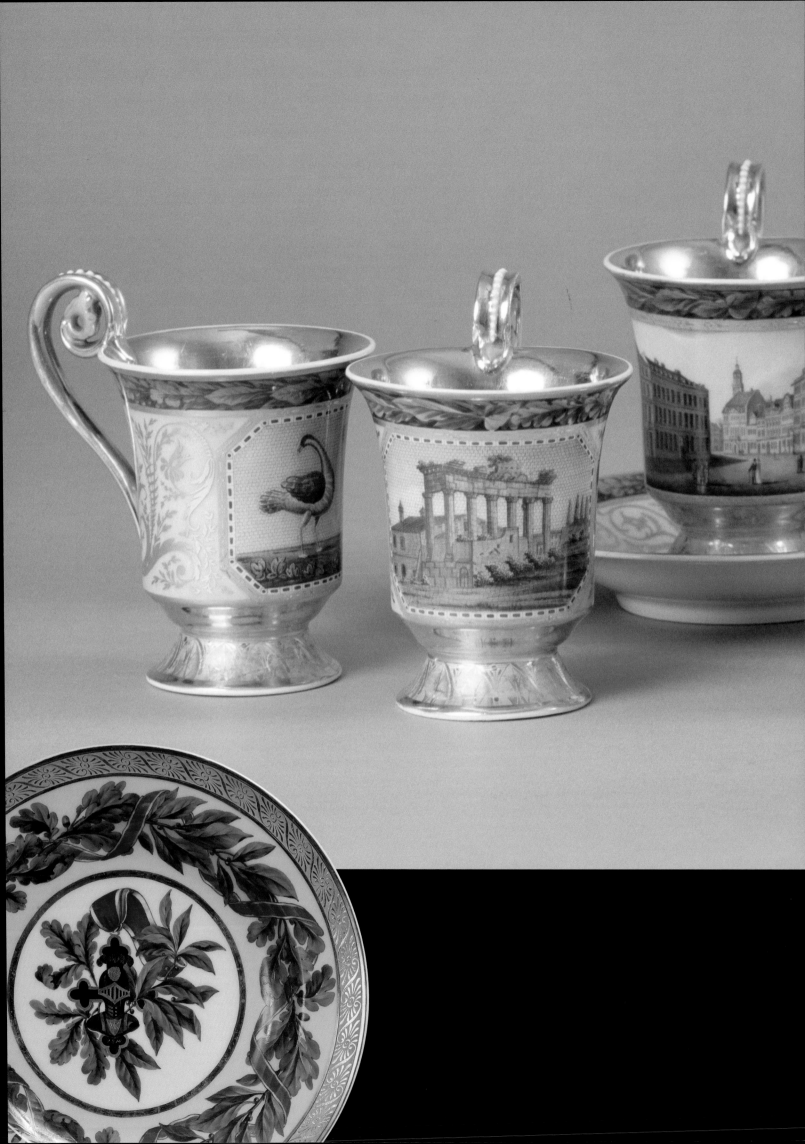

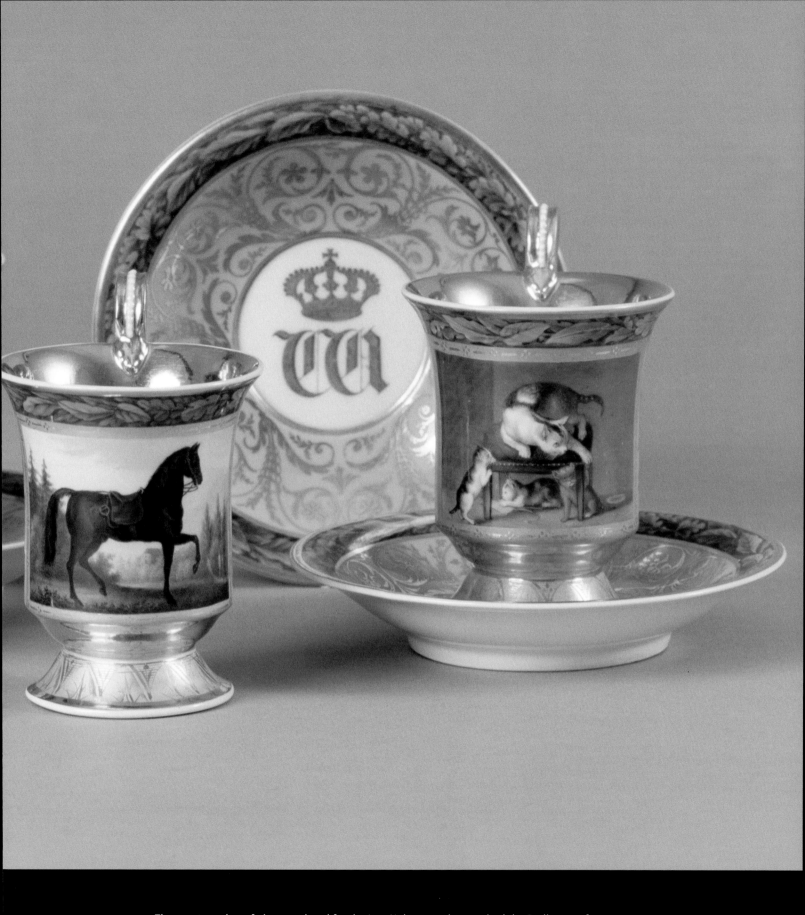

The great number of pieces ordered for the Iron Helmet service required the Berlin manufactory to exploit the talents of their porcelain painters in a repertoire of subjects that went beyond plates featuring the order from which the service took its name (facing page) to contemporary views (above, a cup with a scene of downtown Frankfurt), and even painting imitating micro-mosaic (above left).

German Romantic painting

The sweeping intellectual and political change at the end of the 18th century ushered in a new era in the history of German painting characterized by two parallel movements: Neo-classicism and Romanticism. Neo-classicists steeped themselves in antiquity, seeking an ideal of beauty through balance and harmony, while exponents of Romanticism embraced poetic and mystic ideas to awaken the viewer's imagination and emotions. Both movements originated in Italy, where German artists found not only antique models but also the sensuous impressions that shaped their art. Mediterranean warmth and scenery as well as the cosmopolitan atmosphere of Italian cities offered a welcome contrast to the harsh climate and narrow provincialism of Germany.

Johann August Nahl the Younger dedicated himself to the study of antiquities in Rome. He participated in the competitions organized by the influential writer Johann Wolfgang von Goethe to introduce the German public to the Neo-classical ideal of beauty. Rendered in his preferred technique of sepia monochrome, Nahl's figures recall antique stone sculptures but are integrated into landscapes to achieve fully realized mythological scenes.

Jakob Philipp Hackert laid the way for landscape to become the most important type of painting in the 19th century. His approach was to render the visible in nature, stripped of traditional conventions. His work was appreciated not only in Naples, where he was court painter, but brought high prices from all the great European dynasties and Grand Tour travelers.

Hackert set the tone for other German painters in Italy, including Johann Martin of Rohden and Johann Heinrich Schilbach, court painters at Kassel and Darmstadt respectively. Their landscapes are filled with closely studied realistic elements in compositions infused with a new "Romantic" light.

Carl Philipp Fohr represents full-fledged German Romanticism. Even his early landscapes of the Neckar River include references to German history and folklore that were central to the movement. His Italian scenes do not illustrate real views but depict landscapes born in the artist's imagination. Fohr suppressed aerial perspective to contour topographical features, whether near or far, with the same sharpness, and layer them one behind the other. Revealing the new cult of the drawing, six hundred sheets, but only seven paintings, survive from Fohr's brief career. From around 1820, drawings were prized for their intimacy and immediacy of natural description and widely exchanged between artists.

An important current in German Romantic painting is the art of the Nazarenes, members of an artist commune formed in 1809 in Vienna and soon relocated to an unused monastery in Rome. They sought to revive religious art by emulating Raphael and early German painting. Wilhelm von Schadow was part of the community from 1811 to 1819. His portrait of Princess Marianne of Prussia and her children (see p. 221) reveals his reverence for Raphael in its Madonna-like composition, clear drawing, and smooth application of paint. The paintings of Friedrich Bury, who served as drawing instructor at the Prussian and Kassel courts, demonstrate that the veneration of Raphael's work extended among German artists beyond those working in Rome.

MM

JAKOB PHILIPP HACKERT (Prenzlau 1737 – San Piero di Careggio 1807)

Philipp Hackert was one of the most important and sought after landscape painters in late-18th-century Europe. An ambitious artist, he had a strong work ethic and was known for his straightforwardness. Inspired by 17th-century Dutch masters and French landscape painter Claude Lorrain, Hackert painted idealized landscapes with atmospheric delicacy—a style which anticipated the later Romantic Movement. He spent the years 1765 to 1768 in Paris where he sold small landscape paintings and learned to make his way in the art market. In 1768 Hackert began an eighteen-year stay in Rome, where he furthered his study of nature and cemented his fame with Grand Tour travelers and noble patrons, including Catherine the Great of Russia. In 1782 Hackert met King Ferdinand IV of Naples, who appointed him court painter four years later. After revolution broke out in Italy in 1799, Hackert was forced to flee—first to Pisa and then Florence. After his death in 1807, Goethe, for whom Hackert had been both close friend and painting teacher, edited and published the artist's memoirs.

JMS

View of the Volturno Valley, 1800
Oil on canvas
H. 25¾ in. (65.4 cm); W. 38⅛ in. (96.6 cm)
Signed lower right: *Filippo Hackert 1800*
FAS B 369

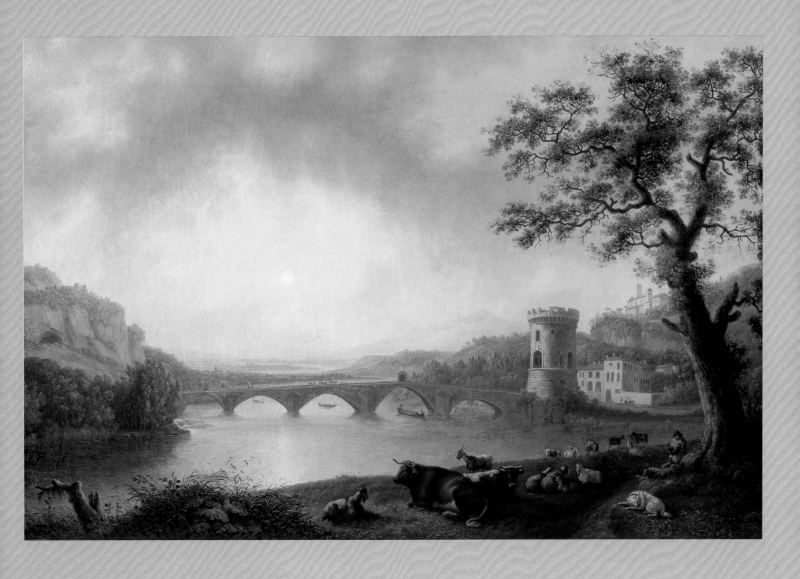

Bridge over a River [Arno?], 1800
Oil on canvas
H. 25¾ in. (65.1 cm); W. 37¾ in. (96 cm)
Signed lower right: *Filippo Hackert 1800*
FAS B 855

JOHANN AUGUST NAHL THE YOUNGER (Zollikofern 1752–Kassel 1825)

The younger son of Hesse-Kassel court sculptor and furniture designer Johann August Nahl the Elder (see p. 46), Nahl distinguished himself with mythological subjects in the classical tradition, which was waning in favor of Romantic and naturalistic tendencies. After studying in Kassel, Strasbourg, Bern, and Paris, he traveled frequently to London and Italy. In 1786 he spent half a year in Naples with Hackert, who inspired his appreciation for directly observing nature and asked Nahl to produce grisaille pictures for King Ferdinand IV. By 1792 Nahl developed a sepia technique that emphasized linearity and monochromatic elegance. Political turbulence precluded his desire to settle permanently in Rome, and Nahl returned to Kassel. Through Ludwig Völckel (1762–1829), the librarian and antiquarian at the Fridericianum in Kassel, Nahl deepened his knowledge of classical literary sources for his art. Two Goethe Weimar prizes in 1800 and 1801 added to his prestige. In 1809 Nahl sold thirteen sepia drawings to Queen Katharina, wife of Napoleon's brother Jérôme, who was installed as King of Westphalia in Kassel. In 1815, at the age of sixty-three, he entered a new professional phase when Elector Wilhelm I appointed him Director and Professor of Painting at the Academy in Kassel.

JMS

Cupid and Psyche in Grotto, early 19th century
Pen, brown ink, brown wash
H. 21½ in. (54.5 cm); W. 30⅜ in. (77.2 cm)
FAS H 104

FRIEDRICH BURY (Hanau 1763–Aachen 1823)

Known for his enthusiastic character, Friedrich Bury earned his reputation as a portraitist. After drawing lessons from his father, the goldsmith and engraver Jean Jacques Bury, he studied with Anton Wilhelm Tischbein in Kassel (see pp. 56–58) and attended the Düsseldorf Art Academy. In 1782 he began a seventeen-year stay in Rome where he befriended Goethe and gained recognition for his portraits and copies of the Old Masters. Goethe championed Bury's work and introduced him to Anna Amalia of Saxe-Weimar. Bury accompanied her to Naples where he made drawings of antiquities and paintings for her, after which he traveled with Goethe through northern Italy. Moving to Berlin in 1800, Bury painted a copy of Rafael's *Sistine Madonna* for Queen Louise of Prussia, which led to his introduction to Electoress Auguste of Hesse-Kassel in 1803. They became better acquainted when Auguste exiled herself to Berlin in 1806 during the French occupation of Kassel. After her return to Kassel in 1813, Bury divided his time between her court, where he gave painting lessons to Auguste and her children, and the Hague and Brussels, where he worked for Auguste's sister, Princess Wilhelmine of Oranien.

JMS

Electoress Auguste of Hesse Copying the Sistine Madonna, 1808–1809
Oil on canvas
H. 35⅜ in. (89.7 cm); W. 28⅛ in. (71.5 cm)
FAS B 362

Bury's second portrait of the electoress and art patron, *Auguste Copying the Sistine Madonna,* depicts her in the act of painting a copy of Raphael's famous Madonna. Positioning Auguste directly before her canvas, Bury ingeniously situated her so that she appears to take up the Madonna's position. At the same time that the palette, brushes, and painter's stick identify Auguste as an artist, her proximity to the Christ Child—who seems to sit on her lap—celebrates her role as a mother. In 2003 the Neue Galerie in Kassel acquired another version of this painting from the Bury family.

JMS

JOHANN MARTIN VON ROHDEN (Kassel 1778–Rome 1868)

A sympathetic extrovert, Johann Martin von Rohden spent most of his career as a painter of heroic landscapes in Rome. After training at the Art Academy in Kassel, Rohden moved to Italy in 1796. He abandoned the classical approach to landscape early on and became one of the first German artists to paint directly from nature. Rohden's realistic landscapes generally give line precedence over color, even as he infused them with a sunny clarity. During an 1800–1802 stay in Germany, he won first place in the competitions Goethe established in Weimar, after which he returned to Rome and solidified his membership in the community of German artists there. In 1814, inspired by the Nazarene painters and his friend, Romantic writer Ernst Platner, Rohden converted to Catholicism. Correspondingly, he developed a monumental landscape style with sparsely populated scenes meant to evoke the viewer's sense of awe in the wonders of creation. In 1826 Elector Wilhelm II of Hesse appointed Rohden court painter in Kassel, which allowed him to continue his practice of producing meticulous compositions at a relatively slow pace. Rohden's landscapes here were acquired by Wilhelm around the time they were painted.

JMS

Lute Player at Lake Nemi, 1826
Oil on paper mounted on panel
H. 12⅜ in. (31.3 cm); W. 16¾ in. (43.1 cm)
Dated lower left: *1826*
FAS B 384

Neptune Grotto with Heron, 1816
Oil on canvas
H. 29½ in. (74.8 cm); W. 38⅛ in. (96.7 cm)
Signed bottom right: *J. Rohden p. 1816 Romae*
FAS B 366

JOHANN MARTIN VON ROHDEN (Kassel 1778–Rome 1868)
Landscape with Young Pilgrim, 1816
Oil on canvas
H. 29½ in. (74.8 cm); W. 40⅛ in. (101.9 cm)
Signed bottom right: *1816 J. Rohden Roman px*
FAS B 383

JOHANN MARTIN VON ROHDEN (Kassel 1778–Rome 1868)
Landscape with Hunters, 1817
Oil on canvas
H. 29½ in. (75 cm); W. 40¼ in. (102 cm)
Signed bottom left: *J. Rohden pin. Roma 1817*
FAS B 382

CARL PHILIPP FOHR (Heidelberg 1795–Rome 1818)

Heidelberg native Carl Philipp Fohr typified the Romantic artist in his love of nature and medieval history, nascent nationalism, and tragic end. At age fifteen Fohr met Georg Wilhelm Issel, who became his teacher and helped him gain patronage at the Hesse-Darmstadt court through Grand Duchess Wilhelmine. There Fohr first discovered his enthusiasm for medieval German sagas that he would incorporate into his landscapes. Formative for Fohr's approach was the art of Joseph Anton Koch and Albrecht Dürer and the writings of leading Romantics such as de la Motte-Fouqué, Tieck, and Bretano. In 1815–1816 Fohr studied landscape painting at the Art Academy in Munich and hiked through the Tirol, northern Italy, and Salzburg. The views of Ehrenberg and Zwingenberg were among three he sent to Wilhelmine to help finance his trip to Rome on which he embarked—by foot—in October 1816. During long walks through Rome's outskirts, such as Rocca Canterano, he sketched views that he transformed into idealized oil paintings. In 1818 the twenty-two-year-old Fohr drowned while bathing with friends in the Tiber.

JMS

View of Zwingenberg on the Neckar, 1815–1816
Oil on panel
H. 8⅝ in. (21.8 cm); W. 10⅝ in. (26 cm)
WO B 8269

Ehrenberg Castle on the Neckar, 1815–1816
Oil on panel
H. 8⅝ in. (21.8 cm); W. 10⅝ in. (26.8 cm)
WO B 8268

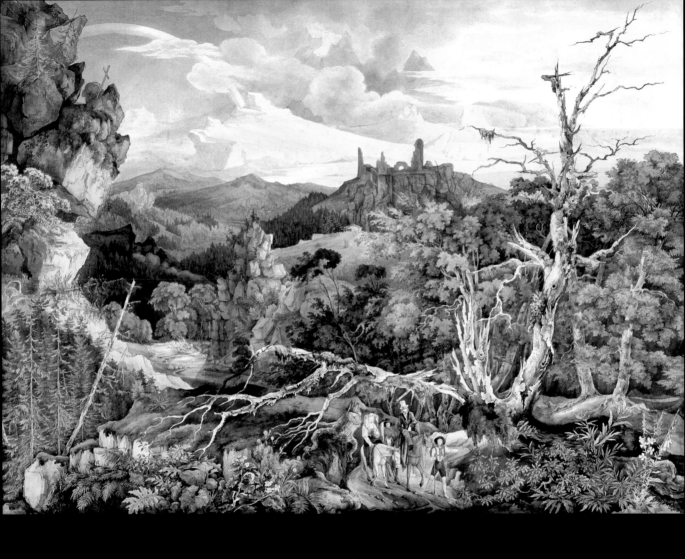

CARL PHILIPP FOHR (Heidelberg 1795–Rome 1818)
Landscape with Broken Tree, Abruzza, 1816–1818
Watercolor
H. 23¼ in. (59 cm); W. 31½ in. (80 cm)

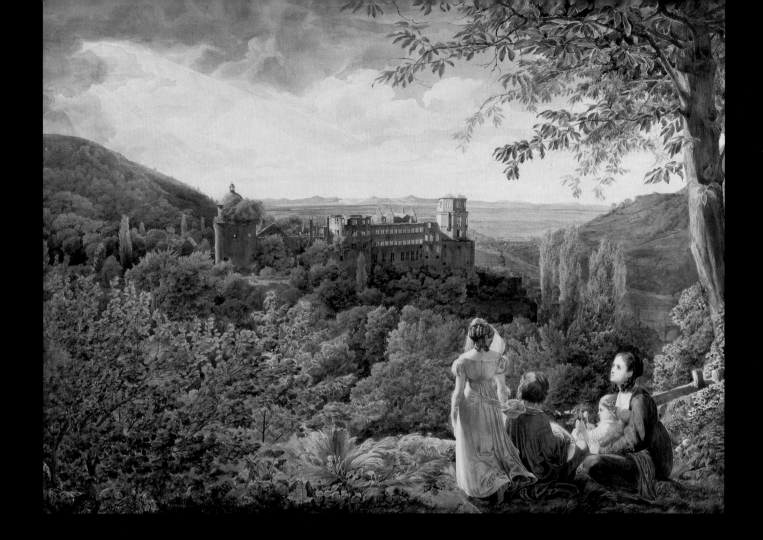

CARL PHILIPP FOHR (Heidelberg 1795–Rome 1818)
Woman and Children Overlooking Heidelberg, 1811–1813
Watercolor
H. 19¾ in. (50 cm); W. 26¾ in. (68.5 cm)
WO H 8272

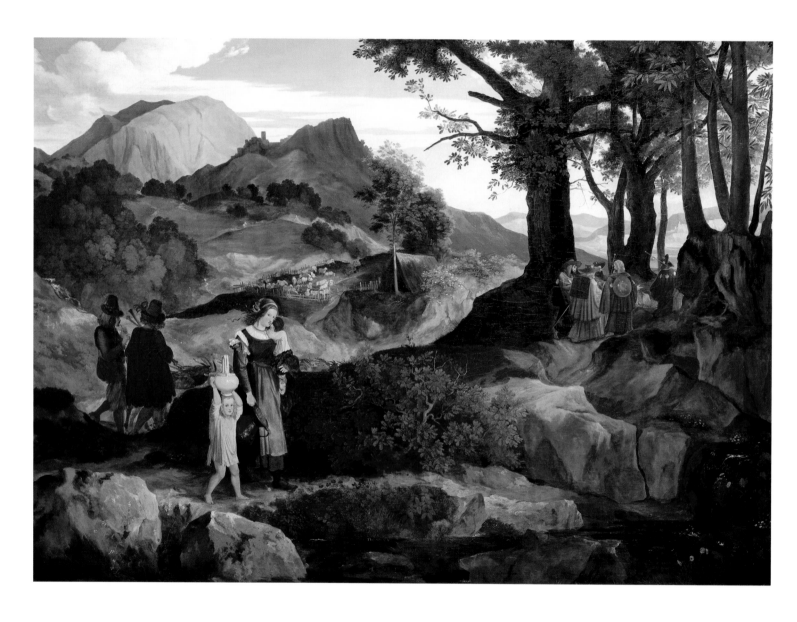

CARL PHILIPP FOHR (Heidelberg 1795 – Rome 1818)
Landscape near Rocca Canterano, 1818
Oil on canvas
H. 38⅝ in. (98 cm); W. 53⅛ in. (135 cm)
WO B 8278

JOHANN HEINRICH SCHILBACH (Barchfeld/Werra 1798–Weimar 1851)

A member of the younger generation of German Romantics, Johann Heinrich Schilbach skillfully synthesized a masterful linear technique and open-air painting practice. He often composed his landscapes with a sweeping diagonal in the foreground offset by a lighter, atmospheric background, drawing the viewer deep into the scene. In 1812, after studying in Darmstadt, he secured support from Grand Duke Ludwig I of Hesse to train under the theater painter Georg Primavesi. He learned etching, copied Dutch graphics, and sketched after nature, a practice enriched by his studies in perspective drawing with Darmstadt court architect Georg Moeller. In 1823, with financial support from the grand duke, Schilbach embarked for Rome and traveled widely in Italy, including a visit to the theater workshops of La Scala in Milan. On his return to Darmstadt in 1828, he was appointed court painter and later received commissions to paint set designs for Moeller's new theater in Mainz. To supplement his income, Schilbach continued to produce landscapes based on his Italian sketches in small format for middle-class clients and large scale for noble patrons.

JMS

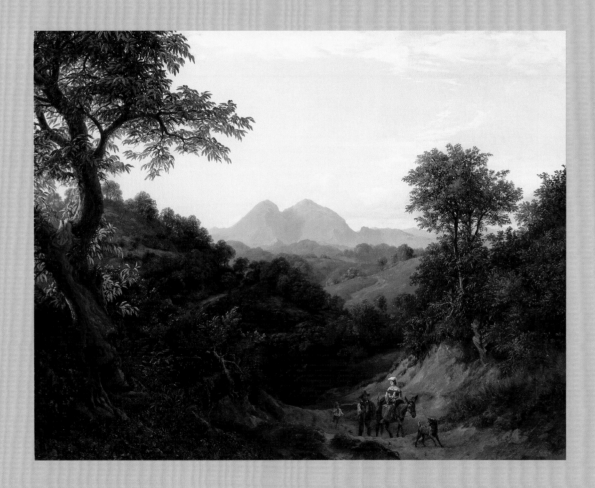

Italian Mountainscape, Rocca di Mezzo, 1838
Oil on canvas
H. 25⅝ in. (65 cm); W. 32½ in. (82.5 cm)
Signed lower right: *Schilbach 1838*
WO B 8259

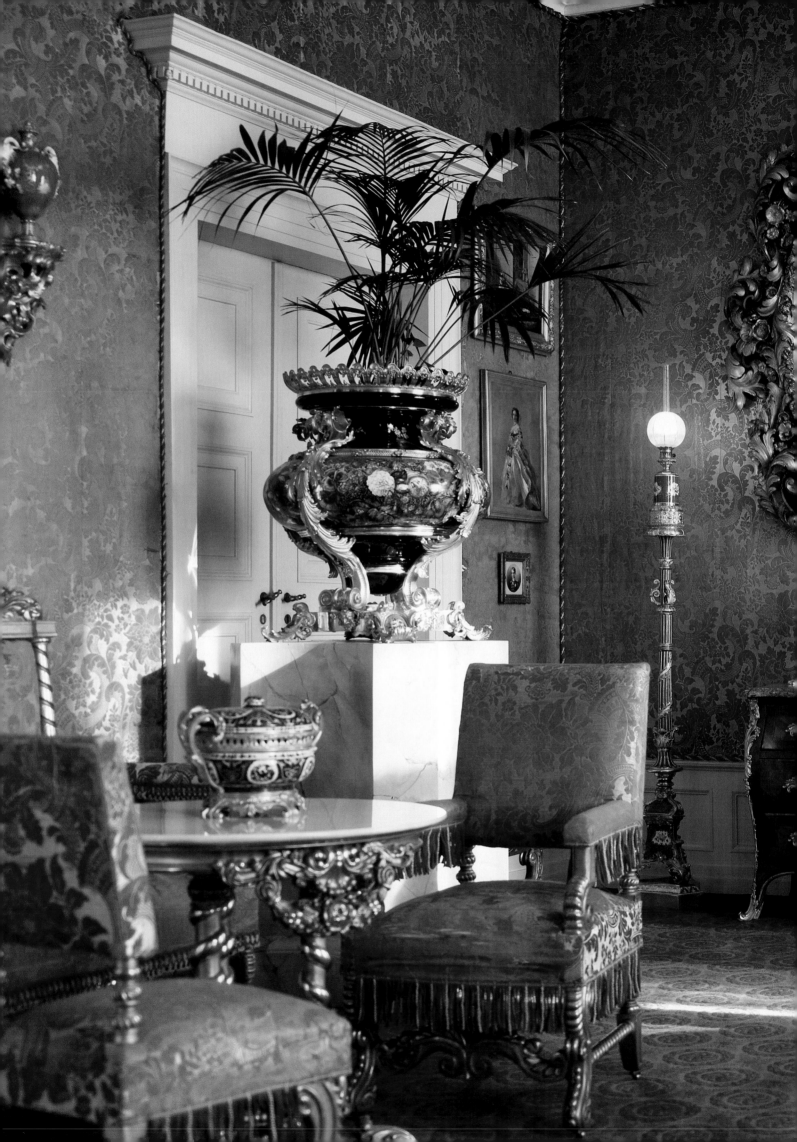

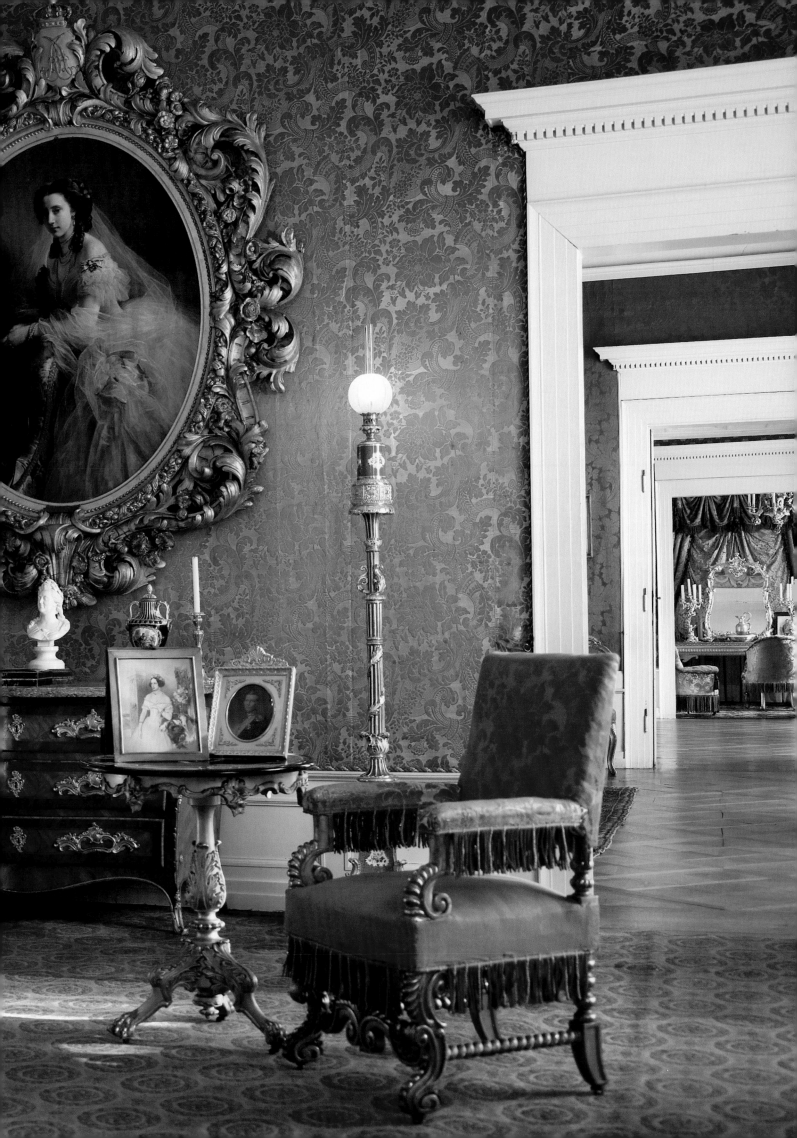

royal web

Members of the German princely families played a vital role in the international alliance of marriages, by which the ruling houses of Europe attempted to create a stabilizing network to ride the waves of revolutionary change in the 19th century. In Denmark, a ducal pair from Germany, Christian of Schleswig-Holstein-Sonderburg-Glücksburg and his wife Louise of Hesse-Kassel, succeeded to the throne. In Greece and Bulgaria, members of German royal families were selected to found new dynasties. Great Britain was governed for years in a personal union with the kingdom of Hanover under Georg III, until his granddaughter Victoria inherited the throne.

Family connections were cultivated by visits, vacations, and regular reunions in which younger generations were given the opportunity to bond. Extensive letter-writing allowed for the transmission of detailed news and daily experiences, while the exchange of gifts and photographs was encouraged to further strengthen relationships.

The House of Saxe-Coburg took the lead in the grand scheme of marital politics. In 1830, the new country of Belgium chose Duke Leopold of Saxe-Coburg to be its first king. He in turn encouraged the marriage of his niece Queen Victoria (whose mother was a Saxe-Coburg) to her cousin Duke Albert of Saxe-Coburg in 1840. Victoria continued the program even after Albert's death in 1861, marrying their nine children into the royal and princely families of Europe. Their oldest daughter, Princess Victoria, married the Prussian Crown Prince Friedrich Wilhelm, while Crown Prince Edward took the hand of Danish Princess Alexandra. Princess Alice wed Grand Duke Ludwig IV of Hesse-Darmstadt. Prince Alfred married Maria, daughter of Alexander II, and later succeeded his uncle as Duke of Saxe-Coburg. Daughters Helena and Beatrice married into German courts as their older sisters had, while sons Arthur and Leopold wed German princesses. Only Princess Louise married a compatriot, the Duke of Argyll.

Beyond the parents' natural wish to see their children well provided for was the intent to shape politics through the family ties. Prince Albert advocated a progressive monarchy in which domestic political matters were governed by a strong parliament, and he passed his liberal ideas on to his children. This attitude put his daughter Victoria and her husband at severe odds with the conservative Prussian court. Crown Grand Duchess Alice of Hesse-Darmstadt, like her father Prince Albert, championed the German unification movement under Prussian leadership but was critical of the archconservative Prime Minister Otto von Bismarck. In the 1860s, the frontline of the German Wars of Unification (in which Hesse-Kassel was annexed to Prussia) cut right through the family, destabilizing the network Victoria had so carefully created.

Meanwhile, the ambitious Hessian Queen Louise of Denmark succeeded in marrying her children into the royal houses of England, Russia, Sweden, and Greece, as well as the house of Hanover and the former royal house of France. If Queen Victoria was "the grandmother of Europe," Queen Louise could be called "Europe's mother-in-law."

CK

Hesse-Windsor connection

1 *Prince Albert of Saxe-Coburg* (1819–1861), ca. 1840
Attributed to Sir William Charles Ross, R.A. (London 1794–1860)
Watercolor on ivory
H. 2⅜ in. (6 cm); W. 1¾ in. (4.9 cm)
Inscribed on reverse: *Albert Herzog v. Sachsen-Coburg-Gotha/ Prince Gemahl der Königin Victoria v. England/geb. 26. Aug. 1819/vermählt 10. Feb. 1840/+ 14. Dez. 1861*
FAS I 126

2 *Prince Friedrich Wilhelm of Prussia*
(later Emperor Friedrich III of Germany, 1831–1888), ca. 1858
German School, after Franz Xaver Winterhalter (Menzenschwand 1805–Frankfurt am Main 1873)
Watercolor on card
H. 1¼ in. (3 cm); W. 1 in. (2.5 cm)
FAS I 135

3 *Princess Royal Victoria of Great Britain*
(later Empress of Germany, 1840–1901), ca. 1858
German School
Watercolor on ivory
H. 1 in. (2.6 cm); W. ¾ in. (2.1 cm)
FAS I 137

4 *Emperor Wilhelm II as a Young Boy* (1859–1941), 1863
Edward Tayler (Orbe 1828–London 1906)
Watercolor on ivory
H. 2⅛ in. (5.2 cm); W. 1⅝ in. (4.2 cm)
FAS I 118

5 *Landgräfin Margarethe of Hesse-Kassel*
(born Princess of Prussia, 1872–1954), ca. 1892
Johannes Zehngraf (St. Petersburg 1857–1908)
Watercolor on ivory
H. 1⅞ in. (4.7 cm); W. 1½ in. (3.7 cm)
Signed left center: *Zehngraf;* engraved on reverse: *Porträt Ihre Königl. Hoheit der Prinzessin Margarethe von Prussen im Kostume wie Höchste die selben solches auf der Mascarade in Erbprinzlich Meiningischen Hause zu Berlin am 17. Februar 1892 getragen haben* ("Portrait of Her Royal Highness, Princess Margarethe of Prussia in costume as her Highness wore at the Masquerade in the house of the Crown Prince of Meiningen in Berlin on February 17, 1892")
FAS I 245

6 *Landgraf Friedrich Karl of Hesse-Kassel* (1868–1940), ca. 1892
Johannes Zehngraf (St. Petersburg 1857–1908)
Watercolor on ivory
H. 2⅜ in. (5.8 cm); W. 1⅝ in. (4.2 cm)
FAS I 248

1

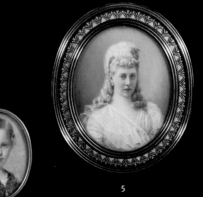

2

3

5

6

4

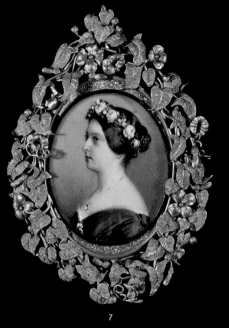

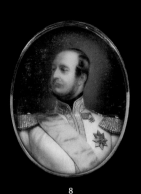

7

8

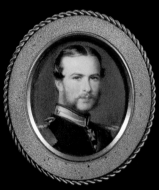

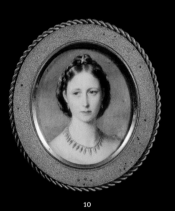

9

10

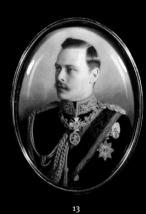

11

12

13

7 *Queen Victoria of Great Britain* (1819–1901),
ca. 1840
Attributed to Sir William Charles Ross, R.A. (London
1794–1860)
Watercolor on ivory
H. 2⅜ in. (6 cm); W. 1¾ in. (4.9 cm)
Inscribed on reverse: *Victoria Königin von England/geb.
24 Mai 1819/Königin 20. Juni 1837/vermählt 10. Feb.
1840/L. 79/FAS Nr. I 124*
FAS I 124

8 *King Georg V of Hanover* (1819–1878), ca. 1845
German School
Watercolor on ivory
Inscribed on reverse: monogram of Georg V
H. 1¼ in. (3 cm); W. ¾ in. (2.4 cm)
FAS I 123

9 *Crown Prince Ludwig IV of Hesse* (1837–1892),
1864
Edward Tayler (Orbe 1828–London 1906)
Watercolor on ivory
H. 1⅞ in. (4.8 cm); W. 1⅝ in. (4 cm)
Signed and dated lower right: *ET/1864*
WO I 8601

10 *Princess Alice of Hesse-Darmstadt*
(born Princess of Great Britain, 1843–1878), 1864
Edward Tayler (Orbe 1828–London 1906)
Watercolor on ivory
H. 1⅞ in. (4.8 cm); W. 1⅝ in. (4 cm)
Signed and dated lower right: *ET/1864*
WO I 8604

11 *Princess Irene of Prussia*
(born Princess of Hesse-Darmstadt, 1866–1953), 1897
A. Kantor (act. Berlin 1895–1910)
Enamel on copper
H. 2¾ in. (7.2 cm); W. 2¼ in. (5.7 cm)
WO I 8719

12 *Grand Duchess Eleonore of Hesse*
(born Princess of Solms-Hohensolms-Lich, 1871–1937),
1908
Wilhelm Horst (b. Pfungstadt bei Darmstadt 1852)
Watercolor on ivory
Signed and dated lower left: *W. Horst/1908*
H. 4½ in. (11.4 cm); W. 3⅜ in. (8.4 cm)
WO I 8712

13 *Grand Duke Ernst Ludwig of Hesse* (1868–1937),
1897
A. Kantor (act. Berlin 1895–1910)
Enamel on metal
H. 4½ in. (7.9 cm); W. 3¼ in. (5.5 cm)
Engraved on reverse: *Ernst Ludwig Grossherzog Hessen
und bei Rhein gem. von Kantor 1897*
WO I 8722

FRANZ XAVER WINTERHALTER (Menzenschwand 1805–Frankfurt am Main 1873)

The celebrated portraitist of the courts of Europe, Winterhalter was one of eight children born to a farmer in a village in the Black Forest of Germany. The village priest brought the artistic talents of Xaver and his brother Hermann to the attention of a local industrialist, who sponsored their training. Studying in Munich, Xaver found himself at odds with the German nationalism and religious intensity of the current Nazarene movement; his affinity lay with French painting. In 1825 a modest stipend from the Grand Duke of Baden marked the beginning of his court career. In 1834 he was officially appointed as painter to the court of Baden in Karlsruhe, but within the year he abandoned the post to move to Paris where he exhibited in the Salons to great success. King Louis-Philippe was in need of a painter to record his new dynasty and Winterhalter filled the bill with dignified, full-length portraits of the men in uniform and porcelain-perfect renderings of the ladies in their finery. The demand for his work spread to England, and he spent every summer from 1842 to 1871 at Buckingham Palace or Windsor Castle painting more than one hundred oils of Queen Victoria and her family. Affable and modest, Winterhalter endeared himself to Victoria, who enjoyed watching his facile wielding of the brush. Back in Paris, where his studio was run by his brother Hermann, all the aristocracy of Europe competed to sit for him. Winterhalter was called to the service of Napoleon III and the Second Empire court, where he painted his 1855 masterpiece of the French Empress Eugénie (now at Compiègne) surrounded by her ladies-in-waiting. Painting the Tsar and Tsarina (Maria of Hesse-Darmstadt) in 1857 triggered a decade of commissions from Russian aristocrats. With the defeat of Napoleon III in the Franco-Prussian War, however, Winterhalter retired to Germany, where he found patronage in his final years from Frankfurt bankers.

PH–S

Landgräfin Anna of Hesse (born Princess of Prussia, 1836–1918), 1858
Oil on canvas
H. 57⅞ in. (147 cm); W. 45½ in. (115.5 cm)
Signed center left: *F. Winterhalter Paris 1858.*
FAS B 316

This portrait has been called the ultimate expression of Winterhalter's skill. In it he exploits the properties of the newly fashionable tulle fabric, which seems to have a life of its own as it creates a gossamer enclosure for the Prussian princess.

Hers was to be a lonely life. As the second wife of Friedrich Wilhelm of Hesse-Kassel (after the death of Alexandra Nicolaievna in 1844), Anna was never close to her husband. In 1866 her Prussian family turned against her when Friedrich Wilhelm chose the Austrian side in the Austro-Prussian War. After her husband's death in 1884, she lived out her lonesome years at the summer castle of Fasanerie (one of the few Hessian castles the victorious Prussians allowed the family to keep), retreating in winters to Frankfurt. She was an accomplished pianist who looked to artists for friendship, including Brahms, who dedicated a piano quintet to her, and Hans Christian Anderson, who dedicated an edition of his fairy tales to the lonesome landgräfin.

PH–S

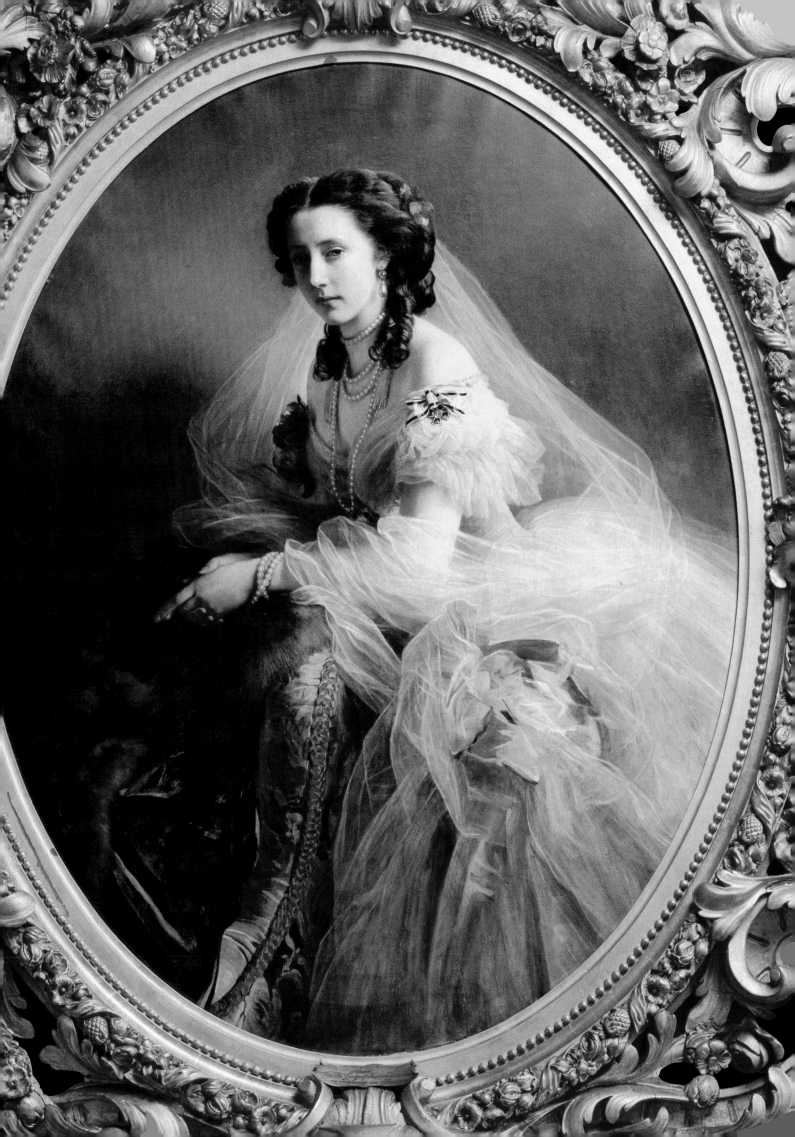

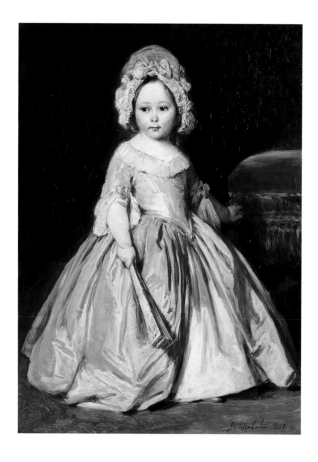

Princess Alice (future Grand Duchess of Hesse, 1843–1878), 1845
Oil on canvas
H. 28¾ in. (72 cm); W. 20½ in. (52 cm)
Signed and dated lower right: *Winterhalter 1845;* inscribed on reverse: *HRH P.ss Alice, at the age of 1 year & 9 months,*
F. Winterhalter 1845.
FAS B 3188

Winterhalter had great success as a painter of children. He clearly liked them and portrayed them as individual personalities.

At age eighteen, Queen Victoria's second daughter Alice would spend the months prior to her marriage to Ludwig of Hesse-Darmstadt nursing her father in his final days and her grieving mother. She later used her position in Darmstadt to crusade for the profession of nursing and the improvement of social conditions for women (see pp. 264–65). Her son, Ernst Ludwig, would bring Darmstadt to cultural prominence by founding a Jugendstil artists' colony, and her daughter Alexandra would marry Nicolas II of Russia and become the last tsarina.

ph–s

Princess Victoria (future Empress Friedrich of Germany, 1840–1901), mid-19th century
Oil on canvas
H. 19¾ in. (50 cm); W. 14⅞ in. (37.5 cm)
FAS B 3194

This sketch reveals Winterhalter's virtuosity, in which he paints loosely on the canvas, without preliminary drawings.

As the eldest child of Victoria and Albert, Vicky was educated by her father in his liberal ideals of government and was groomed from childhood to become the consort of the future King of Prussia. Unfortunately, her progressive thinking alienated her from the Prussian court and her German subjects.

ph–s

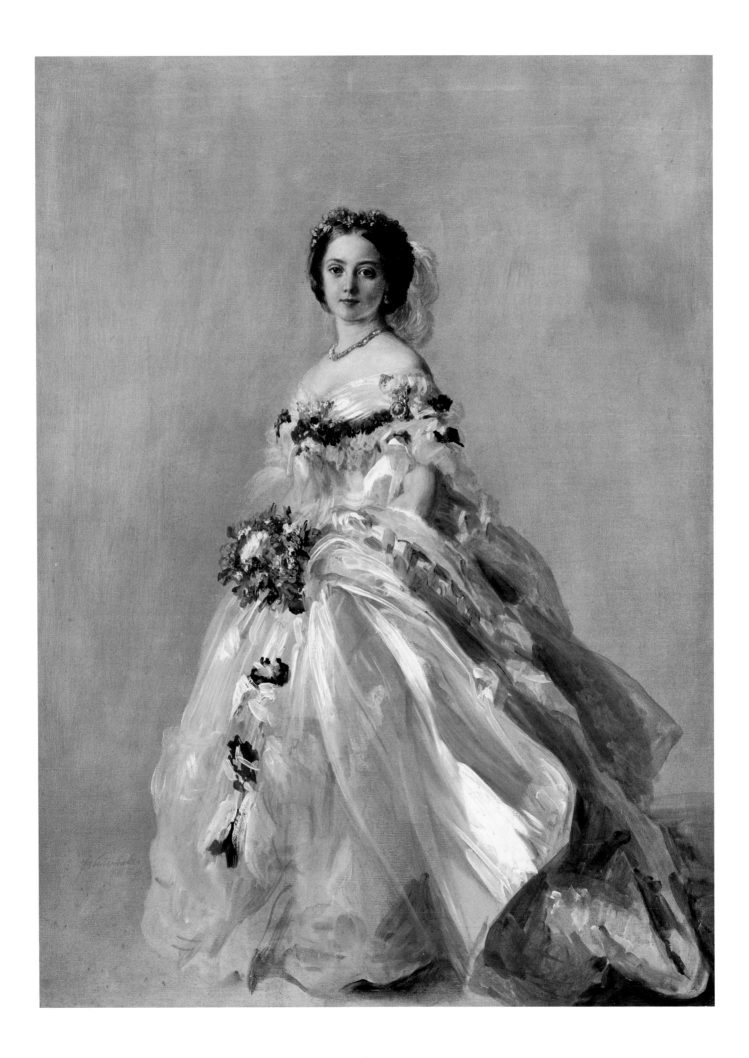

FRANZ XAVER WINTERHALTER (Menzenschwand 1805-Frankfurt am Main 1873)
Tsarina Maria Alexandrovna of Russia (born Princess Maria of Hesse, 1824–1880), 1858
Oil on canvas
H. 50¾ in. (129 cm); W. 37¾ in. (96 cm)
Inscribed on reverse: *Maria, Kaiserin von Rußland, geborene Prinzessin von Hessen und bei Rhein. Geschenk Ihrer Majestät der Kaiserin von Russland and SKH den Großherzog Ludwig III. von Hessen überreicht den 22ten Juny 1858.*
SM B 21063

Winterhalter painted this monochromatic study of the ailing tsarina Maria, the youngest child of Grand Duke Ludwig II of Hesse, in the German spa town of Brückinau, which was frequented by Russian aristocrats. As was common with Winterhalter portraits, several versions were executed after the first (now in the Hermitage) was completed, and Maria presented this one to her father on June 22, 1858.

pн-s

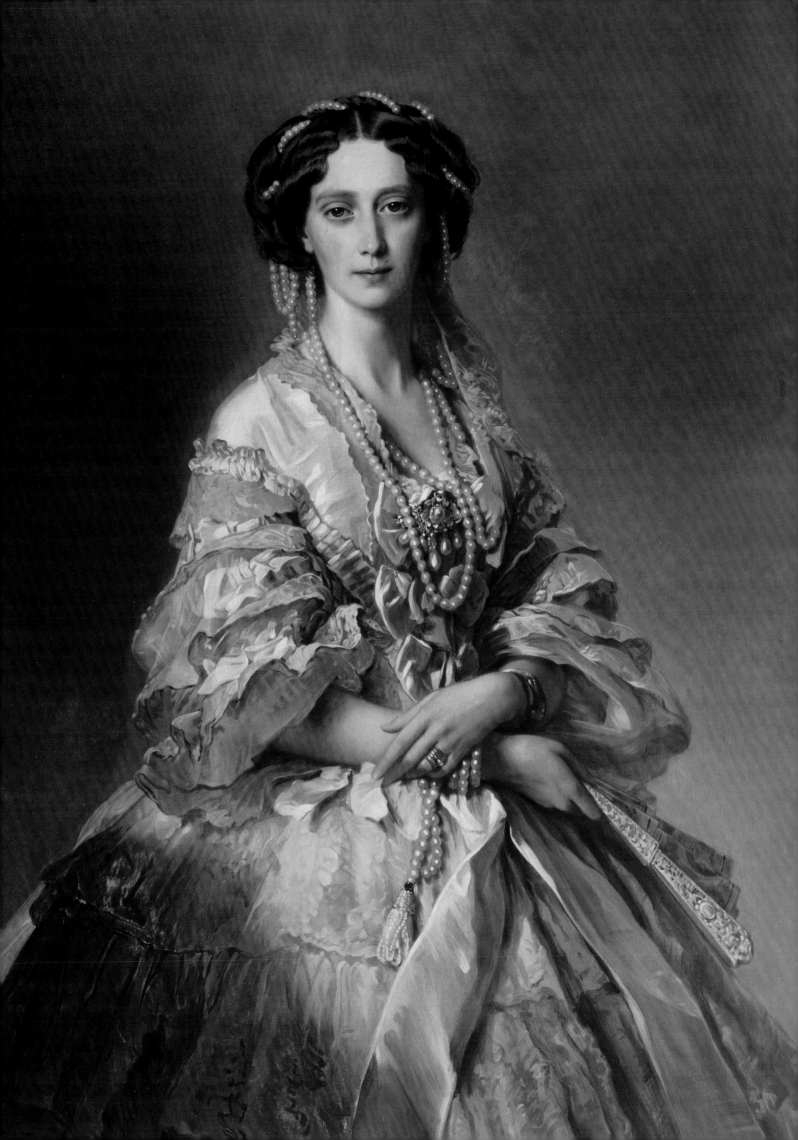

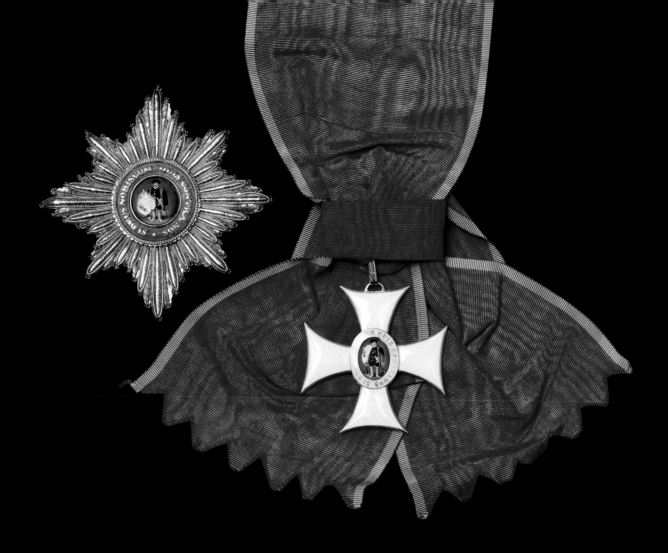

ORDERS OF HESSE

The first orders originated during the Crusades as emblems of membership in an elite religious association. As society evolved, secular orders were initiated and became increasingly identified with specific states and dynasties. House orders were founded by great families to secure the affiliation and service of select nobles. In the 18th century, the practice was extended as a reward for military service. Different classes within the orders were introduced for various merits, with form and size distinguishing the honors.

CK

Cross from the Order of Philipp the Magnanimous, Grand Duchy of Hesse
German (order founded May 1, 1840)
Enamel, bronze, fabric
H. 2½ in. (6.3 cm); W. 2⅜ in. (6.1 cm); Wt. 27.48g
Inscribed on obverse: *SI DEUS NOBISCUM QUIS CONTRA NOS;* on reverse: *Ludovicus II. Magn.(us) Dux Hassiae Instit.(uit).*
SM O 21392

Star from the Order of Philipp the Magnanimous, Grand Duchy of Hesse
German (order founded May 1, 1840)
Silver thread, cardboard
Dia. 3¾ in. (9.6 cm)
SM O 21393

The Order of Philipp the Magnanimous was founded as a Hessian Grand Ducal merit award in 1840. The distinction was meant as a reward for excellent services rendered to the Grand Ducal house and state. In 1876 the order was renamed the Hessian Grand Ducal Order of Philipp and was given the motto: *Si Deus Nobiscum quis Contra Nos* ("With God for us, who wants to be against us"). This star pin belonged to Grand Duke Ludwig III (1806–1877).

CK

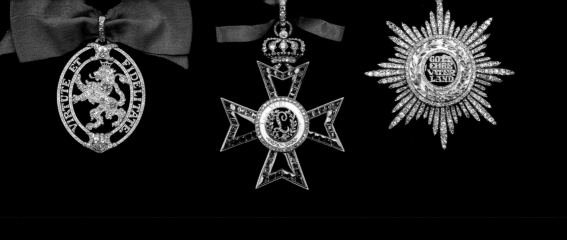

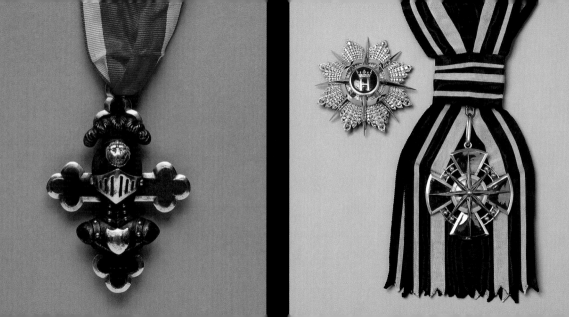

Gold, agate, enamel, pearls

Headband: L. 19⅝ in. (49.7 cm); bracelets: L. 7⅛ in. (18 cm); comb: L. 4¾ in. (12.2 cm); earrings: L. 2 in. (5.1 cm);

oval cameo: L. ⅞ in. (2.3 cm); necklace: L. 17½ in. (44.5 cm)

Headband: two cameos with head of Neptune and king inscribed: *Dorelli;* comb: cameo inscribed: *Mastini* [Angelo Antonio

Amastini, Fossombrone 1754–Rome 1815]; center cameo inscribed: *KAP* [Giuseppe Capparoni]; necklace: outer two cameos,

left and right, inscribed: *Dorelli.*

FAS K 930/1-6

Among the few pieces of jewelry preserved in the Hesse House (see p. 174) is an eight-piece parure in the Empire style. Its first owner was Grand Duchess Wilhelmine of Hesse (1788–1836), who passed it on to her daughter Maria, wife of Tsar Alexander II (1824–1880). Inherited back into the Hessian family, the pieces became part of the house jewelry in 1883.

The ensemble consists of a necklace and headband, two bracelets, a pair of earrings, an individual cameo—presumably from a clasp or waistband—and a hair comb. The filigree gold work is based on antique models, as are the sixteen onyx-cut cameos. The jewelry bands composed of individual, opposing hearts with lily leaves are set with blue enameled blossoms and a small pearl at each center. Signatures on several of the cameos verify them as the product of specialized craftsmen in Rome, then a center of cameo-cutting.

AD

FACING PAGE BOTTOM

Tiara of Alexandra Nicolaievna, sheaves (Russian), ca. 1844; tiara (German), 2nd half of 19th century

Diamonds, gold, silver, hair

H. 3½ in. (9 cm); Dia. 7⅛ in. (18 cm)

WO

As the daughter of the tsar, Alexandra Nicolaievna had entire parures of precious stones in different colors. Because she died just eight months after her wedding, most of her jewelry remained in Russia. It was transferred by her bereft groom, Friedrich Wilhelm of Hesse-Kassel, to the minister of the Romanov Imperial House in order to fund a hospital in St. Petersburg in her memory. Six diamond sheaves of wheat sewn onto one of her gowns were the only jewels that became part of the Hesse inheritance. At the end of the century, Anna of Hesse commissioned the Frankfurt goldsmith firm Koch to use them to create the present tiara, which recalls the gold wreaths of classical Greece. Since then it has become part of the family's traditional wedding jewelry and was worn by Malfalda of Hesse in 1925 and by Floria of Hesse in 2003.

PH-S

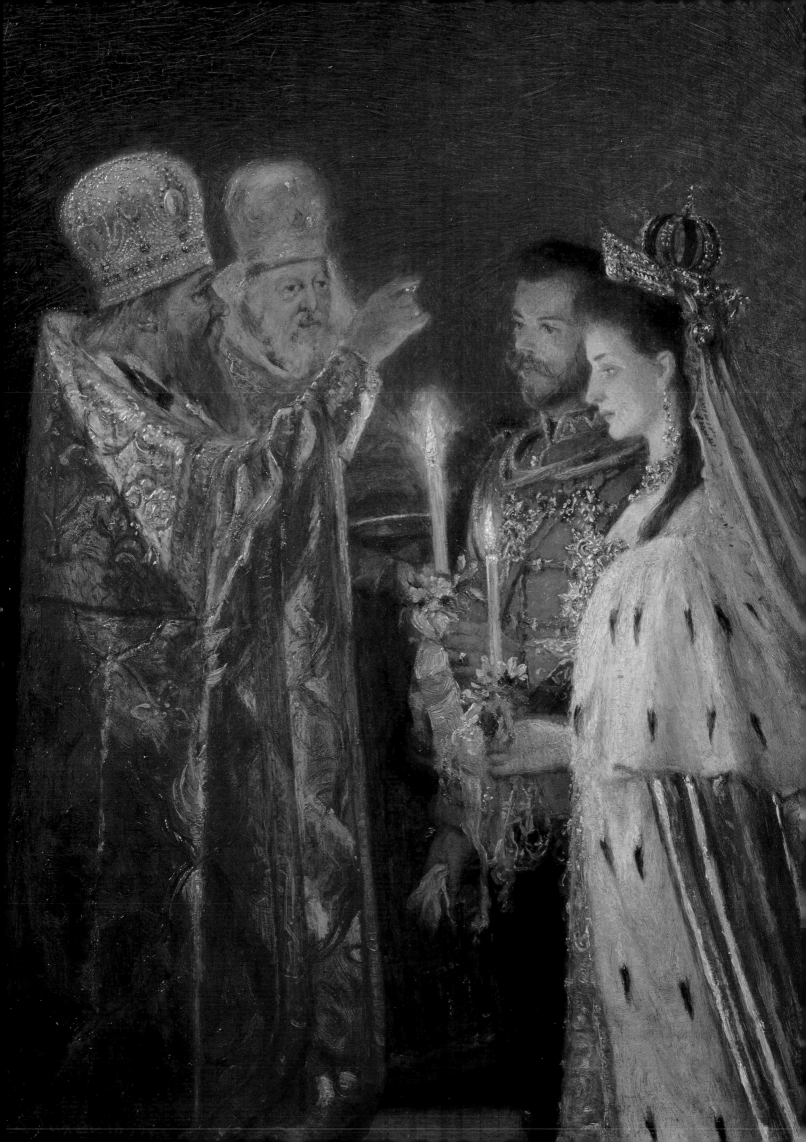

russian connection

From 1773 to 1894, five intermarriages took place between the Hesse and Romanov royal houses. Tsars Paul I, Alexander II, and Nicolas II and Grand Duke Serge each took Princesses of Hesse-Darmstadt as brides, and Alexander's sister, Grand Duchess Alexandra of Russia, married Landgraf Friedrich Wilhelm of Hesse-Kassel. As a powerful empire with one-eighth of the world's population, Russia was a desirable ally for its European neighbors. Though much smaller, Hesse was an attractive partner for the Romanov dynasty, too. It helped establish vital political bonds with Germany, and its Protestant faith was favorable in light of Russia's Orthodox religion (spouses of the imperial sovereign were required to convert).

In 1773 Paul of Russia and Wilhelmine of Hesse-Darmstadt were the first of these couples to wed. But only three years later the twenty-one-year-old Wilhelmine died giving birth to her first child. Paul subsequently remarried and in 1796 became tsar.

In the 1840s, two of his son Nicolas's children, Alexander II and Alexandra, took spouses from Hesse. Alexander met his future bride Princess Maria of Hesse-Darmstadt in 1839 at the Darmstadt Theater. Beautiful and intelligent, Maria was a good match for the well-educated Alexander. She discussed state affairs with him and ran her own salon; together they had eight children.

The marriage between Alexandra Nicolaievna of Russia and Prince Friedrich Wilhelm of Hesse-Kassel proved tragically short. The two met on June 30, 1843, when Friedrich visited the Romanov court. Instantly captivated by the youngest daughter, he asked for her hand the same evening. They wed on January 28, 1844, planning to move soon after to Copenhagen, largely the home of Friedrich's youth.

For this first daughter to leave the St. Petersburg nest, an extensive dowry was prepared. Not only did it need to provide for her future household in a manner befitting her imperial status, but, for the much favored Alexandra, it also had to ease the transition to a new life far from her family. Along with silver and porcelain services, bronze, crystal, and glasswares, bedroom and toiletry furniture, linens, and a wardrobe, the dowry would also include jewels, portraits, and personal memorabilia.

Unknown to all on the wedding day, however, Alexandra soon would be gravely ill. In April, the pregnant Princess of Hesse was diagnosed with tuberculosis. On August 10 she and son Wilhelm died shortly after childbirth, never seeing their new homeland. Devastated, Friedrich founded a hospital for fatally ill women in her memory. Nicolas, in both great mourning for his daughter and sympathy for his son-in-law, broke custom and ordered that the dowry not be returned to the imperial family. Instead it was to remain in Friedrich's possession and subsequently became part of the Hesse collections.

Forty years later, Elisabeth and Alix (Alice), daughters of Grand Duke Ludwig IV and Grand Duchess Alice, and granddaughters of Queen Victoria of Great Britain, were the last Hesse princesses to marry into the Romanov dynasty. Elisabeth, known as Ella, married Grand Duke Serge of Russia in 1884. Younger sister Alix visited Ella and soon the tsarevich Nicolas was smitten with her. Alix returned his affection but was reluctant to give up her Lutheran faith, and it was not until 1894 that she agreed to marry him, subsequently taking on the Russian form of her name, Alexandra Feodorovna. Their close personal alliance ended in tragedy as the last Tsar and Tsarina, along with their five children, were arrested by Bolsheviks and executed in 1918.

JMS

Hesse-Romanov connection

1

1 **Tsar Peter III of Russia** (1728–1762), ca. 1760
Russian School
Watercolor on vellum
H. 2½ in. (6.4 cm); W. 1¾ in. (4.4 cm)
WO I 8980

2 **Tsar Paul I of Russia** (1754–1801), ca. 1800
Attributed to Gerin
Watercolor on ivory
Dia. 2¾ in. (7.2 cm)
Engraved on reverse: *Paul I Kaiser von Rußland 1754–*
1801 (412)
WO I 8974

2

3 **Tsar Alexander I of Russia** (1777–1825), ca. 1800
Russian School
Watercolor on ivory
Dia. 2⅝ in. (6.5 cm)
Inscribed on reverse: *Alexander I Kaiser von Russland*
No. 173/406
WO I 8971

4 **Grand Duchess Helena Pavlovna of Russia**
(born Princess Charlotte of Württemberg, 1807–1873),
1825
Franz Kronnowetter (Vienna 1795–St. Petersburg 1837)
Watercolor on ivory
H. 2⅛ in. (5.4 cm); W. 1¾ in. (4.3 cm)
Signed and dated center right: *Kronnowetter 1825;* on
reverse: *Helene Gem. Michael Paulowitsch v. Russland*
(Charlotte) Tochter Pauls Herzog v. Württemberg
9.I.1807–2.II.1824 (411)
WO I 8973

3

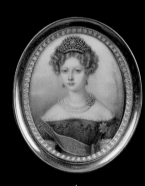

4

5 **Landgraf Friedrich Wilhelm of Hesse-Kassel**
(1820–1884), ca. 1843
German School
Watercolor on ivory
H. 1¾ in. (4.5 cm); W. 1¼ in. (3.2 cm)
Inscribed on reverse: *Landgraf Friedrich von Hesse-Cassel*
26.XI.1820 +14.X.1884
WO I 8809

5

6 **Tsar Alexander III of Russia** (1845–1894), ca. 1890
Russian School
Watercolor on card
H. 3¾ in. (9.3 cm); W. 2⅞ in. (7.3 cm)
Engraved on reverse: *Alexander III Alexandrowitsch, Kaiser*
v. Russland Geb. 26.Febr. 1849 Gest. 20 Okt. 1894
WO I 8808

7 **Grand Duchess Elisabeth Feodorovna of Russia**
(born Princess of Hesse-Darmstadt, 1864–1918), 1902
Maria Gradowsky (Russian, act. 1890–1905)
Watercolor on ivory
H. 2½ in. (6.4 cm); W. 1¾ in. (5 cm)
Signed center left: *Gradowsky;* on reverse: *Gradowsky (22)*
WO I 8968

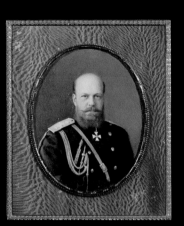

6

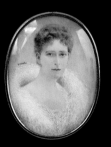

7

8

9

10

11

12

13

14

8 *Tsarina Catharine II (the Great) of Russia*
 (born Princess Sofie August Friederike of Anhalt-Zerbst,
 1729–1796), ca. 1775
 Attributed to De Sompsois (act. La Haye-du-Puits
 1775–1778)
 Watercolor on ivory
 Dia. 3⅛ in. (7.7 cm)
 WO I 8995a

9 *Grand Duchess Nathalie of Russia*
 (born Princess Wilhelmine of Hesse-Darmstadt,
 1755–1776), ca. 1775
 Attributed to Hornung
 Watercolor on ivory
 H. 1⅝ in. (4.1 cm); W. 1⅜ in. (3.3 cm)
 Inscribed on reverse: *Nathalie, Großfürstin v. Rußland*
 Wilhelmine v. Hessen D. Gem. des Thronfolgers Paul v.
 Rußland 1755–1776 Nr. 169 (500)
 WO I 8998

10 *Tsar Nicolas I of Russia* (1796–1855), 1835
 Ivan Winberg (St. Petersburg, act. 1830–1846)
 Watercolor on ivory
 H. 1⅝ in. (4.2 cm); W. 1½ in. (3.6 cm)
 Signed center right: *Winberg;* inscribed on reverse: *Nikolas I*
 Kaiser v. Russland geb. 6 Juli 1796 gest. 2 März 1855
 Winberg (430)
 WO I 8989

11 *Tsarina Alexandra Feodorovna of Russia*
 (born Princess Charlotte of Prussia, 1798–1860), ca. 1817
 Heinrich Abel Seyffert (Magdeburg 1768–Berlin 1834)
 Watercolor on ivory
 H. 1¾ in. (4.3 cm); W. 1⅛ in. (2.7 cm)
 Inscribed on reverse: *Alexandra Kaiser von Russland*
 (g. K. Nikolas I) Nr. 888 (425)
 WO I 8984

12 *Tsar Alexander II of Russia* (1818–1881), 1875
 Alexander Matveievish Wegner (St. Petersburg 1826–1894)
 Watercolor on ivory
 H. 2¼ in. (5.7 cm); W. 1⅞ in. (4.8 cm)
 Inscribed on reverse: *Alexander II Nikolajewitsch Kaiser*
 von Russland Geb. 29.April.1818 Gest. 13. März.1881
 WO I 8978

13 *Tsarina Maria Alexandrovna of Russia*
 (born Princess Marie of Hesse-Darmstadt, 1824–1880),
 ca. 1875
 Alexander Matveievish Wegner (St. Petersburg 1836–1895)
 Watercolor on ivory
 H. 2⅜ in. (6.1 cm); W. 1¾ in. (4.6 cm)
 Signed in cyrillic lower right: *Wegner;* on reverse: *Maria*
 Alexandrowna Kaiserin von Russland Geb. Prinzessin von
 Hessen Geb. 8.August.1824 Gest. 3.Juni.1880 (416)
 WO I 8977

14 *Tsarina Alexandra Feodorovna of Russia*
 (born Princess Alix of Hesse-Darmstadt, 1872–1918), 1899
 Hedda M. Stoffregen
 Watercolor on ivory
 H. 4½ in. (11.3 cm); W. 3½ in. (8.3 cm)
 Signed and inscribed lower left: *Chateau de Wolfsgarten*
 Hedda M. Stoffregen
 WO I 8747

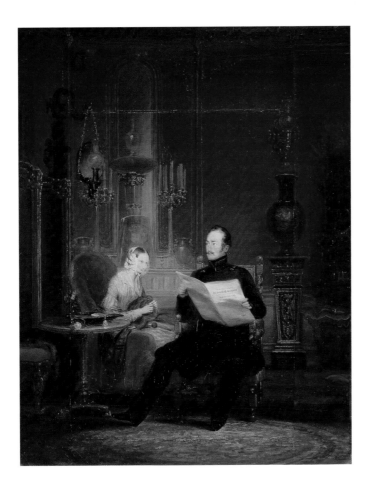

CHRISTINA ROBERTSON (Kinghorn, Scotland 1796–St. Petersburg 1854)
Tsar Nicolas I of Russia and Tsarina Alexandra Feodorovna in the Empress's Red Room,
Winter Palace, St. Petersburg, ca. 1843
Oil on canvas
H. 17¾ in. (45.2 cm); W. 14 in. (35.6 cm)
Dated on document below Cyrillic text: *184[?]*
Label on reverse: *No. 6. His imperial Majesty, Nicolas the First—Emperor of all the Russias, and the Empress Alexandra*
Feodorovna—their Imperial Majesties are represented in the Cabinet of the Empress (where the picture was painted) in the
Winter Palace of St. Petersburg. Painted for Her Imperial Highness the Grand Duchess Alexandra Nicolaievna. Painted by
Mrs. James Robertson, Member of the Imperial Academy of St. Petersburg, 36 Harley St.
FAS B 189

Nicolas I made it a regular practice to take tea alone with his wife in the Red Room of St. Peters-
burg's Winter Palace. Christina Robertson recorded the intimate scene with realistic details
and a glowing palette. It was part of the home life the tsar and tsarina wanted their daughter
Alexandra to remember as she went out into the world as a married woman. They gave her sister
Olga a watercolor version of the same scene.

PH–S

(GIOVANNI) IWAN PETROWITSCH VITALI (St. Petersburg 1794–1855)
Bust of Alexandra Nicolaievna, 1845
White marble
H. 27¼ in. (69 cm); W. 17¾ in. (45 cm); D. 7½ in. (19 cm)
Inscribed along truncation: *Prinzessin Fr. Wlhl. Von Hessen Alexandra Nikolajewna Grossfupstin* [sic] *Von Russland*
FAS R 18

This bust was presented to Prince Friedrich Wilhelm when he came to St. Petersburg for the
inauguration of a memorial chapel dedicated to his bride on the first anniversary of her death.
Although the bust was posthumous, Vitali sought to make it as lifelike as possible, even to the
braids of Alexandra's up-to-date hairstyle, called *à la Clothilde.*

PH–S

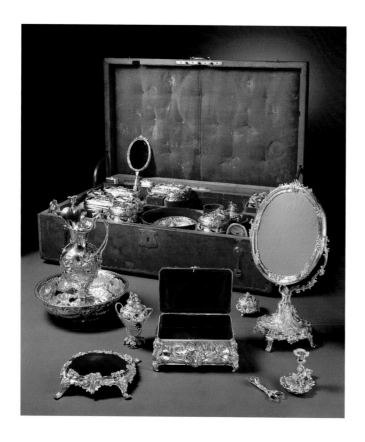

Dressing Table Mirror, Pair of Six-Light Candelabra, and *Traveling Toilette Service,* 1842,
from the dowry of Alexandra Nicolaievna
Carl Tegelsten (Karis-Lojo 1798–St. Petersburg 1852)
Silver, glass, velvet, wood
Mirror: H. 42⅞ in. (109 cm); W. 30⁵⁄₁₆ in. (77 cm); candelabra: H. 23½ in. (59.7 cm)
FAS S 28, 6a–b; FAS S 7-27

The ensemble of dressing table equipment is usually referred to as a "toilet set." The term refers to the French practice called the *toilette,* after the cloth or *toile* draped over the simple dressing tables on which articles of hygiene, cosmetics, and hair care were laid out. In the 18th century, the word *toilette* was adopted for a social occasion in which an important man or woman invited guests to attend them as they made themselves ready for the day. By the 19th century, elaborate, multi-part traveling toilet services in fitted cases were in vogue for men as well as women. Alexandra Nicolaievna's set comprises thirty-three pieces: a mirror, a pair of candlesticks and snuffers, and a bowl and basin for washing, accessorized with a variety of containers for cosmetics, creams, and notions and even a bell to summon her maid. The spectacular Rococo Revival silversmithing of Carl Tegelsten and the completeness of the set make the toilet service an important part of her dowry.

 PH-S

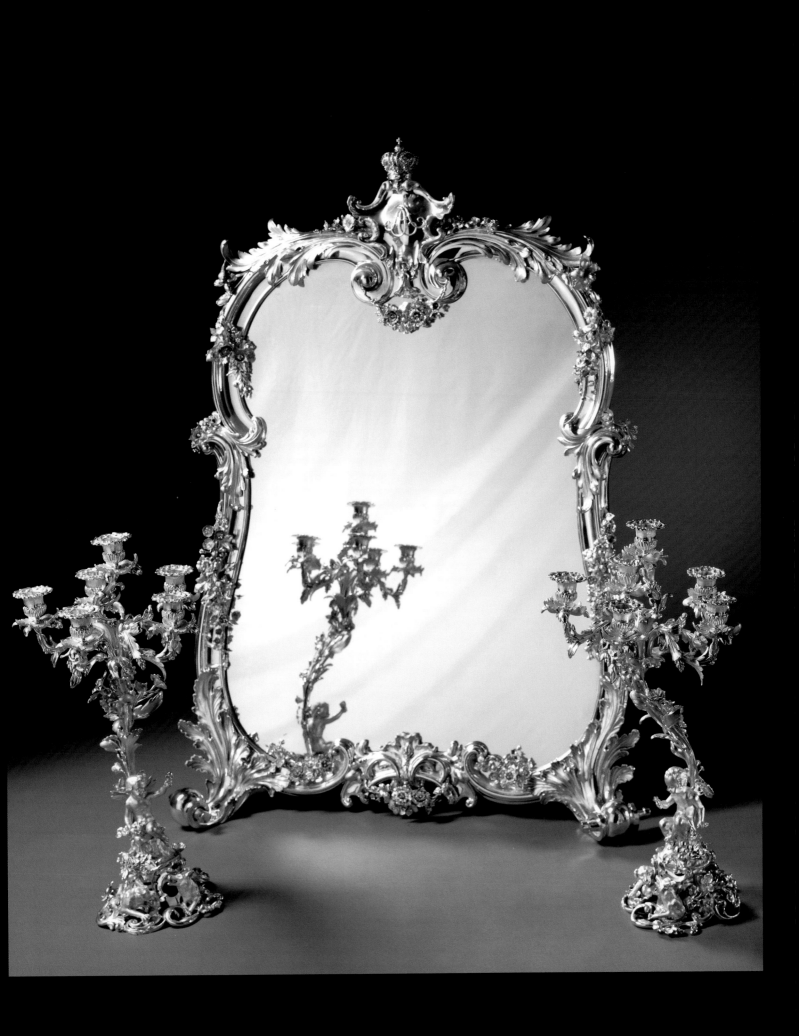

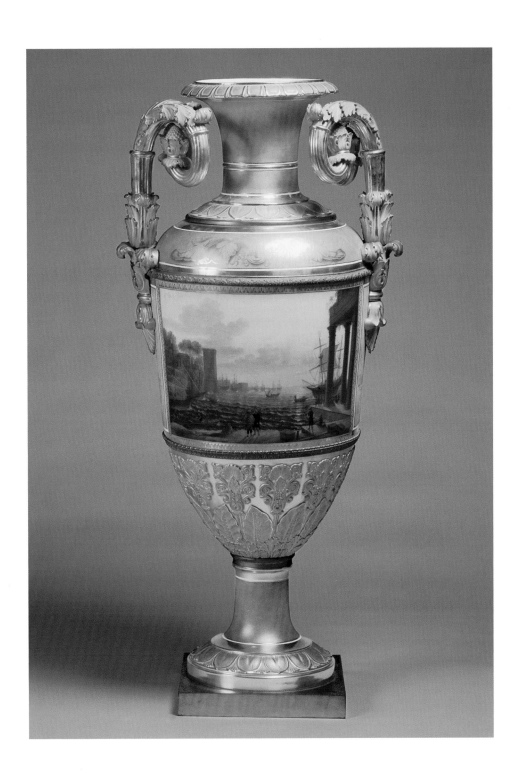

Bandeau Vase, 1843

Imperial Porcelain Factory, St. Petersburg; landscape painted by P. Schtschetinin after Claude Lorrain (Champagne 1600 – Rome 1662)

Porcelain

H. 54¾ in. (139.5 cm); Dia. 26⅜ in. (67 cm)

FAS P(E) 226b

This vase is one of a pair that was a Christmas gift from Tsar Nicolas I to Prince Friedrich Wilhelm of Hesse in 1843. Such monumental vases were a specialty of the Russian Imperial Porcelain Factory. The huge scale was achieved by casting the porcelain in separate pieces. The body of this vase has five parts, with the joins concealed by gilded bronze bands. The front of the central band was usually treated as a field for reproducing a painting from the Russian Imperial collection, with the remainder providing a field for decoration rendered in tooled gilding.

 pH-s

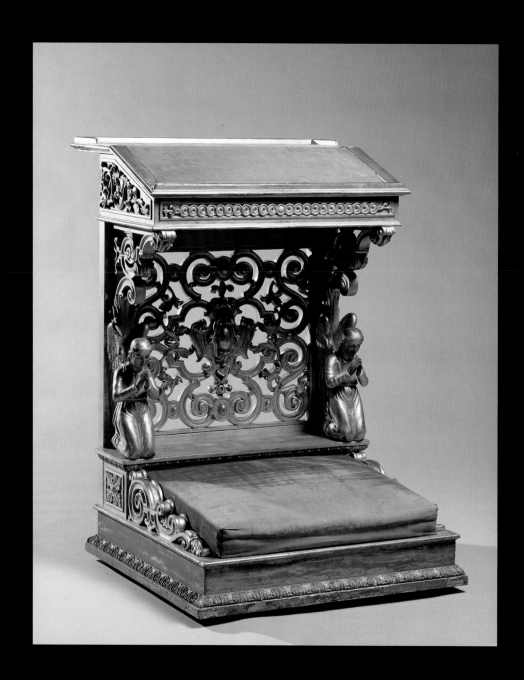

Prie-Dieu, 1830–1844
Peter Gambs (St. Petersburg 1802–1871) and Ernst Gambs (St. Petersburg 1805–1849)
Birch, cedar, gilt, velvet, metal
H. 38¼ in. (97 cm); W. 26⅜ in. (67 cm); D. 24¾ in. (63 cm)
FAS M 0849

This gilded prie-dieu from the bedroom suite of Alexandra Nicolaievna's dowry is for kneeling on during prayer. Resembling a lectern, it has a space for holding a book and resting the elbows. Its name, literally "pray God," derived from the French around the early 17th century. As a traditional part of a personal oratory, Alexandra's prie-dieu would have faced a matching display cabinet for icons and probably stood near the head of her bed.

 JMS

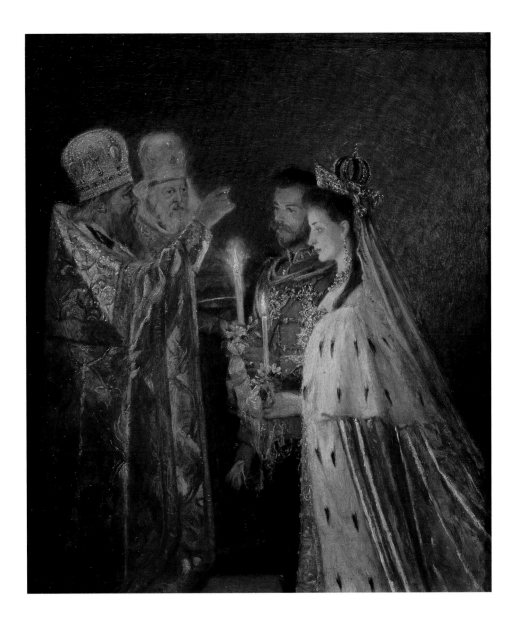

LAURITS REGNER TUXEN (Copenhagen 1853–1927)
The Wedding of Nicolas II and Alexandra Feodorovna (Alix) of Hesse, 1895
Oil on panel
H. 15¾ in. (40 cm); W. 14 in. (35.5 cm)
Signed and dated lower left: *1895*
SM B 21057

Moving away from the academic mode of his studies in Paris, the Danish artist Tuxen developed his own style of free and expressive brushwork. A commission in 1883 to paint the Danish King Christian IX surrounded by his family led to a similar commission from Queen Victoria in 1887. It was only natural that Christian IX should recommend Tuxen to paint the grand occasion of the marriage of his grandson Nicolas II of Russia, which he attended on November 15, 1894. The present picture is a study for a much larger work now in Buckingham Palace; another preparatory study is in the Hermitage in St. Petersburg. While the other versions convey the dazzling effect of the palace's new electric lights that so impressed eye-witnesses, this version highlights the personal union at the center of the ceremony, illuminated by the glow of the candles held by Nicolas and Alexandra.

pH-s

carl fabergé (St. Petersburg 1846–La Rosiaz 1920)

With the perspective of history, Fabergé appears as the successor to Johann Melchior Dinglinger (1664–1731), the great Baroque goldsmith of the court of Augustus the Strong in Dresden. Fabergé, like Dinglinger, is remembered for unique objects made with virtuoso craftsmanship and ingenious gadgetry for the delectation of sophisticated and wealthy rulers. As the son of a St. Petersburg jeweler who moved to Dresden in 1860, the young Fabergé possessed an ambition that could well have been fired by the works of Dinglinger exhibited in Dresden's Green Vaults. While Dinglinger astonished Augustus with tours de force like the 132-piece miniature *Grand Mogul's Birthday Party,* Fabergé would delight Tsar Alexander III in 1885 with the first of the jeweled Easter eggs, each fitted with a tiny, intricate "surprise," which the tsar would present to his wife annually. Nicolas II continued the Imperial Easter Egg tradition begun by his father but doubled the order to give one to both his mother and his wife.

Fabergé took over his father's jewelry firm in St. Petersburg in 1870 and expanded to branches in Moscow (1886), Odessa (1900), London (1903), and Kiev (1906). His company was estimated to have made over 150,000 pieces before Fabergé fled the Revolution and the Bolsheviks closed down the enterprise in 1918.

Fabergé produced traditional jewelry and silverware but his reputation was built on high-end gift items exchanged among the courts of Europe. Comparing himself to his competition, Tiffany and Cartier, Fabergé said disdainfully, "I am less interested in an expensive object, if its high cost is only because many diamonds and pearls have been planted on it." He offered exquisite craftsmanship in tastefully conservative designs often based on 18th-century French models. In the creations of the "workmasters" who headed the firm's workshops, precious gems were used to accessorize the semiprecious stones of Russia as were a spectrum of enameled colors that characterized the products. Most importantly, each object was unique. When searching for the just the right present for someone who had everything, his clients could be sure that an offering from Fabergé would not be duplicated.

The Romanovs regularly marked family occasions with gifts from Fabergé. The numerous works by Fabergé in the Hesse family collection are tokens of the close ties between Tsarina Alexandra, her older sister Grand Duchess Elizabeth, and their brother, Grand Duke Ernst Ludwig of Hesse-Darmstadt.

ph–s

Cigarette Case with Lily, 1899–1908
Carl Fabergé (St. Petersburg 1846–La Rosiaz 1920)
Silver, cabochon sapphire
L. 3⅜ in.
Mark of K. Fabergé, Imperial warrant, Moscow, 1899–1908, inv. no. 12348
WO S 8063

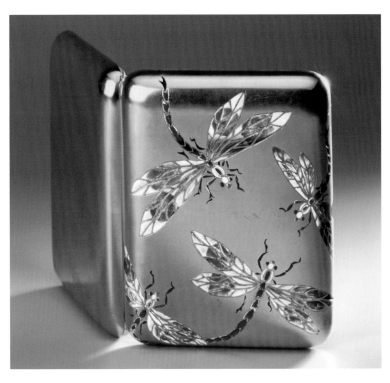

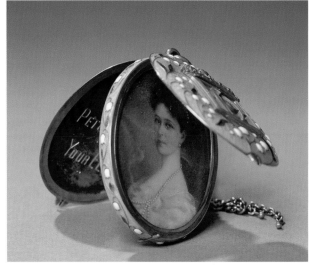

Cigarette Case with Dragonflies, 1899–1908
Carl Fabergé (St. Petersburg 1846–La Rosiaz 1920)
Gold, plique-à-jour enamel
L. ¾ in. (1.7 cm); W. 3⅛ in. (9.5 cm); D. 2¾ in. (7.1 cm)
Mark of K. Fabergé, Imperial warrant, inv. no. 13002
WO S 8187

The inscription inside this case in a facsimile of Tsarina Alexandra's handwriting is evidence of the warm affection between Nicolas and Alexandra and her brother Grand Duke Ernst Ludwig:
For darling Ernie from Nicky & Alix Xmas 1900.
 PH–S

Oval Locket with Lilies of the Valley, 1904
Carl Fabergé (St. Petersburg 1846–La Rosiaz 1920)
Gold, enamel, glass
L. 3¾ in. (13.6 cm); W. 1¾ in. (6.5 cm); D. 1¾ in. (6.5 cm)
Mirror monogram on upper cover below crown: *EE* [Grand Duchess Elisabeth]; engraved interior: *3 June 1884 Petersburg –
3 June 1904 Moscow, your Ella;* silver stand inscribed on base: *1904 Großfürsten Elisabeth Feodorovna/geb. P. von Hessen/
20 Hochzeitstag. Gem. [paintings by] Miss Nicolson*
WO K 8406

The locket, which contains two miniatures of Grand Duchess Elisabeth of Russia (born Princess of Hesse-Darmstadt), was a gift she gave to her younger brother Grand Duke Ernst Ludwig of Hesse in 1904 on the occasion of her twentieth wedding anniversary.
 JMS

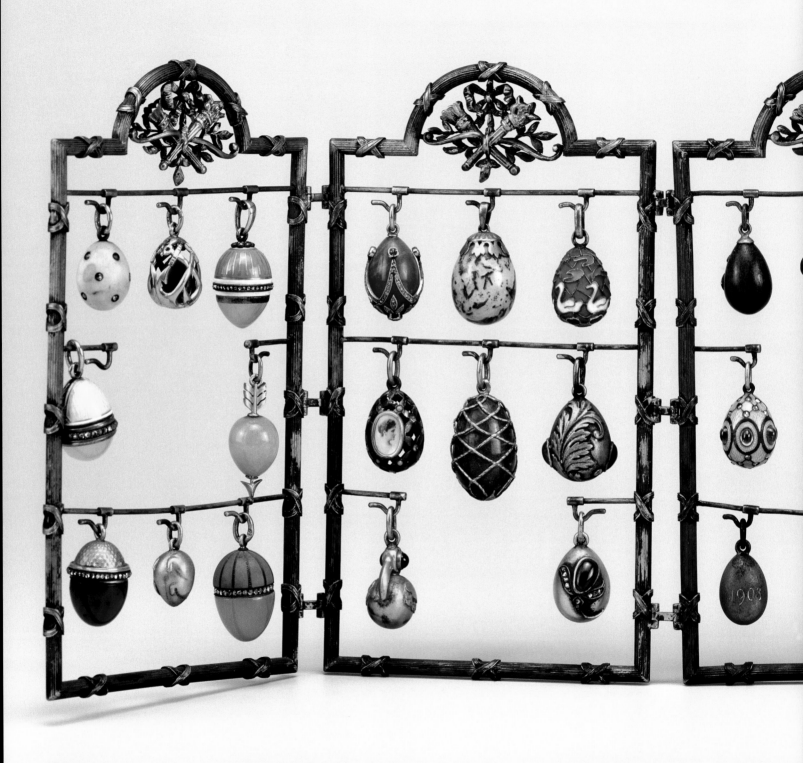

Five-Part Screen with Forty Miniature Eggs, early 20th century

Carl Fabergé (St. Petersburg 1846 – La Rosiaz 1920)

Partly gilded silver, enamel, bowenite, purpurine, pink chalcedony, aventurine, nephrite, cabochon ruby, red quartz, turquoise,

sapphire, chrysoprase, lapis, pearl, onyx, amethyst, agate, porcelain, wood, photograph, blue stone

H. 5⅛ in. (13 cm); W. 15¾ in. (40 cm)

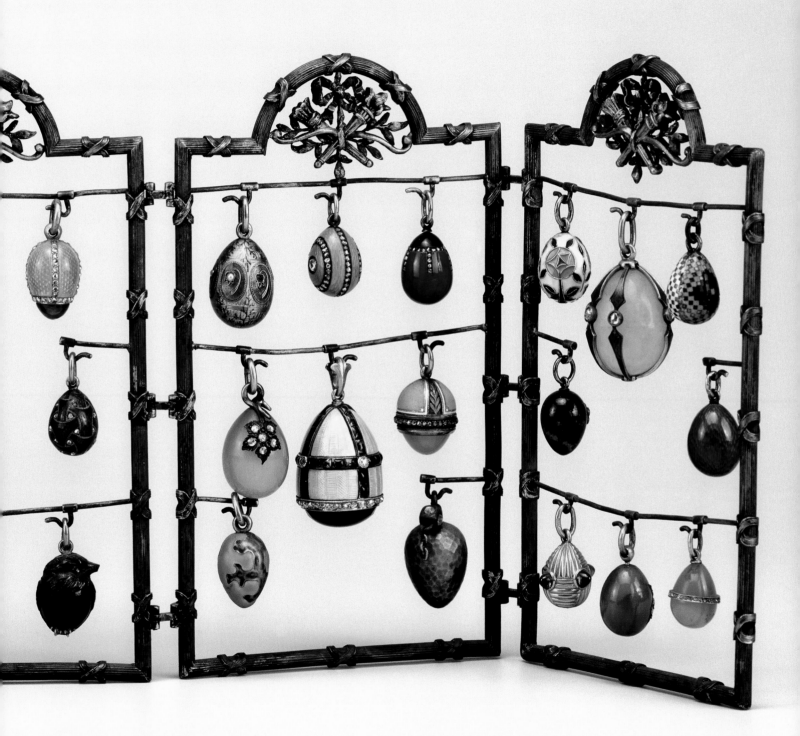

Table Clock, ca. 1905
Carl Fabergé (St. Petersburg 1846 – La Rosiaz 1920);
workmaster, Henrik Wigström (Tamminsaarie 1862 –
Kivennapa 1923)
Gilded silver, enamel, gold, split-seed pearl, ivory
H. 4⅛ in. (10.4 cm); W. 4⅛ in. (10.4 cm); D. ⅝ in. (1.6 cm)
Mark of Fabergé; workmaster, Henrik Wigström,
St. Petersburg, 1899–1908, inv. no. 16554
WO U 8519

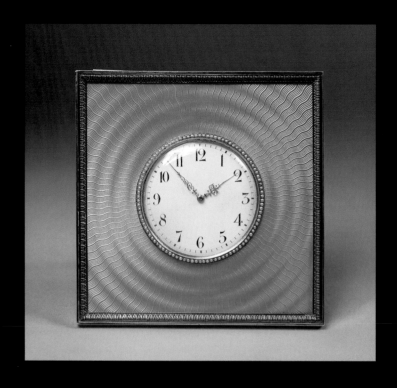

Letter Opener, n.d.

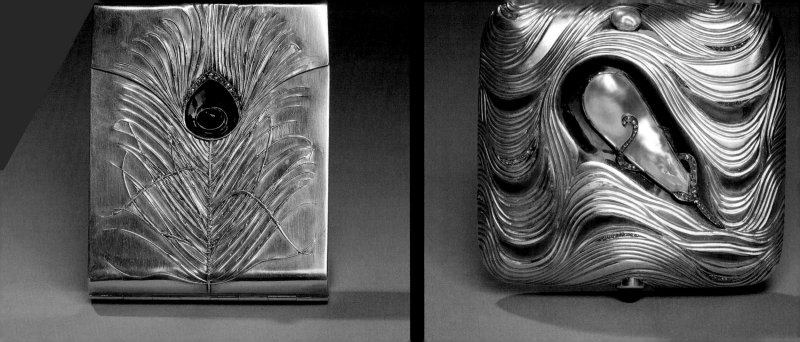

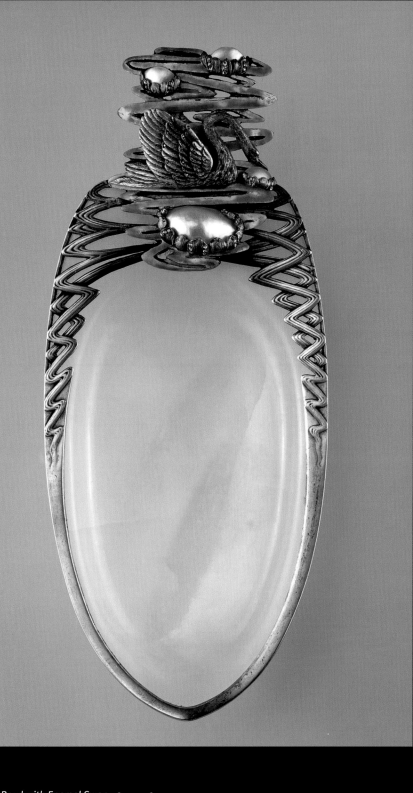

White Oval Bowl with Enamel Swan, 1899–1908

W. A. Bolin Russian Imperial Jewelers

Silver, chalcedony, enamel, pearls, diamonds

L. 8⁵⁄₁₆ in. (21.1 cm); W. 3⅛ in. (8 cm)

Mark of Bolin, Moscow, 1899–1908

ernst Ludwig and Jugendstil

Jugendstil is the German version of the movement that swept Europe and America at the turn of the 19th century, which is better known today by the French term, Art Nouveau. The style found its most cogent German expression in Darmstadt. That this provincial capital played such an important role, surpassing the political and economic power base of Berlin and challenging the advanced artistic circles of Munich, was the work of an inspired patron, Ernst Ludwig of Hesse.

By nature an aesthete, Ernst Ludwig was drawn to the work of avant-garde writers and artists, most particularly those of the Symbolist Movement. He had spent much of his youth with his grandmother Queen Victoria and was profoundly imbued with English ideas and ideals. As the young Grand Duke of Hesse, his first act of official patronage came in 1897 when he undertook the decoration of three rooms in the Neue Palais, his residence in Darmstadt, in a modern style contrasting with the heavy historicism then popular in Germany. He commissioned the Munich Symbolist artist Otto Eckmann to design and furnish a Jugendstil study. That same year, he requested a reception room and breakfast room from a leading English Arts and Crafts designer, Mackay Hugh Baillie Scott. More than an expression of personal taste, this was an attempt to bring the spirit and energy of the avant-garde to Hesse.

Ernst Ludwig had the furniture for the reception room manufactured in the London workshops of Charles Ashbee, but he gave the Darmstadt furniture company Glückertsche Möbelfabrik the challenge of executing Baillie Scott's designs for the breakfast room. By the completion of the project in 1898, Baillie Scott and Ashbee had made several trips to Darmstadt, giving the grand duke firsthand exposure to the ideals that underlay their work. Soon after this commission, Ashbee moved his Guild and School of Handicraft to a village outside of London with the aim of creating a utopian community grounded in the social theories of William Morris. Influenced by this, Ernst Ludwig took a central Arts and Crafts tenet—one that brought together the artist and the craftsman—out of its utopian context and applied it to the advancement of image and industry for the state of Hesse in the new modern age.

The grand duke decided to create an artists' colony on Mathildenhöhe, a verdant hill on the outskirts of Darmstadt. Here artists were to collaborate with artisans to design and create their own homes, teach in the applied arts school (founded in 1907), and showcase their work to the public. In 1899 the Austrian architect Joseph Maria Olbrich, a founder of the Vienna Secession, accepted the grand duke's invitation to head the Darmstadt project. Olbrich prepared exhibitions in 1901, 1904, and 1908 and brought worldwide attention to Mathildenhöhe before his death in 1908. By 1914, the date of the last exhibition before World War I bought an end to the colony, twenty-three artists had participated in the small and changing community of painters, sculptors, ceramicists, metalworkers, and architects who brought to the Hessian capital the latest impulses from Vienna, Munich, and elsewhere. The artists' homes and exhibition hall exist to this day. Their communal atelier is now a museum whose collection documents the success of Ernst Ludwig in establishing Darmstadt's leadership in the arts at the onset of the 20th century. Olbrich's tower (illustrated p. 168) in the shape of a hand has become a landmark of the city.

PH-S

Two Songs for Voice and Piano and *Two Poems of Olaf Composed for Voice and Piano*

Composed by Grand Duke Ernst Ludwig von Hessen (1868–1937), published ca. 1902; graphic design by Joseph Maria Olbrich (Troppau 1867–Düsseldorf 1908)

Book print red, gold, black

L. 13½ in. (34.3 cm); W. 11 in. (28 cm); and L. 13⅝ in. (34.5 cm); W. 10⅞ in. (27.8 cm)

FAS MN Hessen 5 c-e WO and MN Hessen 6 d + e WO

Ernst Ludwig's passion for music extended to writing his own compositions in the art song tradition of German *Lieder.*

ph-s

FRANZ VON STUCK (Tettenweis 1863–Tetschen 1928)
Grand Duke Ernst Ludwig of Hesse, 1907
Oil on panel
H. 40⅝ in. (103 cm); W. 32¾ in. (83 cm)
B 21005

The sensitivity of this portrait conveys the empathy and mutual admiration of artist and sitter. An outstanding exponent of the Symbolist movement, known for his dark, sensuous imagery,

Armchair, 1897–1898

Designed by Mackay Hugh Baillie Scott (Isle of Man 1865–Bedford 1945); made by Guild and School of Handicraft, London

Oak, leather, silk

H. 63⅛ in. (160.6 cm); W. 26⅜ in. (67 cm); D. 22⅜ in. (57 cm)

WO M 21000

A stellar example of the English Arts and Crafts movement, this high-backed chair was part of the furnishings of the radically novel reception room Ernst Ludwig commissioned for the Darmstadt Neue Palais. The architect and designer Ballie Scott collaborated with Charles Ashbee, whose Guild and School of Handicraft executed the work.

 PH–S

SIR EDWARD BURNE-JONES (Birmingham 1833–London 1898)

Saint George, dated 1897

Oil on canvas

H. 74¾ in. (190 cm); W. 23¼ in. (59 cm)

WO B 8081

This late Pre-Raphaelite image exemplifies the movement that had gained wide popularity in England. Burne-Jones favored medieval subjects interpreted with conscious references to Italian painting of the early Renaissance, but his idealized figures, lost in reverie, presaged the vocabulary of Symbolism. The monumental work speaks to both the Anglophile and mystical aspects of Ernst Ludwig's taste.

 PH–S

OTTO ECKMANN (Hamburg 1865–Badenweiler 1902)

A successful Symbolist artist in Munich, Eckmann abandoned painting for the applied arts in 1894. His woodcuts as well as his textile designs show the influence of Japanese prints. He was a regular contributor to the Munich periodical *Jugend* ("Youth"), which was founded in 1896 and from which the stylistic designation "Jugendstil" derived its name.

PH-S

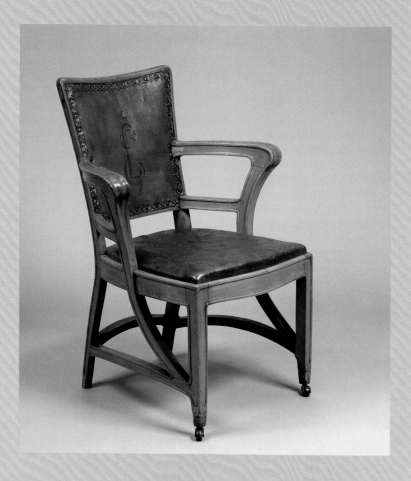

Desk Chair, 1897
Designed by Otto Eckmann (Hamburg 1865–Badenweiler 1902)
Beech, leather
H. 35¾ in. (91 cm); W. 28 in. (71 cm); D. 22⅝ in. (57.5 cm)
WO M 8156

The crowned "EL" embossed on the leather of the back indicates that this was part of the furniture Eckmann designed for Ernst Ludwig's study in the Darmstadt Neue Palais in 1897.

PH-S

Swan Tapestry, 1896–1897
Designed by Otto Eckmann (Hamburg 1865–Badenweiler 1902); made by Kunstwebschule Scherrebek
Wool
H. 94½ in. (240 cm); W. 29½ in. (75 cm)
Inscribed with monogram lower left: *OE*
WO T 8035

Eckmann's Swan Tapestry was published in international periodicals and acclaimed as one of the freshest statements of the new style. It was so much in demand that about one hundred examples were woven.

PH-S

176

Cabinet, 1897–1900
Probably German
Birch, silver, metal, paint, ivory
H. 89¾ in. (228 cm); W. 28⅛ in. (71.5 cm); D. 15¾ in. (40 cm)
WO M 8173

Although the designer and origin of this cabinet remain uncertain, the imagery places it in the mainstream of the Symbolist Movement.

JOSEPH MARIA OLBRICH (Troppau 1867–Düsseldorf 1908)

Olbrich joined the firm of the modernist architect Otto Wagner in 1894 after completing his studies in Vienna. In 1897 he became one of the founders of the Vienna Secession, along with Gustav Wagner, Gustav Klimt, and Josef Hoffmann. In 1899 he accepted the invitation to head the Mathildenhöhe colony fresh from the triumph of his Vienna Secession exhibition hall, which he designed to display cutting-edge modern art. He worked closely with the grand duke, laying out the plan of the Darmstadt colony, designing key buildings down to the smallest detail, and organizing exhibitions. For Ernst Ludwig himself, Olbrich created a unique playhouse for Princess Elisabeth at Wolfsgarten (1902), a grandiose music room in the Darmstadt Neue Palais (1902–1903), and an informal apartment in Schloss Giessen (1906). In the last year of his life he completed the great "Wedding Tower" in the shape of the five fingers of a hand (see p. 168). It was presented by the city of Darmstadt to the grand duke on the occasion of his second marriage and still dominates the region around Mathildenhöhe. Olbrich continued to accept outside commissions and was a founder of the Deutsches Werkbund (Applied Arts Coalition) in Munich in 1907.

DH-S

Jewelry Box, ca. 1901

Designed by Joseph Maria Olbrich (Troppau 1867–Düsseldorf 1908); made by Robert Macco, Heidelberg

Maple, ivory, mother-of-pearl, silver gilded copper, ebony, boxwood

H. 15¾ in. (40 cm); W. 7⅞ in. (20 cm); D. 6⅛ in. (15.5 cm)

WO K 8102

Embroidered Wall Hanging, 1902–1904

Designed by Joseph Maria Olbrich (Troppau 1867–Düsseldorf 1908); made by Misses Appel, Schippel, Riedel, Schnittspahn, and Kress

Silk, wool

H. 85 ¼ in. (216.5 cm); W. 50 ¾ in. (129 cm)

Signed lower right: *JO*

WO T 8036

The wall hanging was made for the music room Olbrich created in the Darmstadt Neue Palais. The embroidery served as a showpiece for the Mathildenhöhe artists' colony at its 1904 exposition in Darmstadt and in its pavilion at the St. Louis World's Fair in the same year. Its intricate design evokes the harmonics of the celestial spheres and reflects the grand duke's mystical bent as well as his passion for music.

The inscription at the bottom of the embroidery is from the "Prologue in Heaven" of Goethe's *Faust* and translates:

> *The sun intones its age-old song*
> *To rival chants of brother spheres.*
> *A preset course it moves along*
> *In thund' ring march throughout the years*
> *Its very sight gives Angels power*
> *Though not a one could know its way.*
> *Transcendent works beyond us tower*
> *Sublime as on Creation's day.*

A central column of mystical scenes rises from arches of all-seeing eyes to branch out at the top into clanging bells; while on either side, circles of birds echo the motif surrounding the skylight of the music room's vaulted ceiling. Tucked into rectangular cartouches are small views of Olbrich's architectural projects in Hesse.

PH-S

Stained Glass Panel with Arms of Ernst Ludwig and Eleonore, 1905
Designed by Joseph Maria Olbrich (Troppau 1867–Düsseldorf 1908); made by Benz & Rast Kunstglaserei, Darmstadt
Glass, oak
H. 13⅞ in. (35.3 cm); W. 13⅞ in. (35.3 cm)
Inscribed bottom center: *Benz Rast/2 Februar 1905 Olbrich.*
SM G 21000

The panel commemorates the marriage of Ernst Ludwig and his second wife, Princess Eleonore
of Solms-Hohensolms-Lich, on February 2, 1903.

 PH-S

FACING PAGE

*Centerpiece with Figure of a Woman Holding
a Peacock,* 1908
Ernst Riegel (Münnerstadt 1871–Cologne 1939)
Silver, nephrite, red jade, semiprecious stones
H. 25¼ in. (64 cm); Dia. 15¾ in. (40.2 cm)
WO S 8513

Riegel trained and worked as a goldsmith in Munich before he was summoned to the Mathildenhöhe artists' colony in 1907. His creations were highly original in design, often incorporating semiprecious stones in a manner recalling treasures of the Early Christian era. He was an influential teacher, first in Darmstadt at the grand duke's atelier of applied arts, then from 1912 as a professor for the city's Applied Arts School *(Kunstgewerbe- und Handwerkerschule)* in Cologne. Much of his production was for liturgical use, and from 1920 on, he worked closely with the Institute for Religious Art, also in Cologne.

PH-S

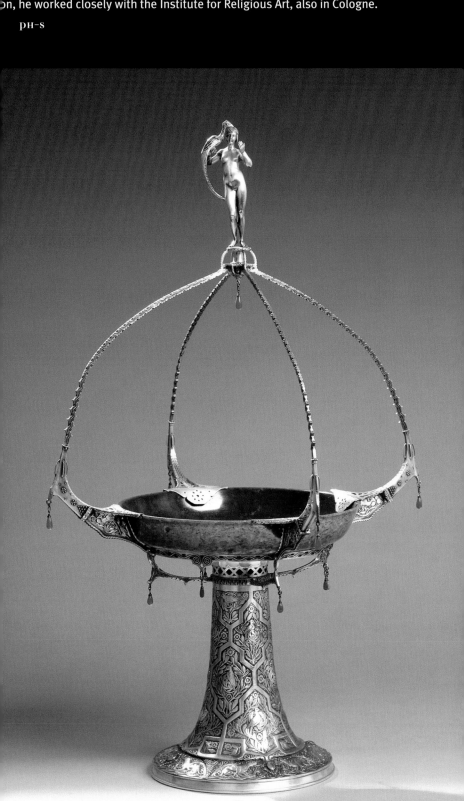

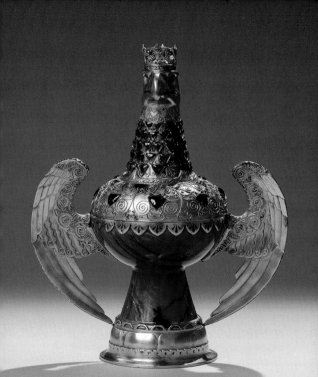

Covered Cup in the Form of a Crowned Eagle, ca. 1908
Ernst Riegel (Münnerstadt 1871–Cologne 1939)
Red agate, gilded silver, gold, amethyst, pearls
H. 9⅞ in. (25.2 cm); W. 8⅜ in. (21 cm)
WO S 8074

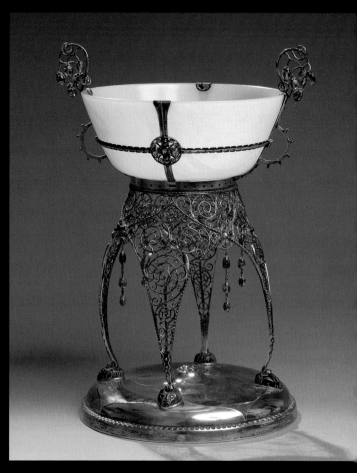

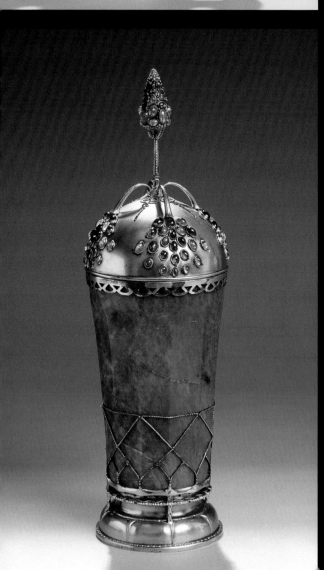

Centerpiece, ca. 1908
Ernst Riegel (Münnerstadt 1871–Cologne 1939)
Silver, nephrite, amethyst, jade, agate, gold
H. 10¾ in. (26.2 cm); Dia. 6⅜ in. (16.2 cm)
WO S 8075

Covered Beaker, 1908
Ernst Riegel (Münnerstadt 1871–Cologne 1939)
Nephrite, gilded silver, gold, semiprecious stones
H. 12¼ in. (31 cm); Dia. 3¾ in. (9.5 cm)
WO S 8072

SEINEM GELIEBTEN
GROSZHERZOG
ERNST LVDWIG
ZVM 25 JAEHRIGEN
REGIERVNGSJVBILAVM
IN DANKBARKEIT VND TREVE
DAS HESSISCHE VOLK

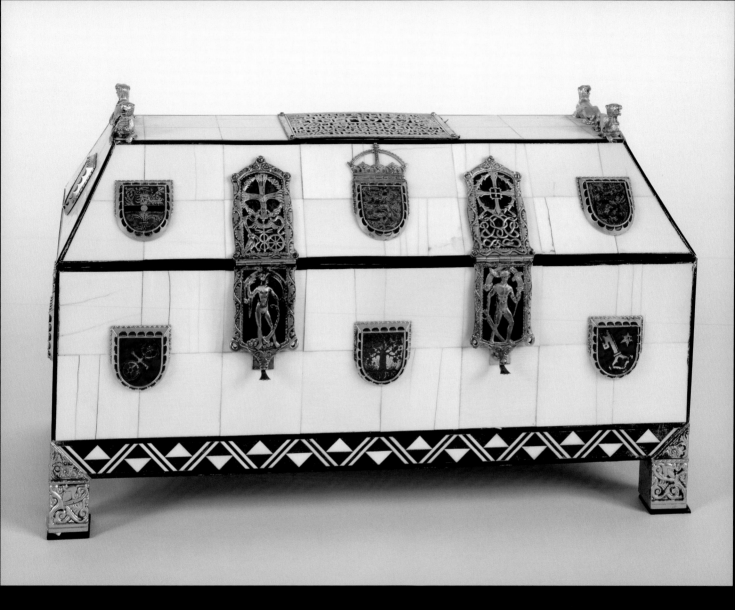

Casket, 1917

Ernst Riegel (Münnerstadt 1871 – Cologne 1939)

Ivory, wood, gilded silver, malachite, lapis lazuli, jasper

H. 9⅛ in. (23 cm); L. 15¼ in. (38.5 cm); W. 6¾ in. (17 cm)

Inscribed left side bottom: *Riegel 1917*

WO K21005

The casket was presented to Ernst Ludwig by the city of Darmstadt and held a document pledging a donation of over 2.5 million marks for the care of wounded war veterans. The clasps of the casket are worked with symbols of war on one and of peace on the other. Individual enamel plaques represent the Hessian coat of arms and the arms of each of the cities and regions of Hesse. A dedication on the top translates: "To our beloved Grand Duke Ernst Ludwig on the 25th jubilee year of his reign with the gratitude and loyalty of the Hessian people."

PH-S

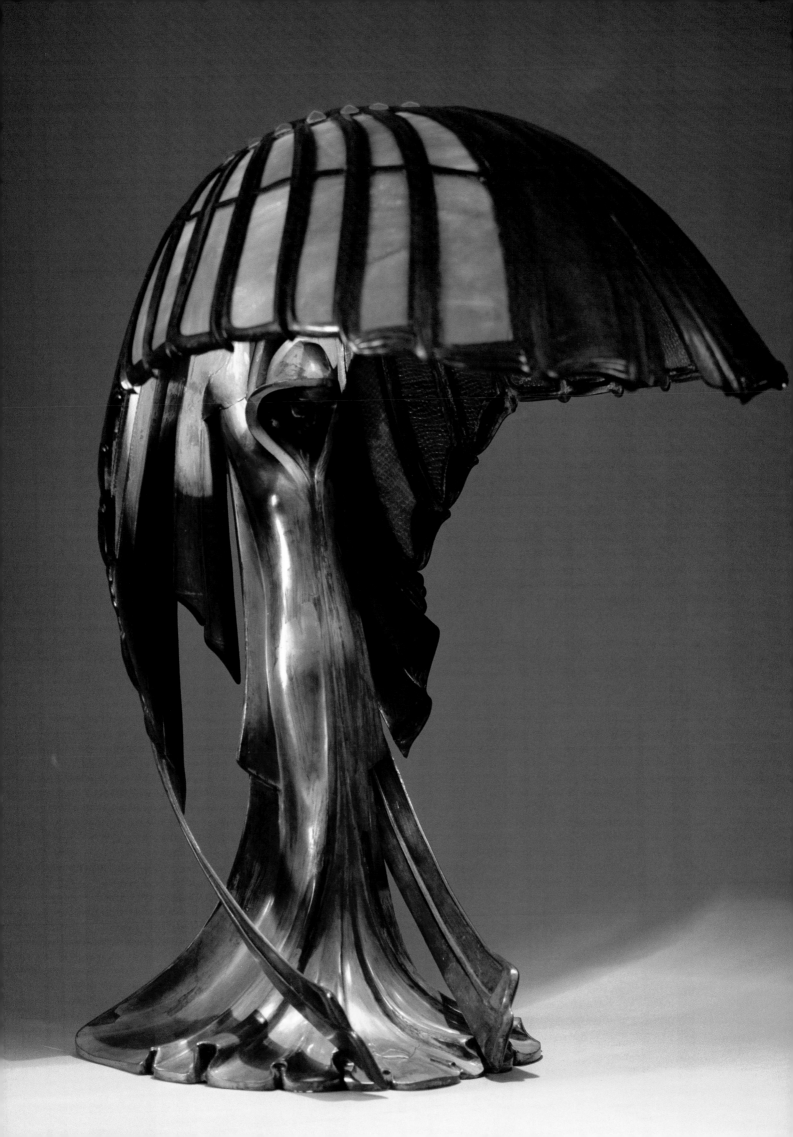

HANNS PELLAR (Vienna 1886–1971)
Lady in a Loge, 1912
Oil on canvas
H. 37⅜ in. (95 cm); W. 36 in. (91.5 cm)
SM B 21007

Hanns Pellar trained in Vienna before studying with Franz von Stuck in Munich. At the Mathildenhöhe colony from 1911 to 1917, he became known as "the Painter of Elegance" for his arch depictions of bewigged ladies in 18th-century costume.

PH–S

PETER BEHRENS (Hamburg 1868–Berlin 1940)
Behrens ranks prominently in the history of modern design as the first to create a corporate identity in advertising, product design, and architecture for an industrial company (the Berlin electrical combine A.E.G, 1906–1914). It was as a painter and graphic artist, however, that he was invited to become a founding member of the Mathildenhöhe artists' colony. He had already gained a reputation as an exponent of Jugendstil and was a founder of the Munich Secession in 1897. In Darmstadt he became more involved in architecture and interior design, creating the only house on Mathildenhöhe not designed by Olbrich. Leaving Darmstadt in 1903, Behrens pursued a career as an architect and teacher, as well as an industrial designer. Among his protégés were Walter Gropius, Ludwig Mies van der Rohe, and Le Corbusier.

PH–S

FACING PAGE

Table Lamp, ca. 1902
Designed by Peter Behrens (Hamburg 1868–Berlin 1940)
Bronze, glass
H. 26¼ in. (66.5 cm); D. 23⅝ in. (60 cm)
WO L 8041

Ernst Ludwig's Album of Mathildenhöhe Artists

Leather album with metal clasp, ca. 1915; drawings, watercolors, woodcuts, etchings, 1892–1926

L. 9¼ in. (23.5 cm); W. 2¾ in. (15.1 cm); D. 1 in. (2.5 cm)

In relief on clasp: nude figure of man reaching toward star in upper left corner; lower right: monogram signature: *LH* [Ludwig Habich].

WO

With a text banner that translates "Art lies not in the will-to, but in the know-how," architect Emanuel Josef Margold (Vienna 1889–Brünn 1962) connects a single futuristic flower and an Expressionist building design titled "The House of Flowers" with the notation "Glass tubes colored inside, illuminated evenings."

Margold's is just one of the contributions made in personal gestures of friendship by artists who had been part of the Mathildenhöhe colony, including Peter Behrens (Hamburg 1868–Berlin 1940), Rudolph Bossalt (Perleberg 1871–Berlin 1938), Paul Bürck (Elberfeld 1878–1947), Hans Christiansen (Flensburg 1866–Wiesbaden 1945), Johann Vincenz Cissarz (Danzig 1873–Frankfurt am Main 1942), Ludwig Habich (Darmsadt 1872–Jugenheim 1949), Paul Haustein (Chemnitz 1880–Stuttgart 1944), Heinrich Jobst (Schönland 1874–Darmstadt 1943), Christian Heinrich Kleukens (Achim 1890–Darmstadt 1954), Friedrich Wilhelm Kleukens (Achim 1887–Darmstadt 1956), Albin Müller (Dittersbach 1871–Darmstadt 1941), Claire Neumann Olbrich (widow of Joseph Maria Olbrich), Fritz Osswald (Zurich 1878–Starnberg 1966), Hanns Pellar (Vienna 1886–1971), Ernst Riegel (Münnerstadt 1871–Cologne 1939), and Theodor Wende (Berlin 1883–Pforzheim

ERN IM KÖNNEN ·

DAS HAUS DER BLUMEN

GLASRÖHREN
FARBIG-INNEN
ABEND
BELEUCHTET.

25. NOV.
1924

princess Elisabeth (March 11, 1895 – November 16, 1903)

Daughter of Ernst Ludwig and his first wife, Victoria Melita, Elisabeth was the sole product of an unhappy marriage that ended in a bitter divorce in 1903. The beautiful child with curly dark hair and large soulful eyes was the object of her father's devotion. Her mother, after leaving the court, fought for what amounted to joint custody, but Elisabeth favored her father. It was shortly after the divorce that Ernst Ludwig's sister Alix, Tsarina Alexandra Feodorovna, invited him and his daughter to vacation with the Russian royal family. Previous visits to the Russian court had built a close friendship between Elisabeth, her aunt Alix, and her Russian cousins Olga (only eight months her junior) and Tatiana (two years younger). When Elisabeth fell ill the day after Olga's birthday celebration, it was first ascribed to over-excitement. Two days later the eight-year-old Elisabeth was dead of typhoid. She soon became the sainted figure of legend to her father and the people of Hesse-Darmstadt. To prevent her jewelry from passing into other hands, Ernst Ludwig had it incorporated into a chalice, bible cover, and liturgical lamp. He preserved the playhouse he had created for her as a personal shrine to his beloved child.

PH-s

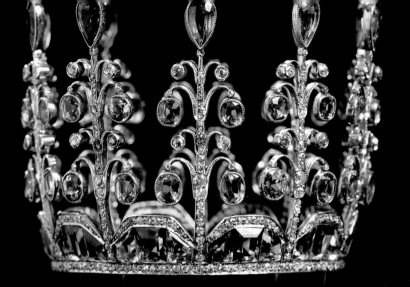

Small Crown for Princess Elisabeth, ca. 1900
Commissioned by Grand Duke Ernst Ludwig
Darmstadt
Gold, silver, peridots, diamonds
H: 2⅝ in. (6.8 cm); Dia: 3⅛ in. (8 cm)
WO

**Heart-Shaped Frame for a Miniature of
Princess Elisabeth,** 1908–1917
Carl Fabergé (St. Petersburg 1846–La Rosiaz 1920);
workmaster, Henrik Wigström (Tamminsaarie 1862–
Livennapa 1923)
Gold, enamel, ivory
H. 3¾ in. (9.4 cm)
Signed in Cyrillic and dated center right: *V. Zuev 1904;*
reverse: mark of Fabergé; workmaster, Henrik Wigström,
St. Petersburg 1908–1917
WO K 8400

Furniture for the Playhouse of Princess Elisabeth
Tall-Case Clock, High-Back Settee, and *Armchair,* 1902
Josef Maria Olbrich (Troppau 1867–Düsseldorf 1908)
Clock: yellow pine; weights and pendulum: copper; face: paint, gilt, paper, glass; hands: brass, glass
H. 78¾ in. (200 cm); W. 16½ in. (42 cm); D. 6¹¹⁄₁₆ in. (17 cm)
WO U 8514

Settee and Armchair: yellow pine, silk
H. 62⅝ in. (159 cm); W. 64³⁄₁₆ in. (163 cm); D. 20½ in. (52 cm); and H. 42½ in. (108 cm); W. 23⅝ in. (60 cm);
D. 23⅝ in. (60 cm)
WO M 8907-8

The inscription, which translates "Once upon a time / so began the fairy
tale / and the children's words became true / and this little house is now
mine / built just for me in the year 1902," appears large over the front
door of the playhouse Olbrich created for Ernst Ludwig to present as a
surprise to his seven-year-old daughter. Though it consisted of only
two rooms, a living room and a working kitchen, it shares the com-
plex vocabulary of form and ornament that Olbrich was using for
the homes in the artists' colony of Mathildenhöhe. Every detail
was inventively treated in this fantasy house where the little
princess allowed only her playmates to enter, and it is
the only one of Olbrich's architectural works to
survive intact and unaltered.

 DH-S

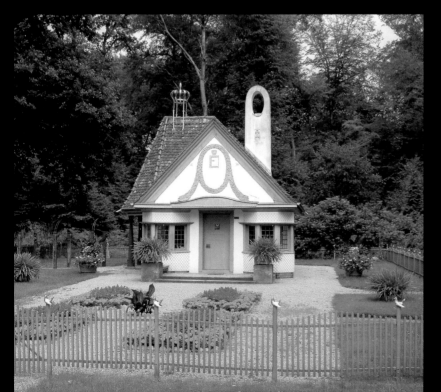

ABOVE

Book illustration from *Es war einmal* ("Once Upon a Time"), 1904
Text by G.I.N.A. [Georgina Freiin von Rotsman]; illustrations by
Josef Maria Olbrich (Troppau 1867–Düsseldorf 1908); published

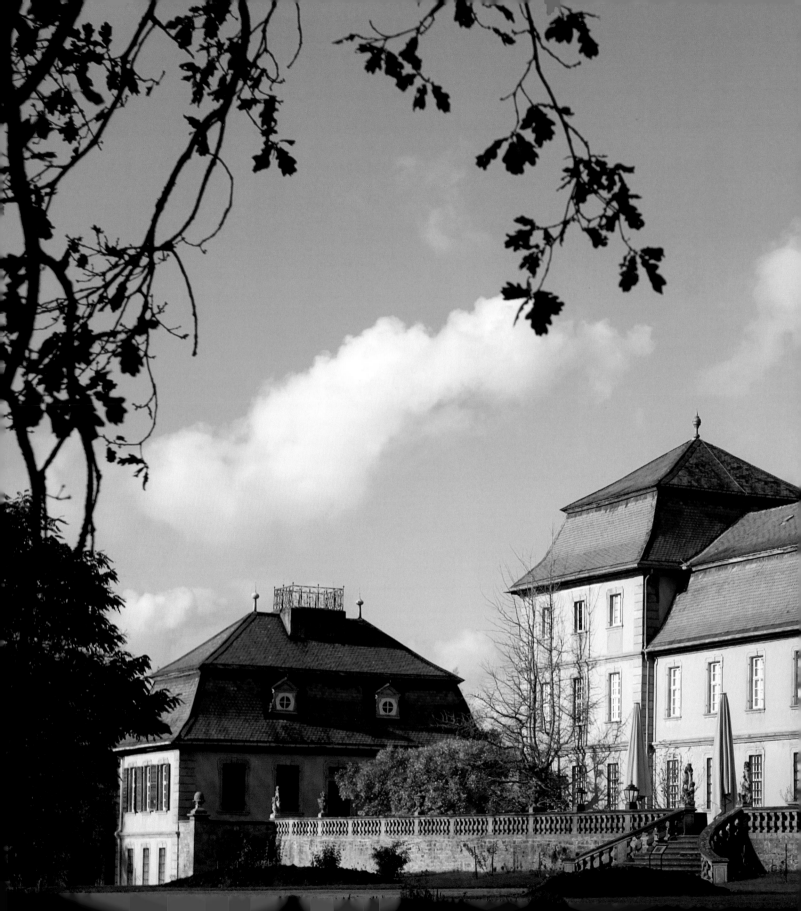

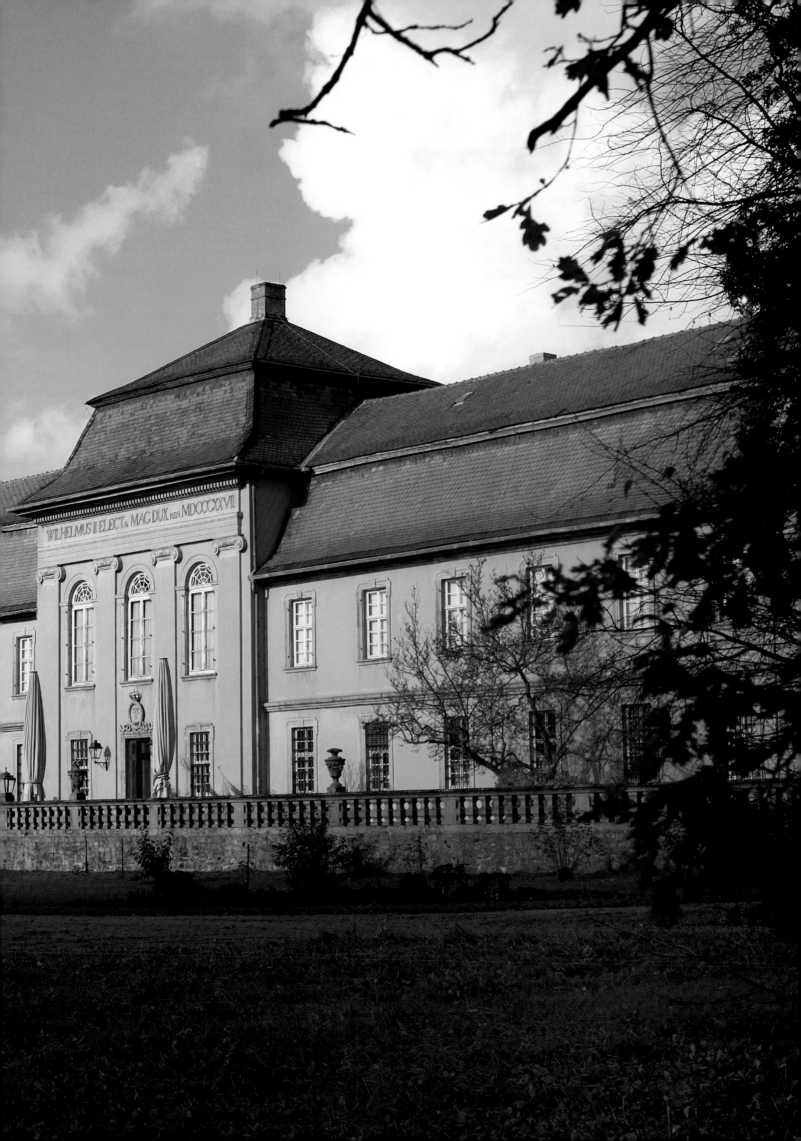

postwar cultural recovery

The antiquities of the Hessian House Foundation rank today as the most important private collection of its kind in Germany, with pieces frequently reproduced in specialist literature and loaned to significant exhibitions.

The collecting and study of classical antiquities has a long and distinguished history in the Hesse family. Landgraf Friedrich II (1720–1785) founded the Museum Fridericianum in Kassel, the first large antiquities collection in Germany accessible to the public. These works formed the basis for the collection now housed in Schloss Wilhelmshöhe, part of the State Museums of Kassel. In the 19th century, Empress Friedrich (1840–1901) also was a devoted collector of antiquities, and these passed into the Hessian House Foundation along with her wide assortment of decorative arts. The empress strived for the broadest possible range in her classical collection and developed personal contacts with the archaeologists and scholars of her day. Less than two years before her death, a guide to the antiquities in the museums of Rome was dedicated to her and is still regarded as a standard work.

Empress Friedrich's grandson Philipp of Hesse (1896–1980) followed in the family tradition and became one of the important collectors in its history. His love of collecting was already evident in his youth when he frequented the art dealers of Frankfurt. After completing his architectural and art history studies in Berlin, he moved to Rome where he worked as an interior architect. In the 1920s in Rome, intense building activity and the regulation of the Tiber River brought many antiquities to light, fueling Philipp's enthusiasm and giving him the opportunity to develop a discriminating eye. In Rome, Philipp also met Mafalda, the daughter of Italian King Vittorio Emmanuele III, and the two were married in 1925.

Despite his status and connections, Philipp pursued his collecting interests as a private person making purchases from dealers and exchanges with other collectors. His selections were informed by his knowledge and his ability to evaluate works critically, qualities for which the collection is known today.

Early on, Philipp presented the family's classical antiquities to the public in galleries of the Landgrafenmuseum in Kassel, which he installed in 1935. This was destroyed in World War II. In 1949 he undertook the renovation of Schloss Fasanerie as a public museum, bringing together art of all the eras covered by the family holdings. This former summer residence was to become the home for the antiquities that Philipp had previously exhibited in his Kassel museum. He himself designed the installation of the collection in various rooms of the Schloss and created an architectural addition, the airy *Gartensaal* (facing page). Here sculptures and vitrine objects are illuminated by light from windows that open onto the garden on three sides. Philipp continued to add to the collection throughout his life and brought it to the level of importance it has today.

AD

PHILIP ALEXIUS DE LÁSZLÓ DE LOMBOS (Budapest 1869–London 1937)
Landgraf Philipp of Hesse in Costume, 1928
Oil on canvas
H. 45¾ in. (116 cm); W. 35½ in. (90 cm)
Signed and dated upper length: *1928*
FAS B 3141

Landgraf Philipp's love of the culture of historical eras is revealed in his choice of costume when sitting for László, the leading society portraitist of the day.

 PH-S

Head of Diadumenos, CA. A.D. 160
Roman, after a Greek original
Marble
H. 13¼ in. (33.5 cm)
FAS AMa 8

This marble head of an athlete who wears a victor's band around his forehead is a Roman replica of a slightly larger-than-life-size Greek bronze statue. The original, made around 420 B.C. by the Greek sculptor Polykleitos, belongs to his late work and ranks among the most celebrated representations of its time. Praised in contemporary literature, Polykleitos's work was already copied by the 2nd century B.C. Among a handful of well-known surviving Roman heads, this one is exceptional in having retained its neck down to the beginning of the right shoulder, making clear the inclination and turn of the head. The soft modeling and the deeply carved temple curls identify the sculptor as an exceedingly well versed copyist of Greek models.

 AD

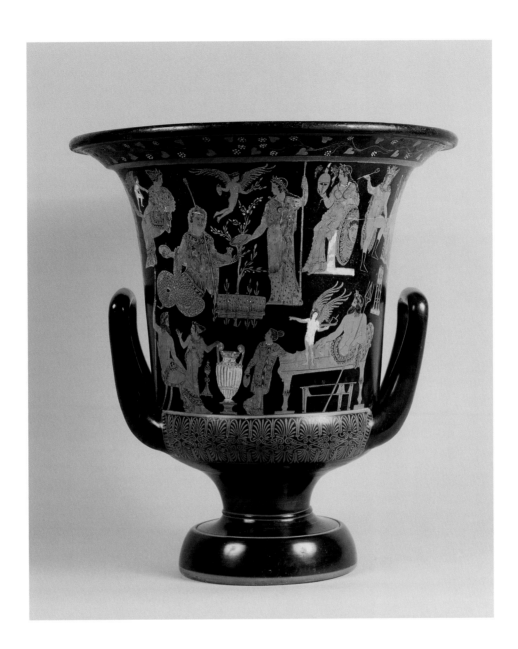

Attic Red-Figure Calyx-Krater, ca. 410 B.C.
Attributed to Kecrops Painter
Terracotta
H. 22⅝ in. (57.5 cm); Dia. 20⅞ in. (53 cm)
FAS AV 77

Named "Kecrops Krater" after the motif it represents, this vessel for mixing wine and water is one of the most important works of vase painting in the late 5th century B.C. It is the centerpiece of Landgraf Philipp's Greek vase collection, which ranges from the Geometric and Attic black- and red-figure periods to Apulian works of the 3rd century B.C.

The exceptionally rich figural decoration extends over the vase's entire body in several registers. The front presents a scene from the Legend of Erichthonios, an important narrative in Greek mythology. It focuses on a basket, seen here to the left of Athena, which contains the boy Erichthonios. Athena placed him in the care of Kecrop's daughters, and he is the figure on whom Athenians base their origin. Kecrops, the mythological king of Attica, appears to the left of the basket, with the lower body of a snake, and holds a sacrificial lamb in his left hand.

The painting on the reverse (detail facing page) provides a clue as to the vase's purpose. Nike awards the victor's crown to Hercules, who lunges toward the Minoan bull. The subject, the awarding of a prize, relates to the function of the crater itself. It would have been the prize awarded at a *dithyramb,* a poetry and/or singing competition, whose theme would have been the Legend of Erichthonios.

AD

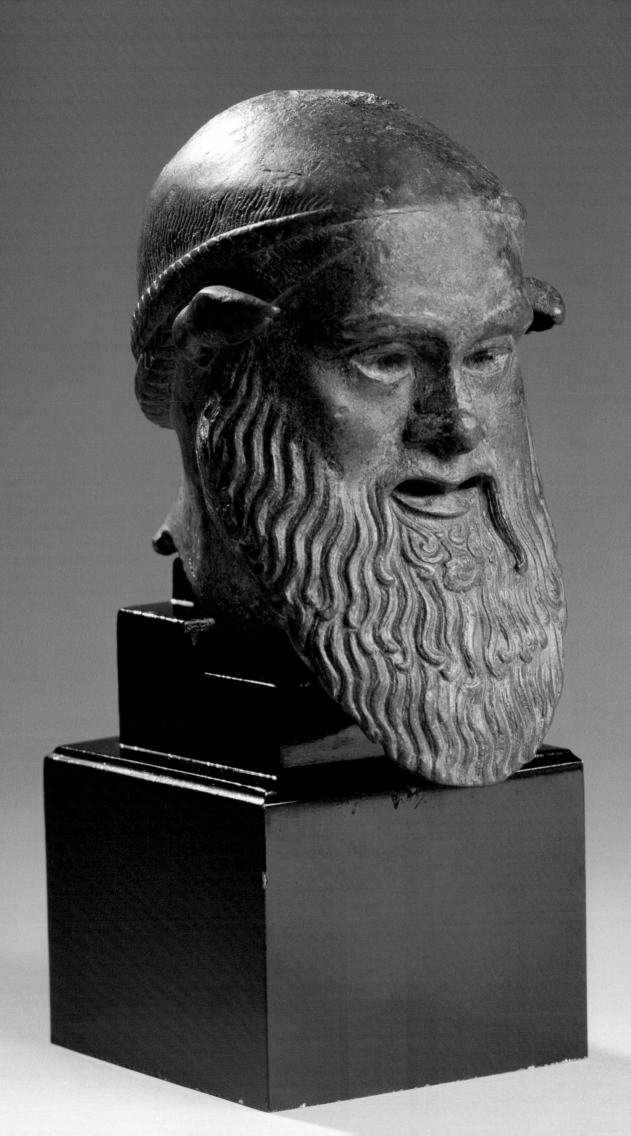

Corinthian Helmet, 5th century B.C.
Greek
Bronze
H. 11 in. (28 cm); W. 7¾ in. (19.5 cm); D. 9⅛ in. (23 cm)
Inscribed left cheek piece: *ΤΑΡΓΕΙΘΙ ΑΝ..... ΘΟΘΕΝ*
FAS ABr 1

Corinthian Helmet, 5th century B.C.
Greek
Bronze
H. 10¼ in. (26 cm); W. 7⅛ in. (18 cm); D. 9⅛ in. (23 cm)
FAS ABr 2

These two Corinthian helmets cover the head completely and have openings only for the eyes and mouth, lending the wearer a masked appearance. Both pieces belong to the thin-walled type with relatively elastic cheek pieces that allowed their bearer to slide the helmet back toward the neck. This manner of wearing the helmet is seen in vase painting and carved reliefs.

The example with the pronounced brow was found during late 19th-century excavations in Olympia. Its cheek piece's seam of fine boreholes served to secure a lining of leather or linen. The inscription on the left cheek piece indicates it was meant as a votive offering given by a citizen of the state of Argos at a sanctuary of Olympia.

FACING PAGE

Head of Silenus, 1st century A.D.
Roman
Bronze
H. 6¾ in. (17 cm)
FAS ABr 56

One of the most unusual works in the Hesse antiquities collection, the bronze head of Silenus presents him as a wise and distinguished counsel of the god Dionysus, a departure from his usual depiction as a drunken, unruly reveler. A trim beard and neatly braided hair are in marked contrast to the donkey ears that are his identifying feature. The head was presumably part of a herm of the sort that decorated the gardens of Roman villas. This example was probably discovered in the late 19th century during excavations of the Roman fort Saalburg in the Taunus mountains near Frankfurt.

AD

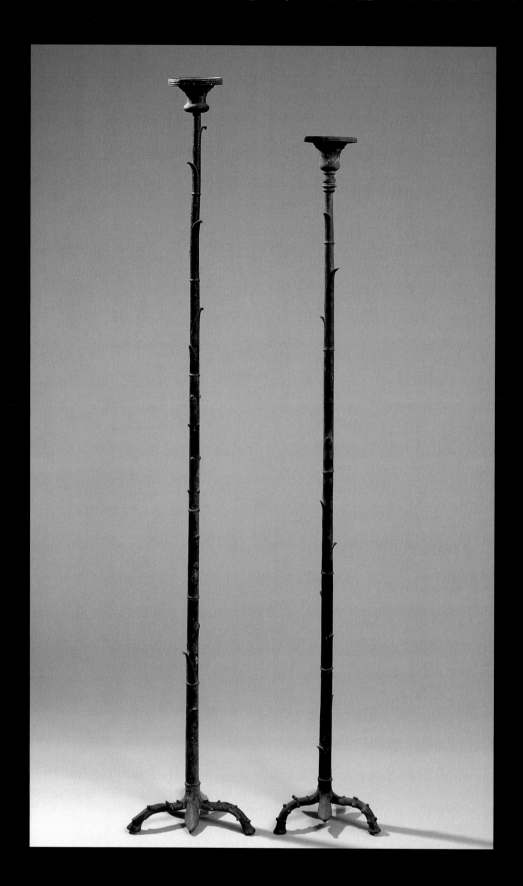

Two Roman Candelabra, 1st century A.D.

Pompeii

Bronze

H. 49 in. (124.5 cm); W. 8¼ in. (21 cm); D. 7¼ in. (18.5 cm); and H. 53½ in. (136 cm); W. 9¾ in. (24.6 cm); D. 8⅜ in. (21.2 cm)

FAS ABr 40 & ABr 64

Tripod candelabra of this type were found in Pompeii where they were used for domestic lighting and for burial rituals. Small terracotta oil lamps that provided dim light would have been set on top. Landgraf Philip added a second example to the candelabrum acquired by Kaiser Friedrich.

 AD

Enthroned Isis Pendant, late 2nd century B.C.
Hellenistic
Gold
H. 2⅜ in. (6 cm)
FAS Ag0 2

Her horned headdress with solar disc and characteristic garment-knot between her breasts
identify the beaten gold figure as the Egyptian goddess Isis. With her is her infant son, Horus
who is the earthly personification of the ruler-god Osiris. Worn as an amulet, the goddess
was to bring its wearer health and long life. The work's stylistic features, such as the almost
baroque modeling of the fine facial features and the full folds of the garments, place it among
the late Hellenistic work of 2nd century B.C. The Egyptian motive is the source from which the
Madonna of Christian iconography derives.

AD

Cross with Two Fish, 5th–6th century A.D.
Byzantine
Rock crystal, gold (modern)
H. 2 in. (5 cm); W. 2 in. (5 cm)
FAS AVaria 4

This early Christian pendant from the Egyptian-Coptic culture comprises three symbols of carved
rock crystal that later were mounted onto gold wire. Since the Council of Ephesus in 431, the
cross was regarded as an official sign of Christianity. The fish, which referred to the redeemer
with the initials of his Greek name, was among early Christians' secret markers of identification.
Combined, they intensify the symbolic power of this early Christian amulet.

AD

Bowl and Stand, 4th–5th century A.D.
Byzantine
Bronze
Bowl: H. 1¾ in. (4.5 cm); Dia. 7½ in. (19 cm); stand: H. 5½ in. (14 cm)
FAS A Varia 7 & 6

Both the bowl and its stand were gifts from
Queen Friederike of Greece (1917–1981) to Land-
graf Philipp of Hesse. They presumably served
for sacrificial rituals. The four-footed stand with
panther heads is made of two parts that allow it
to be dismantled for compact transport.

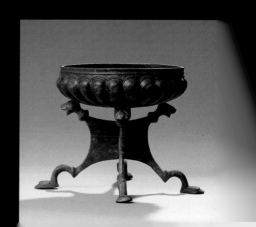

AD

Geometric Amphora, 9th century B.C.
Cypriot
Terracotta
H. 19¼ in. (49 cm); Dia. 10¼ in. (26 cm)
FAS AV 81

Dating from the Early Iron Age, this storage vessel is one of the earliest antiquities in Empress Friedrich's collection. The bands that encircle the body of the shoulder-handled amphora are typical of the decoration of this type of two-toned Cypriot pottery.

AD

Pair of Trefoil-Lipped Oinochoe, ca. 3rd century B.C.
Canosan
Terracotta
H. 11⅜ in. (29 cm)
FAS AV 238, 239

These two oinochoe, or cloverleaf pitchers—so called because of the form of their lip edge—were collected by Empress Friedrich. Traces of their original white coating are still discernable on the fired clay. Their material and slim form are typical of pottery once produced in Canosa in northern Apulia. They belong to the type of vessel used in burial practices, particularly those

Rhyton in Form of a Mule's Head, 4th century B.C.

Apulian

Terracotta

H. 9⅜ in. (24 cm); Dia. 4⅜ in. (11 cm)

FAS AV 245

This mule rhyton comes from Empress Friedrich's collection. The form originated as a receptacle for donations and was later increasingly used as a ceremonial drinking cup. The symbolic animal strength delivered by the creature represented increased the use and popularity of the form.

AR

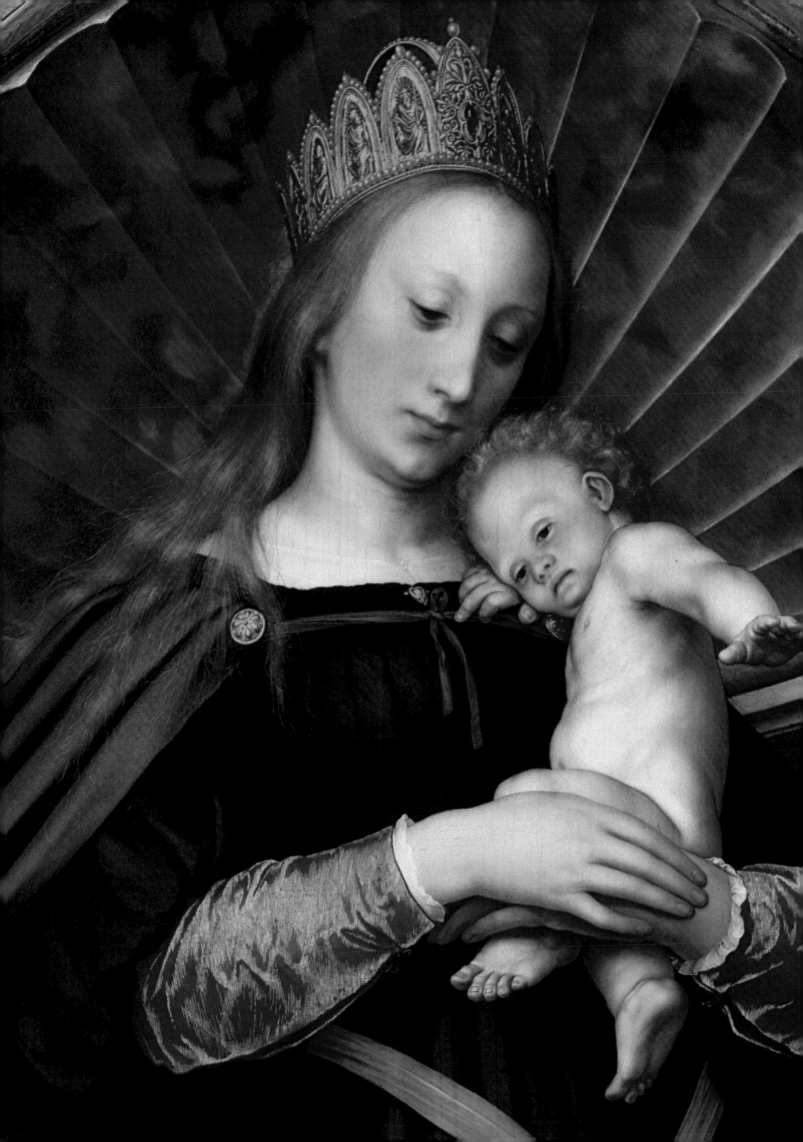

Holbein's madonna and cranach's princes

Among the works of early German painting belonging to the Hessian House Foundation, *The Madonna with Basel Mayor Jakob Meyer and his Family* by Hans Holbein the Younger (1497/98–1543) and the portraits of Saxon Princes Moritz and Severin by Lucas Cranach the Elder (1472–1553) stand out in particular. All three paintings were produced at nearly the same time—Holbein painted the picture of the Virgin Mary around 1525–1526 and varied it somewhat around 1528–1529, while Cranach dated both the prince portraits in 1526. Even so, they reveal very different aspects of German portrait painting of the 16th century.

Holbein's painting remained with the heirs of the patron who commissioned it until around 1606, when it was sold by the family in Basel. In the 1630s it was with Michel LeBlon, a dealer in Amsterdam, who commissioned a copy that Marie de' Medici probably purchased as an authentic Holbein. It subsequently entered the Dresden Gemäldegalerie where it has remained since 1744. The original disappeared until 1822, when Prince Wilhelm of Prussia purchased it on the Paris art market as a gift for his wife Marianne of Hesse-Homburg. It hung in their apartments in the Berlin Palace and can be seen in the view of the Green Room in 1852 (see p. 220). They gave it to their daughter Elisabeth, who had married Prince Karl of Hesse-Darmstadt in 1836, and it has since been part of the inherited property of the Princes of Hesse-Darmstadt, now the Hessian House Foundation.

The painting of the Madonna commissioned from Hans Holbein by the former Basel mayor Jakob Meyer zum Hasen stands as one of the most important works of German Renaissance painting. In breathtaking fashion, the artist managed to merge the German Gothic tradition with the innovations of the Italian Renaissance to create something completely new. The world of the patron family is rendered in the Old Netherlandish portrait painting style. Highly detailed realism characterizes the portrayal of the Meyer family and also the incidental details, like the sumptuous garments and the precisely rendered carpet. In contrast, the Virgin, Christ Child, infant John the Baptist, and young man with him are depicted in the idealizing manner of the Italians. For these heavenly figures Holbein uses the technique known as *sfumato,* delicate passages of light and shadow found in works by the great Leonardo da Vinci.

Let us consider the picture a little more closely. The Mother of God with the Christ Child appear before an architectural niche spanned by a huge shell. Following the tradition of the "Madonna of Mercy" *(Schutzmantelmadonna),* Mary's cloak is opened to envelop the family of the patron kneeling at her feet, bringing them symbolically under her protection. In Jakob Meyer's home city of Basel, supporters of the Reformation were becoming increasingly powerful, and by commissioning this painting dominated by the Virgin Mary, Meyer was making a statement of his adherence to the Catholic faith.

Meyer called upon Hans Holbein, the most important painter of Basel, as well as the southern German-speaking lands, to represent the Virgin Mary not only in the role of the Madonna of Mercy but also as the Queen of Heaven. According to the Catholic faith, after her death, Mary was bodily received into heaven where she was crowned Queen by her son. This coronation symbolizes Mary's special, even unique, role as intercessor for the individual believer as well as for all mankind under Christ. Holbein's painting refers to her role as Queen of Heaven with the crown she wears and conforms to contemporary woodcut illustrations of the imperial crown of the Holy Roman Empire. Already five hundred years old by Holbein's time, the crown was kept with the surviving imperial crown jewels in Nuremberg and used only for imperial coronations. It survives to this day and is exhibited in the Schatzkammer of the Kunsthistorisches Museum in Vienna.

Holbein also makes reference to Mary's ascension into heaven with the striking pink belt that contrasts with the blue of her dress and is so loosely tied that it does not seem to

support anything. This belt would remind the pious contemporary viewer of the account in the *Golden Legend (Legenda Aurea),* a collection of stories written by Jacobus de Voragine around 1263–1275, which was extremely popular throughout Europe during the Middle Ages. According to one legend, the twelve apostles gathered at Mary's deathbed in Ephesus in Asia Minor, but one came late. This was Thomas, who had doubted the Resurrection of Christ, too, until he placed his fingers into Christ's side wound. When Thomas arrived, Mary was already on her way to heaven but paused to give him a clear proof of her bodily ascension by lowering her belt to him. The belt is still a revered relic in the Prato Cathedral in Tuscany.

Mary is not, however, the only saintly figure that Jakob Meyer wished to have represented in his painting: as in countless other medieval and Renaissance paintings, John the Baptist, the last prophet of the Old Testament and precursor to Christ, accompanies Mary and the Christ Child. Like his cousin of the same age, John appears in the picture as a naked infant who somewhat uncertainly attempts his first steps on the soft carpet.

Meyer's commission to Holbein for an iconographically enriched Madonna of Mercy included the representation of the patron's family. Jakob Meyer zum Hasen himself kneels on the viewer's left. Opposite him is his late first wife Magdalena Baer, who died in 1511; before her is his spouse, Dorothea Kannengiesser, with their daughter Anna. All the figures appear in the sumptuous dress that as members of the upper middle class in Basel they wore for churchgoing. In addition, according to the dress code of the period, the bonnet and scarf of Meyer's late first wife (whose scarf is placed even over her chin) and those of his second wife characterize them as married women. Still today in the German-speaking countries of Europe, "to come under the bonnet" *(unter die Haube kommen)* remains a common expression for "to marry." Meyer's daughter Anna, on the other hand, wears with her white feast-day clothing a cap decorated with red and white carnations. This "maiden's cap" indicates she has come into marriageable age and is engaged. Moreover, all three women hold prayer beads in their hands as signs of their piety.

Jakob Meyer zum Hasen was born in 1482 into the family of a Basel goldsmith and businessman. He rapidly made a career and fortune as a banker, businessman, real estate speculator, and military leader. A council member of Basel since 1510, he reached the peak of his political career in 1516 when he was elected mayor. In 1518 and 1520, Meyer again was reelected to this most important political office of Basel. In June 1521, the Basel City Council, still under its mayor Jakob Meyer zum Hasen, awarded Hans Holbein the most prestigious commission that the city had to offer: Holbein was to paint the Hall of the Grand Council. By October 1521, however, Meyer was accused of being bribed by the French king, removed as mayor, and even temporarily arrested. Only partially rehabilitated, he was never able to regain his former political influence. Nonetheless, in the intra-urban conflicts of the advancing Reformation, Meyer was a leader of the Catholic party and remained true to his Catholic faith even after Basel became a Protestant city. Meyer's decision around 1525–1526 to commission the large painting of the Madonna of Mercy may also have been a reaction to his beleaguered personal situation in Basel, in that he wished to programmatically place himself under the protection of the Mother of God and Heavenly Queen.

Directly before Meyer kneels a boy in the rich attire of a young nobleman, clothing that a family member of the upper-middle-class Basel mayor never would have dared to wear. The boy's facial features are idealized in the same Italianate manner as the holy figures of the Madonna, Christ Child, and infant John, distinguishing him from the members of the Meyer family. Nevertheless, in the past, the youth has most often been interpreted as the son of Jakob Meyer, even though no trace has been found in the Basel archives to indicate Meyer had any children besides the daughter represented in the Madonna painting. Why, then, is the figure of the young man placed in the picture and exactly who might he represent? One

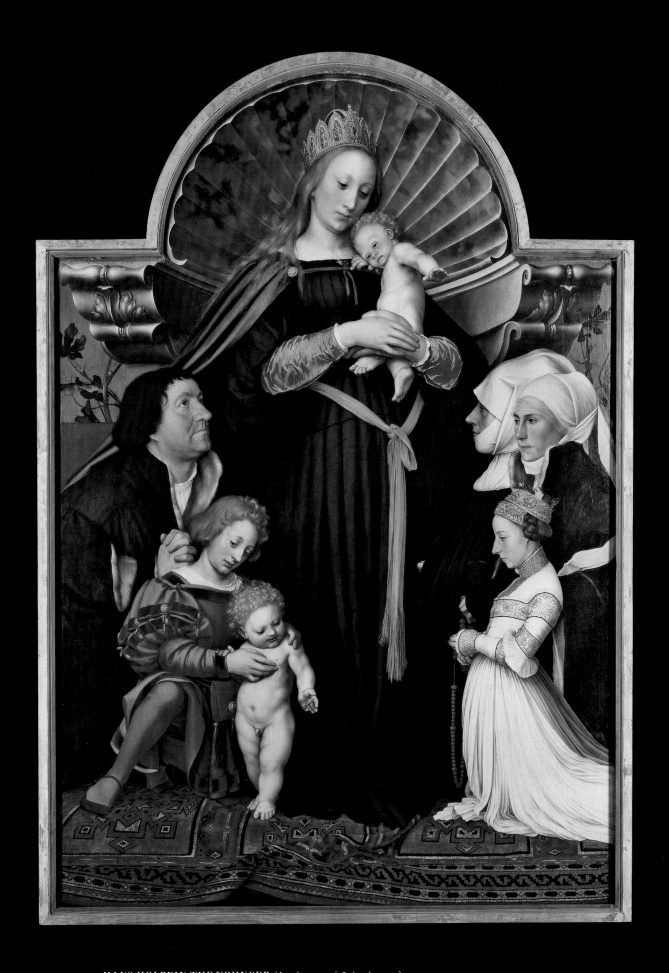

HANS HOLBEIN THE YOUNGER (Augsburg 1497/98–London 1543)
The Madonna with Basel Mayor Jakob Meyer and his Family, 1525–1526 and 1528
Oil on panel
H. 66¾ in. (169.5 cm); W. 49¾ in. (126.5 cm); D. 5¾ in. (14.5 cm)
SM B 21206

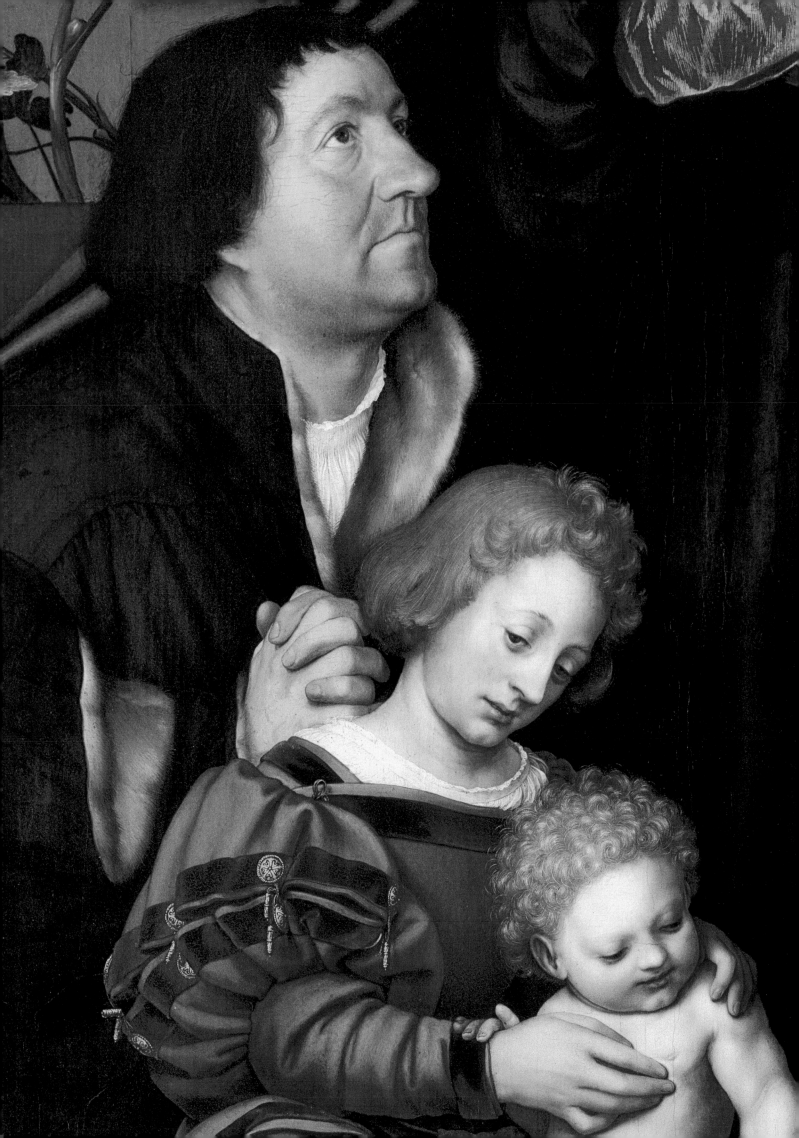

possible explanation for this much-discussed question is provided by the compositional conventions of Renaissance religious painting.

Meyer clearly wanted a painting depicting the Madonna of Mercy combined with a representation of the young Baptist and his own family. Holbein, however, as the artist implementing these wishes, was less than free in his distribution of these figures. He had to follow the hierarchy observed in religious ceremonies, court etiquette, and heraldry, and thus place figures on the right and left, not as seen by the viewer but, rather, as seen by the highest-ranking figure represented. As such, Holbein could only place the masculine figures to the right on the superior side of the Madonna (the left side for viewers of the picture), and all the feminine figures to the Madonna's left, and thus on the subordinate side. This meant that the three adult women would face a single adult and a child, the infant John the Baptist, on the opposite side. Surely the need to eliminate this compositional imbalance led Holbein to include the figure of the richly dressed young man, whose significance is multi-layered.

As already noted, the youth's features correspond to those of the religious figures in the painting. On closer study it becomes clear that he is a quotation from Leonardo da Vinci's *Madonna of the Rocks*. Holbein would have seen this famous painting in the French royal court during his trip to France around 1523–1524. Holbein's youth derives from Leonardo's classically dressed angel who supports the Christ Child. He is blessing his cousin John, who in turn is protected by Mary in a pose similar to that of Holbein's Madonna of Mercy. We can presume that Holbein's knowledge and esteem of Leonardo's works were shared by his educated Basel patron. Meyer zum Hasen repeatedly traveled to northern Italy and, in 1512, represented the city of Basel in Venice and at Massimiliano Sforza's inauguration as Duke of Milan.

The boy dressed in red has yet another level of meaning. He wears an eye-catching green belt purse that—together with the monumental shell over the Madonna—may refer to the apostle St. James the Elder who, as pilgrim saint, usually is represented with a belt purse and shell, symbolic of his pilgrimage into Santiago de Compostella in northern Spain. Notably, "James" is the Latinized form of the German name Jakob borne by the patron who commissioned the painting. Departing from established pictorial tradition, however, Holbein depicted the patron saint as smaller and more youthful than his namesake. This could be explained if the reference were not only to James the Elder but also James the Younger, both of whom were among the twelve apostles. According to pious tradition, the latter was a half-brother of Christ and thus a cousin of John the Baptist. This would explain the familiar association of Holbein's youth with the infant Baptist and, at the same time, underscore the allusion to Jakob Meyer's first name. This religious interpretation, while perhaps surprising to the modern viewer, is entirely in keeping with the spirit of late medieval representational piety. Moreover, playing with different layers of meaning within a painting is highly characteristic of Holbein's work.

Holbein was named after his father (1460/68–1524), who was a painter in Augsburg, and thus is known as Hans Holbein the Younger. In 1515, after his initial training in the paternal workshop, Holbein moved with his elder brother Ambrosius to Basel. Such travel was considered part of an artist's training at the time. In Basel, an important university city, a number of book printers offered small fees to young artists for book illustrations and Hans Holbein's career quickly advanced. In 1516 he painted a portrait of Jakob Meyer zum Hasen and his wife Dorothea Kannengiesser for the first time. This won him further patronage from other leading families of the city. Even so, the art market in Basel was limited and the situation became even more problematic with the advancing Reformation. The Protestants rejected the devotional paintings of the old faith, and there were no more commissions for altarpieces. In the early 1520s, Holbein began to search for lucrative employment, aspiring to a post as a court painter for one of the important European courts. In 1523–1524 he tried

Infrared reflectography showing
Holbein's revisions.

his luck with the French King François I and, in 1526–1528, with Henry VIII of England; both attempts were unsuccessful and he returned to Basel. There in 1529, however, the Reformation prevailed and in the ensuing iconoclastic riots all the religious works of art in the city's churches and chapels were destroyed, including some of Holbein's own paintings. Not surprisingly, in 1532 the artist again tried his luck in London, where he finally obtained his longed-for position as court painter to Henry VIII. Before his premature death in 1543, probably as victim of the plague, he spent a decade as a portrait painter in the English court, whose members were immortalized in his depictions.

Holbein completed *The Madonna of Mayor Jakob Meyer zum Hasen* in the period prior to his first journey to England, which must have taken place in the second half of 1526. After his return in the summer of 1528, Meyer asked the artist to take the painting back to his workshop for revisions. These circumstances presumably saved the painting from the riots of 1529. The present appearance of the heads of Dorothea Kannengiesser and her daughter Anna Meyer dates from the reworking. Over time the original version has become discernable through the ageing of the overlying layer of paint. The initial appearance of mother and daughter is also documented by two portrait drawings that Holbein produced in preparation for the painting. These, along with a portrait drawing of Jakob Meyer, are preserved in the Basel Kunstmuseum. They show Anna with her hair down, falling over her shoulders and without the maiden's cap, and Dorothea Kannengiesser with a larger, more projecting bonnet and an imposing neckband pulled over her chin. In the case of Dorothea, the over painting with an up-to-date, less face-concealing bonnet appears to have been done for reasons of fashion. In the case of her daughter Anna, though, the modifications express her changed social position: from a young, virginal girl who, like the Virgin Mary, could wear her hair down, she had become a betrothed young woman who would no longer do so in public.

A recent technological examination of the painting has brought a much more complicated history to light. Infrared studies (above) show numerous modifications to the heads of the family members (Meyer zum Hasen, Dorothea Kannengiesser, and Anna Meyer) who still were living at the time of the painting's production. These alterations of the positions of the heads, particularly striking in the case of Dorothea Kannengiesser, document that Meyer obviously was not satisfied with the first depictions and requested that Holbein make changes. To provide Meyer with a clear idea of the appearance of the anticipated revisions, Holbein produced the three drawings preserved in Basel that correspond to the corrections he subsequently rendered in the painting.

The naturalistic achievement of Holbein in this depiction of children, like the sleepy infant Christ Child and the toddler St. John, contrasts with the formality of the two portraits of the young princes of Saxony by Lucas Cranach. The latter was determined by the demands of court etiquette related to the sitters' noble birth. Prince Moritz, who later became Elector of Saxony, was only five years old in 1526, the year the two portraits were painted. His brother Severin, who died in 1533, was a year younger. Nonetheless, their portraits convey the stature of their rank. Their pose, dress, and accessories are those of young adults, or more precisely, young noblemen. Cranach's talent as a portrait artist, however, overrides the encumbrance of the convention to animate the faces of what we recognize as exceptionally lively children. First recorded in the Hesse-Darmstadt collection in the late 19th century, this pair of paintings by Cranach joins Holbein's depiction of the family of Jakob Meyer zum Hasen to demonstrate the range and importance of German portraiture in the Renaissance.

Jochen Sander

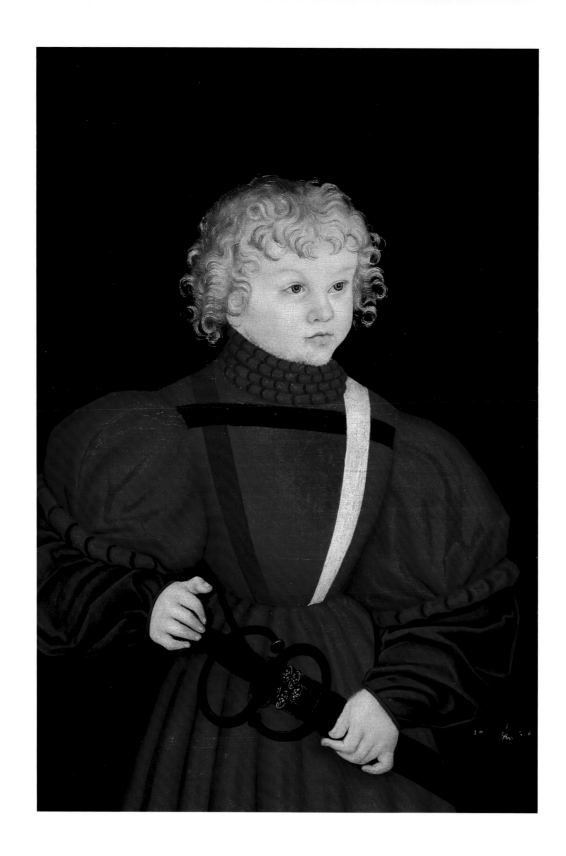

LUCAS CRANACH THE ELDER (Kronach 1472–Weimar 1553)
Prince Severin of Saxony (1522–1533), 1526
Oil on panel
H. 22½ in. (57 cm); W. 15¼ in. (38.5 cm)
Signed with serpent device and dated lower right: *1526*
WO B 8265

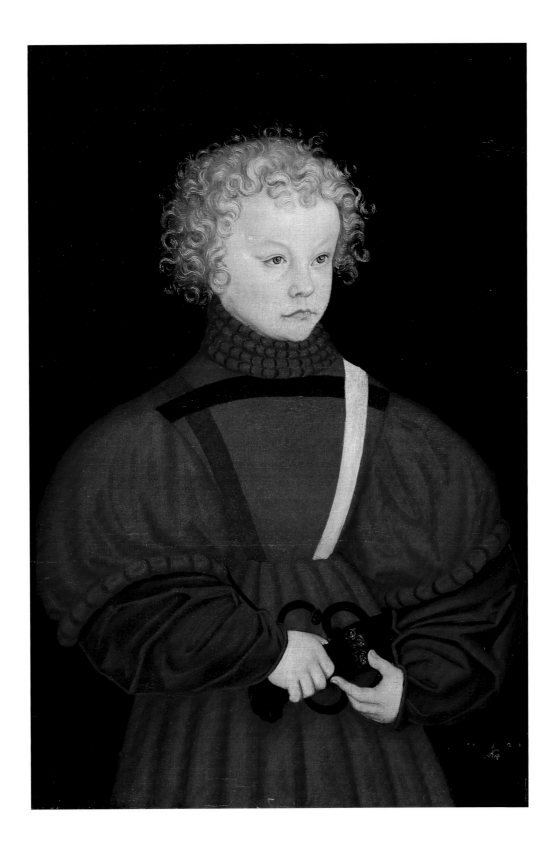

Prince Moritz of Saxony (1521–1553), 1526
Oil on panel
H. 22½ in. (57 cm); W. 15¼ in. (38.5 cm)
Signed with serpent device and dated lower right: *1526*
WO B 8266

Moritz was to grow up to be a cunning politician. He gained the electoral throne of Saxony in 1547 by switching his alliance from the league of Protestant states, led by his cousin, the then elector, and his father-in-law, Philipp the Magnanimous of Hesse, to the Catholic Emperor Charles V (see p. 245). He is remembered today for developing the city of Dresden into one of the great capitals of Europe.

 PH-S

EDUARD GAERTNER (Berlin 1801–1877)
Green Room, Berlin Castle, 1852
Watercolor and pencil on paper
H. 11½ in. (29.1 cm); W. 13⅝ in. (34.5 cm)
Signed and dated bottom right: *E. Gaertner fc. 1852*
FAS StAD, D23, Kasten I/15

The Holbein Madonna hung in the salon of
Princess Marianne.

PH-S

UNKNOWN
Red Room, Berlin Castle, ca. 1830
Watercolor and pencil on paper
H. 6½ in. (16.3 cm); W. 9 in. (22.8 cm)
FAS WO Alb 412 (Fischbach-Album)

The Schadow portrait can be seen in the
antechamber of the apartments of Prince
Wilhelm and Princess Marianne.

PH-S

FACING PAGE

FRIEDRICH WILHELM VON SCHADOW (Berlin 1788–Düsseldorf 1862)
Marianne of Prussia and Her Children, 1822
Oil on canvas
H. 89 in. (226 cm); W. 68¾ in. (174.5 cm)
Signed and dated lower right: *WS.AD. MDCCCXXII*
SM B 21042

Although Schadow is known for the religious paintings of his later years, his first important
commissions were portraits of the Prussian family. Here we see Marianne of Prussia (1785–1846)
with her children. Marianne was of Hessian descent; her father was Friedrich of Hesse-Homburg
and her mother, Karoline, was the daughter of Ludwig IX of Hesse-Darmstadt. It was her husband
Wilhelm of Prussia who purchased the Holbein Madonna, which passed into the Hesse-Darmstadt
inheritance when they gave it to their only daughter Elisabeth (1815–1885), wife of Prince Karl
of Hesse-Darmstadt.

PH-S

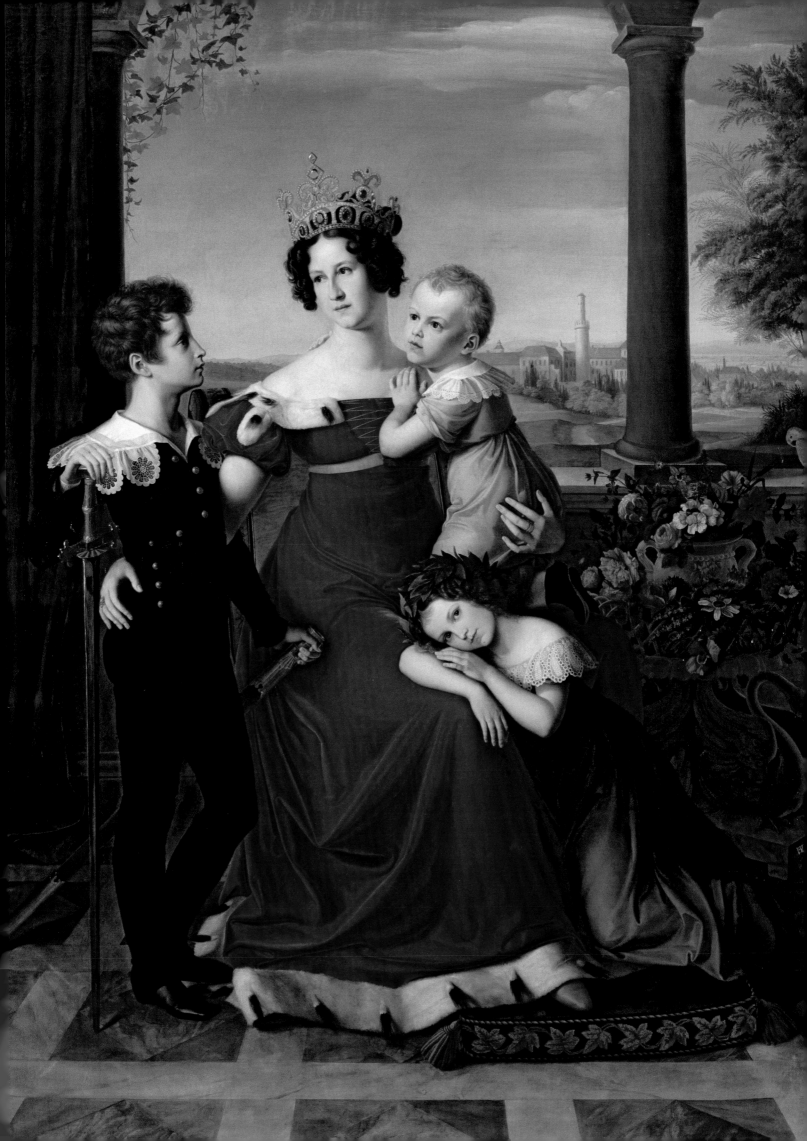

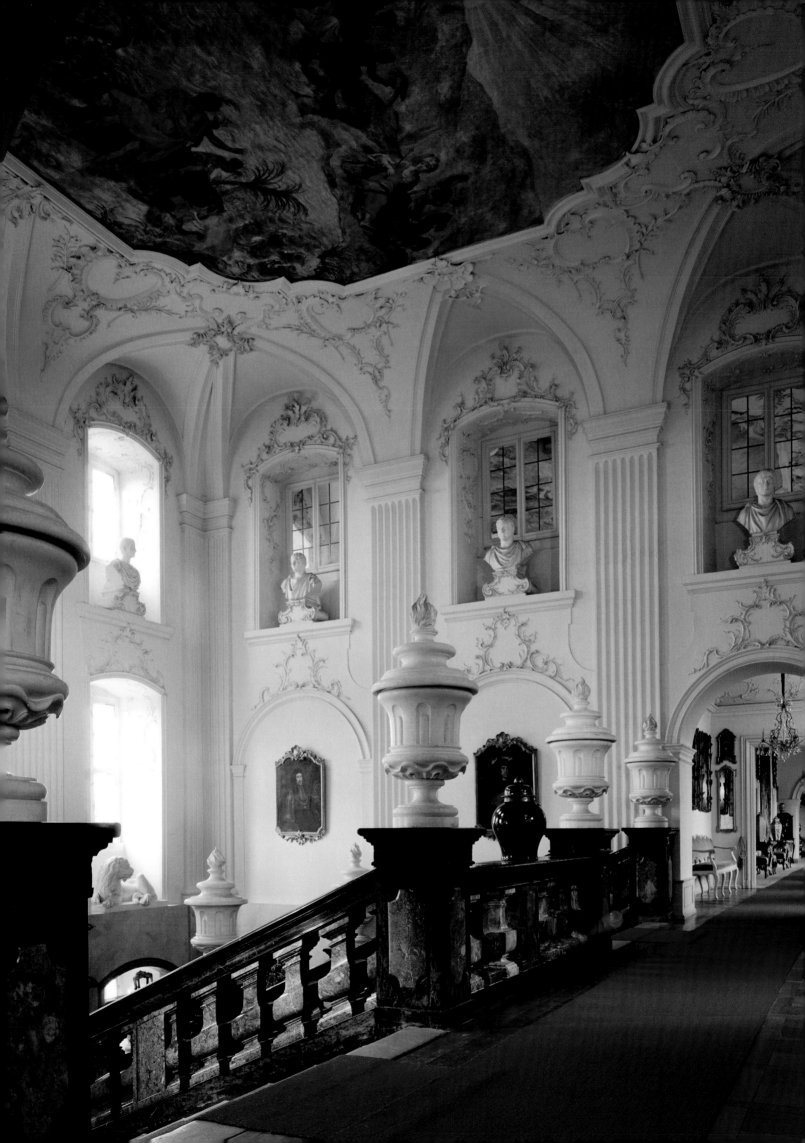

FASANERIE

Known as one of Hesse's most beautiful Baroque castles, Fasanerie is located on a gentle slope four miles south of Fulda, a city between Frankfurt and Kassel. Originally constructed at the beginning of the 18th century as a hunting lodge by the Prince Bishop of Fulda, it was enlarged into a summer residence by Prince Bishop Amand of Buseck in 1739. An engraving from 1770 (see p. 53) shows Fasanerie to be a liberal interpretation of an 18th-century French chateau, with a driveway leading from the nearby village passing through a series of courtyards to culminate at the sovereign's residential building.

Fasanerie fell to the Prussians in 1803 when secularization dispossessed the clerical princes. The Congress of Vienna in 1816 transferred the property to Elector Wilhelm I of Hesse-Kassel, along with most of the territory that had formerly belonged to the Prince Bishops of Fulda. Beginning in 1824, the castle was again made habitable for the summer visits of Wilhelm II and was subsequently used by his wife Auguste. Wilhelm had the court architect Johann Conrad Bromeis (1788–1854) remodel the southern wing and large halls in the Neo-classical style while preserving the Rococo stucco ceilings in the south wing. The terraced Baroque garden on the south side was transformed into a more naturally landscaped park.

With the Prussian annexation of Hesse-Kassel in 1866, the Hesse family lost Fasanerie, but after long negotiations with the Prussian crown, it was returned to their custody in 1878, along with the Prince Bishop's palace in the city of Fulda. Until 1918 the family used Fasanerie for summer and hunting visits. Its last inhabitant was Landgräfin Anna, wife of Friedrich Wilhelm. In World War II the castle sustained such heavy damage from bombing that roofs were shattered, doors and windows torn from their hinges, and walls partially blown apart.

In 1948 Landgraf Philipp of Hesse selected Fasanerie to realize his vision of a "family museum." After three years of extensive renovations, the first museum rooms opened to the public. In 1965 Philipp designed an addition to the castle in the form of an octagonal gallery (see p. 198) for the display of his antiquities collection, considered the most important private collection of its kind in Germany.

Today the Museum Schloss Fasanerie presents works of art from the Hessian House Foundation, gathered from various Hesse residences, in the setting of a princely home. This includes a room lined with Johann Heinrich Tischbein's large-format paintings depicting one of the heron hunts of Landgraf Friedrich II (see pp. 34–35), as well as the exquisite furniture ensemble that Landgraf Wilhelm IX commissioned for his retreat at Wilhelmsbad (see pp. 58–59). In the castle's southern wing is a series of period rooms that traces the history of interior décor through the 19th century, from the Empire style to Historicism. The furnishings are enhanced by the paintings of renowned artists such as Tischbein, Johann Martin von Rohden, Johann Friedrich Bury, and Franz Xaver Wintherhalter.

It was the concept of Landgraf Philipp to create a public museum in a castle where the rooms would appear as if their inhabitants had just left. As such, it is a unique document in the development of historic house museums in the mid-20th century.

The grounds of Fasanerie are enjoyed by the public year-round but the castle itself, built for summer occupancy and thus lacking heat, is only open from April to October. Since 2000 a June garden festival has advanced its public presence. In 1991 the original bathhouse was refitted as a modern exhibition hall for annual shows with scholarly catalogs focusing on individual aspects of the Hesse collections.

MM

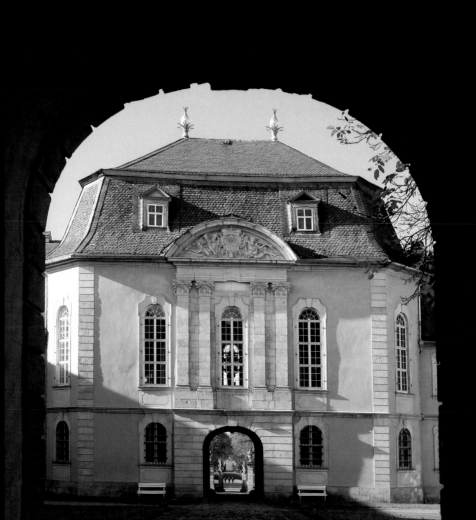

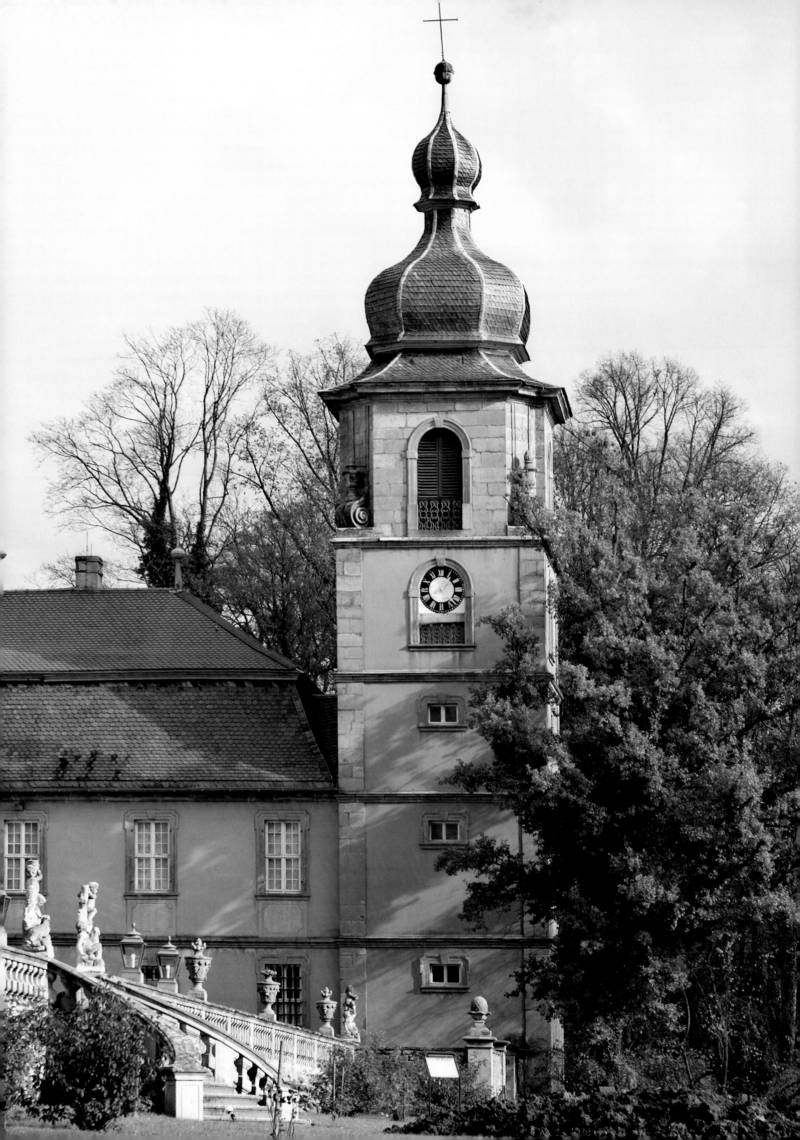

WOLFSGARTEN

Commissioned by Landgraf Ernst Ludwig, Wolfsgarten was built in 1722–1724 as a hunting castle near Darmstadt, where the generous wooded grounds provided space for the new parforce hunt. Designed by the Huguenot architect Remy de la Fosse (1659–1726), the buildings surround a rectangular court and include the Manor House *(Herrenbau)* and stable building opposite it, flanked by the Prince, Cavalier, Princess, and Ladies Buildings. Named after the area's ferocious gray wolves, Wolfsgarten remained a favorite gathering place until Landgraf Ludwig IX abolished the parforce hunt in 1768 and, like many hunting castles, it fell into neglect.

Renovated by Crown Prince Ludwig III in the 1830s, Wolfsgarten became a summer residence and hunting castle for Grand Duke Ludwig IV in 1879. It was Grand Duke Ernst Ludwig, however, who truly gave it new life—and its present appearance—which included the removal of the buildings' plaster exterior to reveal the reddish Main River sandstone beneath. Ernst Ludwig also redesigned the park, installing a Japanese garden with a pond and bridges, a tea house, fountains and pergolas, and two chapels, as well as planting a garden of rhododendrons imported from England. The park's gem, however, remains the Jugendstil playhouse for Princess Elisabeth (see pp. 194–95), composed of a living room and kitchen whose size and function are tailored for a child.

Following World War II, Wolfsgarten became the residence of Prince Ludwig and Princess Margaret, who made it a gathering place again for family and friends. Among its regular visitors were their nephews from the Hesse-Kassel line, Moritz and Heinrich, the elder of whom the couple adopted in 1960. Since Margaret's death in 1997, Landgraf Moritz has made the castle his home. The rhododendron garden remains open to the public two weekends a year in early summer.

JMS

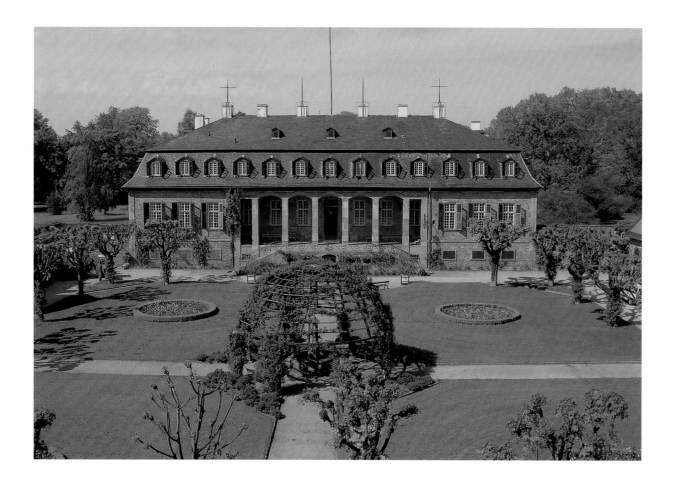

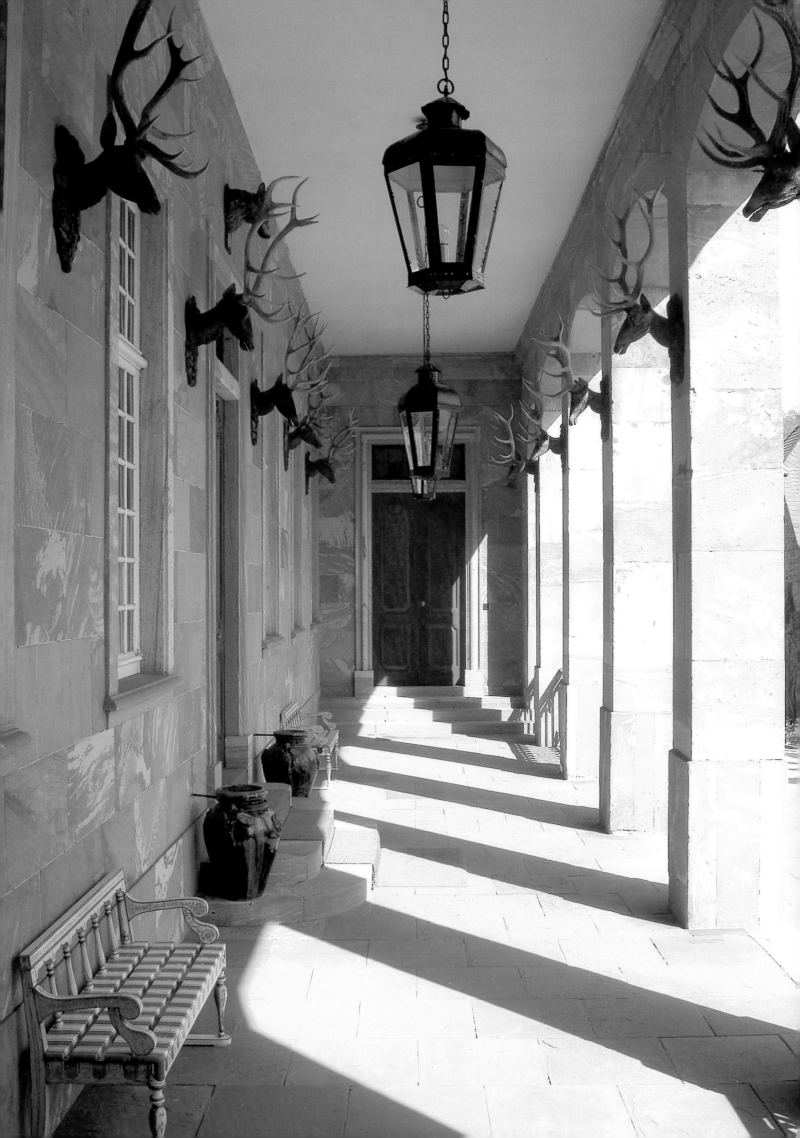

DARMSTADT RESIDENCE CASTLE

The north façade is all that remains of the original castle from 1567, which was expanded to be the residence of the landgrafs of Hesse-Darmstadt. While the building complex now contains the city administration, a wing adjacent to the bell tower houses the Schloss-museum. Funds ran out before the completion of the early 18th-century additions to the castle designed by architect Remy de la Fosse, but his southern façade, built in 1727, still stands facing the market square.

By 1820 Grand Duke Ludwig I declared that his collection of paintings, drawings, antiquities, firearms, and natural science specimens should be made available for the public's enjoyment and education in a Grand Ducal Museum. The works were displayed on the upper floor of the Baroque Residence Castle. At the century's end, Ludwig IV commissioned a new museum building on the site of the former Drill House between the castle and its gardens. His son Ernst Ludwig selected a more progressive architect, Alfred Messel (1853–1909), to complete the building that is the Landesmuseum today. Inaugurated in 1906, it housed most of the Grand Ducal collections in what was then the most up-to-date of museum facilities.

With the advent of the Weimar Republic in 1918, the Grand Duchy became the "People's State of Hesse," and the new state assumed responsibility for the care of the princely collections in the Landesmuseum and Residence Castle. For the new Schlossmuseum founded in 1924—installed in a series of historical rooms in the Residence Castle—Ernst Ludwig made significant loans from his private collections at Wolfsgarten, Kranichstein, and the Neue Palais.

In World War II the castle and museum went up in flames during the bombardment of the city, and the galleries and storage rooms were destroyed. A few exceptional pieces, such as the Holbein Madonna, had been previously evacuated, while many other works, including a large part of the silver collection, burned.

In 1965 the Schlossmuseum reopened in the reconstructed castle. Among its most important exhibits are its collections of coaches, militaria, and examples of Darmstadt Jugendstil.

MM

FRANZ HUTH (Pössneck 1876–Weimar 1970)
Second Assembly Room, Darmstadt Residence Castle, 1919
Watercolor, gouache
H. 25¼ in. (64 cm); W. 30⅜ in. (77 cm)
Signed lower left: *Franz Huth 1919*
SM H 21409

In the 1860s, at Queen Victoria's insistence, a new residence, called the Neue Palais, was built in Darmstadt for her daughter Alice and son-in-law Crown Prince Ludwig; but the royal apartments in the Darmstadt Residence Castle retained their decor and were used for ceremonies even after the declaration of a republic in 1918.

ᴘʜ-s

Franz Huth, 1936.

castles in his Hessian homeland to him. Thereafter Panker remained a favored summer seat of the family.

Surrounded by a large park, the rectangular building is finished with white plaster, its edges and cornices trimmed with gray stone. On the western side is a small, French-style Baroque garden. After World War II the castle and its adjoining buildings were used as a refugee camp. During this time the entire furnishings were so completely destroyed that only the roof and the external walls survived. In 1954 Landgraf Philipp of Hesse undertook the restoration of the castle's interior.

CK

FRIEDRICHSHOF

Friedrichshof was built in 1889–1894 by Empress Dowager Victoria, the eldest daughter of Queen Victoria, who, as widow of Kaiser Friedrich III, was also known as Empress Friedrich. She dedicated this summer retreat in the Taunus hills above Frankfurt to the memory of her beloved husband, who had reigned as German Kaiser for only ninety-nine days. The latest modern amenities, including electricity, were incorporated into interiors decorated in the Renaissance Revival style. The Empress made it an artful framework for her collection of antiquities and decorative arts from the most varied epochs and countries.

Empress Friedrich bequeathed Friedrichshof and its contents to her youngest daughter, Margarethe (1872–1954), who spent summers there with her husband, Friedrich Karl of Hesse, and their children. The castle remained largely in its original state even during its occupation by the French after World War I, when the family lived in a cottage on the grounds. In 1928 Landgraf Friedrich Karl became head of both the Hesse-Kassel branch of the family and the Hessian Electoral House Foundation, which had been instituted that year. He died in 1940, leaving his widow to experience the second occupation of Castle Friedrichshof. Beginning in April 1945, American forces used it as a club for military and civilian personnel. Among the visitors was nearly every important American who came to Germany during the period, including General Eisenhower.

After the castle's release to the family in 1953, it was decided that the only way to maintain the property was to put it to commercial use. The enormous building was restored as a luxury hotel with a golf course incorporated into the park. Only Empress Friedrich's two personal rooms and offices for the Hessian House Foundation Administration were inaccessible to the public. Opened on Easter 1954 as the Schlosshotel Kronberg, Friedrichshof continues to receive visitors in a unique artistic and historical ambience. The faithfully preserved decoration of its salons conveys the spirit of its builder, Empress Friedrich.

CK

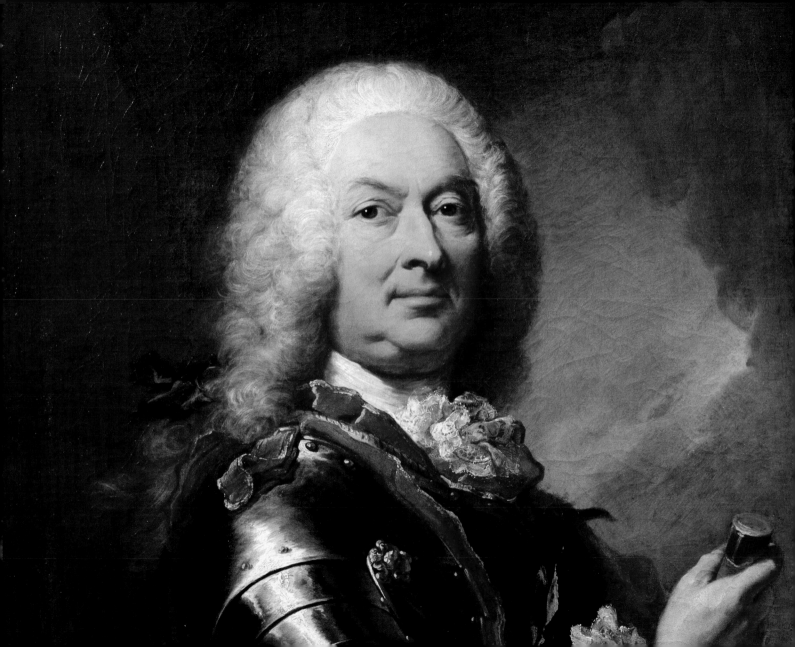

The story of a German Dynasty

The origin of the Hessian dynasty is the stuff of legend. Once upon a time, at the beginning of the 13th century, Elisabeth (1207–1231), the daughter of the Hungarian king, was engaged by her parents to a German prince. The four-year-old bride was brought to one of the most splendid courts in medieval Germany, the Wartburg in Thuringia, site of the legendary *Sängerkrieg* ("competition of singers") immortalized in Wagner's *Tannhäuser.* When first her fiancé and then his father died, Elisabeth was about to be sent back to Hungary, but the younger son Ludwig, now Landgraf Ludwig IV of Thuringia (1200–1227) and one of the most promising princes in the German Empire, had fallen in love with her. They married in 1221, when she was fourteen and he twenty-one.

Elisabeth's cheerless childhood at a foreign court might have influenced her finding comfort in religion. She took a particular interest in the Franciscan order, whose friars devoted their lives to the poor and sick. She founded a St. Francis hospital near the Wartburg, where she personally took care of those who were ill. The court, however, considered her uncompromising commitment to the underprivileged scandalous.

Legend has it that at the time of a famine Elisabeth spent her money, against the will of her husband, to buy food for the poor. One day he caught her by surprise as she was carrying victuals in her apron. Asked what she was hiding, she answered, "just roses." When he obliged her to reveal her apron's contents, miraculously, there were indeed only roses.

When Ludwig died in 1227 on Crusade to Jerusalem, his brother became regent. Elisabeth and her children followed her religious counselor to Marburg in the county of Hesse, which then was part of Thuringia. There she founded another hospital, having renounced her noble status to devote herself to nursing the poor. After four years she died of exhaustion when she was just twenty-four years old.

Her grave at the chapel of the Marburg hospital soon became a place of pilgrimage where miraculous healings were believed to occur, and in 1235 Pope Gregory pronounced Elisabeth a saint. In the next year, an assembly of worshippers from all over Europe gathered in Marburg to assist the "elevation" of her remains from the original grave. After Emperor Friedrich II (1194–1250) himself had consecrated the bones with his crown, they were laid in a precious jeweled shrine. The first Gothic church in Germany was constructed over her tomb. Completed in 1283, it is still standing. Elisabeth remains the most popular woman saint in Germany.

Elisabeth was distinguished by her remarkable self-denial and social commitment. It is a perfect paradox that although she personally renounced riches and power, the Church, the Order of Teutonic Knights that took charge of her shrine—even her own family—used the cult that grew up around Elisabeth to further their wealth and authority.

Elisabeth's only surviving child, Sophie (1224–1275), was married to the Duke of Brabant, with whom she had one son, Heinrich (1244–1308). But in these times early mortality frequently reshuffled the cards in the dynastic gamble. Within one year both the last male heir of Thuringia and Sophie's husband had died. Since his son from an earlier marriage inherited the duchy of Brabant, Sophie realized that her son's only chance to reign lay in Thuringia. But a pretender from the Saxon House of Wettin, also of Thuringian descent, claimed the right of succession; moreover, he was endorsed by the German emperor.

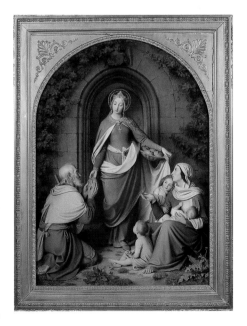

AUGUST SCHOTT (Giessen 1811–Munich 1843)

St. Elisabeth of Thuringia, 1835
FAS B1135

Sophie was a resolute woman, however, determined to use all means in her power to secure at least the Hessian part of the heritage for her son. Confident that the sainthood of her mother was an important asset for her claim, Sophie installed herself at Marburg in the vicinity of St. Elisabeth's grave. In doing so she won the support of its guardians, the Teutonic Order and the Hessian nobility, for four-year-old Heinrich, who became known as *das Kind von Hessen* ("the Child of Hesse").

Though the greater part of Hesse had been bestowed as a fief on the landgrafs of Thuringia, it ultimately belonged to the powerful archbishopric of Mainz. Now that the Thuringian dynasty was extinct, the archbishop wanted to return Hesse to his direct rule. As both a secular and ecclesiastical state, Mainz played an influential role in German politics. Its archbishop was a *Kurfürst,* or Elector—one of only seven princes entitled to elect the German emperor. Though facing such formidable opposition from both Mainz and Thuringia, Sophie led a force of knightly warriors in a twenty-year campaign to secure the Hessian reign for her son. When Sophie died, Heinrich continued to fight and outmaneuver several successive archbishops, forcing Mainz to cede Hesse.

In 1292 Hesse was elevated to a member state of the empire and Heinrich was recognized as Hesse's ruling prince with the title of "Landgraf." The only reminder of Heinrich's Thuringian descent was the coat of arms, the red-and-white-striped lion on blue ground that today is the official coat of arms of both federal states of Hesse and Thuringia. As the first Hessian landgraf, Heinrich was buried at the St. Elisabeth Church in Marburg after a reign of forty-four years, during which he consolidated control of his scattered territories. For two hundred years to come, his successors would be buried there beside their holy ancestor Elisabeth, who became the icon of the House of Hesse. The array of tombs with sculpted stone effigies remains today as a unique dynastic monument that links Hesse to its medieval origins.

Hesse at the close of the Middle Ages

The 14th and 15th centuries saw the biggest territorial expansion in Hessian history, primarily due to advantageous marriages. In a marriage contract two families would grant each other a mutual *Erbverbrüderung,* the right to inherit the other's territories should the male line of the clan die out. In the beginning, the Hessian territory was mainly scattered patches of land interspersed with the domains of powerful regional counts and knights. But the Hesses were lucky enough to outlive some of them and gradually gave the territory a more coherent structure.

Among the most significant of these gains was the inheritance of Katzenelnbogen in 1479. Although not connected with the main territory, it granted Hesse access to the Rhine River with the fortress of Rheinfels on the left bank. This enabled the landgraf to collect lucrative tolls on the river traffic, which was one of the most important arteries of commerce in central Europe. The revenues granted him a certain independence from the right to control taxation exercised by the Hessian *Landtag* ("diet"), a pre-parliamentary institution with representatives of the *Landstände* ("estates"): clergy, nobles, and townspeople. Nevertheless, the Katzenelnbogen heritage was disputed by neighbor states over several generations before a final settlement was reached in Hesse's favor.

The end of the 15th century also saw the systematic development of the early modern state, as the medieval fiefdom was replaced by an administration of princely civil servants. Further, the judicial system was given new order by a supreme court and the financial system by the founding of a chamber of revenues.

Wilhelm II (1468–1509) was said to be an ambitious, zealous, and inconsiderate ruler. Even so, his policy of support for the Habsburg Emperor Maximilian against the Elector of the Palatinate paid off in territorial gains. Additionally, the emperor granted him the *Guldenweinzoll,* a profitable custom on wine transports through Hesse.

A Mother's struggle

At several crucial points in Hesse's history, determined mothers held the reins of power until their sons came of age. Anna (1485–1525), the daughter of the Duke of Mecklenburg, took on this role as the wife of Wilhelm II (1468–1509) and the mother of the most distinguished Hessian leader, Philipp the Magnanimous (1504–1567).

By 1506 Wilhelm II was showing signs of mental incapacitation due to what contemporaries called "the French disease," the newly rampaging epidemic of syphilis (presumably imported by the Spanish from South America). Caught during one of the landgraf's military campaigns, the infection led to a progressive paralysis and "melancholy madness." At the onset of the disease, Wilhelm made a will setting up a regency council, which would consist of five councilors from the nobility who would form the government and have guardianship over his son Philipp.

As soon as he had given up power, the incapacitated landgraf suffered cruel treatment. He was locked up in a chamber, deprived of fresh air and food, and mocked by the servants. "Whatever we are given to eat," he complained bitterly, "we have had to eat like a senseless animal tearing [the food] apart with our hands and fingernails as if we were mad or as if we were a werewolf."[1] What he experienced might have been partly revenge since, as one of the court officials put it, "He does not deserve to implore God for mercy, since he never showed mercy to [other] people."[2]

On the other hand, the nobility, resisting the growth of princely power, seized the opportunity to gain more control over government. Countering the nobility's attempts, Wilhelm's wife Anna had her husband change his will to make her guardian of their four-year-old son. Female regency, however, did not correspond to the legal terms of the time, which required a related male guardian. The consequence was a fierce tug-of-war between Anna and the estates of the Diet. When William II died in 1509, the estates declared that "Jesus didn't entrust the care of the Church to his mother Mary, but to the apostles," adding that they would "rather wade up to their spurs in blood than to submit to the rule of a woman."[3] Consequently they deposed the widowed landgräfin, formed a regency of their own, and conferred the chief guardianship to the Saxon Wettin dynasty with which the Hessian landgrafs had a mutual inheritance agreement. The twenty-four-year-old Anna, however, responded with great determination, ingenuity, and a good share of subterfuge. With the help of three advisors, of whom two were learned jurists rather than nobles, she managed to profit from the increasing division of her adversaries and to enforce her argument that "the mother of the landgraf was more qualified than others to administrate the country."[4]

At the 1514 *Landtag* of Kassel, Anna and her counselors finally succeeded in getting rid of the regency council and establishing control of the government. In the course of the struggle, her opponents accused her of being violent, inconsiderate, and, in financial matters, greedy. The nobility lost ground, though, and Anna not only secured rule for her son but also set a precedent for future female regencies.

philipp the Magnanimous

During the conflict over his guardianship, the five-year-old Philipp was separated from his mother for four years. After she had won him back, Philipp is said to have told her that he wished to be grown, so he could "chop off the heads of those who are against you."[5] To hold their opponents in check, Anna obtained a declaration of majority for her thirteen-year-old son from Emperor Maximilian. Subsequent circumstances forced the teenage landgraf to grow up fast. With the support of malcontent Hessian nobles and neighboring counts, the popular knight Franz von Sickingen (1481–1523) invaded the south of Hesse with an armed force of mercenaries and occupied the town of Darmstadt, causing Philipp a costly defeat.

Anna remarried in 1519, adding to the tensions between mother and son on one side and the nobility on the other, and in the end she was forced to retire from government.

Remarkably, Philipp kept the counselors who had served his mother, and it was these advisors, independent from the nobility and loyal to their sovereign, that formed the future core of civil servants.

At the Imperial Diet held in 1521 at Worms, the sixteen-year-old Philipp made an impressive appearance at the head of four hundred horsemen. While he distinguished himself in a tournament, it was his counselors that inspired the admiration of a grocer's wife, who remarked, as Philipp rode by with his entourage, "His best adornment is that he has so many grey beards, that is, so many fine, old and steady men around him."[6]

In Worms, Philipp met the two men who were to define his destiny: the world's most powerful monarch, the Habsburg ruler Charles V (1500–1558), who was German Emperor, Archduke of Austria, King of Spain, Duke of Burgundy, and future master of the Spanish colonies in America, and the little rebellious monk, Martin Luther (1483–1546). Philipp was impressed by Luther's bold refusal to revoke the convictions of his conscience in the face of the emperor, preferring to be outlawed instead.

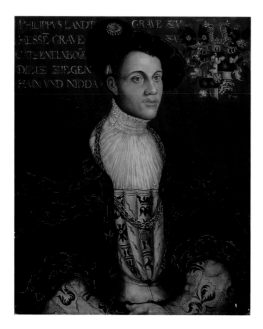

But the young landgraf was too preoccupied with his own problems to give it much further thought. Instead, he was busy forming alliances that enabled him to finally defeat Sickingen and the rebellious Hessian nobles in 1523. Two years later, he fought with the same energy against the spreading rural and urban insurrection known as the Peasants' War. Together with Saxon troops, he crushed the untrained mobs led by the revolutionary clergyman Thomas Müntzer (1486–1525) in Thuringia. According to an outraged witness, the landgraf "raved voraciously and cruelly like a wild boar."[7] As forceful as Philipp was in repressing armed rebellion, he also sought to cure the abuses that caused the uprising by organizing hearings for complaints and grievances.

The general unrest was part of a crisis of social and economic change that had developed at the end of the Middle Ages. This was reinforced by the religious Reformation initiated in 1517 by Martin Luther in Saxony, which was directed against papal abuse and clerical corruption. The letterpress (invented in Mainz around 1450) helped spread the new doctrine quickly and in the local parishes of Hesse there was growing support for the Reformation movement. Landgraf Philipp decided to join the Lutherans after an encounter in 1524 with Luther's closest collaborator, Philipp Melanchthon (1497–1560), and he took careful measures to reform the church in Hesse following the Saxon example. It was decided that clerical matters no longer would depend on the authority of the pope or archbishops, but rather on the state. Anticipating the French Revolution two hundred and fifty years later, convents were dissolved and their monies used for public works. Landgraf Philipp founded the University of Marburg in 1527 as the first Protestant university, established state hospitals for the poor, sick, blind, epileptic, and insane, and set up "community chests" to fund charities and schools in towns and rural communities.

Philipp was well aware, however, that the reforms were doomed if he did not gain the emperor's approval. Fortunately for him, war with France kept Charles V away from Germany for nine years. During this time the Imperial Diet's resolutions were generally tolerant of the progress of the Lutherans. Nevertheless, when the emperor returned to Germany in 1529, he prevailed on the Diet to declare all reform measures illegal. The session ended with the protest of the Lutherans, headed by the Saxon elector and the Hessian landgraf, who thereby earned the name "Protestants."

Philipp now took the lead in the Protestant political movement. He invited the most important reformers, including Luther and the Swiss Huldrych Zwingli (1484–1531), to a conference in Marburg to settle their ideological differences. In contrast to other Protestant

rulers, Philipp practiced religious tolerance, announcing, "It is also our will and opinion that nobody shall be punished with death on behalf of matters of faith, unless he arouses rebellion or bloodshed."[8] In 1531 he and his Saxon ally organized the *Schmalkaldische Bund,* a political federation of Protestant states and Imperial cities. He negotiated with the Danish and Hungarian kings and Britain's Henry VIII (1491–1547), and met with France's François I (1494–1547). With the aid of French money, he successfully campaigned against Habsburg King Ferdinand (1503–1564), the brother and deputy of Emperor Charles V, to reinstate Philipp's friend and cousin, the Duke of Württemberg, on his throne. This unselfish act made him known throughout Europe as "Philipp the Magnanimous." In 1541 Philipp entered into secret negotiations to reconcile with Charles V, who needed support against the French and the Turks.

But Philipp had an Achilles heel. In the late 1530s he had fallen in love with one of his sister's ladies-in-waiting, seventeen-year-old Margarethe von der Saale (1523–1566). For princes to have mistresses was not unusual, as their marriages were arranged for reasons of politics, not affection. Philipp, however, declared that his conscience did not allow him to live in a state of adultery and, moreover, the girl's mother would not allow her daughter to enter into an adulterous relationship. But a divorce from his wife, Christine of Saxony (1505–1549), was out of the question as it would have offended his Saxon ally and, besides, he still felt affection for her. As a zealous bible reader, Philipp thought he discovered the solution to the problem in the Old Testament, where some of the patriarchs appeared to have had several wives. He consulted the theologians Luther and Melanchthon as to whether they thought a "collateral marriage" possible. Afraid to lose their most important protector, the reformers gave their consent—on condition that the affair remain secret. In 1540, after Philipp's wife Christine (having borne her husband seven children, with three yet to come) reluctantly consented, the marriage with Margarethe was secretly performed in the presence of Melanchthon.

The scandalous news leaked out, causing an outcry throughout Hesse, Germany, and Europe. Embarrassed, Luther and Melanchthon distanced themselves from the matter. The integrity of Protestantism was at stake. Moreover, bigamy, according to the laws of the Empire, was a capital offense. Philipp not only had compromised himself as the political leader of Protestantism, he also had made himself dependent on the mercy of his most dangerous enemy, the emperor. Once he had beaten the French, Charles V took on the Protestant princes in the Schmalkaldian War and defeated them in 1547. The Saxon elector was taken prisoner. Duke Moritz of Saxony (1521–1553), a Protestant cousin of the elector and Philipp's own son-in-law, contributed to the Protestants' defeat by taking the emperor's side in return for the Saxon throne. The emperor demanded Philipp's formal surrender. Thanks to the intervention of his son-in-law, the newly installed elector, Philipp was assured safe-conduct to the Saxon town of Halle, where he went to kneel before the emperor. However, the emperor took his revenge on the landgraf who had so fiercely opposed him. Philipp was first confined in humiliating conditions in several southern German cities and then deported to the Netherlands where he remained a prisoner for five years.

Charles V's triumph proved short-lived. His ambitious plans to create a Habsburg "universal monarchy" prevented him from taking measures in time to stop the Reformation in Germany. In 1552 a new confederate Protestant army was formed under Philipp's Saxon son-in-law Moritz and the landgraf's eldest son, Wilhelm, and was supported by the French king. The emperor was forced to retreat over the Alps and Philipp was liberated. In 1555, Charles's brother Ferdinand was obliged to conclude the *Augsburg Religions- und Landfrieden* ("religious and political peace"), following the principle *Cuius regio, eius religio.* This meant that each sovereign was free to choose his religion, but his subjects would have to follow him or emigrate. In 1556 Charles V resigned, leaving the German Imperial crown to his brother Ferdinand. In the meantime, Philipp's captivity had purged his reputation; he

was now considered a "martyr of freedom and religion."[9] As he was the grand old man of the Reformation, the young British Queen Elizabeth I (1533–1603) consulted him, and he was on cordial terms with the French King Henri II (1519–1559).

But the unfortunate "collateral marriage" also caused collateral damage in the family. After Philipp's wife Christine had died during his captivity, his second wife Margarethe demanded a share in Philipp's estate for her eight sons. Originally, Philipp had made a will introducing the right of primogeniture. His eldest son, Wilhelm, would succeed his father on the throne, while the three younger sons by his first wife, Christine, would receive appanages in the form of lands that would provide them income but not the right of sovereignty. When Philipp showed signs of giving in to Margarethe's demands to provide her sons with appanages as well, the sons by his first wife protested. The three younger sons in particular objected to being treated equally to the half-brothers they considered illegitimate. To save the family peace, Philipp reluctantly changed his will and divided Hesse among the sons of his first marriage and provided the sons of the second marriage with appanages.

Wilhelm, who had loyally governed Hesse during his father's imprisonment and raised a formidable sum for the required reparations, received the northern half of Hesse with Kassel as the capital. The second son received a quarter in the center, with Marburg as capital. The third son, one-eighth in the west, with Rheinfels as his residence, and the youngest, one-eighth in the south, with Darmstadt as residence. The division of its territory ended Hesse's influential position in the center of Germany, although the Kassel rulers continued to aspire to become electors. When the Rheinfels and Marburg lines died out after one generation, their heritage was disputed between the two remaining Kassel and Darmstadt lines.

When Philipp died in 1567 at the age of sixty-three, he was the first landgraf to be buried, according to his wish, in St. Martin's church in Kassel. Some thirty years earlier he had broken with the St. Elisabeth cult of his ancestors, following the Lutheran teaching that Jesus was the only saint in the Christian Church and, as a shocking consequence, had ordered Elisabeth's remains removed from the shrine in her church at Marburg. By this gesture, he dissociated Elisabeth's memory from the accouterments of sainthood that actually belied her life's work. He paid her homage in a human context with a stone relief sculpture he had set in the wall of the hospital he founded in Haina. In this image, Elisabeth, in widow's attire, is feeding a sick person, with Philipp himself standing opposite,

PHILIPP SOLDAN

Stone relief in the former
Cloister Church in Haina, 1542

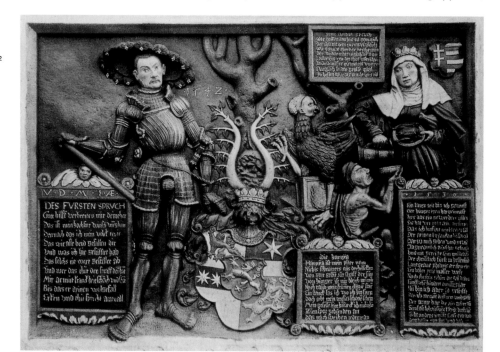

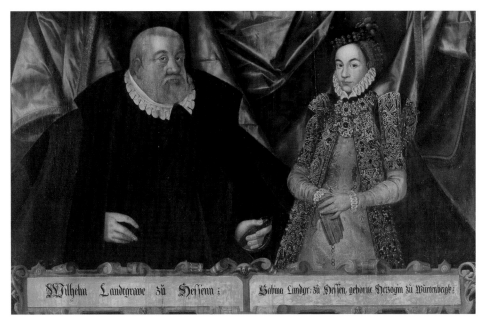

JOST VOM HOFF
(Kassel, act. 1577 – 1592)
AND CASPAR VAN DE
BERCHT (act. ca. 1600)

*Landgraf Wilhelm IV and
Landgräfin Sabine of
Hesse,* ca. 1590
Oil on oak panel
H. 44⅛ in. (112 cm); W. 69½ in.
(176.5 cm)
Inscribed below figures: *Wilhelm
Landgrave zu Hessen; Sabina
Landgr. zu Hessen, geborene
Herzogin zu Württemberg*
FAS B 1078

emphasizing the role he inherited from her as a prince taking responsibility for the needs of his subjects. The bird chained to the money chest symbolizes monarchism having yielded its power to public welfare.

wilhelm the wise

Wilhelm IV (1532–1592) had a thankless task. At age eighteen he assumed rule in place of his imprisoned father, undertook diplomatic and military efforts for his liberation, and raised reparations stipulated by Charles V. He later had to consent to share the succession—originally destined for him alone—with his brothers, although he took on these tasks with rare filial and brotherly loyalty. Good relations within the family were aided, no doubt, by the fact that Wilhelm and two of his brothers married sisters, the daughters of the Duke of Württemberg.

Wilhelm had received a humanistic education at the university in Strasbourg. A frail, stuttering scholar in his youth, he later developed an inclination to obesity. He nonetheless had several affairs, which produced children, but was reluctant to marry. When Wilhelm was thirty-five, however, his sister-in-law pushed him into marriage with her sister, seventeen-year-old Sabine of Württemberg (1549–1581). A young woman of delicate complexion, she was well educated and spoke Latin. Wilhelm grew very fond of his *"Bienchen"* ("little bee"), as he called her, who gave birth to eleven children. When Sabine died at thirty-two, the widower was inconsolable and refused to remarry.

Wilhelm went beyond the reconstruction necessary after the Schmalkaldian War, completing his father's princely residence in Kassel. Relishing the role of architect, he built the arsenal and revenue office in the city as well as the Wilhelmsburg castle that still stands in Schmalkalden.

A true Renaissance spirit, Wilhelm brought the court in Kassel renown as a center of scientific activity. He founded the natural history collection, art collection, library, and botanical garden, where some of the first potato plants in Germany were cultivated. He studied the healing power of plants, encouraged by Sabine, who had set up a pharmacy in the castle and distributed medicinal herbs to the poor.

Wilhelm's greatest passion, however, was astronomy. In 1560 he installed the first modern observatory in Europe on a balcony of his Kassel residence. By the time he became landgraf in 1567, he had measured and catalogued the position of fifty-eight stars. This was quite an accomplishment—the telescope was not invented until the early 17th century, and observations in Wilhelm's time were made with the naked eye. "In astronomy," as he

defined his principle, "everything must be thoroughly researched and by means of direct observation."[10]

Wilhelm's collection of rare early instruments to measure space and time survives in Kassel as a testament to the landgraf's scientific interests. In this collection is the first clock to mark the passage of seconds, made for the landgraf's observatory by the Swiss mathematician, astronomist, and instrument maker Jost Bürgi (1552–1632). Another one of Bürgi's Kassel clocks is engraved with a depiction of Copernicus (1473–1543), and the earliest known representation of his concept of the earth revolving around the sun. It is an expression of intellectual daring considering the Inquisition would continue to persecute anyone contradicting the belief that the earth was the center of the universe for more than half a century.

Wilhelm IV steered a mediating course through the growing rift between Lutherans and Calvinists, admonishing his son in his will not to introduce a division of religion in his country. In practical terms, he believed persecution or eviction of subjects to be harmful to the economy. Leaving his son a well-organized state and restructured finances on his death in 1592, William IV had earned the sobriquet "Wilhelm the Wise."

moritz the Learned

Moritz (1572–1632) was an internationally admired intellectual who benefited from the humanist education organized by his father, with whom he shared an interest in sciences. He spoke eight languages and corresponded with renowned scholars, and, on a visit to the French King Henry IV (1553–1610), even settled a dispute between classical authorities.

Moritz was particularly inclined toward the arts. He wrote poetry and plays and was an accomplished musician, playing several instruments and composing operas. He discovered the musical talent of Heinrich Schütz (1585–1672), the son of an innkeeper, and sponsored the education of the musician who later would become the greatest German composer of the 17th century.

In 1595 Moritz founded an academy at court, the *Collegium Mauritianum,* to improve the crude manners of noblemen. The school's curriculum listed among its disciplines "exercises for both the body and spirit with riding, tournaments, fencing, dancing, horse jumping, ball games, exercises in arms, as well as instrumental and vocal music, drafting and painting."[11] This education followed Castiglione's (1478–1529) *Il cortegiano* ("The Courtier"), a famous Italian guide for noble behavior. It was seen as a means to form an elite group within the princely entourage, one that was based on personal achievement rather than pride of birth.

In the manner of great Baroque courts, Moritz celebrated dynastic occasions with large, open-air spectacles featuring allegories, knightly games, and fireworks. Like his father, Moritz was also an accomplished architect. In 1605 he built the first permanent theater in Germany, the Ottoneum, named after his late favorite son, Otto. Moritz engaged English traveling theater groups to perform in his Kassel playhouse, which was equipped with an arena-stage following the model of theaters of antiquity. (In a related note, it is interesting to speculate that as "Rosenkrantz" and "Guildenstern" were actual members of the court at Kassel, the traveling players might have returned to England with the names that Shakespeare used for Hamlet's courtiers.) Unfortunately, by 1613 the costs of the theater so exceeded its budget that the landgraf's counselors insisted it be closed.

More lasting innovations included instituting a professorship for modern languages at the University of Marburg in 1602, setting up the anatomical collection for scientific study in 1604, and founding the university's first chair for medical chemistry in 1609. Moritz himself wrote a theoretical work on poetics and collaborated on a French-German dictionary.

Despite his father's warnings against "practitioners of the black arts, alchemists, and others betraying body and soul for money,"[12] Moritz developed an interest in the

"hermetic sciences" and saw alchemy as a means to penetrate to the essence of natural phenomena. Scholars have recently established that the famous first editions of the two anonymous Rosicrucian manifestos, *Fama fraternitatis R.C.* and *Confessio fraternitatis R.C.,* printed in 1614–1615 by the court publisher in Kassel, were actually edited by none other than the landgraf himself. The essays called for worldwide reform in all scientific and political domains to reconcile Christian humanism and empirical research. The Kassel publications triggered an immense international reaction and were translated into several languages.

After the death of his first wife, Agnes of Solms-Laubach (1578–1602), with whom he had five children, Moritz married the bright and ambitious sixteen-year-old Juliane of Nassau Dillenburg (1587–1643). The act had far-ranging and disastrous consequences for the country as well as the Hessian dynasty. Juliane's father, a militant Calvinist, hoped to use the marriage to win Kassel over to the Calvinist side. Educated by Calvinist intellectuals, Moritz already was intrigued by their rationalist dogma, and in 1603 he decided to replace the Lutheran faith with Calvinism as the religion of Hesse-Kassel. Since Kassel had already taken a position between the two denominations, the transition was more or less uncontested. The Calvinist prohibition on religious imagery, however, led to a wave of iconoclasm in which churches were vandalized and an irreplaceable medieval heritage was lost.

There was a further political consequence as Ludwig IV of Hesse-Marburg, Moritz's uncle and Philipp the Magnanimous' last surviving son, had died in 1604 without an heir. According to his will, his territory *Oberhessen* (Upper Hesse) was to be divided between Moritz and his Darmstadt cousin Ludwig V (1577–1626) on the condition that it remain Lutheran. Moritz's introduction of Calvinism in his part of Upper Hesse, including the university town of Marburg, it forced Lutheran theologians to emigrate. Ludwig, a fervent Lutheran, claimed it violated the will and brought a suit at the Imperial Court of Justice, demanding Moritz's share. Correspondingly, Ludwig founded a Lutheran university at Giessen (south of Marburg in the Darmstadt part of Upper Hesse), welcoming the Lutheran theologians who were forced to leave Marburg.

The juridical dispute led to a bloody conflict that lasted half a century. Kassel and Darmstadt fought each other in the Thirty Years' War (1618–1648), which began as a German religious conflict and ended as a struggle among the Continental powers for hegemony in Europe. While Moritz fought on the side of the Protestant Union, his Darmstadt cousin Ludwig—despite being Lutheran—found it advantageous to join the Catholic League led by the Habsburg emperor. In 1623, when the Bavarian troops of the Catholic League invaded Hesse-Kassel, the Imperial Court of Justice ruled that Moritz had to deliver his part of Upper Hesse to Darmstadt. The landgraf fled to northern Germany, leaving his son Wilhelm (1572–1632) to enforce the ruling, which was backed by the Hessian nobility. As soon as the occupying forces left, Moritz returned, but by this time he was so inflexible and politically and financially bankrupt that he was forced to abdicate in 1627. He lived near the Thuringian frontier, estranged from his wife Juliane and son Wilhelm V, whom he criticized incessantly and denounced at the Imperial Court. An unyielding visionary who had failed to realize his utopian goals, Moritz spent his declining years absorbed in his studies of alchemy and the writings of Dante and Machiavelli. Despite his disastrous politics, he remains one of the most fascinating Hessian personalities, comparable to the Shakespearean characters of Richard II, Lear, Prospero, or even Hamlet in his complexity.

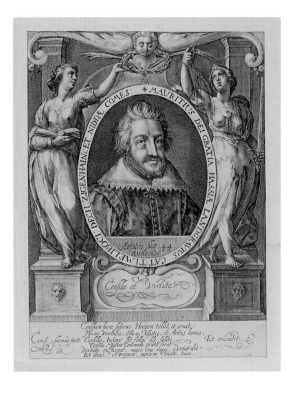

CRISPIJN DE PASSE
(Arnemuiden, ca. 1560–
Utrecht 1637)

Landgraf Moritz of Hesse, 1616
Engraving
H. 10½ in. (26.7 cm); W. 7⅞ in. (20 cm)
Inscribed at foot of portrait:
Aetasis suae 44 anno 1616
FAS H 566

war and peace

It was Wilhelm V's bad luck to have inherited a devastating war, a torn, occupied, and bankrupt country, and a cousin as his fiercest adversary. The Darmstadt Landgraf Georg II (1605–1661), like his father Ludwig V, was loyal to the emperor, hoping not only to win the disputed Marburg territory but also to reunite Hesse under his leadership. Wilhelm V saw a foreign alliance as his only chance for political survival. His stepmother Juliane helped him to forge an alliance with Protestant Gustavus Adolphus of Sweden (1594–1632), who, like Wilhelm, was a great-grandson of Philipp the Magnanimous. Sweden's entry into the Thirty Years' War shifted the balance in favor of the Protestants. Juliane, a smart businesswoman who increased her personal fortune by private commerce in wine, cereal, and livestock, helped her stepson with money to bring an army of twelve thousand men to the field on the Swedish side, allowing Wilhelm to continue the fight for the integrity of his territory.

Although Gustavus Adolphus died in battle in 1632, Wilhelm continued to fight with the Swedish forces. In 1635 Emperor Ferdinand II (1578–1637) concluded a peace with the German princes of the Protestant Union in Prague, but as Calvinists were not granted the concessions made to Lutherans, Wilhelm alone refused to sign the treaty. In 1636 when Wilhelm sought an alliance with France, the traditional antagonist of the Habsburg rulers, Emperor Ferdinand retaliated by placing a ban on Wilhelm as an "enemy of the empire," and naming the Darmstadt landgraf as administrator of the Hesse-Kassel territory.

In 1637 imperial and Bavarian troops invaded Hesse-Kassel again, and Croatian mercenaries in particular ravaged and looted eighteen towns, forty-eight noble estates, and three hundred villages. One-third of the population perished in half a year of famine and epidemic. Wilhelm fled with his wife, Amalie Elisabeth, son Wilhelm, and his troops to northwestern Germany, occupying East Frisia near the Dutch border by force. Thanks to French subsidies, however, he was able to keep his army, allowing him to remain a political factor in the war and in future peace negotiations. But he did not live long enough to see it, for he died of exhaustion in the same year, at the age of thirty-six.

Wilhelm V left the impossible task of governing an occupied country to his wife, Amalie Elisabeth of Hanau (1602–1650), another in the line of exceptionally energetic and competent women who decided the fate of Hesse. She was the mother of twelve children, of whom two sons and three daughters reached adulthood.

Georg II of Darmstadt prepared for the takeover in Kassel, thinking that he would have no opposition from the exiled widow; he soon found himself very much mistaken. Thanks to the excellent fortifications designed by Landgraf Moritz, Kassel was never conquered during the war. In a surprise coup, Amalie Elisabeth had the regency council in the besieged capital declare an oath of allegiance to her eight-year-old son, Wilhelm VI (1629–1663), to whom the Imperial ban did not apply. She then refused to sign the compromise negotiated between the regency council and Darmstadt and renewed the alliance with Sweden and France instead.

In 1640 Amalie Elisabeth returned with her army to Kassel, delivering the country from the occupation forces, and drove the Imperial army out of Westphalia two years later. In 1645 she ordered the commander of her troops, along with French and Swedish forces, to reconquer Upper Hesse. Subsidies from Cardinal Mazarin (1602–1661), prime minister of young Louis XIV, permitted her to increase the Hessian forces. The fratricidal "Hessian War" constituted the sinister last act in the most atrocious war Europe had seen thus far. The last decisive battle, won by a Hesse-Kassel general in Westphalia against a much larger Imperial force, secured a favorable position for Kassel in the peace negotiations.

With great diplomatic tenacity and astuteness, Amalie Elisabeth played an important role at the peace conference in Westphalia, defending the interests of the minor states. She succeeded in having a representative for every reigning German prince at the conference with

the right to vote, thereby neutralizing an essential privilege of the emperor and the electors. Her envoys further ensured that the peace be guaranteed by France and Sweden and that the Calvinist and Lutheran faiths henceforth be recognized as equal in the German Empire.

Provisions of the Treaty of Westphalia in 1648 established the lasting division of the two Hesses, with Kassel keeping Marburg, and Darmstadt retaining a major part of Upper-Hesse. Kassel had made some territorial gains, been awarded financial reparations, and, most importantly, established a reputation as a military power.

The most significant result of the Thirty Years' War was the weakening of the empire's central power in favor of its member states. Germany was fragmented into more than three hundred sovereign states and cities and close to fifteen hundred knightly estates. The ultimate winner was France, because the defeat of the Habsburg "Universal Monarchy" cleared the way for France to pursue hegemony on the European continent. The constitution of the German empire with an elected figurehead as emperor (usually a Habsburg) was to remain in effect until it was abolished by Napoleon in 1806.

Amalie Elisabeth was a workaholic. "She commands her armies from her cabinet," reported the French ambassador.[13] By the end of her life she was a renowned personality throughout Europe. Although contemporary critics called her "evil widow," "hermaphrodite genius," "double-faced oracle," or "queen of the Amazons,"[14] the dramatist Friedrich Schiller (1759–1805), in his *History of the Thirty Years' War,* commended her as "a lady with as much genius as resolution, who had at her disposal a combative army, fine conquests, and a considerable principality."[15]

The ailing Amalie Elisabeth died in 1651, soon after conferring the government on her twenty-one-year-old son Wilhelm VI. She had prepared him for the job by sending him to France to break "that bad Kassel habit of silence or little talking."[16] In Paris, Wilhelm made the acquaintance of the reigning Queen Anne (1601–1666), her prime minister Cardinal Mazarin (1602–1661), and ten-year-old Louis XIV (1638–1715). In 1649, Wilhelm went on to Berlin, where he was married to Hedwig Sophie of Brandenburg (1623–1683), from the House of Hohenzollern, in one of the first of several marital alliances between Hesse and Prussia.

In his thirteen-year reign, Wilhelm VI (called "Wilhelm the Just") attempted to heal the wounds of war. He resettled discharged soldiers and peasants forced from their lands, closed the frontiers to foreign recruiters, and reinforced laws against highwaymen and poachers. He also restructured labor and the economy, reorganized the civil service, and reconciled Calvinists and Lutherans, which proved almost harder than reconciling Protestants and Catholics.

After Wilhelm's death in 1663, his widow Hedwig Sophie continued his work as regent, first for her eldest son, Wilhelm VII, and, when he died at age nineteen, for her second son, Karl. Kassel's military reputation made it a desirable ally, especially for Hedwig's brother, the belligerent Great Elector Friedrich Wilhelm of Brandenburg (1620–1688). But Hedwig was conscious of her small, exhausted country's need for peace and tried to keep out of foreign conflicts.

She used marital alliances to help Kassel become part of a network that would chart politics in northern Europe for two hundred years. Her eldest daughter Amalie (1650–1714)

JOHANN CHRISTOPH
JOBST (Kassel 1599–1657)

Landgräfin Amalie Elisabeth of Hesse-Kassel, 1639
Oil on canvas
H. 42⁵⁄₁₆ in. (107.4 cm); W. 34¾ in. (88.2 cm)
Signed: *H. C. JOBSTP;* inscribed upper left: *Quus iacta stupent Heroica vesper et ortus Quui cancri festo Teutones ore vehunt. Landgravia haec illa est, Quae cum Germania turpi Iam submisisset libera colla.*
FAS on loan from City of Kassel

was married to the Danish King Christian V (1646–1699), and her youngest, Elisabeth Henrietta (1661–1683), wed the future King Friedrich I of Prussia (1657–1713). When Hedwig Sophie finally was forced to turn over the reins of power to her twenty-three-year-old son Karl in 1677, she complained: "It wouldn't have done him any harm to have asked me for further advice."[17]

Karl's Dream of a Greater Hesse

In his long reign of over half a century, Landgraf Karl of Hesse-Kassel (1654–1730) became the most important Hessian ruler since Philipp the Magnanimous. He pushed his country to the limits of its potential, hoping to regain the powerful position Hesse had held before its division by Philipp in 1567, and to play a more influential role in European politics.

Louis XIV's attacks along the Rhine came to mark a fundamental change in Kassel's foreign politics. Breaking off relations with France, which had been an ally since the days of Philipp the Magnanimous, Karl joined forces with the main Protestant states of Brandenburg-Prussia, England, Hanover, and the Netherlands—even with Catholic Emperor Leopold I (1640–1705).

Kassel's excellent soldiers had long been attractive to allies in constant need of troops. Landgraf Karl had expanded and reorganized his forces on a professional scale, but the modest economy of Hesse-Kassel was insufficient to support a large standing army. Financing was achieved by subsidy contracts whereby the country desiring the use of Hessian troops paid the costs plus a profit to the Hessian government. The eighteen subsidy contracts, usually termed "defensive alliances," that Karl negotiated between 1677 and 1726 with the emperor, Denmark, Sweden, the Netherlands, England-Hanover, Spain, and the Republic of Venice yielded considerable profits to the treasury. Thanks to these foreign subsidies, the landgraf became increasingly independent from financial control by the Hessian *Landtag* and exerted a practically absolute power.

The Kassel "military enterprise" was frequently commanded in action by the landgraf himself, and later by his sons.[18] It proved its effectiveness against the army of Louis XIV. While the French conquered Alsace and ravaged the Palatinate, transforming the electoral residence at Heidelberg into the "romantic" ruin familiar to tourists today, the Rhine-Mosel region was preserved. This was chiefly due to the efforts of Hesse-Kassel, as the Hessian fortress of Rheinfels was the only bridgehead to resist the French assault in 1693.

In 1685 Louis XIV triggered a wave of emigration by revoking the Edict of Nantes, which had granted religious freedom to French Protestants. Karl was one of the first princes to welcome the Huguenot refugees. Earlier, Philipp the Magnanimous had supported the Reformation in France diplomatically and financially, and Hessian captains commanded German auxiliary forces in the religious wars in France. Now, under Karl's reign, Hesse-Kassel received about four thousand French immigrants. Twenty-one Huguenot colonies were founded, including the towns Karlshafen on the Weser River and Kassel-Oberneustadt. With a population of around 180,000, Hesse-Kassel received a proportionally greater number of immigrants than any other German state. Appreciated for the work ethic that accompanied their Calvinist faith, the immigrants were granted their own administration and the use of their own language, enriching the country culturally and economically.

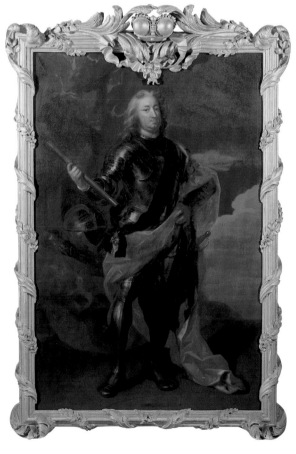

HERMAN HENDRIK QUITER I

Landgraf Karl of Hesse-Kassel, ca. 1700

FAS B 538

The landgraf sought to emulate the efficient administration of civil servants developed within the absolutist regimes of France and Prussia. Karl was not an intellectual, but had a practical mind and was interested in technical progress. In 1709 he founded the *Collegium Carolinum* in Kassel which, in connection with natural-scientific institutes, represented the first type of technical college in Germany.

Proceeds from military subsidies allowed Karl to undertake ambitious architectural projects in and around Kassel. The most extraordinary was the work of the Italian architect Giovanni Francesco Guernieri (ca. 1665–1745), whom the landgraf had brought back from a journey to Italy in 1700. A lofty hilltop castle in the shape of an octagon crowned by a pyramid served as the base for a colossal bronze figure of Hercules (see p. 52). From a grotto at the foot of the edifice, a waterfall gushed down over artificial rock cascades, filling several basins and ending in a pond with a grotto of Neptune. The work took thirteen years to build. In fact, it was only one-third of a project meant to eclipse the Sun King's Versailles, but was never completed as the constant repair of construction faults swallowed up the budget and the architect fled. Still, the Hercules cascade was described as "a miracle that seems to have emanated from the hand of a supernatural power."[19]

The colossal monument was not only an allegory of princely power, but its defects symbolized absolutist ambitions overstraining the capabilities of a minor state, for Landgraf Karl strove to raise the prestige of his dynasty with the splendor of a royal crown. In 1715, in exchange for the offer of a Hessian auxiliary corps of six thousand men, he obtained the hand of Ulrike Eleanora (1688–1741), the sister of Karl XII of Sweden (1682–1718), for his eldest son Friedrich. But his hopes to benefit from the union with Sweden were soon disappointed. In 1720, when the Swedish bachelor king died in battle against Russia, the nobility of the Swedish Parliament elected Friedrich of Hesse-Kassel (1676–1751) as his successor. Friedrich, a brave but simple military mind without governmental experience, turned out to be a mere tool in the hands of the powerful nobility. Instead of receiving an appropriate royal salary, Friedrich constantly had to ask for money from Kassel. After four years on the Swedish throne, the Hessian king sighed: "Oh, if only I had never come to this country!"[20] For thirty years, a steady cash flow passed one-way from Kassel to Stockholm, adding up to the astronomical sum of about 4.5 million *thalers*. Hesse was paying dearly for the vain dream of royalty.

In the meantime, the king consoled himself by "hunting bears and beauties," as the Swedes mocked.[21] While his marriage remained childless, he had two sons with his mistress Hedwig Taube (1717–1744), a lady-in-waiting of his wife nicknamed by Friedrich's brother *"la belle Colombe"* (*Taube* meaning *colombe* in French and "dove" in English). The sons received the title of counts of Hessenstein. Several estates in northern Germany including Panker (today still a residence of the Hesse family—see p. 237) were purchased with Hessian money and united to form the so-called *"Herrschaft Hessenstein"* to provide for the living of the illegitimate offsprings.

In 1730 when Landgraf Karl died at the age of seventy-six, King Friedrich was given a leave from Sweden to receive the official homage as Landgraf Friedrich I in his homeland. It was the only time that he was allowed to leave Sweden. He even had to take an oath that he would rule his homeland to the advantage of Sweden (presumably in reference to the cash flow). Meanwhile in Kassel, his brother Wilhelm acted as Friedrich's loyal deputy for twenty-one years with an exemplary economic administration, balancing the costly royal interlude in Sweden that ended with Friedrich's death in 1751.

Darmstadt's Extravagant Hunters

There is a certain symmetry in the biographies of the cousins (five times removed) Ernst Ludwig of Hesse-Darmstadt (1667–1739) and Karl of Hesse-Kassel. Ernst Ludwig was also a second son, whose mother held the regency until his majority. During an equally long reign of over fifty years, he confronted similar problems of reconstructing an administrative and military state, though on a smaller scale. As a reaction to repeated devastations by French armies during the Palatinate Succession War, Ernst created a small standing armed unit in 1691, which he at times also rented to alliance partners. He likewise received Protestant refugees from the French-Italian border and founded several settlements.

As typical Baroque sovereigns, both princes enjoyed a glamorous court and cultural life. Ernst, however, indulged in his enthusiasms more recklessly. He engaged the French architect Louis Remy de la Fosse (1659–1726) and, like Karl, undertook large-scale projects, such as an orangerie, two French gardens, an opera house, and a huge castle in the center of Darmstadt. Both the castle and orangerie, however, remained unfinished because their cost greatly exceeded their budgets.

Ernst Ludwig's passion for the hunt entailed the construction of hunting seats all over the country. (One castle, Wolfsgarten, also designed by de la Fosse, situated in the woods fifteen miles north of Darmstadt, is still the residence of the Hesse family, see p. 228.) Ernst's favorite sport was the French *chasse à courre* ("coursing hunt"), a stag hunt requiring *piqeurs* ("outriders"), French liveries, horns, horses, and packs of English hounds. The stag was chased cross-country, causing considerable damage to agricultural fields and unrecompensed hardship for the peasants. Fortunately, within ten years the landgraf could no longer afford this most expensive form of the sport. In fact, the burden of the 2 million *florins* debt at the beginning of his reign had doubled by the end of his life.

Because of his father's longevity, Ludwig VIII (1691–1768) only took over at the age of forty-eight. He is remembered as a hunting enthusiast, and Kranichstein, his favorite hunting seat in the woods near Darmstadt, survives as one of Germany's finest hunting museums. The charming eccentric, who loved to drive about in a special open carriage drawn by six trained stags, was popular and generous with his hunting guests and aides, though less so with the rural population whose fields suffered severely from his hunts and who were forbidden themselves to shoot game.

ZACHARIS SONNTAG

Landgraf Ludwig VIII of Hesse-Darmstadt in his Stag Drawn Coach,
ca. 1740
SDJ 004/001/1

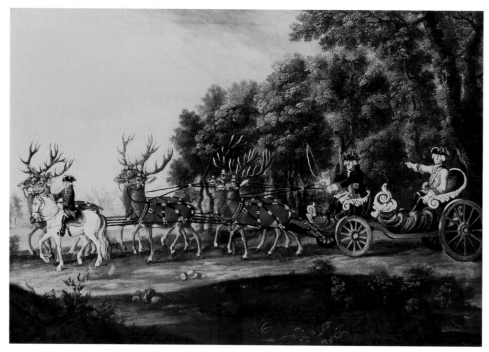

Ludwig VIII was on excellent terms with Empress Marie Theresa (1717–1780) in Vienna, taking her side in the Seven Years' War against Friedrich the Great of Prussia (1712–1786) (although Ludwig's support was merely moral as he lacked the means to enforce it). The empress graciously saved his country from bankruptcy by preventing the Imperial Court of Justice from taking action against Darmstadt. Ludwig thus was able to enjoy his life to the last minute, dying of a heart attack in his opera box at the age of seventy-eight.

Kassel's passionate Art Lover

In 1751, when Wilhelm VIII (1682–1760) finally became landgraf in Kassel, he was almost seventy years old. He had already governed the country for twenty-one years in place of his older brother Friedrich, who was king of Sweden. Before that he had served as a general in the Netherlands for almost thirty years. In 1713 the future landgraf was named governor of the Fortress of Breda and ten years later of Maastricht. During this time he bought an estate and felt completely at home in the Netherlands.

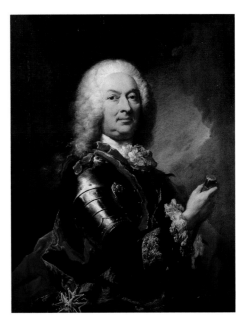

It was in the Netherlands that Wilhelm discovered his interest in paintings and began assembling what was to become a great collection of Dutch, Flemish and, to a lesser extent, French and Italian art. In the 1740s and 1750s, he purchased entire collections at estate auctions through Dutch art agents. A private collection he acquired in 1750 contained eight Rembrandts, including *The Descent from the Cross* (now in the Hermitage), *Portrait of Saskia,* and *Self-portrait with Morion Helmet.* Two years later he purchased Rembrandt's *Jacob Blessing the Sons of Joseph.* Wilhelm's collection also contained paintings by Rubens (1577–1640), Frans Hals (1582/3–1666), Anthony van Dyck (1599–1641), Jordaens (1593–1678), and Terborch (1617–1681), among others. One of his last acquisitions was Titian's (1490–1576) portrait of a nobleman with a putto and dog from an estate auction in Paris. All of the above are now in the Gemäldegalerie Alte Meister, Staatliche Museen, Kassel. To house the collection of around four hundred works he had inherited and the five hundred he himself had acquired, Wilhelm commissioned the Bavarian court architect and master of the Rococo style, François de Cuvilliés (1695–1768) to design a picture gallery. Charles du Ry (1692–1757), of the famous Huguenot architectural dynasty, carried out Cuvilliés's plans next to Wilhelm's Kassel residence. Along with the galleries in Berlin, Dresden, and Munich, the Kassel collection became known as one of the finest in Germany.

When the landgraf was looking for a court painter in 1753, the young artist Johann Heinrich Tischbein (1722–1789, see p. 54) was introduced to him. Tischbein showed him a lady's portrait he was working on at the time and Wilhelm asked: "Did he paint that?" When Tischbein said yes, Wilhelm shook his head incredulously: "I don't believe it, a German can't make something like that. Where is he from?"

"I'm a Hessian from Haina."

"Ah, from the madhouse?" the landgraf said jokingly, as Haina was synonymous with its mental hospital founded by Philipp the Magnanimous. "Does he dare to paint me?"[22] Tischbein agreed to accept, if the landgraf would sit for him for three hours.

Wilhelm was so satisfied with the result that he engaged Tischbein on the spot as court painter. In many portraits and animated scenes he immortalized the Rococo lifestyle of the court and the wealthy bourgeoisie of Kassel.

Wilhelm's favorite creation was Wilhelmsthal, a country residence near Kassel begun in 1743 according to the plans of Cuvilliés, who also designed its French-style garden. August Nahl the Elder (1710–1781, see p. 46) created sculptures for the park and rococo stucco and woodwork for the interiors. Tischbein contributed portraits of ladies to Wilhelm's

JOHANN HEINRICH
TISCHBEIN THE ELDER
(Haina 1722–Kassel 1789)

*Wilhelm VIII of Hesse-Kassel
Wearing the Order of the
White Falcon,* 1753
Oil on canvas
H. 38⁵⁄₁₆ in. (97.3 cm); W. 29⁷⁄₁₆ in.
(74.8 cm)
FAS B 74

"Gallery Beauties." Wilhelm VIII, however, never saw the completion of his country seat. After the Seven Years' War broke out in 1756, French troops occupied Hesse, forcing him into exile in the county of Schaumburg, a Hessian exclave on the Weser River. There he died in 1760.

Like his father, Wilhelm VIII pursued the elusive goal of territorial gain and appointment as an elector of the empire. This obsession involved him in both sides of the War of the Austrian Succession, hiring out troops to the opposing parties as each seemed to justify his hopes for advancement. As usual, these hopes amounted to nothing, since the major powers were interested in Kassel's excellent troops, not in increasing its political influence.

The Seven Years' War was triggered in 1756 by the attack of the Prussian King Friedrich II ("the Great") on Saxony. The year before, Kassel, a traditional ally of England and Prussia, had settled a subsidy treaty with England in which it was to supply 12,000 (later 20,000) men. Although well paid, the landgraf was deprived control of his army that, together with the allied Hanover-Brunswick troops, came under the command of Duke Ferdinand of Brunswick (1735–1792). This left Hesse-Kassel defenseless against England's main adversary, France. As a result, French troops occupied the country, including Kassel, five times within seven years.

Light and shadow of enlightenment

Friedrich II (1720–1785) had grown up without his mother, Dorothea of Saxe-Zeitz (1691–1743); due to a depressive mental condition, she had been confined ever since he was an infant. Friedrich also never had an easy relationship with his rigidly Calvinist father, who seemed more comfortable expressing his affections when it came to art. At the age of twelve, Friedrich was sent with a tutor to the University of Geneva where he received lessons from renowned professors in the spirit of Calvinism and the French Enlightenment. Although he showed interest in enlightened ideas, his tutor frequently complained of his susceptibility to pleasure and amusement. Returning to Kassel at age sixteen, Friedrich underwent military training. Tall and handsome, he impressed women, but to critical observers he appeared superficial and easily influenced by courtiers.

At twenty he was married to Mary (1723–1772), the seventeen-year-old daughter of George II of England (1682–1760), the second Hanover elector on the British throne. The union was a political match, "concluded," as the marriage contract stated, "to strengthen the friendship between both Houses, particularly for the best of the Protestant religion."[23] The friendship was sealed immediately via the subsidy treaty by which England leased six thousand soldiers.

Mary and Friedrich had little in common besides their three sons. Friedrich was absent most of the time on military business. In 1746 he accompanied the Kassel corps to Scotland where he kept the Scottish reinforcements in check, while his brother-in-law, the Duke of Cumberland, was in Culloden decisively beating the Highland army of the Catholic Stuart pretender, Bonnie Prince Charlie (1720–1788). Horace Walpole (1717–1797), who saw Friedrich in London, did not have a very high opinion of him, remarking, "His love affairs are very base and numerous, for he doesn't care much about our daughter [Mary]."[24]

In 1754 Friedrich's father learned from a relative that his son had secretly become a Catholic. As Friedrich was not particularly religious, many suspected that Catholic powers, interested in the Kassel military force, were pulling the strings behind the scenes. The rigorous Calvinist landgraf immediately forced his son to sign a declaration known as the Security Act, in which Friedrich promised to preserve the Protestant religion of the country; employ no Catholic civil servants or officers; renounce the education of his sons; and agree to a separation from his wife Mary (rather than a divorce, so as to prevent him from remarrying a Catholic). Finally, Friedrich had to give up the county of Hanau (which came to Hesse

thanks to an inheritance treaty). It passed directly to Friedrich's son Wilhelm to provide for him, his mother and brothers living independently of their father. The declaration was guaranteed by the main Protestant powers: Hanover-England, Prussia, the Netherlands, and Denmark.

During the Seven Years' War, Friedrich the Great of Prussia gave the Hessian Friedrich the rank of field marshal in the Prussian army to prevent him from taking service with the enemy. The king did not think much of Friedrich's military qualifications, though, and instead of a field command, he gave him the honorary post of vice-governor of Magdeburg.

When Wilhelm VIII died in exile, Friedrich did not attend the funeral, making it clear that he had not forgiven his father for the humiliations following his change of religion. As the new landgraf, he only returned to his country when the French had moved out in November 1762. The peace concluded in 1763 led to Prussia becoming a major European power and henceforth disputing Austria's control of the Empire. Hesse-Kassel's only gain—the subsidies paid by Great Britain—were largely used to repair damages caused by the French occupation.

The Hessian Friedrich greatly admired the Prussian Friedrich, his military, and bureaucracy and wanted to pursue the enlightened absolutism advocated by Voltaire (1694–1778), with whom he corresponded. Lacking the ambition to govern as an autocrat, however, he instead appointed qualified cabinet ministers (mostly Prussian officers) to realize the intended reforms.

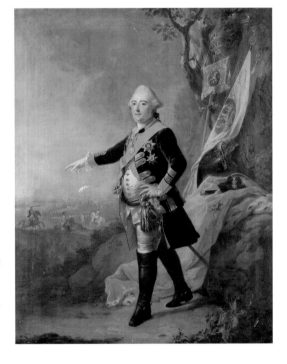

Education was at the core of the Enlightenment. To enhance his reputation, Friedrich founded the Art Academy, and the court painter Tischbein was appointed as one of its first professors. The landgraf modernized the *Collegium Carolinum* and brought in first-rate professors who were part of a regularly communicating network of international intellectuals. Critical thinking was encouraged even though it subverted the goals of enlightened absolutism, which subscribed to the maxim "everything for the people, nothing by the people."

One of Friedrich's main concerns was to reshape his capital and make Kassel, a town with 18,000 inhabitants, an internationally admired attraction. The old fortifications were demolished, and Simon Louis du Ry (1726–1799) directed the construction of modern buildings and squares. A maternity and foundling home, hospital, opera house, and theater were built. Du Ry's masterwork was the *Fridericianum,* constructed in the English Palladian style, to house the Hessian antiquities and scientific collections as well as the princely library. Inaugurated in 1779, it was the first building on the continent to be designed as a public museum, following the model of the British Museum, founded in 1753.

The image of a cultured capital was completed by an orchestra, Italian and French opera ensemble, ballet, and French actors. Admission was free for court members, and officers paid according to their rank, but commoners were charged and therefore were not regular theatergoers. Of Friedrich, a chronicler said that he "could have been a conductor, as during orchestra rehearsals that he sometimes attended, he reproved and corrected the slightest error."[25]

Friedrich also liked to conduct the daily parade drill of his Guard regiments, the pride of his army. In spring and autumn he personally directed the maneuvers of his 20,000-man army, composed of conscripts (mainly the younger sons of peasants), militia (who were given leave twice a year to help with agriculture), and recruited mercenaries.

The Hessians in America

While his grandfather had settled eighteen subsidy treaties and his father twelve, Friedrich II concluded only one, in January of the memorable year 1776. It was the most lucrative deal ever made by a landgraf. England was desperate for troops to put down the rebellion in her American colonies. Called a "treaty of friendship and assistance," England leased 12,000 men (later increased to 17,000), paying £7 per recruit, plus the regular pay of a British soldier, and an annual subsidy of £108,000 that was to be paid until a year after the return of the troops. The Hessian soldiers were to be engaged only in their own units and commanded by Hessian officers. Even though no Hessian interests were at stake in America, the treaty was approved by the *Landstände* (the pre-parliamentary representation of the estates), which welcomed the benefit to the country. Besides the money Hessian soldiers sent to their families back home, they also enjoyed a fifty percent tax relief. The subsidies brought a net profit to the war treasury of 12.6 million *thalers,* equaling about $4.35 million. Besides the development of his capital city, the landgraf used the income to found sixteen new villages, each comprised of ten families. Each settler received thirty acres and three hundred *thalers* for building, a loan of one hundred *thalers* to purchase livestock, and three years exemption from taxes and military service.

England also leased troops from several other small German states, among them Brunswick and Hanau. Friedrich II's son Wilhelm had governed Hanau since 1764, the county being transferred to him directly from his grandfather Wilhelm VIII by the Security Act. Wilhelm was twelve years old when he last saw his father and was on bad terms with him, since the landgraf disputed his right to reign in Hanau. Despite their differences, they had at least one thing in common: their military passion. Wilhelm himself had created and drilled his little army and he and his father both were distressed to see their favorite objects of attention being shipped to America. Their Darmstadt cousin Ludwig IX (1719–1790) was so fond of drilling his soldiers (see p. 93) that he would not dream of sending them to war. Inspired by his enlightened minister, who introduced excellent reforms in Darmstadt and restructured its ruined finances, Ludwig disdainfully called subsidies "blood money" and prohibited the Kassel and Hanau recruiters, notorious for their harsh methods, from recruiting in his country.

Since the Hessian units, together with the Hesse-Hanauers, represented well over half of the German contingent (about 30,000 men) engaged on the English side in the Revolutionary War, Americans called all German soldiers "the Hessians." Revolutionary propaganda, inspired by the ideals of mankind's "inalienable rights," condemned the "soldier trade" by "tyrannical petty princes of Germany" who "sold their subjects, like cattle, to a foreign monarch."[26] The term "sold Hessians" soon became a catchword, especially once the French Count Mirabeau (1749–1791) published his famous pamphlet *Avis aux Hessois* ("Appeal to the Hessians") in 1777, calling upon Germans not to tolerate such abuse any longer. Like Mirabeau, American publications, however, failed to mention that the French also were employing German mercenaries from the Palatinate and Trier to fight on the American side, disguised in French uniforms. Thanks to the propaganda and American politics, the relatively high number of deserters amounted to 2,900. Of 17,000 men, 4,600 died of disease (mainly dysentery). One Hessian officer explained the small number of 400 casualties in action by declaring that compared to European conflicts American battles were just "serious skirmishes."

Although historians largely ignore it, the treatment of Hessian soldiers taken prisoner after the American victories at Trenton, Saratoga, and Yorktown is worth mentioning. They were in great demand as skilled workers and artisans. The prisoner commissioners rented them out as cheap labor—at cheaper rates than English prisoners and black slaves—to private operators and public enterprises. Hessians worked in shoe factories, as army tailors, and army blacksmiths. They also worked in salt and iron mines. The Hessians' usefulness

for military and civil purposes made the Americans reluctant to exchange them according to prisoner conventions. The official excuse was that "Hessians were not eager to return to their units."[27]

At war's end, great efforts were made to recruit Hessians as cheap labor for three more years. The prisoners were told that the £30 cost of their upkeep would no longer be covered. Therefore they had to work it off, either by entering the American army or indentured service. Feeling treated "like under the Turks," two-thirds of the Hessian soldiers in Philadelphia obstinately refused.[28] They succeeded, but had to endure confinement in overcrowded prisons. The whole practice of bound service contradicted the conditions of the Treaty of Paris and was hardly compatible with the Declaration of Independence.

Ironically, during the course of the war, Hessian troops replaced their army musicians with black runaway slaves, who felt safe in the ranks from the claims of their former masters. Paid employees, they worked as drummers and pipers and as officers' servants. Many even returned with the soldiers to Hesse, where they enjoyed the relative freedom of subjects in the current social order.

A princely Banker

Thanks to his grandfather's settlement, Wilhelm (1743–1821) ruled Hanau for twenty-one years before he succeeded his father Friedrich II in 1785 and Hanau was joined to Hesse-Kassel. He first displayed his remarkable entrepreneurial sense when he used the subsidy contracts to bring prosperity to his domain during what was called Hanau's "golden age." He invested the profit in developing the site of a mineral spring where he created Wilhelmsbad, a commercial spa resort with lodgings, gambling casino, theater, and elaborate gardens with entertainment areas (see pp. 56–59). It soon became a fashionable European tourist destination that boosted the local economy and today remains a popular public park. Thomas Jefferson (1743–1826), then ambassador to France, visited Wilhelmsbad in 1788 and was so taken with the picturesque mock medieval ruin in the park that he sketched it in his notebook.

Inside Wilhelmsbad's neo-Gothic tower was an intimate retreat where Wilhelm could retire with a paramour to escape his unhappy marriage. Even before his wedding to his first cousin Caroline of Denmark (1747–1820), he confessed in his memoirs, "I felt with horror that in no way did we suit each other."[29] He took comfort with several mistresses (albeit only one at a time), whom he had ennobled through the emperor. The economical father provided for the children of these liaisons by increasing the salt tax by one *Kreuzer* ("cent").

Wilhelm replaced his father's enlightened government with autocratic rule. Based on a bad experience in Hanau, he believed all advisors to be dishonest. Thinking that he could do without advice, he dismissed the Prussian ministers on whom his father had relied. Fully confident in his own abilities, he took over personal control of finances. To cut court expenses he closed the French and Italian opera and dismissed the French artists and courtiers. Between 1786 and 1798, however, he had the architects Simon Louis du Ry and Heinrich Christoph Jussow (1754–1825) construct the palace of Wilhelmshöhe near Kassel. The three-part Neo-classical edifice ingeniously completed the grand Hercules cascade project of his great-grandfather Landgraf Karl. He transformed the grounds into one of the most remarkable English landscape parks in Europe, with romantic waterfalls and another neo-Gothic castle ruin, the "Löwenburg."

Wilhelm not only made new subsidy contracts with England to continue the enrichment of the Kassel treasury but also put the monies to work. He took on the role of a princely banker, making loans to states, kings, princes, and private persons. At the beginning of his reign, he occasionally extended credit to Hessian farmers, artisans, and communities. But the money lending business soon degenerated into mere profit making without being reinvested in the country's economy.

Wilhelm was less talented in politics than with money. He initially had been disposed to continue the reforms of his father and particularly that of liberating peasants and farmers from feudal burdens. His militant opposition to the French Revolution, however, pushed him into a reactionary position. In 1792 he took part at the side of the Prussian King Friedrich Wilhelm II (1744–1797) in an intended punitive expedition against revolutionary France. The venture ended with the coalition forces' inglorious retreat and the revolutionary troops' advance toward the Rhine. Two years later the French occupied Kassel's Rhine territory. In 1795 Wilhelm was forced to follow the Prussian example, making peace with France.

In 1803 Wilhelm was able to fulfill the dynastic ambitions of his ancestors when he attained the rank of *Kurfürst,* or elector, of the German Empire. By a resolution of the Imperial Diet approved by the emperor and all the German princes, Landgraf Wilhelm IX was elevated to the rank of Elector Wilhelm I. After German princes had lost lands on the left bank of the Rhine to the French, as a consequence of a treaty between the European coalition and the new French ruler Napoleon, they were compensated with secularized ecclesiastical territory and possessions. In reality, the elector's crown was a poor consolation for Wilhelm's losses of Rhine territories. Although he was the wealthiest German prince, he was undercompensated because he had refused to pay bribes to Napoleon's foreign minister Talleyrand (1754–1838), who was the arbiter of the peace settlement. In contrast, his pragmatic Darmstadt cousin, Ludwig X, paid without hesitation, thereby gaining seven times as much territory as he had lost.

Only three years later, the elector status lost its only remaining privilege—to elect the German emperor. In 1806, to Wilhelm's dismay, the south German princes deserted the German Empire to join the new Confederation of the Rhine created by Napoleon (1769–1821), who had become its protector. As a consequence, Emperor Francis II (1768–1835) renounced the crown of the German Empire and followed Napoleon's suggestion to declare himself Emperor Francis I of Austria. Even Wilhelm was given the chance for an upgrade, to become King of Hesse. He refused, however, because the offer came from the hated upstart Napoleon. Less scrupulous, the electors of Bavaria and Württemberg accepted the offer and were made kings. But the biggest shock for the Kassel elector must have been the realization that his Darmstadt cousin had outdone him again: he had joined the Confederation of the Rhine, by which he gained still more territory and was named Grand Duke.

In a further misstep that year, the elector claimed neutrality but secretly prepared to join forces with Prussia when it declared war on France. After the French victory over the Prussian army at Jena, Napoleon, seeing through Wilhelm's maneuver, ignored his neutrality, and ordered the occupation of Hesse-Kassel. The elector fled to northern Germany where his brother was governor of the duchies of Schleswig-Holstein, and the electorate of Hesse was wiped off the map. It was integrated into the newly created kingdom of Westphalia that Napoleon's brother Jérôme (1784–1860) governed. Wilhelm's favorite creation, Wilhelmshöhe, was rebaptized "Napoleonshöhe." When the French advanced to occupy Holstein in 1808, Wilhelm moved on to Prague.

From exile, Wilhelm managed to revive his financial fortunes. Devoted servants in Kassel bribed the French general in charge and smuggled out forty-two cases, which contained the greater part of the Kassel treasury's assets in the form of bonds, securities, and promissory notes on loans to clients across Europe. Carl Buderus (1759–1819), Wilhelm's longtime accountant, used the Frankfurt banker Meyer Amschel Rothschild (1744–1812) and his sons in London, Paris, and Vienna to collect interest, reinvest, and otherwise maximize the value of the assets. The arrangement increased Wilhelm's fortune considerably and at the same time laid the foundations of the wealth of the House of Rothschild.

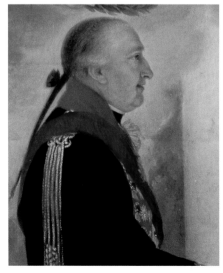

Elevation of Elector Wilhelm I of Hesse-Kassel, 1805 (detail, see p. 99)

At the end of 1813 Wilhelm returned to Kassel after Russian coalition troops had expelled the French. Determined to set back the clock, the seventy-year-old elector annulled almost all the progressive institutions the Napoleonic regime had introduced during his seven-year exile, including the constitution, parliament, and civil code. One exception was the emancipation of the Jews. Although revoked in most other German states, the reform remained partly in effect in Hesse-Kassel, probably thanks to the Rothschilds' good services. At the same time, the Liberation Wars against Napoleon had evoked the *Nationalgefühl*, a consciousness of a German Nation, among intellectuals and the rising middle class. Enhanced by the French revolutionary principles of civil liberty and equality, it transcended the borders of principalities and threatened princely thrones.

The 1815 Congress of Vienna, presided over by the Austrian chancellor Metternich (1773–1859), attempted to restore the old social order by establishing a new political order for Europe. The German Confederation was created as a loose organization of sovereign German principalities under the presidency of Austria, but its stability was soon put in question as Austria and Prussia competed for hegemony in Germany. Although Hesse-Kassel was restored as an electorate, the designation was an anachronism from the defunct German Empire. Even with the addition of the former bishopric of Fulda, Hesse-Kassel had a population of only 568,000, which was less than the Grand Duchy of Hesse-Darmstadt's 627,000 inhabitants. Both the Kassel elector and the Darmstadt grand duke were granted the hereditary title of "Royal Highness."

Wilhelm joined other German sovereigns in consenting to give his country a constitution, but he soon clashed with the *Landtag* over the question of finances, considering the treasury to be his personal property. When the *Landtag* demanded an evaluation of the state treasury and its separation from the elector's private purse, he broke off negotiations on the constitution and suspended the *Landtag*. Aged, obstinate, and having outlived his time, the elector died in 1821. He was buried at his beloved neo-Gothic ruin, the Löwenburg, symbolic of his attachment to the past.

Darmstadt's Advance

The son of the military enthusiast Ludwig IX and the gifted intellectual Caroline (1721–1774), whom Goethe dubbed "the great landgräfin" and to whom Friedrich the Great attributed "the appearance of a woman, but the mind of a man,"[30] succeeded his father in 1777 as Landgraf Ludwig X (1753–1830). In exchange for subsidies from the German emperor and England, he contributed a unit of 5,000 men to the war against revolutionary France. When he reluctantly joined the Napoleonic Confederation of the Rhine, after French forces occupied his territory in 1806, he was elevated to Grand Duke Ludwig I and in return was obliged to put his troops at Napoleon's disposal. They suffered severe casualties fighting against Spain, Austria, and Russia. Finally, in 1813, he reversed alliances and joined the anti-Napoleon coalition liberating Germany. Still, he did not forget to whom he owed his elevation and the modernization of his state: "Napoleon is my friend," he wrote in 1814, "and I shall be grateful to him as long as I live."[31] In the resulting peace settlement he had to cede territory to Prussia but was compensated with the former bishoprics of Mainz and Worms on the Rhine. He added this to his title, which became *Grossherzog von Hessen und bei Rhein.* Moreover, whereas his cousin Wilhelm had denied Kassel a constitution, Grand Duke Ludwig I granted Darmstadt a constitution in 1820 after a four-year negotiation.

Ludwig's real love was theater and opera. In 1819 he built a new 2,000-seat theater in Darmstadt that welcomed the public, unlike the small traditional court theaters for the exclusive use of the court circle. The new theater's size was all the more remarkable since Darmstadt's population was only 20,000. The company of two hundred to three hundred included an orchestra of eighty-five musicians. The grand duke himself engaged the singers and occasionally conducted an opera. Inspired by Enlightenment principles, Ludwig

also opened the princely library and art collections "for the pleasure and education of the public."[32] Today he is remembered in Darmstadt by his monument which stands in the center of the city. The tall column topped with a figure of the grand duke is popularly known as *der lange Lui* ("the long Louis").

rulers out of touch with their times

Beginning with Wilhelm I, the electors increasingly lost touch with their times. While the landgrafs had been either strong personalities setting the pace for innovation, or at least managed to balance personal and public interests, the scales clearly shifted with the electors who favored their personal interests at the state's expense. The first elector's son, Wilhelm II (1777–1847), unlike his parsimonious father, was lavish with money. As he also refused to give up control of the treasury, the constitutional crisis his father had triggered dragged on.

Wilhelm II's private life exacerbated the political crisis. His marriage in 1797 to the Prussian king's daughter Auguste (1780–1841) was arranged to reinforce political ties

G. ZAHN
Elector Wilhelm II of Hesse,
ca. 1821
FAS B 415

*Princess Electoress
Auguste of Hesse
Copying the Sistine
Madonna,* 1808–1809
FAS B 362 (see p. 118)

between Kassel and Berlin. Wilhelm, with his irascible, narrow-minded personality, was incompatible with Auguste, who was bright, sociable, and a talented painter. From the time of their exile to Berlin during the Napoleonic era, the couple lived apart. Wilhelm fell in love with Emilie Ortlöpp (1791–1843), the daughter of a Berlin goldsmith, and brought her back with him to Kassel, where he set her up in an apartment in town. When Wilhelm I died in 1821, Wilhelm II ennobled his mistress and their nine children as countesses and counts of Reichenbach.

The popular Electoress Auguste attracted a cultural and intellectual circle. It included the Grimm brothers, who were working in Kassel on the edition of their fairy tales that would become the best-read book in all of German literature. After long negotiations mediated by Prussia and Austria, a separation settlement was reached in 1829. Auguste received the castle at Fulda and the nearby summer residence of Fasanerie, which Wilhelm's architect, Johann Conrad Bromeis (1788–1854), had just refurbished.

The elector's mistress, on the other hand, aggravated the political situation when she tried to take an active role in government. She became the focus of public resentment over generally bad conditions, which included a police state and rural poverty so extreme that it drove many families to emigrate to America. The French July Revolution of 1830 spread unrest across the Rhine to southern Germany and Hesse, rekindling demands for a constitutional government and a separation of public and princely funds. Wilhelm's mistress fled to Hanau where he joined her in 1831, after having agreed to the division of the treasury. Henceforth, one half formed the state treasury and the other constituted the private fortune of the dynasty. At the last minute, Wilhelm also signed the constitution (the most liberal in Germany), drafted by a *Landtag* committee, before leaving the government to his twenty-nine-year-old son, Friedrich Wilhelm.

Grand Duke Ludwig II (1777–1848) of Hesse-Darmstadt was also criticized for his extramarital affairs. Reigning in stormy times between the revolutions of 1830 and 1848, he left government to his prime minister. A series of bad harvests in the mid-1840s led to increased emigration of the rural population to America. Ailing and not particularly strong-willed, Ludwig II preferred a life at his countryseats while his uncle Emil, a qualified general, exerted political influence following Metternich's system of repressing civil liberties.

Kassel Elector Friedrich Wilhelm's regency (1831–1847) for his father Wilhelm II was anything but favorable. His youth had been marked by the marital conflict of his parents. Although he took his mother's side against his father, he possessed his father's narrow-mindedness and lack of judgment. He fell in love with Gertrud Lehmann (1803–1882), the wife of an officer, and obtained her divorce in exchange for financial compensation to

her husband. He married her as soon as he became regent. Although he made Gertrud a countess, first of Schaumburg and later of Hanau, German dynastic law prohibited the inheritance of the throne by descendants of an *unebenbürtig* ("unequal rank") union. Hence, the marriage was morganatic.

Friedrich Wilhelm then precipitated a political crisis by trying to revise the constitution. The situation soon degenerated into what was to become a catchphrase in German politics: the *kurhessische Zustände,* meaning "chaotic affairs." During the Austro-Prussian War of 1866, the Prussian army marched in without firing a shot. Friedrich Wilhelm, who had been elector since 1847, was taken prisoner and then exiled, to the population's general relief. When Prussian chancellor Bismarck (1815–1898) annexed Hesse-Kassel as a province of Prussia, there was little regret.

Amid the revolutionary turbulences of 1848 in Darmstadt, Grand Duke Ludwig III (1806–1877) followed his father to the throne. To prevent the spread of riots from neighboring Baden and the Palatinate, he named the liberal Heinrich von Gagern (1799–1880) as his prime minister. But soon after, Gagern had to resign his post, as he also presided over the First Democratic German Parliament in Frankfurt, representing the rising middle class. The assembly voted in a liberal constitution for Germany that included Austria and offered the imperial crown to Friedrich Wilhelm IV of Prussia (1795–1861). But the Prussian king believed that a crown could only be bestowed "by the grace of God" and refused what he called "the trash crown [*Lumpenkrone*] of the National Assembly deserving only disgust and contempt."[33] The first and last attempt to unify Germany democratically had failed. The uprising in Germany and Austria was bloodily repressed. In Darmstadt the liberal government was replaced by a conservative authoritarian government.

In 1866 the ongoing struggle between Austria and Prussia for hegemony in Germany led to war, in which both Hesses, along with the other major German states, sided with Austria. Following the Prussian victory, Austria was excluded from a future German national state and Bismarck created the North German Confederation. Hanover, Nassau, and Hesse-Kassel were annexed by Prussia. Darmstadt was spared this fate thanks to the intervention of Tsar Alexander II (1818–1881), who was married to Ludwig III's sister, Maria (1824–1880) (see p. 141).

After Prussia had defeated France in 1870 with the help of her German allies, Bismarck created a new German Empire. In 1871 the reigning German princes proclaimed the seventy-three-year-old Wilhelm I of Prussia (1797–1888) the German emperor. Ludwig III participated without great enthusiasm, having lost the greater part of sovereignty of his country. The well-meaning but colorless grand duke essentially retired to private life and left official duties to his heir Ludwig, the son of his younger brother Karl and Elisabeth of Prussia.

"Daring the New, conserving the old"[34]

Queen Victoria considered the future Grand Duke Ludwig IV (1837–1892) a candidate for the hand of her second daughter Alice. He was recommended by the queen's older daughter, Victoria, wife of the Prussian crown prince, and he would bring Darmstadt into the international network of marriage alliances that the queen was planning. In 1860, when Ludwig was invited to Windsor, he not only conquered Alice but also her mother, who found him "so nice, natural, sensible, quiet, and unblasé."[35] The wedding had to be postponed because the bride's father, Prince Albert of Saxe-Coburg (1819–1861), fell ill with typhoid fever. Alice nursed her father through his final days, and then her mother in her inconsolable grief over his death. The wedding finally took place on July 1, 1862, in an atmosphere of mourning.

Prince Albert gave his daughters Victoria and Alice an education grounded on liberal principles and focused particularly on social commitment. For Alice's husband, Ludwig, the possibilities for political activity were limited, first by the constitution's growing restrictions, then by the integration of the grand duchy into Bismarck's German empire.

There was, however, room for Alice to act in improving social conditions, although at first she met with considerable opposition. It seems remarkably little had changed since the court opposed the charitable work of St. Elisabeth six centuries earlier. Ernst Ludwig (1868–1937) recalls that when his mother fought for a modern water system in Darmstadt, a city official protested: "it's luxury, if everybody is to have a bathroom. I never had a bath in my life, and yet I am clean. These are all just fancy English ideas."[36] Another of those "English ideas" was the 1864 founding of the *Bauverein für Arbeiterwohnungen* ("Association for Workers' Housing"), based on London's "Prince Albert House." The *Bauverein* today remains the biggest low-income-housing construction firm in Darmstadt. In 1866 Alice initiated a committee for a modern institution to care for the mentally disabled. To realize the project, she organized fundraising bazaars in Darmstadt and other Hessian cities.

During the wars of 1866 and 1870, in which Alice's husband participated with the Hessian troops, she saw the need for skilled professional nurses to care for the increasing numbers of wounded soldiers. Stimulated by her visits to English infirmaries during the Crimean War and contacts with Florence Nightingale, the princess created the *Alice-Frauenverein für Krankenpflege* ("Women's Association for Nursing"). English nurses were brought in for the initial training of personnel. The Alice Hospital developed out of these efforts and still today is directed by the Alice Sisterhood. Alice was personally involved in the work, which included caring for the sick in the city's poor quarters.

Alice and Ernst Ludwig, 1878
FAS B 454, FAS Archive photograph

Alice was also vitally concerned with the plight of women. She consulted with English philanthropists, such as Mary Carpenter, Florence Hill, Susan and Catherine Winkworth, and Octavia Hill, with whom she visited London's slums. Together with Louise Büchner, an early German feminist, she founded the *Alice-Verein für Frauenbildung und Erwerb* ("Union for Women's Training and Work") in 1867. The *Alice-Schule* ("school for women") that she founded in 1874 still exists. As Ernst Ludwig wrote in his memoirs, his mother

> *perished of her human kindness. She had already exhausted herself to a degree that doctors said she was not to have any more children. And then she still had Alix and May . . . Then came the diphtheria epidemic. Except for Ella (Elisabeth), we all fell ill. First Victoria, then Irene. No sooner did she seem a little better, when it was my turn. For a long time I was near death, then my father, he too was affected dangerously, and in the meantime my favorite youngest sister May died.*[37]

Alice had already lost her two-year-old son, Fritty, who suffered from hemophilia. She was only thirty-five when in 1878 she succumbed to the diphtheria she caught while nursing her family.

Alice's children all married cousins. One result of the intermarriage was the transmission of hemophilia in the line. Its best-known victim was the Tsarevich Alexei (1904–1918), son of Alice's youngest daughter Alix (1872–1918) and Tsar Nicolas II (1868–1918).

Victoria (1863–1950), the eldest, married Louis of Battenberg (1854–1921) (her cousin once removed), whose father Alexander (1823–1888) was the brother of Ludwig III. Alexander had married Countess Julie Hauke (1825–1895) morganatically, whereupon she and her children were made princesses and princes of Battenberg. Louis, a giant of 6'10", made his career in the British Royal Navy. In 1917, when the Royal House changed its German name from Saxe-Coburg to Windsor and German relatives were asked to do likewise, Louis and Victoria chose to call themselves Mountbatten.

Ernst Ludwig became Grand Duke at the age of twenty-four. An English author described him as "good looking, excitable, wayward, and high spirited. He had inherited little of the military traditions and prowess of his father and grandfather, and was inclined toward the arts rather than militarism."[38] One of his first acts was to reject the prize-winning plans for a new *Landesmuseum,* which he found "ugly and insensible," and make his own selection of the modernist architect Alfred Messel (1853–1909). Messel's museum in Darmstadt opened in 1906 and he went on to plan Berlin's Pergamon Museum.

Ernst Ludwig loved to direct plays and operas and also to design stage sets and costumes. A critic called his 1907 staging of Oscar Wilde's *Salome* "one of the greatest sensations of contemporary theater."[39]

The grand duke's greatest achievement was the creation of the artists' colony at Mathildenhöhe in Darmstadt. The institution was led by architect Josef Maria Olbrich (1868–1908), who had just completed the Secession building in Vienna before coming to Darmstadt at Ernst Ludwig's invitation in 1899. Exhibitions held at Mathildenhöhe from 1901 until the outbreak of World War I in 1914 presented a German version of Art Nouveau, known as Jugendstil, which rivaled that of the world's great Art Nouveau centers.

One of Olbrich's most enchanting works is the playhouse for Ernst Ludwig's seven-year-old daughter Elisabeth, built in 1902 in the park of Wolfsgarten. Elisabeth, who died only a year later of typhoid fever, was the only child from Ernst Ludwig's first marriage. In 1894 Queen Victoria had tried to secure the happiness of her favorite grandson by marrying him to her granddaughter Victoria Melita of Saxe-Coburg (1876–1936). The match turned out to be a failure. Victoria Melita, described as "a highly volatile young woman, plunging from moods of jubilation to those of deep melancholy," was not prepared to handle her late mother-in-law's social obligations.[40] Instead, rumors of a romance with Grand Duke Cyril of Russia (1876–1938) reached Buckingham Palace. "I will never try and marry anyone again," was the reaction of the shocked grandmother.[41] Queen Victoria categorically ruled out the possibility of a divorce, but it took place nevertheless after her death in 1901.

The choice Ernst Ludwig made for himself outside the royal circle turned out to be a happy one. In 1905 he married Eleonore of Solms-Lich (1871–1937) from a Hessian noble family. The couple had two sons, Georg Donatus (1906–1937), and Ludwig (1908–1968). Eleonore continued and completed Alice's social work in an exemplary manner. In 1906 she added the *Ernst Ludwig und Eleonoren-Stiftung,* a foundation for mother and infant care, and in 1911 the *Eleonorenheim,* a hospital for infants and children.

Ernst Ludwig, seeing his Prussian cousin Wilhelm (the Kaiser) (1859–1941) commit one faux pas after another in foreign politics, offered his diplomatic services. "I could have helped out a great deal," he wrote in his memoirs, "as I was so closely related with England and Russia. Edward VII (1841–1910) and George V (1865–1936) as well as Nicolas II spoke quite frankly with me about everything concerning Germany, and poured out their hearts to me, touching [upon] many questions, inconveniences, etc."[42] But the Kaiser declined his services, suspecting his liberal Darmstadt cousin to be *undeutsch*—not truly German. The Russian and English relatives were frequently guests in Darmstadt and vice versa, until the outbreak of World War I put an end to their visits.

The grand duke, nominally the head of the Hessian troops, but not their commander, was left with little to do but visit them in the field and try to boost their morale, while his wife organized means of transportation and care for the wounded.

On his fiftieth birthday in November 1918, when defeat followed by revolution had put an end to German monarchies, Ernst Ludwig wrote: "It has happened . . . the old thrones have tumbled, the Kaiser has fled, the princes have moved to lonesome castles, only I myself and my family live in Darmstadt." It could not have been easy for him—still full of creative ideas and plans after twenty-six years on the throne—to suddenly be condemned to a life in retirement. Even so, he added: "I am not disappointed and don't perceive the

so-called ingratitude of the people in the way others [of my colleagues] do, as I recognized long ago the mistakes made in the years before."[43]

In 1930 a settlement was reached with the new *Volksstaat* ("popular state") of Hesse, whereby Ernst Ludwig recognized the nationalization of princely domains, forests, and public collections in exchange for a state pension paid for twenty years. Apart from the agreement, he kept Wolfsgarten as well as castles in Upper Hesse, Silesia, and Tarasp in the Swiss Engadine.

Contact with England, which had been cut off during the war, was resumed immediately by George V and Queen Mary. Two days after the armistice, they sent an emissary to Darmstadt to say "how happy they were to be in touch again, and that blood was stronger than water, and that their old affection hadn't suffered under the war."[44] Ernst Ludwig's sister, Victoria Mountbatten, Marchioness of Milford-Haven, came over with her family. Only the sisters Ella and Alix, who had married Romanovs, did not return. The news of the assassination of the Tsar's family came as a shock. A mysterious epilogue then arose with the emergence of a woman claiming to be Ernst's niece Anastasia. Despite the fact that none of the family was able to recognize her, the episode remained one of the most popular myths of the 20th century. In the 1990s, after the discovery of the graves in Yekaterinburg and Alapayevsk, a DNA test removed the last doubt that all of Nicolas and Alexandra's children had perished with their parents in 1918.

Ernst Ludwig died in October 1937 at Wolfsgarten at the age of sixty-nine. He was spared the fate that struck his family just weeks later. The plane carrying the guests to his younger son Ludwig's wedding in London crashed, killing Grand Duchess Eleonore, her older son Georg Donatus, his wife Cécile of Greece, and their two sons as well as three companions.

Landgrafs without a Land

To trace the direct lineage of today's House of Hesse, we have to go back to a cadet branch of the Hesse-Kassel line that originated with Friedrich (1747–1837), the youngest son of Landgraf Friedrich II of Hesse-Kassel. Together with his older brothers, he spent the duration of the Seven Years' War at the Danish court. Friedrich remained there to become an army officer in Denmark and then in the Netherlands. In 1780 he purchased the mansion of Rumpenheim on the Main River between Hanau and Frankfurt, which he enlarged into an idyllic Neo-classical castle and park. Rumpenheim became the site of the annual gatherings of the families of Friedrich's children, who married into the ruling houses of Denmark, Great Britain, Greece, and Russia.

One of Friedrich's grandsons, Friedrich Wilhelm (1820–1884), known as Fritz, faced a choice between two crowns. He was heir to the Kassel line because the offspring of his cousin Elector Friedrich Wilhelm's morganatic marriage could not inherit the throne. At the same time, Fritz had the chance to inherit the Danish throne through his mother, Charlotte of Denmark (1789–1864). In 1844 Fritz married Alexandra Nicolaievna (1825–1844) (see p. 152), daughter of Nicolas I of Russia (1796–1855) and sister of Alexander II (1818–1881), who died only months later in childbirth. Bereft, the young widower asked his father-in-law to advise him on the course he should take. The Tsar replied, "Go where your name is calling you."[45] In 1852 Fritz decided in favor of the succession in Kassel and renounced his claim to the Danish throne.

In 1866 Fritz also missed his last chance to ever reign in Kassel. Before the outbreak of the Austro-Prussian War, Bismarck offered him a maliciously calculated choice: If Fritz would take the Prussian side, he would be rewarded by replacing his unpopular cousin on the Kassel throne. If he were to take the Austrian side, however, Prussia would have no use for him. Indignant at Bismarck's proposal, Fritz went straight to Kassel, offering his loyal services to the elector. The latter was so surprised by the cousin he usually regarded as his rival that he appointed him commander-in-chief of his troops, but then withdrew the command within

Russian and Hessian family group at Wolfsgarten, autumn 1910
FAS B 455, FAS Archive photograph

Children first row: Crown Prince Alexi of Russia, Georg Donatus and Ludwig of Hesse, Tatiana of Russia. Second row: Irene of Prussia, Maria and Olga of Russia. Third row: Grand Duchess Eleonore of Hesse, Anastasia of Russia, Heinrich of Prussia, Tsar Nicolas II and Tsarina Alexandra Feodorowna. Above Nicolas II: Grand Duke Ernst Ludwig as well as Russian and Hessian staff and servants.

twenty-four hours. In any case, Fritz was no longer an obstacle to Bismarck's annexation plans for Hesse-Kassel, even though his second wife, Anna (1836–1918), was a Prussian princess (see p. 137). Moreover, the couple were regarded as traitors by Anna's Prussian family.

After the Prussian occupation of his country in 1866, the deposed elector went into exile in Bohemia. In 1873 Fritz concluded a treaty with Prussia, renouncing his claim to the Kassel throne and the electoral fortune. In exchange he was given an annual pension and the castles of Philippsruhe, Fulda, and Fasanerie. He had inherited Panker in eastern Holstein already in 1867.

While Fritz loved hunting and raising horses, Anna devoted her life to music and the society of musicians and composers, among them, Anton Rubinstein (1829–1894), Clara Schumann (1819–1896), and Johannes Brahms (1833–1897). Brahms said of her that if she weren't born a princess, she could have earned her living as a concert pianist. After the death of her husband in 1884, Anna spent summers at the Fasanerie and winters in her Frankfurt residence.

The marriage of their son Friedrich Karl (1868–1940) to the kaiser's sister, Margarethe of Prussia (1872–1954), known as Mossy, was to bring, unexpectedly, an important inheritance to the family. Mossy's mother was Queen Victoria's eldest daughter Victoria, the

widowed Empress Friedrich (1840–1901), who lost her husband in 1888 after a reign of only ninety-nine days. The liberal empress was a fierce but powerless opponent of Bismarck. As a consequence of tensions with her son, the kaiser, she left Berlin and in the early 1890s retreated to Kronberg in the Taunus hills above Frankfurt. Here she built Schloss Friedrichshof, a historicizing castle equipped with all the modern conveniences, including electricity. Even the kaiser, who usually disagreed with his mother, thought it "a marvel of good taste and arrangement." As he wrote to Queen Victoria after his first visit, "The extensive grounds are laid out with great skill, and show what an excellent landscape gardener she is. I think the whole property is the most delightful site imaginable, and Mama very much to be envied."[46]

Soon after his marriage, Friedrich Karl quit his post in Potsdam since he disliked the arrogant and somewhat decadent atmosphere in the Guards' officer corps, which consisted in large part of drinking bouts and gambling. Instead he pursued his military career in a Hessian infantry regiment in Frankfurt, and the young couple settled nearby in Rumpenheim, not far from Mossy's mother. During the summer months the family, which grew to include six sons, stayed with the Empress at Friedrichshof, where Mossy's favorite sister Sophie (1870–1932), her husband Constantine (Tino) of Greece (1868–1923), and their children would join them. Friedrichshof also became the site of family reunions that brought together the extended circle of relatives.

To everybody's great surprise, when the empress died in 1901, she left Friedrichshof, complete with her art collection, to her youngest daughter Mossy. She wanted it to go to the Hesse-Kassel family as a gesture to make up for the loss to Prussia of their residence and art collections in Kassel.

In World War I, Friedrich Karl and his four elder sons were engaged at different sections of the front. In September 1914, Friedrich Karl, a general leading his regiment in combat, was severely wounded in France. One month later, his son Max was killed in Flanders, and in 1916 Friedrich, the eldest, lost his life in Romania. In September 1918, after Finland had gained independence from Russia and socialist rule with the help of German troops, Friedrich Karl was surprised to be offered the Finnish throne. But Mossy's sister Sophie, who, with her husband Constantine I, had been exiled in 1917 from Greece, wrote her brother-in-law, in a mixture of German and English, from Switzerland: "You must not dream of going to Finland now: *ausgeschlossen* [no way]! whilst Emperors are supposed to be dethroned, would be impossible to make new kingdoms in such an atmosphere."[47]

The untimely royal dream was brought to a sudden end with Germany's military defeat in November 1918, followed by revolution and armistice. In December the French, according to the conditions of the armistice, took possession of the bridgehead Mainz, which included Kronberg. The family was cut off from the outside world, with French troops occupying first the Friedrichshof park and stables and finally the castle itself and "saying repeatedly that they would show that they were the masters," as Friedrich Karl recorded in his diary.[48]

Germany's military leaders had deceived the public about the defeat, boasting until the end of their imminent victory. They were smart enough to leave the responsibility of signing the armistice as well as the Treaty of Versailles to the new Social Democratic government. This allowed the militarists to create the myth that the German army had been "stabbed in the back" by the socialists, thus undermining the new Weimar Republic from the start. This opinion was largely shared in conservative circles, which included the Hesse family, and prevented them from accepting the defeat as a fact. The massive reparations Germany was forced to pay to the Allies led to the wildest inflation in history, with prices doubling within hours. (In 1923 it took 200 billion *marks* to buy a loaf of bread, and the savings of the thrifty middle class of Germany were wiped out.) Severe social unrest and the threat of nationalization of princely property led Friedrich Karl to conclude, reflecting the general opinion of his caste, that "Democracy is the ruin of the German character."[49]

Family Gathering at Schloss Friedrichshof, May 24, 1900
FAS B 450, FAS Archive photograph

Back row: Irene of Prussia, Victoria of Schaumburg-Lippe, Crown Princess Sophie of Greece and her children, Empress Auguste Victoria, Empress Dowager Friedrich, Charlotte of Meiningen (the kaiser's eldest sister), and Margarethe. Front row: Adolf of Schaumburg-Lippe, Friedrich Karl of Hesse, Heinrich of Prussia, the Kaiser, Crown Prince Konstantin (I) of Greece, Bernhard of Meiningen, Ernst Ludwig of Hesse.

Involvement in the Hitler Regime

As early as September 1921, with chaos in government and spiraling inflation, Ernst Ludwig, the former liberal Grand Duke of Hesse-Darmstadt, wrote: "It is already beginning, the cry for the dictator, as the quarrel of parties is tearing the country apart, mutual hatred and, above all, inner and outer cowardice are growing. If a dictator were coming, it would have to be someone who is above egotism and factionalism. He would have to live for the people. The best would be, if the people were to raise him above the parties on its shoulders. . . ."[50]

This startling hope for a savior, a Superman, written well before anybody in Germany had ever heard of Hitler, shows that there was an idealistic, if somewhat naive disposition among the former ruling class to be exploited by a demagogue. Ten years later the demagogue Hitler did precisely that. He blamed Germany's defeat in World War I, the punishing terms of the Treaty of Versailles, and subsequent political turmoil and economic devastation on an international conspiracy of capitalists, Jews, and Marxists and promised to revise the Versailles treaty and make Germany strong again. These slogans were readily taken up by Friedrich Karl and his family. They had not overcome the trauma of their sons' and brothers' senseless deaths, loss of the war, fear of Bolshevism, and humiliations of the occupation forces. On the other hand, they ignored the anti-Semitic agitation or believed they need not take it seriously—until it was too late. They were shocked by the Jewish pogroms that they took for the transgressions of "radical elements." They themselves had Jewish friends, whom they later helped to avoid arrest. After the war, they declared, horrified, to have known nothing of the Holocaust, as did most Germans who preferred to know nothing rather than to expose themselves to the retribution of the Nazis.

Philipp of Hesse and Mafalda in Italy, 1925
FAS B 453, FAS Archive photograph

Philipp (1896–1980), Friedrich Karl's third son, became the heir of the Hesse-Kassel line on the death of his two elder brothers. After the war he had studied art history in Darmstadt. In 1922 he moved to Rome where he studied archaeology and worked as an interior decorator. He also began to collect antiquities and form the basis of an important collection. In 1925 he married Mafalda of Savoy (1902–1944), a daughter of Italian King Victor Emmanuel III (1869–1947). Mussolini (1883–1945) carried out the civil marriage ceremony in his role as head of the Italian government. Philipp was "impressed by fascism's achievements," as he later explained. "I had come to Italy as a young man in 1922 and saw how the circumstances at the beginning had fundamentally improved."[51] Philipp and Mafalda settled into the Villa Polissena, a gift from Mafalda's father that stood in the park of the royal residence. They had three sons and a daughter and until 1933 lived mainly in Italy.

While Philipp was visiting Germany in September 1930, Hitler's party, which previously had received no more than three percent of the vote, now, following the world-wide economic depression and rising unemployment, achieved eighteen percent in the *Reichstag* election. During a visit to Berlin in October, Philipp's cousin August Wilhelm of Prussia (1887–1949), a son of the emperor, introduced him to Hermann Göring (1883–1946). As a youth, the World War I hero and commander of the *Richthofen-Geschwader* ("Red Baron Squadron") had studied at the Berlin-Lichterfelde Cadet Academy with Philipp's older brothers. Through Göring Philipp met Hitler (1889–1945), who was intent on winning the support of princely families. He needed them to overcome the lingering suspicions of conservatives that the National Socialist Party was in fact leftist. As figureheads, the princes made the party *salonfähig* ("suitable for a salon"). The success of Hitler's tactics is conveyed by Philipp's father, Landgraf Friedrich Karl, who in 1933 remarked in his notebook:

For a long time I actually had been ready to become national socialist without, however, knowing what National Socialism was. At the moment I made Hitler's acquaintance and read his book [Mein Kampf, published in 1925] I suddenly made up my mind, that although I disliked certain details in the National Socialist program and the behavior of certain personalities I would put up with it.[52]

By 1933 eighty members of German princely houses, including Philipp and his brothers, had joined the Nazi Party and its organizations. By 1941 the number had increased to two hundred seventy.

Not only was the Hesse family swayed by the dictator's personal dynamism; Göring, the second man in the Nazi Reich, courted the Hessian princes with favors. Landgraf Friedrich Karl, who had never forgotten that Prussia had appropriated the country of his ancestors, saw it as a "reparation" gesture that Göring, in his role as head of the Prussian government, appointed Philipp of Hesse as chief president *(Oberpräsident)* of the Hesse-Nassau province in 1933. As the province's top civil official, the chief president had his seat in Kassel. The appointment was calculated to symbolize the historical reconciliation of the dynastic tradition with the National Socialist revolution. The political power, however, was held by the party's district heads. Philipp, who described himself as a "non-political person," used his position to take up the cultural tradition of his ancestors. Among other things, he commissioned the restoration of historical buildings and created the *Landgrafenmuseum* in which he brought together the state art collections of his ancestors with the private collection of the Hessian family.

Philipp, moreover, was useful to Hitler because of his Italian connections. As son-in-law of the Italian king, he was employed by the *Führer* as an emissary to *Il Duce*. During World War II, Philipp also served the German dictator in his plans for a colossal *"Führermuseum"* in Linz, Austria, for which Philipp purchased art works in Italy. In summer 1943, however, when Mussolini was arrested on the king's initiative and Italy as Germany's ally dropped out of the war, Hitler avenged himself on Victor Emmanuel's daughter Mafalda and her husband. Philipp was imprisoned in Flossenbürg and Mafalda was kidnapped in Italy and sent to the concentration camp of Buchenwald. In August 1944, a stray bomb from an Allied attack on an armament factory near Weimar hit the Buchenwald camp. The blast buried Mafalda and other prisoners, and she died as a result of her injuries.

Philipp, after one and a half years in solitary confinement in Flossenbürg and other concentration camps, was freed in spring 1945 by US troops. Shortly thereafter he was arrested by US Military Police in the round-up of everyone who had served the Hitler regime. Until his release in 1948, Philipp spent time in a total of twenty-six internment camps. To carry out the de-nazification in Germany decreed by the Allied Control Commission, German tribunals *(Spruchkammern)* were appointed under the direction of US occupation forces in the American zone, which included Hesse. Those tried were classified among five categories that ranged from "chief offenders" to "exonerated." Ironically, though, the de-nazification decree was often bypassed when it came to individuals in former leading positions, who now were needed for the construction of the democratic state.

Philipp was brought to trial in December 1947. He explained to the tribunal that he had lost his illusions about the regime once he discovered the unscrupulousness of its district heads and officials, who ran roughshod over all legal restraints within his administrative district. The only reason he did not resign from his post was because through it he was able to help many among the persecuted. As for foreign politics, the defendant said he repeatedly had tried to dissuade Hitler from going to war, particularly after a conversation with his cousin (once removed), the Duke of Kent (brother of George VI), in July 1939 in Florence convinced him that "in the case of a German attack on Poland, Great Britain would enter the war. This, however, would mean the beginning of a new world war."[53] But Hitler

dismissed the warning as "nonsensical." In April 1943 Philipp made one last attempt to change the dictator's mind, as he recalled:

> *exposing to him the disastrous state of affairs with Italy, untenable position of Mussolini, and seemingly inevitable military and political collapse. . . . The conversation threatened to take a dramatic turn. But he [Hitler] soon regained self-control and in one of his endless speeches tried to minimize my fears and present them as totally unfounded.*[54]

From then on, Hitler's distrust of Philipp was roused and until September 1943, when Philipp ultimately was arrested, he was not allowed to move about freely.

At first, Philipp was classified by the de-nazification tribunal in category II as a *Belasteter* ("offender"), not because he had committed an offense, but rather, as the panel's explanation put it, because "by applying his personal renown" he was supposed to have "essentially contributed to the setup, stabilization, and preservation of the National Socialist tyranny."[55] In 1949 the appellate process cancelled this decision and reclassified Philipp into group III (minor offenders), recognizing "the demonstrable political persecution by the national socialist tyranny and the pain that Hitler caused the concerned party and his family"[56] as mitigating circumstances. In 1950 Philipp, like most of those "de-nazified," was reclassified under category IV of *Mitläufer* ("fellow traveler").

Probably the worst punishment for Philipp and his family, however, was finding they had believed in and served someone who had exploited their faith in him and revealed himself to be one of the most unscrupulous criminals and psychopaths in world history. In May 1945, Philipp's sister-in-law Sophia (1914–2001), whose husband Christoph (1901–1943) had been in the SS, then volunteered for the air force at the war's outbreak, and in 1943 suffered a fatal accident with his plane in Italy, wrote to her grandmother Victoria Milford-Haven in England: "For two years now my eyes have been open and you can imagine what feelings one has now about those criminals."[57]

At the war's end, Sophia and her five children along with Philipp's four children and his widowed mother Margarethe were evicted from Friedrichshof when the US Army seized the property. Except for Margarethe, who stayed near Friedrichshof in the estate manager's cottage, all were lodged at Wolfsgarten, some twenty miles away, by her nephew Ludwig (1908–1968) (Grand Duke Ernst Ludwig's surviving son) and his wife, Irish-born Margaret Campbell-Geddes (1913–1997), who had no children themselves. Wolfsgarten already housed a home for the elderly *(Altersheim)* and sheltered refugees from the Russian-occupied zone.

The family jewels had been buried for safekeeping in the cellars of Friedrichshof, which was serving as an American officers' club. In 1946, when Sophia wanted to retrieve her jewelry to wear for her wedding to Georg Wilhelm of Hanover, the cache was gone. The officer in charge of the castle discovered that the heirlooms had been stolen by his predecessor, a WAC captain, with the help of two superior American officers. The thieves were arrested in the United States, where they were about to be discharged from the army, and then court-martialed in Frankfurt and sentenced to prison. Only a small part of the jewelry was recovered. Considered one of the biggest postwar legal proceedings in US military history, the trial was widely covered by the media. From the German point of view, it was remarkable that the victorious power was calling their own officers to account for crimes committed against the defeated.

obligations of a cultural heritage

Prior to the de-nazification of Philipp and his two surviving brothers, the property of the House of Hesse-Kassel was subject to trusteeship. On the one hand, the property consisted

of the Hessian Electoral House Foundation, *Kurhessische Hausstiftung,* the Hesse-Kassel family foundation created in 1928 by state order, comprised of the Hessenstein heritage of Panker, with agricultural estates in Holstein, and the castles Fasanerie, Philippsruhe, and Rumpenheim in Hesse. On the other hand, it consisted of the Empress Friedrich's heritage in Kronberg, still confiscated by US occupation forces. In 1948 Philipp's twin brother, Wolfgang (1896–1989), was exonerated by the de-nazification panel. He was a trained banker who had served as *Landrat* ("district administrator") in Bad Homburg near Kronberg and had lost his wife in a bombing raid on Frankfurt. In agreement with Philipp, he took over the business management of the Foundation.

According to its statute, the main task of the House Foundation was, and is, "to conserve, preserve, and complete its cultural property of artistic, scientific, or historical value in the public interest."[58] In 1948 this task seemed almost impossible to achieve, as the properties had suffered severely during the war and finances were in a chaotic state. Incendiary bombs had burned Rumpenheim, and Fasanerie was heavily damaged. Nevertheless, from the beginning, the brothers were determined that the jewel of the House Foundation, the Baroque castle of Fasanerie, was to be rescued from the shambles at all costs. Rumpenheim and Philippsruhe therefore had to be sold. During the war, after bombs destroyed Philipp's *Landgrafenmuseum* in Kassel from which the collections had already been evacuated, he conceived the idea of creating a museum at Fasanerie that would trace the dynasty's history. It would unite art collections, portrait galleries, furniture, china, silver wares, libraries, and archives from the House Foundation's various castles, including Empress Friedrich's Kronberg collections and Philipp's private collection of antiquities. As soon as the building's damages were repaired and its roofs covered, he installed himself in the castle. For the next thirty years he personally supervised its interior restoration and directed the setup of the rooms, while Wolfgang took care of the financial side. The museum won favorable reviews in Germany and abroad on the opening of its first rooms in 1951, even as its upkeep required substantial annual subsidies that had to be earned by the House Foundation.

The main question facing Wolfgang in his task of restructuring the foundation's finances was how to provide the House Foundation with sustained income to meet its obligations. To solve the problem, he had to think in terms of entrepreneurial innovation. His house in Frankfurt had been destroyed in a bombing raid. Instead of rebuilding it, he decided to

Landgraf Moritz, 2002
FRDH Archive photograph

build a hotel on the grounds and in 1952 opened the *Hessische Hof.* At the same time, when the US Army returned Friedrichshof (known to Americans as "Kronberg Castle") to its owners, the edifice was in a desolate state and its walls contaminated by mold. A thorough renovation was necessary. To preserve the estate, the brothers, inspired by the success of the *Hessische Hof,* decided to transform their grandmother's "sanctuary" into a hotel as well and its park into a golf course. The decision was not easy, but it was the only way to keep the property, whose upkeep was so daunting that their parents had moved out to a cottage in the park after World War I. The sons' embrace of a changed world took on symbolic importance. They realized that democracy was not "the ruin of the German character," as Friedrich Karl earlier had feared. On the contrary, reintroduced by America and her Western Allies, together with the Marshall Plan to boost the economy, it produced the German *Wirtschaftswunder* ("economic miracle"). It offered the Hesses a new beginning in which they could transform a tradition of privilege into a commercial enterprise. Whereas in earlier times kings had been treated as guests, a (paying) guest at the *Schlosshotel* now was treated as a king.

Wedding of Prince Donatus and Princess Floria, 2003
FAS Archive photograph

The bitter experience of two devastating world wars, and political, social, and material instability convinced the brothers that the House Foundation was the best means of permanently preserving the cultural treasures of the Hessian dynasty, inseparably linked to the history of Hesse. Therefore, they made considerable material sacrifices. In the 1960s, when the two hotels—still part of the family's private property—proved themselves to be a solid source of income, they were transferred as additional endowments to the House Foundation, as were a wine-growing estate and other commercial estates, enabling the foundation to provide for the upkeep of the Fasanerie museum.

After Philipp's death in 1980, his eldest son Moritz (b. 1926) followed him as head of the House and took over the management of the House Foundation. He also inherited the title of landgraf that, strictly speaking, is no longer a title, since all titles of nobility were abolished after the fall of the monarchy in 1918. But the law permitted titles to be changed into names. So, to enable the head to be called "landgraf," every member of the family carries in his (or her) passport the name *Prinz und Landgraf* (or *Prinzessin und Landgräfin*) *von Hessen.*

In 1964 Moritz married Tatiana of Sayn-Wittgenstein-Berleburg (b. 1940). They have two sons and two daughters. Besides the Hesse-Kassel inheritance, Landgraf Moritz is also the heir of the Hesse-Darmstadt estate, since he was adopted by his uncle Ludwig, who, as mentioned earlier, had no children and died in 1968. Ludwig had inherited the artistic vein of his father. A trained art historian, he wrote poetry and was a patron and friend of artists, writers, and musicians. In part of the old Darmstadt Residence Castle, which was rebuilt by the Hessian state after it and the *Neue Palais* had been destroyed by bombs, he reinstalled the *Schloss-museum* with the cultural heritage of his ancestors. His wife, the Irish-born Margaret, had taken up the social commitment of Grand Duchesses Alice and Eleonore. In Darmstadt she is remembered particularly for her work at the Red Cross and for disabled children.

As Ludwig's widow, Margaret was motivated by the same concern that had led her Kassel cousins to preserve their cultural heritage in the House Foundation. In 1986, in agreement with Moritz, she entrusted Wolfsgarten (the sole remaining German castle in the Darmstadt line) to the care of the House Foundation and likewise manifested her wish to preserve the Darmstadt art treasures. Correspondingly, the Hessian Electoral House Foundation, *Kurhessische Hausstiftung,* changed its name to Hessian House Foundation, *Hessische Hausstiftung,* to represent the heritage of the reunited House of Hesse that had been separated since the death of Philipp the Magnanimous in 1567.

Like his father, Moritz is a passionate interior decorator, rearranging the rooms of the hotels and completing the collections in the museum. After Margaret's death, he restored the castle of Wolfsgarten. He is also an accomplished gardener, rejuvenating the parks at Panker, Kronberg, Fasanerie, and Wolfsgarten.

In 1994 Landgraf Moritz's eldest son Donatus (b. 1966) joined his father in the management of the foundation. He has taken on responsibility for the direction of its various businesses, such as the Schlosshotel Kronberg and the Hotel Hessisches Hof in Frankfurt, winery Prinz von Hessen and commercial farms including the stud farm for Trakehner horses at Panker. In 2003 he married Floria of Faber-Castell (b. 1974), who has become engaged in the foundation's enterprises. Since a modification of legislation in the 1970s, the House Foundation is subject to an inheritance tax every thirty years, producing substantial financial obligations to the state. This creates a situation contrary to the foundation's task to preserve its cultural heritage and advance the Fasanerie museum. To ensure that the Hessian House Foundation is able to fulfill its mission to maintain its collections and provide

for a costly public commitment, Donatus is motivated to optimize the financial basis of its business enterprises. His efforts include developing a progressive approach to guarantee the continuation of the cultural legacy of the Landgrafs and Princes of Hesse.

Rainer von Hessen

NOTES

1. Midelfort, *Mad Princes*, p. 44.
2. Philippi, *Haus Hessen*, p. 56.
3. Puppel, *Formen von Witwenherrschaft*, p. 145.
4. Puppel, *Die Regentin*, p. 187.
5. Puppel, *Formen der Witwenherrschaft*, p. 158.
6. Heinemeyer, *Philipp der Grossmütige*, p. 8.
7. Franz, *Die Chronik Hessens*, p. 120.
8. Politisches Testament 1536.
9. Heinemeyer, *Philipp*, p. 183.
10. Mackensen, *Die erste Sternwarte*, p. 15.
11. Borggrefe, *Moritz der Gelehrte*, p. 15.
12. Ibid., p. 16.
13. Bettenhäuser, *Familienbriefe*, p. XIX.
14. Press, *Hessen*, p. 312.
15. Schiller, *Geschichte des Dreissigjährigen Krieges*, Fünftes Buch, vol. IV, Winkler Dünndrück-Ausgabe, München 1968, S. 409.
16. Bettenhäuser, *Familienbriefe*, p. XXIII.
17. Philippi, *Landgraf Karl*, p. 33.
18. The term was first used by Fritz Redlich in *The German Military Enterpriser and his Work Force, A Study in European Economic and Social History*, 2 vols., Wiesbaden 1964.
19. Hirschfeld, *Theorie der Gartenkunst*, vol. 4, p. 126.
20. Both/Vogel, *Wilhelm VIII.*, p. 16.
21. Ibid., p. 17.
22. Ibid., p. 158.
23. Ibid., p. 94.
24. Ibid., p. 96.
25. Both/Vogel, *Friedrich II.*, p. 128.
26. Auerbach, *Die Hessen in Amerika*, pp. 157, 159.
27. Ibid., p. 203.
28. Ibid., p. 188.
29. R. Von Hessen, *Wir Wilhelm von Gottes Gnaden*, p. XI.
30. Engraved on her gravestone, the original inscription in Latin reads: "Femina sexu, ingenio vir."
31. Knodt, *Die Regenten von Hessen-Darmstadt*, p. 76.
32. Franz, *Die Chronik Hessens*, p. 213.
33. Gall, *1848*, p. 379.
34. The quotation from Ernst Ludwig reads in German: *Das Neue wagen, das Alte erhalten.* Knodt, *Die Regenten von Hessen-Darmstadt.*
35. Fulford, *Dearest Child*, p. 258.
36. Grossherzog Ernst Ludwig, *Erinnertes*, p. 54.
37. Ibid., p. 56.
38. Hough, *Louis & Victoria*, p. 155.
39. Ernst Ludwig, *Erinnertes*, p. 196, note 133.
40. Duff, *Hessian Tapestry*, p. 260.
41. Ibid., p. 262.
42. Ernst Ludwig, *Erinnertes*, p. 135.
43. Knodt, *Ernst Ludwig*, p. 381.
44. Ernst Ludwig, *Erinnertes*, pp. 86, 88.
45. Landgraf Friedrich Karl, *Notebooks* (unpublished), Archiv Hessische Hausstiftung.
46. Gould Lee, *Empress Frederick writes to Sophie*, p. 97.
47. Wolfgang Prinz von Hessen, *Aufzeichnungen*, p. 114.
48. Wolfgang, *Aufzeichnungen*, p. 141.
49. Friedrich Karl, *Notebooks.*
50. Knodt, *Ernst Ludwig*, S. 388.
51. Philipp Prinz von Hessen, *Lebenslauf* 1947, Archiv Hessische Hausstiftung.
52. Friedrich Karl, *Notebooks.*
53. Wolfgang, *Aufzeichnungen*, p. 190.
54. Ibid., pp. 190–91.
55. Spruchkammer D.Lg./P/-2717/47, Archiv Hessische Hausstiftung.
56. Spruch/Berufungskammer, 10.2.1949, D.L.P.27 17/47. Archiv Hessische Hausstiftung.
57. Vickers, *Alice Princess of Greece*, p. 314.
58. Satzung der *Hessischen Hausstiftung*, 1987, S. 5.

BIBLIOGRAPHY

Atwood, Rodney. *The Hessians: Mercenaries from Hessen-Kassel in the American Revolution.* Cambridge: Cambridge University Press, 1980.

Auerbach, Inge. *Die Hessen in Amerika 1776–1783.* Darmstadt: Hessische Historische Kommission Darmstadt; Marburg: Historische Kommission für Hessen, 1996.

Bettenhäuser, Erwin, ed. *Familienbriefe der Landgräfin Amalie Elisabeth von Hessen-Kassel und ihrer Kinder.* Marburg: Elwert, 1994.

Borggrefe, Heiner, Vera Lüpkes, and Hans Ottomeyer, eds. *Moritz der Gelehrte: Ein Renaissancefürst in Europa.* Eurasburg: Edition Minerva, 1997.

Both, Wolf von, and Hans Vogel. *Landgraf Friedrich II. von Hessen-Kassel.* Munich; Berlin: Deutscher Kunstverlag, 1973.

Both, Wolf von, and Hans Vogel. *Landgraf Wilhelm VIII. von Hessen-Kassel.* Munich: Deutscher Kunstverlag, 1964.

Demandt, Karl E. *Geschichte des Landes Hessen.* Kassel: Bärenreiter-Verlag, 1959.

Duff, David. *Hessian Tapestry.* London: Mulller, 1967.

Franz, Eckhart G. "Victorias Schwester in Darmstadt: Grossherzogin Alice von Hessen und bei Rhein." In *Victoria Kaiserin Friedrich: Mission und Schicksal einer englischen Prinzessin in Deutschland,* edited by Rainer von Hessen. Frankfurt am Main: Campus Verlag, 2002.

Franz, Eckhart G., ed. *Die Chronik Hessens.* Dortmund: Chronik Verlag, 1991.

Franz, Eckhart G., and Karl-Eugen Schlapp, eds. *Margaret Prinzessin von Hessen und bei Rhein: Ein Gedenkbuch.* Darmstadt: Verlag H. L. Schlapp, 1997.

Fulford, Roger, ed. *Dearest Child: Letters between Queen Victoria and the Princess Royal, 1858–1861.* New York: Holt, Rinehart and Winston, 1965.

Gall, Lothar, ed. *1848 Aufbruch zur Freiheit.* Berlin: Nicolai, 1998.

Lee, Arthur Gould, ed. *The Empress Frederick writes to Sophie, her daughter, Crown Princess and later Queen of the Hellenes: Letters 1889–1901.* London: Faber and Faber, 1955.

Heinemeyer, Walter. *Philipp der Grossmütige und die Reformation in Hessen.* Marburg: Elwert, 1997.

Heinemeyer, Walter, ed. *Das Werden Hessens.* Marburg: N. G. Elwert, 1986.

Heinemeyer, Walter, ed. *Hundert Jahre Historische Kommission für Hessen.* 2 vols. Marburg: Elwert, 1997.

Hessen und bei Rhein, Ernst Ludwig Großherzog von. *Erinnertes.* Edited by Eckhart G. Franz. Darmstadt: E. Roether, 1983.

Hessen und bei Rhein, Ernst Ludwig Großherzog von. *Grundideen eines konstitutionellen Fürsten.* Edited by Eckhart G. Franz. Darmstadt: Roether, 1977.

Hessen, Rainer von, ed. *Victoria Kaiserin Friedrich: Mission und Schicksal einer englischen Prinzessin in Deutschland.* Frankfurt am Main: Campus Verlag, 2002.

Hessen, Rainer von, ed. *Wir Wilhelm von Gottes Gnaden: Die Lebenserinnerungen Kurfürst Wilhelms I. von Hessen 1743–1921.* Frankfurt; New York: Campus Verlag, 1996.

Hessen, Wolfgang Prinz von. *Aufzeichnungen.* Kronberg: Privatdruck, 1996.

Hirschfeld, Christian Cay Lorenz. *Theorie der Gartenkunst.* Leipzig, 1785.

Hough, Richard. *Louis & Victoria: The First Mountbattens.* London: Hutchinson, 1974.

Knodt, Manfred. *Ernst Ludwig: Grossherzog von Hessen und bei Rhein.* Darmstadt: Schlapp, 1978.

Knodt, Manfred. *Die Regenten von Hessen-Darmstadt.* Darmstadt: Schlapp, 1977.

Lemberg, Margret. *Juliane Landgräfin zu Hessen.* Darmstadt: Selbstverlag der Hessischen Historischen Kommission, 1994.

Losch, Philipp. *Geschichte des Kurfürstentums Hessen.* Elwert Verlag Marburg: Lahn, 1922.

Mackensen, Ludolf von. *Die erste Sternwarte Europas mit ihren Instrumenten und Uhren. 400 Jahre Jost Bürgi in Kassel.* 3rd ed. Munich: Callwey, 1988.

Malinowski, Stephan. *Vom König zum Führer.* 2nd ed. Berlin: Akademie Verlag, 2003.

Midelfort, H. C. Erik. *Mad Princes of Renaissance Germany*. Charlottesville: University Press of Virginia, 1994.

Philippi, Hans. *Das Haus Hessen: ein europäisches Fürstengeschlecht*. Kassel: Thiele & Schwarz, 1983.

Philippi, Hans. *Landgraf Karl von Hessen-Kassel. Ein deutscher Fürst der Barockzeit*. Marburg: Elwert, 1976.

Press, Volker. "Hessen im Zeitalter der Landesteilung (1567–1655)." In *Das Werden Hessens,* edited by Walter Heinemeyer. Marburg: Elwert Verlag, 1986.

Puppel, Pauline. "Formen von Witwenherrschaft: Landgräfin Anna von Hessen (1485–1525)." In *Witwenschaft in der Frühen Neuzeit. Vol. 6 of Schriften zur sächsischen Geschichte und Volkskunde.* Leipzig: Leipziger Universitätsverlag, 2003.

Puppel, Pauline. *Die Regentin: Vormundschaftliche Herrschaft in Hessen 1500–1700.* Frankfurt am Main: Campus, 2004.

Schiller, Friedrich. *Geschichte des Dreissigjährigen Krieges*. Munich: Winkler Dünndruck-Ausgabe, 1968.

Stobbe, Reimer. "Sophie von Brabant und Anna von Mecklenburg." In *Hundert Jahre Historische Kommission für Hessen,* edited by Walter Heinemeyer. Vol. 1. Marburg: Elwert, 1997.

Vickers, Hugo. *Alice: Princess Andrew of Greece.* London: Hamish Hamilton, 2000.

Wegner, Karl-Hermann. *Kurhessens Beitrag für das heutige Hessen*. Wiesbaden: Hessische Landezentrale für Politische Bildung, 1999.

Wolff, Fritz. "Rosencrantz und Güldenstern in Kassel: Theatralische Sendung und diplomatische Mission am Hofe des Landgrafen Moritz." In *Geschichte lebendig gemacht,* edited by Rainer Olten. Kassel: Freunde des Stadtmuseums, 2002.

FRANZ HUTH (Pössneck 1876–Weimar 1970)

Miniature Room, Neue Palais, Darmstadt, 1937
Pastel
H. 26 in. (66 cm); W. 33⅛ in. (84 cm)
Signed lower left: *Franz Huth 1937*
SM H 21404

The collection of miniature portraits displayed in the Grand Ducal residence in Darmstadt provided a constant reminder of family ties.

hesse family tree

LUDWIG IV (1200–1227) Lg. of Thuringia 1217

∞

1221

ELISABETH of Hungary (1207–1231) / St. Elisabeth of Thuringia 1235

SOPHIE (1224–1275) Langräfin of Hesse of Thuringia

∞

1240

HEINRICH II (1207–1248) Duke of Brabant 1235

HEINRICH I (1244–1308) Lg. of Hesse 1265

OTTO (ca. 1272–1328)
Lg. of Upper Hesse 1308, Lg. of Hesse 1311

JOHANN (1278–1311)
Lg. of Lower Hesse 1308

HEINRICH II (1299–1376)
Lg. of Hesse 1328

Ludwig of Hesse (1305–1345)

OTTO (1322–1366)
Co-regent of Hesse with Heinrich II 1340

HERMANN II The Learned (ca. 1340–1413)
Co-regent of Hesse with Heinrich II 1367, Lg. 1376

LUDWIG I (1402–1458)
Lg. of Hesse 1413

LUDWIG II (1438–1471)
Lg. of Kassel 1458

HEINRICH III (1440–1483)
Lg. of Marburg 1458

WILHELM I (1466–1515)
Lg. 1471 with Wilhelm II to 1493

WILHELM II (1468–1509)
Lg. in Kassel with Wilhelm I 1483–93, then alone;
Lg. of Marburg 1500

∞

B) 1500

Anna of Mecklenburg (1485–1525)

PHILIPP I the Magnanimous (1504–1567)
Lg. of Hesse 1509, indep. 1518, arrested 1547–1552

∞

A) 1523

Christine of Saxony (1505–1549)

B) 1540

Margarethe of the Saale (1522–1566)

A) WILHELM IV The Wise (1532–1592)
Lg. of Hesse-Kassel 1567

∞

1566

Sabine of Württemberg (1549–1581)

A) LUDWIG IV (1537–1604)
Lg. of Hesse-Marburg 1567

A) PHILIPP II (1541–1583)
Lg. of Hesse-Rheinfels 1567

A) GEORG I the Pious (1547–1596)
Lg. of Hesse-Darmstadt 1567

LUDWIG V (1577–1626)
Lg. of Hesse-Darmstadt 1596

MORITZ the Learned (1572–1632)
Lg. of Hesse-Kassel 1592; abdicated 1627

∞

A) 1593

Agnes of Solms-Laubach (1578–1602)

B) 1603

Juliane of Nassau-Siegen (1587–1543)

GEORG II (1605–1661)
Lg. of Hesse-Darmstadt 1626

LUDWIG VI (1630–1678)
Lg. of Hesse-Darmstadt 1661

A) WILHELM V (1602–1637) Lg. of Hesse-Kassel 1627

∞

1619

AMALIE ELISABETH of Hanau-Münzenberg (1602–1651)
Landgräfin of Hesse-Kassel 1637

WILHELM VI The Just (1629–1663)
Lg. of Hesse-Kassel 1637, indep. 1650

∞

1649

HEDWIG SOPHIE of Brandenburg (1623–1683)

Continued on next page

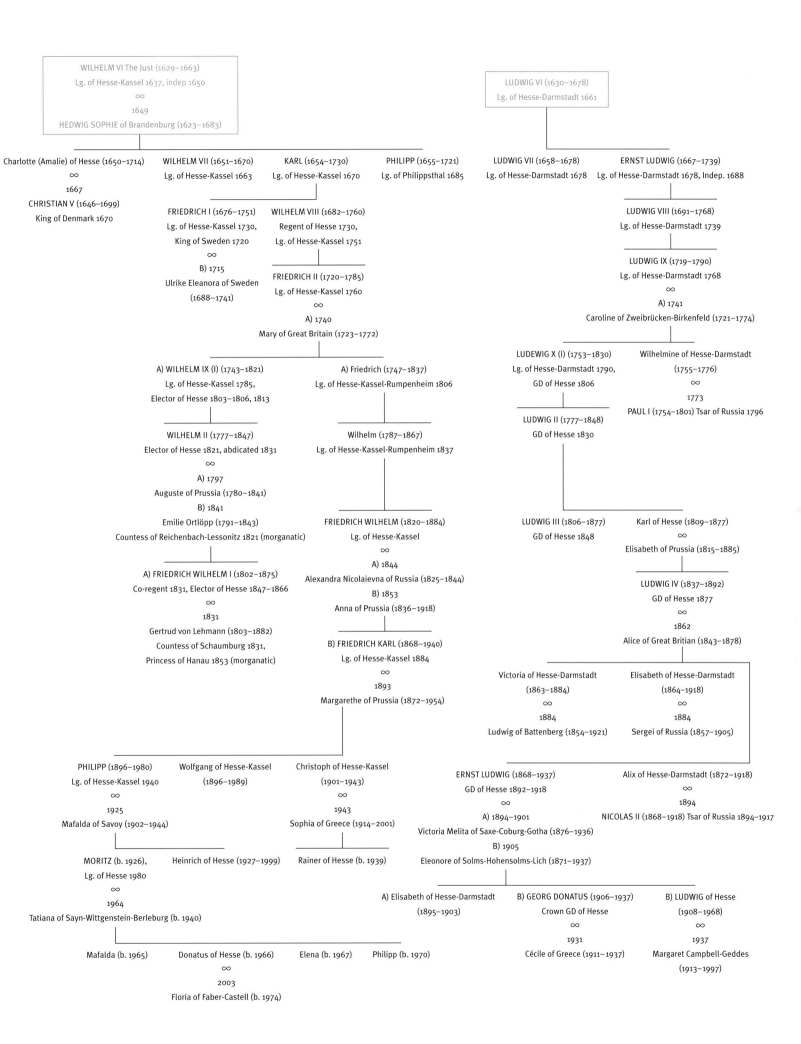

WILHELM VI The Just (1629–1663)
Lg. of Hesse-Kassel 1637, indep 1650
∞
1649
HEDWIG SOPHIE of Brandenburg (1623–1683)

LUDWIG VI (1630–1678)
Lg. of Hesse-Darmstadt 1661

Charlotte (Amalie) of Hesse (1650–1714)
∞
1667
CHRISTIAN V (1646–1699)
King of Denmark 1670

WILHELM VII (1651–1670)
Lg. of Hesse-Kassel 1663

KARL (1654–1730)
Lg. of Hesse-Kassel 1670

PHILIPP (1655–1721)
Lg. of Philippsthal 1685

LUDWIG VII (1658–1678)
Lg. of Hesse-Darmstadt 1678

ERNST LUDWIG (1667–1739)
Lg. of Hesse-Darmstadt 1678, Indep. 1688

FRIEDRICH I (1676–1751)
Lg. of Hesse-Kassel 1730,
King of Sweden 1720
∞
B) 1715
Ulrike Eleanora of Sweden
(1688–1741)

WILHELM VIII (1682–1760)
Regent of Hesse 1730,
Lg. of Hesse-Kassel 1751

LUDWIG VIII (1691–1768)
Lg. of Hesse-Darmstadt 1739

FRIEDRICH II (1720–1785)
Lg. of Hesse-Kassel 1760
∞
A) 1740
Mary of Great Britain (1723–1772)

LUDWIG IX (1719–1790)
Lg. of Hesse-Darmstadt 1768
∞
A) 1741
Caroline of Zweibrücken-Birkenfeld (1721–1774)

A) WILHELM IX (I) (1743–1821)
Lg. of Hesse-Kassel 1785,
Elector of Hesse 1803–1806, 1813

A) Friedrich (1747–1837)
Lg. of Hesse-Kassel-Rumpenheim 1806

LUDEWIG X (I) (1753–1830)
Lg. of Hesse-Darmstadt 1790,
GD of Hesse 1806

Wilhelmine of Hesse-Darmstadt
(1755–1776)
∞
1773
PAUL I (1754–1801) Tsar of Russia 1796

WILHELM II (1777–1847)
Elector of Hesse 1821, abdicated 1831
∞
A) 1797
Auguste of Prussia (1780–1841)
B) 1841
Emilie Ortlöpp (1791–1843)
Countess of Reichenbach-Lessonitz 1821 (morganatic)

Wilhelm (1787–1867)
Lg. of Hesse-Kassel-Rumpenheim 1837

LUDWIG II (1777–1848)
GD of Hesse 1830

A) FRIEDRICH WILHELM I (1802–1875)
Co-regent 1831, Elector of Hesse 1847–1866
∞
1831
Gertrud von Lehmann (1803–1882)
Countess of Schaumburg 1831,
Princess of Hanau 1853 (morganatic)

FRIEDRICH WILHELM (1820–1884)
Lg. of Hesse-Kassel
∞
A) 1844
Alexandra Nicolaievna of Russia (1825–1844)
B) 1853
Anna of Prussia (1836–1918)

LUDWIG III (1806–1877)
GD of Hesse 1848

Karl of Hesse (1809–1877)
∞
Elisabeth of Prussia (1815–1885)

LUDWIG IV (1837–1892)
GD of Hesse 1877
∞
1862
Alice of Great Britian (1843–1878)

B) FRIEDRICH KARL (1868–1940)
Lg. of Hesse-Kassel 1884
∞
1893
Margarethe of Prussia (1872–1954)

Victoria of Hesse-Darmstadt
(1863–1884)
∞
1884
Ludwig of Battenberg (1854–1921)

Elisabeth of Hesse-Darmstadt
(1864–1918)
∞
1884
Sergei of Russia (1857–1905)

PHILIPP (1896–1980)
Lg. of Hesse-Kassel 1940
∞
1925
Mafalda of Savoy (1902–1944)

Wolfgang of Hesse-Kassel
(1896–1989)

Christoph of Hesse-Kassel
(1901–1943)
∞
1943
Sophia of Greece (1914–2001)

ERNST LUDWIG (1868–1937)
GD of Hesse 1892–1918
∞
A) 1894–1901
Victoria Melita of Saxe-Coburg-Gotha (1876–1936)
B) 1905
Eleonore of Solms-Hohensolms-Lich (1871–1937)

Alix of Hesse-Darmstadt (1872–1918)
∞
1894
NICOLAS II (1868–1918) Tsar of Russia 1894–1917

MORITZ (b. 1926),
Lg. of Hesse 1980
∞
1964
Tatiana of Sayn-Wittgenstein-Berleburg (b. 1940)

Heinrich of Hesse (1927–1999)

Rainer of Hesse (b. 1939)

A) Elisabeth of Hesse-Darmstadt
(1895–1903)

B) GEORG DONATUS (1906–1937)
Crown GD of Hesse
∞
1931
Cécile of Greece (1911–1937)

B) LUDWIG of Hesse
(1908–1968)
∞
1937
Margaret Campbell-Geddes
(1913–1997)

Mafalda (b. 1965)

Donatus of Hesse (b. 1966)
∞
2003
Floria of Faber-Castell (b. 1974)

Elena (b. 1967)

Philipp (b. 1970)

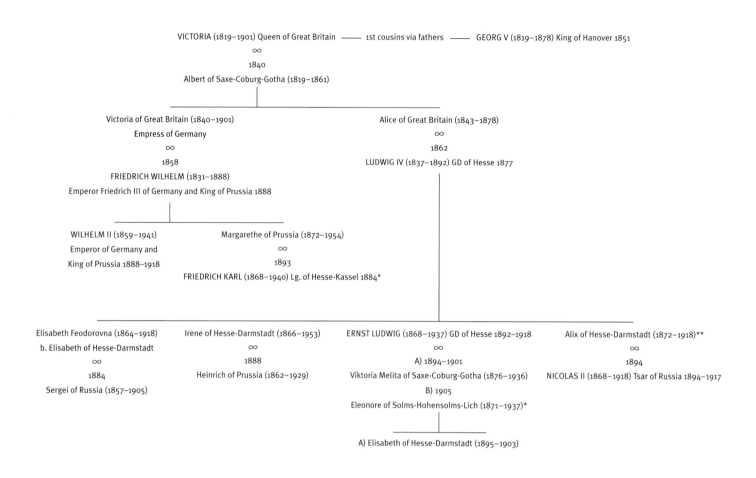

VICTORIA (1819–1901) Queen of Great Britain —— 1st cousins via fathers —— GEORG V (1819–1878) King of Hanover 1851
∞
1840
Albert of Saxe-Coburg-Gotha (1819–1861)

Victoria of Great Britain (1840–1901)
Empress of Germany
∞
1858
FRIEDRICH WILHELM (1831–1888)
Emperor Friedrich III of Germany and King of Prussia 1888

Alice of Great Britain (1843–1878)
∞
1862
LUDWIG IV (1837–1892) GD of Hesse 1877

WILHELM II (1859–1941)
Emperor of Germany and
King of Prussia 1888–1918

Margarethe of Prussia (1872–1954)
∞
1893
FRIEDRICH KARL (1868–1940) Lg. of Hesse-Kassel 1884*

Elisabeth Feodorovna (1864–1918)
b. Elisabeth of Hesse-Darmstadt
∞
1884
Sergei of Russia (1857–1905)

Irene of Hesse-Darmstadt (1866–1953)
∞
1888
Heinrich of Prussia (1862–1929)

ERNST LUDWIG (1868–1937) GD of Hesse 1892–1918
∞
A) 1894–1901
Viktoria Melita of Saxe-Coburg-Gotha (1876–1936)
B) 1905
Eleonore of Solms-Hohensolms-Lich (1871–1937)*

Alix of Hesse-Darmstadt (1872–1918)**
∞
1894
NICOLAS II (1868–1918) Tsar of Russia 1894–1917

A) Elisabeth of Hesse-Darmstadt (1895–1903)

* See Hesse Family Tree
** See Hesse-Romanov Family Tree

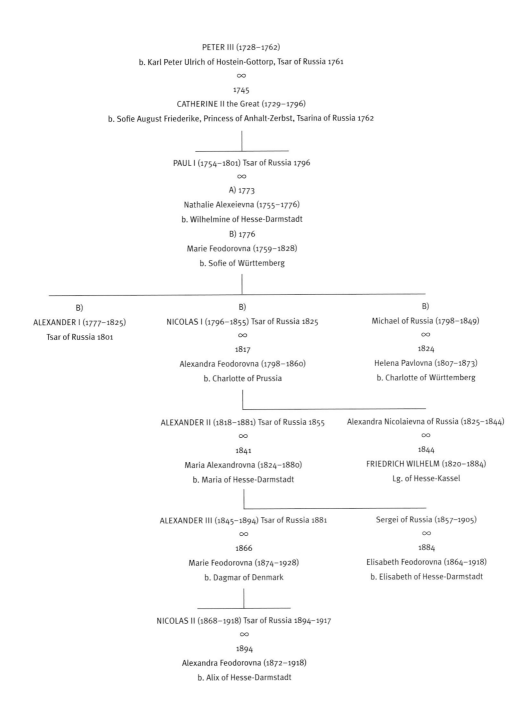

PETER III (1728–1762)
b. Karl Peter Ulrich of Hostein-Gottorp, Tsar of Russia 1761
∞
1745
CATHERINE II the Great (1729–1796)
b. Sofie August Friederike, Princess of Anhalt-Zerbst, Tsarina of Russia 1762

PAUL I (1754–1801) Tsar of Russia 1796
∞
A) 1773
Nathalie Alexeievna (1755–1776)
b. Wilhelmine of Hesse-Darmstadt
B) 1776
Marie Feodorovna (1759–1828)
b. Sofie of Württemberg

B)
ALEXANDER I (1777–1825)
Tsar of Russia 1801

B)
NICOLAS I (1796–1855) Tsar of Russia 1825
∞
1817
Alexandra Feodorovna (1798–1860)
b. Charlotte of Prussia

B)
Michael of Russia (1798–1849)
∞
1824
Helena Pavlovna (1807–1873)
b. Charlotte of Württemberg

ALEXANDER II (1818–1881) Tsar of Russia 1855
∞
1841
Maria Alexandrovna (1824–1880)
b. Maria of Hesse-Darmstadt

Alexandra Nicolaievna of Russia (1825–1844)
∞
1844
FRIEDRICH WILHELM (1820–1884)
Lg. of Hesse-Kassel

ALEXANDER III (1845–1894) Tsar of Russia 1881
∞
1866
Marie Feodorovna (1874–1928)
b. Dagmar of Denmark

Sergei of Russia (1857–1905)
∞
1884
Elisabeth Feodorovna (1864–1918)
b. Elisabeth of Hesse-Darmstadt

NICOLAS II (1868–1918) Tsar of Russia 1894–1917
∞
1894
Alexandra Feodorovna (1872–1918)
b. Alix of Hesse-Darmstadt

READINGS

Adamson, James, ed. *The Princely Courts of Europe: Ritual, Politics and Culture under the Ancien Régime, 1500–1750.* London: Weidenfeld & Nicolson; New York: Distributed in the United States of America by Sterling Pub., 1999.

Atwood, Rodney. *The Hessians: Mercenaries from Hessen-Kassel in the American Revolution.* Cambridge: Cambridge University Press, 1980.

Aufklärung und Klassizismus in Hessen-Kassel unter Landgraf Friedrich II, 1760–1785. Exh. cat. Kassel: Verein für Publikationen, 1979.

Babelon, Jean Pierre, and Claire Constans. *Versailles: Absolutism and Harmony.* New York: Vendome Press, 1998.

Böhm, Uwe Peter. *Hessisches Militär: Die Truppen der Landgrafschaft Hessen-Kassel 1672–1806.* Beckum: Volgel-Druck, 1986.

Boime, Albert. Vol. 1, *Art in an Age of Revolution, 1750–1800,* and Vol. 2, *Art in an Age of Bonapartism, 1800–1815,* in A Social History of Modern Art Series. Chicago: University of Chicago Press, 1990

Borggrefe, Heiner, Vera Lüpkes, and Hans Ottomeyer. *Moritz der Gelehrte: Ein Renaissancefürst in Europa.* Eurasburg: Edition Minerva, 1997.

Brinkman, Bodo, et al. *Hans Holbeins Madonna im Städel.* Fulda: Michael Imhof, 2004.

Buck, Stephanie, and Jochen Sander. *Hans Holbein the Younger: Painter at the Court of Henry VIII.* New York: Thames & Hudson, 2004.

Campbell, Stephen J., ed. *Artists at Court: Image-Making and Identity 1300–1550.* Chicago: University of Chicago Press, distributed for the Isabella Stewart Gardner Museum, 2005.

Christ, Alexa-Beatrice. *Kelsterbacher Porzellan: Der Bestand der Grossherzoglich-Hessischen Porzellansammlung Darmstadt.* Stuttgart: Arnoldsche Art Publishers, 2004.

Christensen, Carl C. *Art and the Reformation in Germany.* Vol. 2 of *Studies in the Reformation.* Athens: Ohio University Press, 1979.

Corpus Vasorum Antiquorum, Deutschland. Vols. 11 and 16. Munich: Beck, 1956–1959.

Craske, Matthew. *Art in Europe 1700–1830.* Oxford: Oxford University Press, 1997.

Das kulturelle Erbe des Hauses Hessen. Marburg: Historische Kommission für Hessen, 2002.

Die Künstlerfamilie Nahl: Rokoko und Klassizismus in Kassel. Exh. cat. Kassel: Staatliche Museen, 1994.

Die Mitgift einer Zarentochter: Meisterwerke russischer Kunst des Historismus aus dem Besitz der Hessischen Hausstiftung Museum Schloß Fasanerie. Exh. cat. Eurasburg: Edition Minerva, 1997.

Dippel, Horst. *Germany and the American Revolution, 1770–1800: A Socio-historical Investigation of Late Eighteenth-Century Political Thinking.* Translated by Bernard A. Uhlendorf. Chapel Hill: University of North Carolina Press, 1979.

Dobler, Andreas, et al. *Im Schatten der Krone: Viktoria Kaiserin Friedrich 1840–1901, Ein Leben mit der Kunst.* Exh. cat. Petersberg: Michael Imhof, 2001.

Greber, Josef Maria. *Abraham und David Roentgen: Möbel für Europa : Werdegang, Kunst und Technik einer deutschen Kabinett-Manufaktur.* Starnberg: J. Keller, 1980.

Greenhalgh, Paul. *Art Nouveau, 1890–1914.* New York: Harry N. Abrams, 2000.

Habsburg, Geza von. *Fabergé: Imperial Jeweler.* New York: Harry N. Abrams, 1994.

Hans Holbein the Younger 1497/98–1543: Portraitist of the Renaissance. Exh. cat. The Hague: Royal Cabinet of Paintings Mauritshuis; Zwolle: Waanders, 2003.

Heinz, Marianne, ed. *Johann Martin von Rohden, 1778–1868.* Exh. cat. Kassel: Staatliche Museen; Wolfrathshausen: Edition Minerva, 2000.

Heller, Carl Benno, and Wolfgang Glüber, with a contribution from Otto Böcher. *Ernst Riegel: Goldschmied zwischen Historismus und Werkbund.* Exh. cat. Heidelberg: Kehrer Verlag, 1996.

Hernmarck, Carl. *The Art of the European Silversmith 1430–1830.* New York: Sotheby Parke Bernet, 1979.

Hessen, Ludwig Prinz von, and Ernst Hofmann. *Kostbarkeiten aus dem Schloßmuseum in Darmstadt.* Darmstadt: Eduard Roether, 1964.

Hessen, Rainer von, ed. *Victoria Kaiserin Friedrich: Mission und Schicksal einer englischen Prinzessin in Deutschland.* Frankfurt am Main: Campus Verlag, 2002.

Hessen, Rainer von, ed. *Wir Wilhelm von Gottes Gnaden: Die Lebenserinnerungen Kurfürst Wilhelms I. von Hessen 1743–1921.* Frankfurt and New York: Campus Verlag, 1996.

Honour, Hugh. *Goldsmiths & Silversmiths.* New York: G. P. Putnam's Sons, 1971.

Huth, Hans. *Roentgen Furniture: Abraham and David Roentgen, European Cabinet-Makers.* New York: Sotheby Parke Bernet, 1974.

Interieurs der Biedermeierzeit: Zimmeraquarelle aus fürstlichen Schlössern im Besitz des Hauses Hessen. Exh. cat. Fulda: Michael Imhof, 2004.

Jedding, Hermann. *Europäishes Porzellan.* Vol. 1 of *Von den Anfängen bis 1800.* Munich: Keyser, 1975.

Knodt, Manfred. *Die Regenten von Hessen-Darmstadt.* Darmstadt: H. L. Schlapp, 1976.

Königliches Porzellan aus Frankreich: Sammlerstücke und Service der Manufaktur Vincennes/Sèvres. Exh. cat. Fulda: Rindt, 1999.

Kreisel, Heinrich. *Prunkwagen und Schlitten.* Leipzig: K. W. Hiersemann, 1927.

Kreisel, Heinrich, and Georg Himmelhaber. *Die Kunst des deutschen Möbels.* Vols. 1–3. Munich: Beck, 1981–1983.

Krönig, Wolfgang, and Reinhard Wegner. *Jakob Philipp Hackert: Der Landschaftsmaler de Goethezeit.* Cologne: Böhlau, 1994.

Lauer, Bernhard, ed. *Kurfürstin Auguste von Hessen (1780–1841) in ihrer Zeit.* Kassel: Brüder Grimm-Gesellschaft, 1995.

Lowell, Edward J. *The Hessians and the Other German Auxiliaries of Great Britain in the Revolutionary War.* Edited by Raymond J. Andrews. Williamston, MA: Corner House Pub., 1970.

Märker, Peter. *Carl Philipp Fohr: Romantik, Landschaft und Historie.* Exh. cat. Heidelberg: Keher Verlag; Darmstadt: Das Museum, 1995.

Morley Fletcher, Hugo. *The Pfleuger Collection of Early European Porcelain and Faience.* Vol. 1 of *German Porcelain.* London: Christie's, 1995.

Mosser, Monique, and Georges Teyssot, eds. *The History of Garden Design: The Western Tradition from the Renaissance to the Present Day.* London and New York: Thames & Hudson, 2000.

Müller, Hans Wolfgang. "Isis mit dem Horuskinde: Ein Beitrag zur ikonograpie der stillenden Gottesmutter im hellenistischen und römischen Ägypten." *Münchner Jahrbuch der bildenden Kunst* XIV, 3, 1963: 7–38.

Munn, Geoffrey C. *Tiaras: A History of Splendour.* Woodbridge, Suffolk: Antique Collectors' Club, 2001.

Museum Künstlerkolonie Darmstadt. Darmstadt: Institut Mathildenhöhe Darmstadt, 1990.

Neuhaus, Rainer, and Ekkehard Schmidberger. *Kasseler Silber.* Eurasburg: Edition Minerva, 1998.

Ormond, Richard, and Carol Blackett-Ord. *Franz Xaver Winterhalter and the Courts of Europe, 1830–70.* New York: Harry N. Abrams, 1992.

Pivka, Otto von. *Napoleon's German Allies: Hessen-Darmstadt and Hessen-Kassel.* Vol. 122 of Men-at-Arms Series. Reading: Osprey Publishing, 1975.

Polyklet: Der Bildhauer der griechischn Klassik. Exh. cat. Mainz am Rhein: P. Von Zabern, 1990.

Reeder, Ellen D., et al. *Pandora: Women in Classical Greece.* Exh. cat. Baltimore: Trustees of the Walters Art Gallery in association with Princeton University Press, 1995.

Rogasch, Wilfried. *Schatzhäuser Deurtschlands; Kunst in adligem Privatbesitz*. Exh. cat. Munich: Prestel, 2004.

Sander, Jochen. *Hans Holbein d. J. Tafelmaler in Basel, 1515–1532*. Munich: Hirmer, 2005.

Scaglione, Aldo. *Knights at Court: Courtliness, Chivalry, & Courtesy from Ottonian Germany to the Italian Renaissance*. Berkeley: University of California Press, 1992.

Schulze, Hagen. *Germany: A New History*. Cambridge, MA: Harvard University Press, 1998.

Seelig, Lorenz. *Silver and Gold: Courtly Splendor from Augsburg*. Munich: Prestel, 1995.

Sembach, Klaus-Jurgen. *Art Nouveau*. Cologne: Taschen, 2002.

Thacker, Christopher. *The History of Gardens*. Reprint, Berkeley: University of California Press, 1985.

Vaughn, William. *German Romantic Painting*. 2nd ed. Boston: Yale University Press, 1994.

Wackernagel, Rudolf H., ed. *Staats- und Galawagen der Wittelsbach: Kutschen, Schlitten und Sänften aus dem Marstallmuseum Schloß Nymphenburg*. 2 vols. Stuttgart: Arnoldsche Art Publishers, 2002.

Wegner, Karl-Hermann. *Kurhessens Beitrag für das heutige Hessen*. Wiesbaden: Hessische Landezentrale für Politische Bildung, 1999.

Zeepvat, Charlotte. *Queen Victoria' s Family: A Century of Photographs*. Stroud: Sutton Publishing, 2001.

contributors

ANDREAS DOBLER earned his M.A. in Art History and Classical Archaeology from the Friedrich-Alexander University in Erlangen. He has been Registrar and Director of Personnel at the Museum Schloss Fasanerie, Hessian House Foundation, in Eichenzell, since 1989.

RAINER VON HESSEN is the second son of Prince Christoph of Hesse (the youngest brother of Landgraf Philipp) and Princess Sophie of Greece. He is a historian and a board member of both the Historische Kommission für Hessen and the Hessische Hausstiftung. His publications include *Wir Wilhelm von Gottes Gnaden: Die Lebenserinnerungen Kurfürst Wilhelms I. von Hessen 1743–1821* (1996) and *Victoria Kaiserin Friedrich (1840–1901): Mission und Schicksal einer englischen Prinzessin in Deutschland* (2002).

PENELOPE HUNTER-STIEBEL is Curator of European Art at the Portland Art Museum and is responsible for the exhibitions and catalogues *Stroganoff: The Palace and Collections of a Russian Noble Family* (2000); *Stuff of Dreams: Matières de Rêves from the Paris Musée des Arts Décoratifs* (2002); and *Triumph of French Painting: 17th Century Masterpieces from the Museums of FRAME* (2003). A former curator at the Metropolitan Museum of Art, she joined its Department of Western European Arts and subsequently transferred to its Department of Twentieth-Century Art. From 1986 to 2000 she was a principal of Rosenberg & Stiebel gallery in New York City. She holds an M.A. from the Institute of Fine Arts of New York University.

CHRISTINE KLÖSSEL received her M.A. from the Georg-August Universität in Göttingen and archival training in Cologne. Since 1995 she has been Director of the Hessian House Foundation Archives at the Schloss Fasanerie in Eichenzell.

CLAUDIA MECKEL is Curator of the Prussian Royal House collection of coaches, sedans, and wagons at the Foundation of Prussian Castles and Gardens in Potsdam and Berlin.

DR. MARKUS MILLER is Director of the Museum Schloss Fasanerie in Eichenzell and Curator of the Hessian House Collections. He received his doctorate from the Ludwig-Maximilian University, Munich, and has worked at the Foundation of Prussian Castles and Gardens in Potsdam and Berlin and at the Landesmuseum in Darmstadt. Among the exhibitions and catalogues for which he has been responsible at the Fasanerie are *Im Shatten der Krone: Victoria Kaiserin Friedrich, 1840–1901, Erin Leben mit der Kunst* (2001) and *Interieurs der Biedermeierzeit* (2004).

PROFESSOR DR. JOCHEN SANDER received his doctorate in Art History from the University of Bochum and is an art historian of the late Middle Ages and early Modern period in the Netherlands, Germany, and Italy. His dissertation was published as *Hugo van der Goes: Stilentwicklung und Chronologie* (1992). Since 1988 he has worked at the Städel Art Institute in Frankfurt and became Director of its Department of Paintings in 1991. Professor Sander has published several works on Hans Holbein the Younger.

JOANN M. SKRYPZAK is completing her dissertation in Art History, "Sporting Modernity: Artists and the Athletic Body in Germany, 1918–1935," at the University of Wisconsin-Madison. In 2003 she curated the exhibition *Design, Vienna 1890s to 1930s* for the Elvehjem Museum in Madison, Wisconsin. Since 2004 she has lived in Cologne.

Published on the occasion of *Hesse: A Princely German Collection* in conjunction with the exhibition organized by the Portland Art Museum, Oregon, in cooperation with the Hessische Hausstiftung.

Portland Art Museum, Oregon
October 29, 2005–March 19, 2006

Support for this catalogue has been made possible by Ann and Bill Swindells.

Major funding for the exhibition provided by

Marty and Kay Brantley
Wells Fargo
Lufthansa
Freightliner Corporation
Margulis Jewelers
Mario's
Maybelle Clark Macdonald Fund
Oregon Patrons for the Vatican Museums
Andrée Stevens
Peter and Julie Stott
Katrina and Ted Wheeler
Don and Mary Frisbee
Janet and Richard Geary
Ronna and Eric Hoffman
John and Willie Kemp
Helen Jo and Bill Whitsell
Fidelity National Title Company of Oregon
Pacific Coast Restaurants
Christie's
The Boeing Company
Stimson Lumber Company

Additional support provided by an indemnity from the Federal Council on the Arts and Humanities.

Library of Congress Cataloging-in-Publication Data
Hunter-Stiebel, Penelope, 1946–
 Hesse : a princely German collection / Penelope Hunter-Stiebel ; with forewords by H.R.H. Moritz Landgraf of Hesse and John E. Buchanan, Jr.
 p. cm.
 Includes bibliographical references.
 ISBN 1-883124-20-4 (hardcover : alk. paper) — ISBN 1-883124-21-2 (softcover : alk. paper)
 1. Art, European—Exhibitions. 2. Hesse family—Art collections—Exhibitions. 3. Royal houses—Germany—Art collections—Exhibitions. 4. Art—Private collections—Germany—Hesse—Exhibitions. 5. Hesse family—History. I. Portland Art Museum (Or.). II. Title.
N6750.H86 2005
709'.4'07479549—dc22 2005020025

Published by
Portland Art Museum, Oregon

Distributed by
University of Washington Press
P.O. Box 50096
Seattle, WA 98145-5096
www.washington.edu/uwpress

Cover: 17th-century German gilded silver pineapple cups (see p. 21)
Page i: *Gala Berlin Coach of Landgraf Ludwig VIII of Hesse-Darmstadt,* ca. 1750 (detail, see p. 39); background: Joseph Maria Olbrich, *Embroidered Wall Hanging,* 1902–1904 (detail, see p. 180)
Pages ii–iii: Carl Philipp Fohr, *View of Zwingenberg on the Neckar,* 1815–1816 (detail, see p. 124)
Pages iv–v: Guest Wing, Castle Fasanerie
Page vi: Johann August Nahl the Younger, *The Rape of Ganymede on Mount Ida,* 1805 (detail, see p. 115)
Page viii: Johann Heinrich Tischbein the Elder, *Landgraf Friedrich II of Hesse-Kassel Heron Hunting with Falcons,* 1766 (detail, see p. 78)
Pages xvi–xvii: Johann Heinrich Tischbein the Elder, *Pastoral Festival in Freienhagen near Kassel,* 1766 (detail, see p. 54)
Pages xviii–xix: Grand Salon, Castle Wolfsgarten
Page xxii: Hans Holbein the Younger, *The Madonna with Basel Mayor Jakob Meyer and his Family,* 1525–1526 and 1528 (see p. 213)
Pages xxvi–xxvii: *Gilded Table Clock* (see p. 14) and 17th-century books
Pages 34–35: Heron Salon, Castle Fasanerie
Pages 70–71: Rotunda, Castle Kranichstein, Hessian Museum of the Hunt
Pages 94–95: Throne Salon, Castle Fasanerie
Pages 130–31: Philippsruhe Room, Castle Fasanerie
Pages 168–69: Mathildenhöhe (with Wedding Tower on left), Darmstadt
Pages 196–97: Terrace, Castle Fasanerie
Pages 222–23: Castle Friedrichshof
Page 226: View from Inner Courtyard toward Allée, Castle Fasanerie
Page 227: Terrace Bell Tower, Castle Fasanerie

Translated by Joann M. Skrypzak
Edited by Melissa Duffes
Proofread by Laura Iwasaki and Susan Egger
Designed by Jeff Wincapaw
Map by Jennifer Shontz
Separations by iocolor, Seattle
Produced by Marquand Books, Inc., Seattle
 www.marquand.com
Printed and bound by CS Graphics Pte., Ltd., Singapore